Adv

The Cheerful Subversive

MW00574365

"Dan Mirvish is a true pioneer of the independent spirit, with one foot in a hot tub and the other on a mountain top, he plants his flag somewhere between heaven and hell. In the great independent tradition of father John Cassavetes, Dan does what he has to do to exist in the inhospitable world of the true independent film artist."

—Alexandre Rockwell, Sundance award-winning director of *In the Soup*; Associate Arts Professor/Academic Director, NYU Tisch School of the Arts

"Hands down the most fun book on filmmaking I've read. I wish this book existed when I first started making films."

—Caveh Zahedi, Gotham award-winning director of *I Am a Sex Addict*; Assistant Professor of Screen Studies, The New School

"The last 25 years has been the most turbulent period in the film industry's history and Dan has continued to navigate through it and survive. He is a legitimate insider with a wealth of information and knowledge."

—Sean Baker, Spirit and Gotham award-winning director of *Tangerine, Starlet* and *Take Out*

"Dan Mirvish's experience along with his intelligence and humor makes *The Cheerful Subversive's Guide to Independent Filmmaking* indispensable in the library of every filmmaker. If you have a budget for only one book, this is the one."

—Patricia Cardoso, Sundance award-winning director of *Real Women Have Curves*; adjunct faculty at USC School of Cinematic Arts

"Spend your hard-earned cash on Dan's book, read it, then go make your movie."

—Matthew Harrison, Sundance award-winning film and TV director of *Rhythm Thief* and *Sex and the City*; UCLA Extension instructor

"Essential reading for all working filmmakers: Equally applicable to traditional indie filmmaking, and also the brave new world of digital content creators working at any level, from YouTube to network TV."

—Jon Reiss, award-winning director of *Better Living Through Circuitry*; author of *Think Outside the Box Office*; film directing faculty at CalArts

"If making a feature film is your dream, but nobody is banging on your door to offer you a deal, *The Cheerful Subversive's Guide to Independent Filmmaking* is an invaluable guide on how to never take 'no' for an answer and make it happen yourself. Dan Mirvish demystifies the nitty-gritty aspects of making your own film with enthusiastic DIY flair."

—Claire Carré, Gotham award-nominated writer/director of *Embers*

"Dan Mirvish is Hollywood's Merry Prankster—a guerrilla filmmaking guru whose wisdom and insights are as valuable as they are entertaining."

—Kevin DiNovis, Slamdance award-winning director of *Surrender Dorothy;* writing faculty, New York Film Academy

"An extremely realistic (not to mention funny) look at how to make a truly memorable independent film, or at least have fun trying! Dan's insight into the independent film world is invaluable, mostly because he's made all the mistakes he wants you to avoid."

—Stephen Dest, award-winning filmmaker of *My Brother Jack*; Professor of Film Studies, University of Connecticut

"*The Cheerful Subversive's Guide to Independent Filmmaking* explains the current independent film industry from a producer–director's perspective in a thorough yet highly accessible manner that is sorely lacking in most film industry books."

—Robert L. Seigel, veteran New York entertainment attorney

"Unlike most authors of filmmaking books, Dan Mirvish has made several feature films, he has been to dozens of festivals with his movies, he has negotiated countless deals with representatives and he has founded and run his own major film festival. I can't think of any other writer of filmmaking books that has that pedigree."

—Marc Pilvinsky, veteran film and video editor

The Cheerful Subversive's Guide to Independent Filmmaking

Award-winning film director and Slamdance Film Festival co-founder Dan Mirvish offers a rich exploration of the process and culture of making low-budget, independent films. Once labeled a "cheerful subversive" by *The New York Times*, Mirvish shares his unfiltered pragmatic approach to writing or acquiring screenplays, casting and directing both A-list and no-list actors, financing, producing, managing a crew, post-production, navigating the film festival circuit without going broke, distributing your film, mounting an Oscar® campaign, dealing with piracy and building a career.

Mirvish gives you soup-to-nuts, cradle-to-grave detailed advice on every aspect of the filmmaking lifestyle and craft while dropping laser-guided truth bombs on playing the Hollywood game, and getting your feature, documentary, short film, YouTube video, TV show or big-budget blockbuster seen.

Filled with sidebar articles, photos, illustrations and even hilarious and insightful poems, *The Cheerful Subversive's Guide to Independent Filmmaking* draws on Dan's own quarter-century of experiences in the trenches of indie filmmaking. He also includes poignant lessons he's learned personally from such luminaries as Robert Altman, Christopher Nolan, Emma Thomas, Steven Soderbergh, Rian Johnson, Alexander Payne, Marc Forster, Whit Stillman, Harold Ramis, John Carpenter, Jon Bokenkamp, Lynn Shelton, Joe & Anthony Russo and many, many more.

An extensive companion website at www.DanMirvish.com features in-depth supplemental videos that dovetail chapters in the book, hours of behind-the-scenes footage from Dan's films, festival resources, bonus material and timely updates.

Mentored by Robert Altman, **Dan Mirvish**'s first film, *omaha (the movie)*, led to the founding of the Slamdance Film Festival as an alternative to Sundance. Dan's movie *Open House* forced the Academy Awards® to rewrite its rules, and Dan co-wrote the critically-acclaimed novel *I Am Martin Eisenstadt*. Dan's award-winning film *Between Us* played in 23 festivals and sold to 144 countries, and his newest film is *Bernard and Huey,* scripted by the legendary Jules Feiffer.

The Cheerful Subversive's Guide to Independent Filmmaking

Dan Mirvish

Routledge
Taylor & Francis Group

NEW YORK AND LONDON

First published 2017
by Routledge
711 Third Avenue, New York, NY 10017

and by Routledge
2 Park Square, Milton Park, Abingdon, Oxon OX14 4RN

Routledge is an imprint of the Taylor & Francis Group, an informa business

Cheerful Subversive logo by Dan Mirvish

Library of Congress Cataloging in Publication Data
A catalog record for this book has been requested

ISBN: 978-1-138-18513-5 (hbk)
ISBN: 978-1-138-18512-8 (pbk)
ISBN: 978-1-31728-987-6 (ebk)

Typeset in Times New Roman
by Keystroke, Neville Lodge, Tettenhall, Wolverhampton

Printed and bound in the United States of America by Publishers Graphics, LLC on sustainably sourced paper.

Dedicated to

Dr. Sidney S. Mirvish

Family man, scientist, outdoorsman, film investor

Table of Contents

Preface

Making a movie is like making stone soup. You start with a stone, and then you persuade everyone you meet to keep adding ingredients: a pot, water, vegetables, spices, chicken, dumplings, etc. When you're done, they will have forgotten that you started with nothing more than an inedible rock, and all everyone will remember is how delicious your stone soup is. Likewise, to make an independent film, you don't need to start with connections, money, talent or even skills. You just need a stone, and the relentless persistence to turn it into soup.

If you're considering buying this book, please do. As you'll see when you keep reading, making independent films is a financially unsustainable proposition. At best, the IRS will consider it a glorified hobby. Your family will consider it a distraction from getting a real job. The Securities and Exchange Commission will consider it borderline criminal. The only way I've continued to survive as an indie filmmaker is to write the occasional book and hope people buy them. So please do.

But *why* should you buy it, and really, *who* should buy it? I've written this book from the perspective that you, the savvy independent filmmaker, already have some preexisting background in filmmaking. You know that you need some sort of a script. You know that you'll need some kind of a camera. You realize that you'll need to edit your film and put in some sound. And you probably know that film festivals are a good way for people to see your movie.

I'd like to think I have a little bit to offer filmmakers of all experience levels, from first-time YouTubers and short filmmakers, to seasoned vets still slugging it out on the festival circuit. What I have is the slightly skewed perspective of what a real indie filmmaker has to do to cajole, con, workaround, psyche-out, out-fox, weasel and otherwise game the system to get your films made and seen. Everything from how to parlay bagels and lox into a screenplay by a Pulitzer/ Oscar/Obie winner; how to get an A-list cast in your microbudget film; how to get into a world-class film festival (or at least how to make your own); and how to get distribution for your film based on *not* winning an Academy Award.

One assumption I make is that you, dear reader, are the sort of filmmaker who is quite likely the director of your movies, perhaps in addition to wearing several other hats, like producer, screenwriter, actor, cinematographer and/or craft service. The kind of movies I'm primarily talking about are narrative feature-length films, made for well under a million dollars, and more often than not, well under a hundred thousand, or even a tenth of that. Broadly speaking, I come more from the perspective of "festival" films, rather than strict genre films (though be sure to check out my Philippine kickboxing movie stories). There are still *many* interesting anecdotes and lessons in here that will be relevant to those of you making short films, documentaries, animation, web series, TV pilots, studio blockbusters, commercials, industrials, music videos, Vines and yes, low-budget kickboxing movies.

By way of advance warning, this book is not for the faint of heart. It is by turns offensive, naughty, rude, puerile, suggestive, salacious and most probably sexist, racist, ageist and heightist. On behalf of myself and my publisher, I would like to apologize in advance for offending you. Though I offer extensive advice on legal, accounting, securities and insecurities matters, please keep in mind that I most definitely am neither a trained nor licensed lawyer, accountant, business advisor or psychiatrist. So, do your own research to see what the latest laws and regulations are. Of course, if you're already *in* prison, this book should be a good way to pass the time.

Many of the chapters in here originally were written as articles that appeared in *Filmmaker Magazine* (particularly the casting and film festivals ones), and also some in *IndieWire*, *FilmThreat* and *The Huffington Post*. I've edited and updated them as necessary. I've also included original and topical poems that I recite every year, usually on opening night of the Slamdance Film Festival and primarily addressed to the new crop of filmmakers. I've included them in more of a contextual order rather than sequential, and with almost no editing from their original versions as delivered in Park City. So if they don't make sense or rhyme very well, that's why.

After interviewing me for a story about the birth of Slamdance, the festival I co-founded, *The New York Times* referred to us as "a group of cheerful subversives." (Fifteen years later, the *Times* would refer to me on the front page of its Arts Section as "an obscure filmmaker." Progress!) So with the spirit of cheerful subversiveness imbuing pretty much my entire career, I give you this book. It's based very largely on my own rather modest body of work (most of which you've probably never seen) and the many articles I've written (most of which you probably haven't read).

Acknowledgments

Many thanks to my supportive family, Rachel, Rebecca, Jonathan and Mimi, without whom I wouldn't have a life, love or illustrations (Jonathan did the portraits, and Mimi did the other drawings). To my mother, Lynda Mirvish, for her years of copywriting and cookies. To my sister, Leora, for her support, and all my wonderful in-laws: Alice, Charles, Marty, Erika, Brendan, Lily and Liam. To my indie filmmaker pals, Matthew Harrison, Paul Rachman, Eugene Martin, Kevin DiNovis, Dana Altman, Frank Hudec, Darryl Wharton-Rigby, Debra Eisenstadt, Eitan Gorlin, Jon Reiss, Whit Stillman, Anthony Artis, Richard Schenkman, Liz Jereski, Matt Smith, Mike Ryan and so many more. To Peter Baxter and the entire Slamdance community. To Lise Raven for exceptional peer reviewing. To my team of hot sweaty young interns toiling in the garage. To my lawyer, Bob Seigel, for keeping me out of jail. To Jun Park and the Spot Café & Lounge in Culver City which miraculously turns caffeine into prepositional phrases. Speaking of the Spot, in which I last ran into him, I still hear the late Scott Shuger (my old *Washington Monthly* editor) encouraging me to write more non-fiction. To the editors and staff at Focal Press (Peter Linsley, Emily McCloskey, David Williams and Galen Glaze) as well as the colourful [sic] British team at Routledge and Keystroke (Emily Boyd, Kelly Winter, Maggie Lindsey-Jones, Sarah Lindsey-Jones, Tracey Preece, Sioned Jones, and Hamish Ironside), thanks for your endless patience with me. To *Filmmaker Magazine*'s Scott Macaulay for his years of publishing my (frequently self-serving) articles and encouragement in turning them into a book. Also, thanks to Dana Harris and Eric Kohn at *IndieWire*, Chris Gore and Mark Bell of *FilmThreat* and Arianna Huffington of her little eponymous blog for all allowing me to reuse my old articles. And of course, to my manager/publicist, Eli Perle, and his crack team at Provocation Entertainment, for their undying devotion to me over so many years. You crush it, Eli. Now get me some real work!

Getting Started

Write a Brilliant Script!

Do you have something *important* to say that can only be expressed as a series of moving images and sound? Did you have a peyote-dosed fever dream at Burning Man that you absolutely *must* share with the rest of the world? Or maybe you and your high school YouTube pals are just *so* friggin' funny that your destiny is to quit your Starbucks barista job so you can change the face of cinema for all eternity? Fair enough! Then it's time to make your first indie film!

The first step is to write a brilliant script. Now, I'm not going to sit here and tell you how to write a brilliant script. If I knew how to do that, I'd be writing one myself instead of writing this book. But what I can tell you is what not to do.

Figure out what your favorite movies have been for the last five years and then come up with something completely different. The worst rookie mistake first-time indie filmmakers can make is to remake the last hot indie films they've seen. If you're even *thinking* of making a found-footage film about six friends who sit around taking drugs and talking endlessly about how they're going to film themselves robbing a haunted zombie bank, please stop. And go beg to get your job back at Starbucks.

Now, it doesn't mean that you have to completely reinvent the wheel and come up with an absolutely original form of cinematic storytelling. But the more familiar the story, characters or plot you have in your film, the higher the bar is for your dialogue, filming, editing or other aesthetic techniques to be unequivocally excellent and original. Likewise, the more mundane your technical execution, the more original and better your story, character or plot have to be. Kevin Smith's *Clerks* was the only $28,000 film that *looked* like it was only made for $10,000. But his characters and dialogue were amazing. Likewise, David Lynch's first film, *Eraserhead*, looked and sounded like a groundbreaking masterpiece, but the story didn't make a damn bit of sense to most people who saw it.

You also need to clarify your goals for your first independent film. If you want to show the movie at glamorous film festivals and sell it to the Weinstein

Company or Netflix, then yes, it needs to be brilliant either in form or execution, or preferably both. But on the other hand, if you're making it just as a fun exercise with your friends, an homage to your favorite film, as practice for a bigger movie yet to come, or as a shallow pretext to sleep with your lead actor, then honestly, don't sweat the brilliance. Just have fun with it and keep your expectations in check.

There are plenty of screenwriting books that will tell you there are only seven, or maybe as many as 11, stories anyone has ever really told. So don't knock yourself out trying to come up with an eighth or 12th story that's never been done. Whether it's boy-meets-girl, boy-loses-girl, girl-turns-into-were-wolf-eats-boy, or some other variation on the Aristotelian classics, just try to lay out the basic story elements and see if it feels like a complete 90-minute film. Does it have a basic three-act structure of a beginning, middle and end? Is there some emotional high point or low point at the end of the second act? Do you have characters that your audience will care about and want to watch for 90 minutes? If not, don't panic: you may still have enough for a short, a TV pilot or a webseries, and those may still be worthwhile to make. So keep reading.

As far as how to write said brilliant script, there are plenty of approaches. One way is to do a strict outline first, filled with lots of Roman numerals, indentations and parentheses. Another popular technique is to write a bunch of different scenes all on index cards and post them up on a big wall. This will look very impressive and professional, in case your spouse walks in and wonders why you aren't spackling cracks in your bathroom drywall. If you use multiple colored cards, it looks even more impressive. (Use blue for night scenes, yellow for daylight, and I'm not really sure what the pink ones are for, but get creative!)

An approach I like to use is to write a treatment first. Basically, a treatment is written like a short story, describing the action and plot and using bits of dialogue if you happen to think of them along the way. Even adjectives are OK! A treatment can be anywhere from two single-spaced typed pages to 20 pages. It's hard to find examples of published treatments, but I do remember once seeing James Cameron's treatment for *Aliens* and it was over 80 pages, almost as long as the script itself. The nice thing about a treatment is that it's a good tool for pitching your project in the early phases. It's hard to pitch a pile of index cards, but you may need that treatment if you plan to apply to any screenwriting labs or get other development money to help you write the full screenplay. And when I say "development money," I don't mean to suggest that there exists such a thing. Maybe at the highest echelons of the Hollywood studio system, there might be development money to pay writers to actually write, but for most of us, we're on our own at least until we write the full script. But if a well-written treatment helps stave off your spouse from making you do that spackling project, then it's well worth the effort!

Another tactic for starting out might be to do a series of storyboards or a comic-book style approach to your screenplay. Strangely enough, for an industry that prides itself on being "a visual medium," it's bizarre that most screenplays are just black-and-white text on 12-point Courier font. Alex Cox's screenplay for *Repo Man* was a rare exception in the mid-1980s. It started with three pages formatted like a comic book, with cool illustrations of the opening sequence. Indie horror director/producer/actor Larry Fessenden commissioned an entire comic book first, before shooting his 2001 film *Wendigo*. He then used the comic book as his storyboards when he was shooting, and also as merchandise to help promote the film when it was finished. In the feature animation world, group storyboarding is exactly how Pixar, Dreamworks and the like start to write their scripts. No reason it can't work for live-action films, too.

Umm, What to Write?

As far as what to write, there are essentially only two kinds of scripts: The kind you want to sell, and the kind you want to make.

If you think of yourself as a professional "screenwriter" who wants to sell your script to Hollywood for lots of money, then that's cool: Give it a high concept, put in lots of action and special effects-driven scenes, and write those explosions, car chases and shoot-outs to your heart's content. Whether, if and how you *actually* sell this next Hollywood blockbuster is another matter entirely, and there are plenty of other books out there that will give you the appropriate level of false hope for that ambition. Good luck, and don't quit your day job!

But if you think of yourself as a fully fledged "filmmaker" who has every intention of directing, producing and/or acting in the film that you absolutely *will* make yourself, then there are a few tips I might suggest.

On Strike
(Opening Night Poem, Slamdance 2008, while the WGA strike was still ongoing)

I wrote for the studios, wrote for TV
Wrote for the web, but nobody paid me
So I picked up my sign, so proudly I'm filled
I bond with my comrades, in the Writers Guild

Met some cute staffers, from *The L Word* were striking
Made my subtle moves, but turns out they were dyking
So I wrote for myself, wrote for my friends
Made my own damn movie, from beginning to end

Cast Ali Larter from *Heroes*, on break from TV
But she won't sleep with a writer, or maybe just me

Made my picketer friends all PAs
They said "you bet, please demote me!"
But when I saw my own script
Those bastards rewrote me

Well, we put it on YouTube, which we all know is free
Now I don't make money, but at least I don't make it for me
It got into Slamdance, I'm wearing cargo pants cords
I'm passing out fliers, making sandwich boards

They honk as they pass, my red-shirted crew
We hold our signs high, passion-filled, we're imbued
Shouting on Main Street to people to please buy a ticket
We've had so much practice walking the picket

We have a great screening, there's buzz all around
Manohla Dargis even says I'm profound
A bidding war starts, on all the street corners
Between Searchlight and Vantage, and Sony and Warners

But just as I'm ready to sign the deal that I like
Turns out they can't sign me . . .
Because I'm on strike.

With an eye toward the eventual budget that you yourself are going to have to raise, you should think about if there are any cool locations you have access to. When I wrote my first film, *omaha (the movie)*, it was largely because my musician buddy Phil Berman said he'd heard of this cool place in Alliance, Nebraska, called Carhenge (an exact replica of Stonehenge with old cars stuck in the ground) and he thought we should shoot a music video there. What the hell, I said, let's shoot a feature there! And so, with a nod to Alfred Hitchcock, who particularly liked to end his films at big iconic locations (think Mt. Rushmore at the end of *North by Northwest*), I came up with a script that would end at Carhenge. For the beginning of the script, I'd start the action in my hometown of Omaha, where I knew I'd have access to a lot of other cool locations—like doing a chase scene amid the cattle in the still-active stockyards!

But, honestly, your locations don't have to be that cool, as long as you have unfettered access to them. Will your parents let you shoot in your house? Do a turgid family drama! Will your landlord let you shoot in your apartment? Make a mumblecore film about twentysomethings! Do you live near a park with easy location permitting? Shoot a kid-friendly, ice-cream truck film with a surprise alien twist!

Also, think about what actors you might already know. Do any of them have any particular talents, and do any of them have rich aunts dying to see them on screen, or at least just dying soon? Now, you certainly don't *have* to think about casting before you write a word of dialogue, but if you do happen to have a best friend who is already a talented (and preferably famous) actor who spent one ill-conceived summer at circus camp, then you might want to think about making your lead character a quirky bowling ball juggler. Even if you don't have a cast in mind, you should think about the *number* of actors you're going to write into your screenplay. Just remember, that for every actor you cast, at the very least you're going to need to feed them. Quite likely, you will also have to pay them. Even on the lowest budget Screen Actors Guild (SAG) scale, that's still $125 per day. On top of that, you have taxes, pensions, agency fees and other so-called "fringes" you'll have to pay. Oh, and makeup, hair, costumes and parking for each of your actors! So, make an effort to avoid huge crowd scenes and massive ensemble casts.

Traditionally, advice for indie film screenwriters would also include telling you to avoid budget-busting special effects, explosions, chimpanzees, space battles, chimpanzee space battles and other Hollywood-level elements that cost both time and money. But these days, there are cheap and sometimes very good ways to accomplish CGI, motion capture and practical special effects on very low budgets. So, don't be afraid to put some of those things in your script if you need to. Just because you may not be able to do a massive alien chimp invasion on your own laptop, doesn't mean you won't eventually find some kid in India or Estonia who happily will become your Visual Effects Supervisor for a couple of bitcoins and a screen credit.

That said, you'll never be able to compete with Hollywood on its own level. You can't make a simple rom com or tear-jerker Nicholas Sparks tragedy with no-name actors and expect it to compete with Hollywood versions where audiences are coming to see their favorite A-list actors fall-in-love-and-die-laughing-of-cancer. And you can't make a superhero movie and compete with Marvel unless you find a way to subvert the genre creatively on a low cost. You're making an indie film, and if you want to get some level of attention at either the festival or commercial level, it can't just be a low-budget version of an otherwise Hollywood film.

Once you do start writing, you'll be both tempted and daunted to go out and buy (or steal) a copy of Final Draft, which is the preeminent software for screen-writers. But don't feel like you have to bother. Any word processing software from TextEdit to Word to GoogleDocs will do the job. Just remember to use Courier for your font: It's an old Hollywood tradition based on old typewritten scripts, but trying to use some new-fangled sans serif font like Helvetica or even Times New Roman will peg you as a rank amateur. If you use Microsoft Word, you may also want to do some macros, or other shortcuts to save a few keystrokes for formatting dialogue or retyping character names. Woody Allen still uses an honest-to-God manual typewriter (a 1950s-era Olympia SM3), and when he wants to move scenes around, he just literally cuts and staples them. If you *are* going to go retro old school, you can pick up a decent manual type-writer at a flea market for well under $100. But check the draw string under the carriage—they're notorious for breaking, nearly impossible to fix yourself and can cost another $100 if you can even find someone to fix them. But you *will* be the coolest cat at Starbucks banging away and not at all annoying your fel-low iPad-swiping latte drinkers. Just don't get your beard stuck in the carriage return.

If you're still staring at a blank page and haven't written anything in five months, it might be worth it to consider that you're not a natural born screen-writer. But you still want to be a filmmaker, right? No worries. Either find a script by someone else (preferably written by a friend who has absolutely zero ambition to ever direct), or write an adaptation of a play or novel.

Adapt or Die

"We're not special. We're not brilliant. We never were," says David Harbour's character in my film, *Between Us*. And he's right. Most of us probably started as writer–directors by necessity, but at a certain point in a filmmaker's career (and of course, if you have an actual "career," you will eventually cease to be a "film-maker," and become instead a "filmsmaker"), you will realize you're probably not as brilliant or talented as you once thought you were. If you were indeed a genius screenwriter, you're probably better off writing scripts for Hollywood

and actually getting paid to write anyway. But if you want to keep directing, you'll realize that you have not got the time, inclination or skill to keep writing your own original material all the time. And that's where the adaptation comes in. But where to begin?

You're No Genius

To assume that every indie filmmaker is as equally adept at writing sparkling dialogue in an original story as they are at directing actors, choosing camera angles or cutting a scene is rationally unrealistic—especially to do so on every film, every time. It's no wonder that barely 15 percent of Hollywood films are based on truly original scripts, and even fewer directed by the sole writer. Step One is acceptance: You're no genius.

You're in Good Company

Step Two is to realize that you're not alone. Sure, Woody Allen can bang out a script every year on his Olympia, and Joe Swanberg can knock out an indie every month or two. It's certainly possible. But many, if not most, of your beloved auteur heroes have done adaptations or worked with other screenwriters on most of their films. Think about Altman, Kubrick, Scorsese, Hitchcock: Their best films were either adapted from books, plays, articles or at the very least came from original screenplays from close collaborators. Meanwhile, their plates were plenty full focusing on directing their movies—and more often than not, producing them, too. But on an indie no-budget film, how can you possibly do what Hollywood does every day? One first step is to figure out who the gatekeepers are to the good material.

Playing Around with George Clooney's Happy Ending

The story of how George Clooney got a happy ending from my sloppy seconds starts with people having sex in a real estate open house.

Several years ago, while a big Broadway agent in New York named Chris Till was getting his shoes shined (literally), he passed the time reading a *GQ* article about the hot phenomenon of "house humping." The real estate bubble was at its peak, and such a trend would arguably be the prick that burst it (or in TV sitcom terms, when real estate jumped the shark). But that agent was no dummy. He went back to his office, Googled "house humping" and saw a connection to a movie I'd just made: a real estate musical called *Open House* that the Weinstein Company had just released. It turns out the *GQ* story—and indeed the whole "trend" of house humping—was the fruit of a viral stealth campaign I'd unleashed to promote the film.

By sheer coincidence, I called Chris that same day and he was eager to talk. There was chatter at the Weinsteins about turning my film into a musical play, and I was looking for a good playwright to adapt it. But while I had him on the phone, I also asked him if he had any plays that would make good film adaptations. Yes! He had stacks of them. I came to New York and stuffed them into my carry-on bag for the flight back to LA.

As I came to understand, if a play wins the Pulitzer or Tony for Best Drama, Scott Rudin or Harvey Weinstein will usually snatch up the rights. But for most Broadway and Off-Broadway plays, there is very little interest in getting the film rights. Why? Because most of the agents that represent playwrights are scrambling to get their clients booked as staff writers on TV dramas. Ever since Aaron Sorkin launched *The West Wing*, there's been a steady migration of playwrights to LA. There's way more money in it for them (and their agents), and that's one reason we're in a new golden age of TV. Each of the Hollywood agencies has one or two playwrights' agents in their New York offices. These agents are usually very bright, talented and a bit more accessible than their hoity-toity colleagues in LA.

Out of the 30 or so plays I'd read, though, only two struck me as good candidates for a film adaptation. The first one I considered was *Farragut North* by Beau Willimon. It was about a young campaign aide working for an idealistic candidate in the runup to the Iowa caucuses. It's smartly written and for so many reasons was a perfect fit for me to direct, not least of which was that I had been a speechwriter for Iowa Senator Tom Harkin just before he launched his presidential campaign in 1992. Beau himself had worked for Democratic presidential candidate Howard Dean in 2004, and his play captured the right tones, drama and locations of an Iowa campaign very well. My only concern was that while it worked as a play, as a movie it might feel a little too much like one of the flashback episodes from *The West Wing* where Sam Seaborn goes to work on Jed Bartlett's campaign. I couldn't help but wonder if indeed it was, in a sense, designed to get Willimon some TV work. And I say that as a genuine compliment: There aren't a lot of writers who can do what Aaron Sorkin can do, and do it well. I also felt it would be a little tough to do on a low budget, which inevitably is what I would have.

The other script I liked was *Between Us*, which had been a hit play at the largest Off-Broadway theater in New York, Manhattan Theatre Club. Written by Joe Hortua, it was largely about two couples yelling and throwing things at each other over the course of two nights in two locations. Aha, I thought, that sounds like it could be done at a low budget (if need be)! Being firmly in the *Who's Afraid of Virginia Woolf?* genre, *Between Us* had the kind of roles and dialogue that actors drool over. It also hit closer to home for me emotionally than most of what I'd read: It was about struggling artists dealing with marriage, children and finances, and the characters were a similar age to me. I could definitely relate.

I helped introduce Joe the Playwright to Chris the Agent, who wound up negotiating our deal—shined shoes and all. After a few false starts interrupted by the 2008 Great Recession (remember the prick that burst the housing bubble? might have been me; oops) we finally made the film on a micro-budget level.

As for *Farragut North?* Leonardo DiCaprio jumped on as a producer, George Clooney directed and starred in it, and they changed the title to *The Ides of March*. A couple of Oscar nominations later, and playwright Beau Willimon became the show-runner on Netflix's *House of Cards*. As for that Clooney fellow? I hear he had to go back to his day job. I dodged a bullet on that one!

Books are Just Screenplays with Adjectives

Beyond plays, don't forget novels. All you need to do is cut out all those pesky adjectives and interior monologues and—presto!—you've got a screenplay. Easy-peasy. But getting the rights to a good book is the hard part.

One of the least known breeds of agents in Hollywood has got to be the elusive "book-to-film" agent. All the big agencies have them, though they're usually tucked into basement offices with no windows. Usually, a boutique book agent or publisher in New York isn't the one dealing directly with the studios and Hollywood production companies. Nope, it's these "book-to-film" agents who do the heavy lifting on these deals. Like their playwright-repping brethren, they also tend to be brighter and more nuanced than their TV-schmoozing colleagues. They "read," to use their secret code.

I first learned about these book-to-filmers when I co-wrote my own satirical novel (*I Am Martin Eisenstadt: One Man's (Wildly Inappropriate) Adventures with the Last Republicans*) with fellow filmmaker Eitan Gorlin (*The Holy Land*, which won the Slamdance Jury Prize in 2002). Even though we arguably had the most prestigious publisher in New York (Farrar, Straus, Giroux—a division of Macmillan) and a shark of a book agent at Endeavor (pre-merge with William Morris), when it came time to pitching it as a TV show or film, we got in touch with these book-to-film agents in LA. After one disastrous meeting with the two Endeavor agents (ending in the memorable phrase, "please escort these gentlemen out of the building"), we were freed up to meet with book-to-filmers at all the other agents, eventually signing with ICM.

What's relevant for the indie filmmaker is that when Hollywood options a book for some ungodly amount of money, it usually gets a few years out of it, commissions a screenplay and then decides not to make the movie. Consequently, those agents have a large stack of books in their offices collecting dust (including mine now). But while those screenplays may come with six- or seven-figure turnaround costs, the rights to the books themselves don't. So if you like one of them, all you may need to do is offer a token option and start from scratch with a new screenplay. The author will be thrilled, the agent will

have new space on her shelf and the next thing you know, you've got a damn fine script with a proven pedigree.

Develop Relationship with Original Author

No matter what kind of deal you strike with an agent, it will always be a better deal—and more importantly a better project in the end—if you've developed a strong relationship with the original author. I know one filmmaker who tried to secure a 15-year-old newspaper article from a writer that she personally knows well. But the agency that reps the newspaper told the filmmaker it wouldn't even start talking for less than a $10,000 option. For an indie film, this is obviously a non-starter. But think about it, the agent's only getting 10 percent; so for him, that's still only $1,000—barely worth the paperwork as far as he's concerned. This is what we're up against.

If the writers are personally motivated to get the film made, they can pressure the agents from their end, and the filmmakers can get things going. Better yet, get the underlying material from someone you're already friends with. Benh Zeitlin had been childhood friends with Lucy Alibar and had always wanted to adapt one of her plays. The next thing you know, *Beasts of the Southern Wild* got a Best Picture Nomination at the Oscars!

But if you don't already know the playwrights or authors, then get to know them. Go to New York, buy them a deli sandwich, hire a Thai "massage" therapist and take incriminating pictures. Whatever it takes!

I was lucky with Joe the Playwright. He'd always wanted to turn *Between Us* into a feature, and he liked my previous work. We had similar Midwestern backgrounds and we got along well: He stayed at my house. I drove him on countless airport runs to LAX. I even bailed his car out of impound once! Things aren't always going to go smoothly with any creative collaborator, and indie films bring out the stress in any relationship. But if you start from a genuine level of mutual respect, you'll get through it.

Use Their Experience to Your Benefit

One advantage of using source material is that there's already a body of reaction to that work. You can read reviews of the book or play: If there was a consistent criticism, you can address the underlying problems. If there was consistent praise about a certain element, then don't mess with it. On *Between Us*, we were also lucky enough to be working with David Harbour, one of the original cast members of the play. Between him and Joe, I could ask them what lines got laughs, what lines fell flat and in general what worked and what didn't with audiences. This is a tremendous advantage compared to working with original material.

We were also lucky enough to have Joe join me for our two-week rehearsal process. If the actors had questions about the backstory for their characters, or their motivations, we could all just ask Joe. And believe me, it's better to have the luxury of asking and answering those questions in rehearsal rather than when you have a room full of grips staring at you wondering when lunch break is.

Connect with the Material

If you're going to spend six years producing a film, three weeks shooting it, two years in post, three years promoting it and another 15 years paying off debts, you'd better relate to it personally. With all the inevitable challenges of making the movie, you've got to have an emotional stake in the script or at some point you will get frustrated and abandon it. You need to make it your baby, as much as it was the original writer's. Your cast and crew will see this, too: They don't want to work for free for a director who's just going through the motions.

For *Between Us*, that meant taking a chapter from my own life and grafting it into the script. When I first read the play, I was still recovering from a very nasty fall off a ladder that left me in a wheelchair for six months, and crutches and a cane for another year after. So when I was looking for a visual catharsis for David Harbour's character in the movie, I literally recreated my accident in the movie (even filming it in my house, close to where I'd actually fallen). Talk about catharsis! But it worked well for the character, and lent itself to visual elements (like a memorable scene of a wheelchair-bound character struggling in the snow) that I knew would help "open up" the play.

Don't Call it "Opening Up"

Remember, you're adapting a play into a film, you're not just filming a play. When you say you're doing an adaptation, most people will ask how you're "opening up" the play. But really what they should be saying is: How are you going to make it more *cinematographic*? Here are three broad techniques that differentiate a play from a movie.

Location, Location, Location

Most obviously, you've got the opportunity to move your dialogue scenes from a play into new and exciting locations. You can shoot scenes in cars, restaurants, airplanes, spaceships, wherever your heart desires. But presumably one reason you picked a play to adapt in the first place is that it would be easy to shoot as an indie film. So don't move your actors to different locations just for the heck of it. The audience will see right through it. Even on a revered classic like the

Mike Nichols-directed adaptation of *Who's Afraid of Virginia Woolf?*, *The New York Times* castigated Nichols for setting part of the movie outside of the stage-bound house. Poor Nichols couldn't win! (But I think he got the last laugh when he picked up a couple of Oscars for the film.) On the other hand, look at the reviews of Roman Polanski's *Carnage* and even the good ones criticized it for being too claustrophobic (never mind the fact that Polanski had certain legal "preclusions" from filming on the streets of New York).

Editing; Macro and Micro

In *Between Us*, the first act of the play took place in a Midwestern house, and the second act was two years later in a New York apartment. In terms of story, character and themes they were quite different from one another. I had the idea to intercut those acts together and go back and forth in time. Joe the Playwright embraced the idea and we started shuffling scenes. My editors and I went even further with these temporal shifts in post-production. Without changing much of the dialogue from the play at all, we were able to bring a whole other dimension to the film that intrinsically makes it feel less like a play and more like a movie.

Meanwhile, the "micro" editing within scenes and between scenes is the most unique part of what makes a movie a movie. Remember back to your *Battleship Potemkin* film-school days: You think ol' Serg' Eisenstein gave a rat's ass about delicate fade-to-black stage lighting between scenes? Hella no! So whether it's using jumpcuts, crashcuts or even a Toasty old star-wipe, these are your unique tools as a filmmaker, so use them!

Putting the "Move" in "Movies"

Through camera placement, movement and framing, you've got the ability in film to literally focus attention on one actor or part of the scene in a way that you can't on stage. The classic example is Hitchcock's *Rope* where the camera is moving toward characters—or the dead body in the trunk—in a way that makes the camera (and therefore the audience) feel like an additional character itself. Altman did this, too, with his infamous zooming lens on his films (including a number of play adaptations, like *Secret Honor*, *Streamers*, *Fool for Love* and *Come Back to the Five and Dime, Jimmy Dean, Jimmy Dean*).

Working with ASC cinematographer Nancy Schreiber on *Between Us*, movement was always something we talked about (if not always achieved): Dollying, slow push-ins, framing close-ups and playing moments on reactions. In editing and post, we kept things moving, too. Having shot on 4K and finished on 2K resolution, we had the luxury of reframing, selective defocusing, zooming up to 170 percent and other visual tricks in color correction. Sound design and

music cues served the same purpose—pushing the audience's attention exactly where we wanted it to go.

Use Your Source Material's Pedigree

There's a reason Hollywood likes to adapt material—it's easier to get them made and to get them seen once they're made. If you have the imprimatur of being based on a "hit" Off-Broadway play or a "best-selling" novel, you will find it easier to get investors, hire actors and sell your movie than if it was just another original writer/director wankjob. It really doesn't even matter if any of these people have heard of, seen or read the source material. Just by virtue of the fact that it was made once before, means that there must be some validity to it.

Don't Apologize for Your Source Material

Nearly as annoying as too-faithful adaptations are the ones that stray too far from their source. You don't want critics who never read the book or saw the play sniping that the movie's not as good as the original. And if your original has a fan base, you can't risk alienating them. You adapted the film from your original for a host of reasons, so don't leave the audience guessing. I've got "Based on a Play by Joe Hortua" right there in my front credits. I like the tight, talky dialogue. I like that there are only four main characters in the movie. I like that there aren't a lot of locations, but the ones we do have look great. I'm proud to say that *Between Us* was adapted from a play. And if audiences don't want to see crackerjack performers yelling and throwing things in a room, well, I know an old Russian silent movie I can suggest they see instead.

Try This On For Size: Improvise!

Another option besides doing an adaptation is to admit that you're never going to have a script, and frankly, you never wanted one anyway. That's right. You want to make a fully improvised film!

Now, having made some of these improvised movies myself, I can tell you that it's certainly a viable option. Maybe not the most prudent, maybe not for everyone, and maybe not for all your films, but it can be done, and occasionally done well.

Even with an improvised film, you still have to prepare one way or another. Whether it's a balls-in-the-face comedy like *Borat* or an indie horror film like *Blair Witch Project*, most improv movies still have a basic outline for the film, delineating a rough order for the scenes. Then within each scene, the filmmakers and cast usually have some semblance of where they're going, what each character's goals are for the scene and where the dramatic high point is going to be

for the scene. Most importantly, you have to make sure that all your actors are actually good at doing improv. Some amazingly talented A-list actors can be brilliant method performers if they've memorized a script, but that doesn't mean they can hold their own as an improvver. And there are plenty of exceptionally talented improv performers in almost every city in America, most of whom aren't, and likely won't ever become, famous.

You might also want to consider "workshopping" your screenplay through a series of improvised rehearsals. Just bring plenty of snacks, then record and transcribe all the great improvving. Slowly shape it into a real script, bring it back for more workshopping, and keep doing that process until you've got something awesome. It's not a bad way to get your talented actor friends to do most of the work for you, squeeze in valuable rehearsal time and if you play your cards right, you still might wind up with the sole screenwriter credit!

Buying a Script on the Open Market

There is one other way to get your hands on a script, and that's to buy one. It seems like a crazy idea: How can you, a lowly indie filmmaker, compete with Hollywood and its million-dollar script deals?

Hopefully you're not looking to make a Hollywood-style or Hollywood-budgeted script anyway. And just because *you* know better than to pitch a little indie-sized feature script to Hollywood, doesn't mean there aren't writers out there who don't. On the contrary, there are thousands of struggling, aspiring writers who are working on perfectly good scripts appropriate for the scope and tone of an indie film. Many of these screenwriters will eventually realize that Hollywood isn't buying their screenplays and they'll decide to become directors and shoot their scripts themselves. (Hopefully some are reading this book now!) But there are probably an equal number who would be more than happy to collaborate with a talented filmmaker like yourself for little or no money.

So how do you find this treasure trove of scripts out there? There are a myriad of screenplay competitions out there, and one suggestion is simply to track down the winners. Of course, if a screenplay wins the Academy's Nicholl Fellowship or winds up at the top of The Black List, the writer will get courted by Hollywood. But there are many more competitions out there (including the now-prestigious Slamdance Screenplay Competition, which we started in 1996 simply as a way to keep the lights on in the festival office during the off-season). Even if a screenplay does well at one of these competitions, if it hasn't sold to a big buyer within the first year, you might still be able to pounce on it. I met with one writer of a script that had made it on The Black List. After one year of making the rounds of Hollywood, he'd gotten an agent and some writing assignments, but his original winning script was still available. Same thing with many Slamdance screenplay finalists: They'll have one year of false

hope of getting an agent and selling their script as a "spec," and then a second year of considering making it themselves. Usually by the third year, they've moved on one way or another and will be perfectly happy to option their script for the price of a chicken-fried-steak dinner at Denny's.

Another good source for scripts is something called InkTip. It's a clearing-house of sorts for scripts mostly by non-agented writers. It charges the writers a fee, but if you're a producer looking for scripts, it's free to join and get access to all their scripts. There are probably other groups, companies or websites, like InkTip, that may or may not take advantage of desperate screenwriters looking for any kind of recognition. Meanwhile, there's also the myriad of screenwriting classes in colleges around the country churning out material. What tenure-track MFA professors wouldn't want to help broker deals for their best students' script to get produced? And what college students wouldn't want to get a call out of the blue asking them if you can read their scripts? Meanwhile, ever since Diablo Cody won an Original Screenplay Oscar for *Juno* in 2007, half the strippers in America are probably working on Oscar-worthy scripts. If you think it's too creepy to prey on desperate young college students, just start hanging out at strip clubs!

Choose a Castable Script

Regardless of how you wrote, bought or stole a script, before you commit to making it, you should think carefully about it in terms of cast. Do you plan to use unknown, maybe non-union, friends in the cast? Or are you hoping to attract famous name actors? Either strategy is fine, but you should know what you're up against in the marketplace. An indie film with no name actors might get into film festivals, occasionally even get distribution, and even more rarely become a big hit. If you're comfortable with those odds, that might be totally fine. Most first-time short or feature directors use their friends or other nonfamous actors. Just don't tell your investors with a straight face that they'll make back a dime on the film. And know that even getting on the film festival circuit will be an uphill battle—not insurmountable, but uphill. There are exceptions, of course: *Napoleon Dynamite*, *Clerks* and just about every found footage movie made since *Blair Witch Project*.

If you get at least some actors who are somewhat famous in your film, your odds for success on every level dramatically increase. Film festivals get more publicity if movies have movie stars in them, distributors will watch your film if it has stars, and sales agents can sell your film to foreign buyers if it's got actors in it who were in other successful movies or TV. I'll explain in the next section how to *get* those famous actors, but for now, the first step is to consider the script itself. Even if you don't expect to get world-famous actors, you still at least want to get *good* actors, so most of these suggestions still apply.

Actors tend to be a bit narrow-minded and egocentric. Most will consider being in a movie primarily based on the specific role that they are considering, not necessarily the piece as a whole. So, even if they're not crazy about the full script, if you're casting them in amazing scenes that will be fun to do and look good on their reels, they may still take the parts.

So what are the things that will attract an actor to a part? First and foremost, actors like to *act*. If you've got a drama with chew-the-scenery moments that will remind them of why they got into acting in the first place, and give them a chance to use their years of Meisner or Adler training, they will jump at the chance.

Actors love to *talk*. Most screenwriting pros will tell you to avoid long mono- logues in your screenplays because they'll make the studio execs and agents' eyes roll. But actors *love* monologues. Second best to monologues are long, snappy pages of dialogue, with nary a scene description to break up the page. The wordier a screenplay, the more likely it will attract actors! Bonus points if it's in iambic pentameter. Start finding your hot British Shakespearean-trained cast now!

Also, actors love to *sing*! Most American actors got their start in high school drama programs. And what do all high school drama programs spend at least half their year on? Musicals! That means that almost every actor in America got their start in musicals, and since then they've graduated high school and been desperate to get the opportunity to sing again. If they've been working in TV or film for several years, chances are they'll jump at the chance of performing in a musical again. Whether they *can* or *should* sing is another matter entirely. The entire reason I made my real estate film *Open House* a musical is because I knew I'd get a higher caliber of actor for the same budget level. Sure enough, I was able to get Broadway stars like Anthony Rapp (*RENT*) and cabaret- singing actresses like Oscar-nominee Sally Kellerman and New York darling Ann Magnuson by promising them a chance to sing live, on set, in a film.

Find a script with *women*! Think about those high school drama programs again: Almost every one has at least twice as many girls as boys. (All that dancing! Ick!!) Project those numbers forward a few years, and the number of actresses vying for jobs in Broadway and Hollywood still far outpaces men. Then consider the common (and very valid) complaint that there are no good parts for women in films. Most Hollywood films focus around the dudes, and the women are relegated to adoring girlfriends, mothers and wacky neighbors while the men battle aliens and supervillains. All of which is to say that if you have good, meaningful parts for women (especially older ones!), then you will get talented, famous actresses banging down your door to get in your movie.

On my film *Between Us*, when Joe the Playwright and I were adapting the play, I made a conscientious choice to boost the prominence of the female roles and write them some scenes that weren't in the original play. I had a feeling

we'd get a higher name-value of talented actresses fighting for those parts than we would for the male roles. Sure enough, when it came time for casting, I had regular meetings with scores of famous, talented actresses fighting for those parts. It even got to the point where after meeting one famous, talented and particularly beautiful actress, I got a call from her agent: "Dan, is there *anything*, I mean *anything* she can do to get the part?" I thought about what he was saying for a moment (and then weighed my stable marriage, kids and house into the equation). I demurred his polite offer and we wound up casting someone else.

Consider, too, the *length* of the parts. Do you have kick-ass cameo parts for actors that they can shoot in one day? If you're filming in LA or New York, you can always find talented, famous actors who would rather be on set—*any* set—than sit around their apartment staring at the wall and wondering when their agent is going to call. Now then, you might not know exactly who you're going to get until the day before you're shooting, but that's fine. At this stage, just think about if you've got some fun parts in the script that are limited to a single location you can shoot out in one or two days.

Finally, consider your *location*. If you're shooting in LA, you're more likely to get Hollywood-based actors who can just drive to set and come home to their families at night. Likewise, if you're in New York, you can easily find Broadway-based actors willing to take a cab or subway to set. On the other hand, if you're shooting a film in an amazing remote location like the Bahamas, Iceland or Hong Kong, what actor wouldn't want to go there for a few weeks? Sadly, the prospect of shooting in Omaha for a month does not send Hollywood hearts aflutter. That said, now's the time to start thinking about budget concerns: Contractually, most SAG actors have to be flown via business class or better. You also have to put them up in nice places. Their agents may even require you to fly and house their assistant, dog or kids. And if they're foreign actors, you may also have to pay upwards of $10,000 for immigration lawyers to sort out their visas to come to the US, or vice versa if you're shooting internationally with American actors. So shooting outside of LA or New York has the potential to get very expensive, even if you're in a state or country with attractive tax credits.

Lawyer Up!

Now that your castable script—or improv outline—is done or otherwise acquired, it's time to meet the most important person in your life, your lawyer.

And not just any lawyer will do! Just like you wouldn't go to a podiatrist to cure your brain tumor, you can't expect great advice on entertainment law issues from a probate, immigration or divorce attorney. Nope, you've got to find yourself a bona fide entertainment lawyer!

So where do you find a good entertainment lawyer these days? If you're lucky, across the street. That's how I found my second entertainment lawyer,

Cam Jones. In a string of odd coincidences, we were old high school-era friends from Nebraska. He'd just graduated from Harvard Law School and started working at a big Century City entertainment law firm. I was finishing up USC film school and Cam happened to move to an apartment exactly 500 feet away from me in LA. (By the way, my *first* entertainment lawyer was recommended to me by one of my faculty at USC. The fact that said faculty turned out to be a bona fide axe murderer may have turned me off a bit from his attorney.)

It's worth knowing that any big entertainment law firm worth its salt will have an office in Century City. And the very *best* entertainment lawyers get an office view of the Los Angeles Country Club golf course adjacent to Century City and Beverly Hills. A golf course that's so elitist, it once denied membership to Randolph Scott just for being an actor, prompting him to retort, "I have 50 movies to prove I'm not an actor." Naturally, if your lawyer *has* one of those offices, either you will be paying hundreds or thousands of dollars per hour, or it will be free, because he's also Tom Cruise's lawyer and has taken you on as a pro bono charity case.

Now, when I was starting in the biz in the mid-1990s, the geography of LA was simple: Lawyers worked in Century City and agents worked a half-mile east in Beverly Hills. But once Creative Artists Agency (CAA) decided that their I. M. Pei-designed office in Beverly Hills was too passé for them and they just *had* to build a giant monument to hubris in Century City, lesser agency ICM followed them across the street. Now when you go to lunch at the Westfield Century City mall food court, you could probably throw a rock and hit at least three agents and half a dozen lawyers at any given table. (Note to self: Set up rock kiosk at Westfield Century City mall. Make fortune.)

Other ways to find entertainment attorneys would be to figure out which of your local law schools have entertainment specialties. One recent *Hollywood Reporter* list showed the top ones as UCLA, USC, Harvard, Southwestern (LA), Columbia, Berkeley, Loyola Marymount (LA), Stanford, Vanderbilt (Nashville) and Fordham (NY). Go to their graduation ceremonies, spot a cute one in the crowd, start dating and marry. You'll be set financially for life and you'll have your own in-house counsel who won't likely charge you an hourly fee. If that list of law schools is too broad, then narrow your potential spouses down to California natives attending either UCLA or Berkeley: They'll have paid in-state tuition and won't saddle you with their private school student loan debt once you're married.

If you don't feel like going "all-in" with an entertainment lawyer spouse (slacker!), then at least track down the Facebook group pages for those entertainment law programs and start picking off the bottom feeders at their monthly cocktail nights: The ones who might be at a large firm but want to hip-pocket some of their own clients, or better yet, ones who want to branch out on their own from an early age. I met one good lawyer recently at a neighborhood block

party. Some of those law schools may also have pro bono clinics where law students will work for free. If all else fails, make your own: I know one married filmmaker couple who are patiently grooming their ten-year-old son to become an entertainment lawyer.

If you're very lucky, whoever you find will charge you a flat 5 percent on whatever you or your film makes. More likely, they'll charge several hundred dollars an hour and bill you a four-digit retainer before they've done any work. If you're not careful, your legal fees could be higher than the rest of your entire production budget. But there are some tricks to get cheap legal service (other than marrying your lawyer).

Usually lawyers won't charge you for your first meeting. They're just trying to get you as a client, so it'll be a lot of chit-chat talking about the project. But in the midst of that casual conversation, you're going to get a lot of really good, free information. So what do you do about your second or third meetings? Traditionally, if you take lawyers out to lunch, they won't charge you their hourly rates. For a nice 40-dollar meal, you could conceivably wind up getting $500 in free legal advice!

However you find a lawyer, make sure you develop a good, trusting relationship with him or her. The more your lawyers think you're an honest-to-God friend, the less likely they are to nickel-and-dime you for every phone call and contract that you're going to run their way. If all else fails, promise them producer credits. Sure it's a massive conflict of interest, and you run the risk of ultimately getting fired as director by your "new" producer, but most good entertainment lawyers probably deserve a better producing credit than most credited producers. So it's not such a crazy idea.

The problem with many good entertainment lawyers is that they're smart, interesting, creative people. (If they weren't, they would have become probate, immigration or divorce attorneys.) Inevitably, your entertainment lawyers will tell you they're dropping out of day-to-day entertainment law to become screen-writers, directors, Hollywood producers or agents. Equally bad for you, they might get full-time, in-house jobs at studios or networks and will be forced to drop all their little indie clients. Mind you, your ex-lawyers may well wind up being great contacts in five, ten or 20 years, but that doesn't actually help you get your movie made now.

Another way to find, and keep, your indie film entertainment lawyer is by seeing which lawyers are making the big deals—or even the little deals—at Sundance and other top festivals. John Sloss, for example, also runs his own film repping company (Cinetic) and distribution company (FilmBuff), but he's surprisingly accessible and may have some young lawyer in his firm that will take you on. Another tall, New York-based indie film lawyer is Jonathan Grey, who is renowned for throwing the best late-night house parties in Park City. It's not a bad place to meet Jonathan, his young associates and a host of other

lawyers all too willing to give you free advice over rum and cokes. LA-based David Pierce is a perennial sponsor of Slamdance and regularly doles out free advice at festival panels and cocktail parties. My own lawyer of late, Robert L. Seigel, in New York, has been in the trenches of indie film since the Coen brothers were starting out, and has done an amazing amount of work for me for little more than the price of a chicken sandwich.

Can you make an indie film without ever using a lawyer? Yes. You absolutely can. Is it a good idea? Not usually. But it depends: If you or your producing partner has a legal-ish background and can read a contract with ease, then you can probably pull it off. Especially if your budget is so low that even a low-priced lawyer will wind up with more than 5 percent of your budget. The problems really come up if you're trying to cast big-name actors, and all of a sudden *their* lawyers want to pull a fast one on you. Or your investor's lawyer wants to talk to your lawyer. Or when your lead actor needs to get bailed out of jail the night before shooting. At the very least, meet a few lawyers, get as much free advice as you can, and then keep their numbers in your contact list so you can call them when you absolutely need them. It may be sooner than you think!

Chain of Title Isn't Just an R&B Song

Depending on the nature of your script, it might have been a good idea to get a lawyer even *before* you started working on your script. Or at least to start *thinking* like a lawyer.

If, for example, you're writing a script with a buddy of yours, then even before you write a word, you're going to want to sign some kind of "collaboration agreement" between the two of you. It doesn't have to be fancy. The Writers Guild of America (WGA) has a perfectly adequate, flexible four-page PDF template on their website for anyone to use, even if you're not in the WGA. In essence, you don't want to finish the script under the assumption that you will be directing, only to find that your co-writer also wants to be your co-director and wants to own 80 percent of the proceeds. The three most important things to agree upon are your credits, your compensation (even if it's nothing now, but some back-end percentage later) and who ultimately owns or controls the rights to the material. You don't absolutely need a lawyer to sort these agreements out before you write, but you'll *certainly* need one to extract you out of any disagreeable situation when things go south. And yes, they *will* go south! Even if you absolutely are on the best possible terms with your writing partner who may be your best friend, your sibling or your spouse, just ask yourself: What happens if one of you dies in ten years? Who owns the script then?

If the screenplay is in any way based on a book, play, article or real person, you're probably going to need a lawyer before you get started writing. There's nothing worse than spending six months writing a script or adapting a short

story only to find out that you won't have the rights to use it when it's done. There are plenty of sample option agreements, life-rights agreements and other such documents you can find online or in other books. But in almost every case, there are going to be little nuances that make your situation at least slightly different from what you find in a template. Hence, getting a real lawyer.

All of these contracts and agreements in the writing stage fall under the general category of "chain of title." That's the catch-all phrase for your paper-trail of rights—from the original concept, through writing and into the film itself. You'll need an airtight chain of title long before shooting your film. Your investors will want to see it (or at least know that it's clear), and SAG may even require seeing all your paperwork before letting their actors show up on your set.

If and when you ever sell your film, you're going to have to get something called Errors and Omissions (E&O) insurance, which is almost always required by distributors. And in order to get E&O insurance, you have to provide documentation of your chain of title. It might be as simple as a two-page collaboration agreement (as my pals Paul Rachman and Steve Blush did when they sold their documentary *American Hardcore* to Sony Pictures Classics), or it could be as complicated as spending three years tracking down 60 years' worth of copyright filings, publishing agreements, option agreements, turnaround contracts, quit claims, purchase agreements, handwritten Library of Congress archives, etc. (as I've done with my film based on a Jules Feiffer-penned screenplay for *Bernard and Huey*).

Even if your film is from a completely original screenplay you wrote by yourself, before you start showing it to anyone you should file it with the Copyright Office in Washington and probably register it with the WGA. The copyright filing is really the more important of the two—it's the one that holds the most legal sway. It's a pretty simple online process to get something copyrighted, but know that you won't get final paper confirmation for at least six months to a year. But that's fine—the piece of paper you get from the Copyright Office looks cool and gives you a nice sense of achievement ("Hey, Mom, I'm a copyrighted writer now!") but the online receipt is just fine for legal purposes. The WGA registration is nice, too, but only really stays in effect for about five years. It's a little quicker and simpler to do than a copyright filing, so it's a good start if, say, you've just done a treatment and you're about to walk into an office to pitch it. You can probably do it in the waiting room while the receptionist is getting you a bottle of water.

Mining for Gold: Discovering the Lost Jules Feiffer Script

As one of the pillars of cinema's Golden Age of the 1970s, Mike Nichols' film *Carnal Knowledge* was a big influence on my own last movie, *Between Us*.

So in the midst of post-production, I happened upon a biography of *Carnal Knowledge* screenwriter Jules Feiffer that mentioned that he had several unproduced screenplays. Hmm, I thought, Feiffer had won a Pulitzer Prize for his cartoon strip in the *Village Voice*, he'd won a couple of Obies for his Off-Broadway plays, and as a screenwriter he'd written *Popeye* for Robert Altman, *Little Murders* that Alan Arkin had directed and won a Best Screenplay award at the Venice Film Fest for *I Want to Go Home*, directed by Alain Resnais. Feiffer's short animated film *Munro* even won an Oscar in 1961! With his Pulitzer, Oscar and Obies, instead of an EGOT, Jules has a "POO."

With a track record like Feiffer's, chances are whatever hadn't gotten made was still probably pretty good! So along with my producing partner Dana Altman (Robert's grandson) we tracked down Feiffer through his speaking bureau. Still very much alive, teaching in the Hamptons, and working on a series of graphic novels, Feiffer responded right away via email. Cryptically, he said he couldn't find any scripts, but to try him again in four months. He'd been divorced a couple of times and kept moving around his archives into various storage units. Four months later and another exchange of emails resulted in no new information: Not only couldn't Feiffer find any unproduced screenplays, but it was still a mystery to Dana and me what they even were.

Completely coincidentally, Jules' daughter Halley Feiffer had a film at Slamdance later that same year (*He's Way More Famous than You*). I struck up a friendship with Halley at the festival and that renewed the exchanges with Jules. But still no luck finding any scripts. Thankfully, my old pal Kevin DiNovis, another Slamdance alumnus (1997 Grand Jury Winner *Surrender Dorothy*), vaguely remembered reading one of Feiffer's screenplays in *Scenario Magazine*, back in the 1990s!

Robert Altman

NAME DROPPER

When I was getting ready to make my first film, *omaha (the movie)*, I went back to Omaha and asked the film commission if there were any producers there who might be interested in working on a feature. They said there was this guy Dana who produced some commercials but wanted to get into features . . . and by the way, his grandfather is Robert Altman. "He's hired!" I cried out. Dana's been a close friend and producing partner on a number of projects ever since.

At one point during pre-production on *omaha (the movie)*, he had me call Bob (as he was known) at his home and I asked him a few questions. He mostly just emphasized that casting was 90 percent of directing. (As to the other 10 percent, he was a bit vague.) Once we finished the film, our first industry screenings were at the Independent Feature Film Market (IFFM, now called IFP Week) in New York. Bob paid for a very nice hotel room for Dana and me in New York not far from his apartment. We spent a few wonderful evenings with him and his wife Kathryn, along with their coterie of producers and other friends. It was there that Bob really opened up about his use of sound and camera, and some of the other 10 percent of directing that set him apart as a trailblazing icon.

That same week, Dana and I took the train out to Long Island where Bob was being honored with a retrospective screening of *A Wedding* and a fancy dinner with some of the actors from that film. Carol Burnett invited Dana and me to ride back to New York in her limo, and she was a complete hoot, giving us big kisses as she finally dropped us off in Manhattan.

The night before our big IFFM screening, Bob asked if he should come, and we insisted he did (he'd already seen a rough cut of the film). Most screenings at the IFFM—which was held at the Angelika multiplex on Houston—barely had a handful of bored acquisitions execs and festival programmers in attendance. But when Robert Altman strode through the entrance of the Angelika and walked into our screening room, he was like the Pied Piper of indie film: Everyone just followed him right into our screening room and we got a packed house! Dana and I sat behind him and Kathryn and in the middle of the movie he got up to leave. I thought, oh dear, that's not a good sign. But Dana reassured me that Bob was old, and he just needed to pee.

When *omaha (the movie)* screened at the Kansas City Film Festival the next year, it happened to coincide with Altman shooting his jazz film *Kansas City*. Dana was the picture-car coordinator on the film, responsible for securing hundreds of vintage vehicles. My lead actress, Jill Anderson, and I were lucky enough to hang out on the set for a couple of days and observe Altman at work. It was no small thrill when he turned to me after one take and asked me what I'd do differently.

Over the years I'd see the elder Altman at various tributes or when Dana would come to LA. My last encounter with Bob was when we both came to see Sally Kellerman do a cabaret show at the Whisky a Go Go on the Sunset Strip. I talked to Bob for a few minutes and told him I'd just shot my real estate musical *Open House* and how great it was working with Sally, who had been in a number of his films, most notably *M*A*S*H* as Hot Lips Houlihan. With a sly look in his eye, he asked me, "Did you film her cleavage?" Indeed I had!!

Known in the last decade of the 20th century as the definitive magazine for Hollywood screenwriters, *Scenario* was a quarterly publication that reprinted famous produced screenplays, and occasionally unproduced ones, too. With the internet in its infancy, and a decade before The Black List made unproduced scripts viral sensations, getting an unmade screenplay published in *Scenario* was a very big deal in Hollywood. Like Feiffer, my buddy Kevin was also divorced and didn't know where *his* copies of *Scenario* were. Another screenwriting friend, Scott Tobis, said he had a copy! But he, too, had a similar tale of divorce and inaccessible magazine storage.

I tracked down a copy of *Scenario* to The Academy Library in LA. Operating more like a monastery than a library, the Academy of Motion Pictures Arts & Sciences has strict guidelines to enter: No cameras, no cell phones, no pens. (If they suspect you of smuggling anything out, I think they even probe you with an Oscar.)

I dutifully adhered to the rules and finally got a chance to read the elusive script, *Bernard and Huey*. It was brilliant: Hilarious, poignant, dramatic and remarkably timeless. Even better, there was an accompanying interview with Feiffer that mentioned that he'd worked with an LA producer who'd tried to get the screenplay made in the mid-1980s, first through Showtime, and then independently. But the name given in the article, "Michael Brandon," didn't show up on IMDb or anyplace else.

As soon as I left the Academy's cloistered building, I immediately contacted Jules again, who was thrilled to hear about the discovery of the script. But he warned me that the version in *Scenario* might have been an edited one. I asked him if his old agent might have one. "He's dead." What about his lawyer? "Dead." Maybe we could track down Jules' old assistant who might still have a floppy drive with the full script? "[She] may no longer be numbered among us," he emailed me.

Fortunately, Jules remembered the old LA producer. Maybe he still had a copy of the final script? Turns out *Scenario* had spelled his name wrong. Michael *Brandman* was very much alive and kicking in LA. After a week of searching his old files, he was able to find an original hard copy of the final script!

I arranged a trip to visit Jules at his home in the Hamptons. Bringing bagels and lox from Russ & Daughters in the Lower East Side (per Halley's recommendation), I spent a lovely afternoon with Jules and we decided to move forward with production of *Bernard and Huey*. I would visit him again, with more bagels and lox, a year later along with my other producing partner Mike Ryan—a visit that we filmed for fun and posterity, and ultimately used for our Kickstarter video. Feiffer's got amazing, hilarious stories about everything from almost writing *Dr. Strangelove* for his pal Stanley Kubrick, to introducing Jack Nicholson to Warren Beatty at a *McCabe and Mrs. Miller* Altman party, to almost getting Hugh Hefner arrested outside the Chicago Democratic convention in 1968.

Of course, anytime you're dealing with a literary property that's nearly 30 years old, you've got to make sure that all the rights are cleared and sorted out. That process alone would take another year and a half. Naturally, it didn't help matters that everyone on Jules' old team is dead.

The characters of *Bernard and Huey* had originated in Jules' *Village Voice* strips dating back to 1957. He drew them as middle-aged characters in a series of cartoons for *Playboy* magazine in the early 1980s. By 1986, Showtime had asked Jules to write the original screenplay but the same week he turned it in, Showtime's ownership had changed hands. The new regime wasn't interested, and never paid Jules for the script. The good news was that Jules had always retained the rights to the script himself (as a subsequent search of the US Copyright Office confirmed).

At one point, I even sent my pal Mike Shubbuck to the Library of Congress in DC where Jules had donated some of his files in 2000. Buried in the archives was Jules' original handwritten script to *Bernard and Huey*, including doodles, crossed-out scenes and margin notes to call his then very much alive lawyer. Mike was able to sneak still shots of the yellow legal pad sheets with the screenplay, and we compiled it as a PDF to use as a Kickstarter perk.

There's No Business Like a Show Business Plan

At some point along the way, you're going to need to write some kind of business plan. Unless you're completely self-financing the film, you will one way or another need to convince other people to part with their hard-earned money and invest, back, donate or otherwise give you cash. And that means writing some kind of business plan.

A business plan is a document that carefully explains what the film is, who's making it, how you're going to make it, what your plan is for distributing it, and if, how or whether anyone expects to make money from it. These days, most people will read a business plan as a PDF, but if you've got an in-person meeting with an old-school investor, you might consider shelling out the time and money to get it copied on nice paper and spring for the fancy binding at FedEx Office.

The way I do business plans for my films is I think fairly traditional for anyone seeking actual investors. I usually include some variation on the following sections.

Project Summary

Usually just a few paragraphs explaining in brief what the film is and how you plan to make it. If people are still interested, they'll keep reading. If not, you haven't wasted a lot of their time.

Project History

If your film has an interesting history or prestigious pedigree, this is the place to talk about it. Is it based on a hit Off-Broadway play? Did it evolve from an award-winning short film? Or was the screenplay developed at the Sundance Lab? Even if it's just an original screenplay with no prestigious backstory, still make its genesis *sound* amazing and unique: Inspired by a cholera fever dream! Occurred to you when you hit your head on the parking garage gate at Universal Studios! Something you've dreamed of since you had polio as a five-year-old and couldn't play baseball with the other kids! Remember, people aren't just investing in a film—they're investing in *you*, and they want to be part of something bigger than just another disposable 90 minutes of iPad content.

Key Production Team

These are the bios of the key people on your team. Don't have a team yet? Then just talk about yourself for now. You can always add people later, when you find a producer, cinematographer, casting director, even accountant. The more it *looks* like you have a real team behind you, the more people will want to *join* that team.

Synopsis

At various times in the life of your film, you will need to write multiple lengths of your synopsis. For IMDb, you'll have to do a one sentence logline. For festival applications, you may need a 50, 100 and/or 200 word synopsis. For business plan purposes, just go ahead and use a one-page or shorter version. Almost no one who gives you money will actually ever read your script. But they do need to know enough about it to justify and/or flaunt it to their spouses, investment advisers or squash partners.

Director's Statement

If you ever get into a big fancy European film festival, it'll ask you to write a "Director's Statement." It's to prove to them and their audiences that you're a real *auteur* and not just some poseur in jodhpurs and a beret. So director's statements are not a bad thing to start thinking about at this early stage. Your investors and other backers will want to know what your directorial vision for the film is. And when you start meeting with your crew and cast, they'll want to hear that you have a coherent creative vision for the film. See, you need that vision thing! That can range from stylistic influences ("it's *Citizen Kane* meets *Three Men and a Baby*") to what kind of camera you want to use, to your editing

style, to soundtrack ideas. Anything you can do to indicate a tone and feel of the film to put everyone on the same page creatively, and hopefully financially, too.

Casting

This is a great place to talk about your plan of action for casting: Are you going with brilliant unknown actors (your cousin and his stoner housemates), or are you hiring a top-notch casting director and making pay-or-play offers to A-list actors? Either way is fine, but it's just good to articulate why and how you're approaching the casting process. If and when you start to cast your film, you'll want to list your actors here, along with pictures of them and lists of their prior films. So when you're organizing the business plan, remember this is where you're going to have to stay flexible and add more space to this section in particular.

Why Support Independent Film?

This is a section I like to throw in that asks (and hopefully answers) the underlying question of why investors should invest in any film at all, rather than put their money into stocks, bonds, real estate, drug cartels or porn films. As I'll talk about later, I'm preternaturally dubious that films are a wise investment from a strictly financial return-on-investment standpoint. So this is the section where you may also want to address the "enormous cultural impact" this and other films like it make to modern society.

Product Integration and Branded Sponsorship

This is a little thing I like to put in my business plans. Big Hollywood movies have been doing product placement since long before James Bond drove an Aston Martin DB5 in *Goldfinger* or E.T. ate his favorite Reese's Pieces. So why not indie films? You never know when potential investors would rather stick their companies' mugs or T-shirts in scenes and write their contributions off as marketing expenses rather than investments. It's a nice option to offer, and if you're smart about using it, you won't have to sell your soul creatively.

Financing Options

I usually divide financing opportunities into three sections, each with easy-to-digest bullet points under "advantages" and "disadvantages." I talk about Private Investments (equity shares in the LLC), Donations, Grants and Crowd Funding (basically any money you don't have to pay back), and Product Integration and Branded Sponsorship (i.e. money you sell your soul for).

Budget Considerations/Options

Anyone who says you need to know the budget of your film before you start raising money has never made an independent film. You need to explain to non-film investors what kind of adjustments you'll make depending on what the ultimate budget is. Quite simply, your budget is whatever you raise. *That's* your budget. If it's bigger, you'll get A-list actors and porta-potties. If it's smaller, you'll shoot on an iPhone and crap in the street. I usually have a page that shows broadly what three or four different budget options will look like; a high, medium, low and micro scenario. Each will have bullet points indicating things like what kind of camera we'll use, which level of SAG agreement we'll use (i.e. Ultra-Low, Modified Low, Low), the extent to which crew will be paid and/ or mistreated. The subtext here is that you can make your movie for very little, but it's better if you make it for more.

Distribution Potential

This section talks a bit more specifically and realistically about what will happen when the film is done. You'll describe film festivals, producers' reps, foreign sales agents and how most distribution deals are with smaller companies who barely give you a theatrical release on the way to Video on Demand (VOD) oblivion. But it's also a good time to talk about how your particular history may apply to distribution of your new film. Do you have a track record with critics and festivals? Do you have a million subscribers on YouTube? Have any of your prior investors ever broken your kneecaps, or are they all pleased as punch with your last film's success?

Distribution Scenarios

I usually throw in about three possible distribution scenarios, each featuring bullet-point descriptions of the timeline and financial waterfall of how that distribution will affect the equity investors. I usually do a Best-Case Scenario (think Oscars and 5,000 percent return on investment!), a Zero-Sum Scenario (nice festival run, good advances and everyone paid back initial investment but no actual profit) and a Grim Case Scenario (the film tanks critically, gets a lousy distribution deal and not even the investors' initial money gets paid back). By the way, this Grim Case Scenario is what happens to over 95 percent of indie films made today. So, better your investors laugh about it now than get shocked later.

Contact Info

This seems obvious, but keep in mind that if all goes well, your business plan will travel. As a PDF, you might embed it on your Kickstarter page, a friend might email it to another friend or the clerk at FedEx Office may run off an extra copy for himself and his Century City lawyer girlfriend. Either way, you want to make it very clear how to get in touch with you.

Disclaimer

This is *super* important. For all kinds of legal reasons that will subject you to the wrath, ire and indignation of sullied investors and the Securities and Exchange Commission (SEC), you need to say very clearly and unequivocally:

> Investment in a project of this nature involves substantial risks, and should not be undertaken by those individuals or organizations that can not afford those risks. Anyone seriously interested in contributing should consult his or her own tax professional for complete tax advice. This document should not be construed as a formal offering or complete business prospectus, but rather is designed to give a general overview of the project.

And yes, it does sound weird to say that you probably won't make money, but trust me: The more you tell prospective investors that they won't make money, the more they'll think that they *will* make money. And yes, it is also bizarre to write a business plan that you then conclude by saying that it's not a business plan. Think of it as a financial Jedi mind trick.

Remember, It's a Visual Medium

Beyond the traditional text-heavy business plan, increasingly people are expecting you to make some kind of visual presentation. This can vary wildly, but might include storyboards, pre-vis animation, a "lookbook," a mood board, a mood reel, a short film, trailer, a Kickstarter-style fundraising video or some combination of all of them.

Storyboard

On most of my films, I usually do a handful of storyboards early in the process. Now, I'm not talking about the simple stick-figure storyboards a director might do to prepare for a particular scene or effects sequence. Rather, I mean full-color, full-page boards prepared by a real artist that are more illustrative of the tone, mood or style of various scenes in the movie. Luckily, my old college roommate, Matt Fuller, is a professional commercial storyboard artist in LA,

and for the price of a good meal I can usually get him to help me out on these. I know my French director pal Frédéric Forestier has his childhood friend do the same. One variation I've seen is at Pixar where they'll do maybe a 20-panel grid just showing the color palette of the film as it progresses through different moods and tones. It's a simple but elegant technique that anyone can do with a 64-crayon box of Crayolas. Either way, these are good visual elements to include in your business plan, website or other presentation material.

Lookbook

If you aren't artistically minded at all, or if you simply have no friends, then what can you do? Find other films that have the kind of style or technique you want to go for in your film. Get screen grabs of your favorite scenes, preferably wide shots that don't really show any recognizable faces. What you don't want is a big close-up of Harrison Ford in *Blade Runner* as a visual reference for your micro-budget sci-fi film. All your investors will wonder why you've cast your cousin Larry, and why you don't have Harrison Ford in your movie. If you're good with Photoshop, blur out faces, or crop around them. It's fine if these are

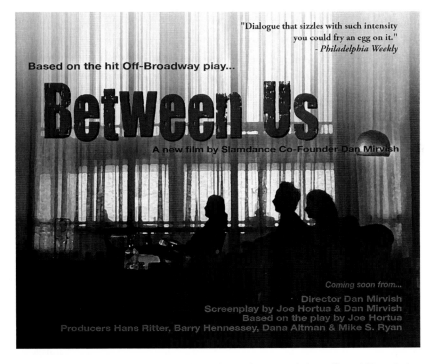

My pitch cover for *Between Us* was based on a frame grab from *Carnal Knowledge*
Courtesy: Bugeater Films

recognizable films (you are telling people, after all, that it's *Blade Runner* meets *Kindergarten Cop*—you may as well show stills from those). Likewise, use any photography you can get your hands on—from perfume ads to car commercials. Better yet, head out to some possible locations, set your DSLR in "still" mode and shoot some actual photographs. Strung together, laid out nicely, these can turn a boring text-heavy business plan into a sleek and sexy "lookbook!"

Pitch Cinema

But wait a minute, aren't films all about *moving* images? That's right! And with the advent of crowdfunding, there is now a whole new genre of short films that may as well be called "pitch cinema." Even if you're not actually doing a crowd-funding campaign, per se, I think most investors these days expect to see *some* kind of video presentation. This could be a short film upon which the feature will be based (I did this with my film *Open House*), it could be the scrawny director with bad posture leaning into the camera and begging for money, it could be a splashy mood reel with quick clips from other films, or it could be some combination. Hey, if it's good enough for Spike Lee and Zach Braff, it should be good enough for you! (Whatever you do, please don't call it a "sizzle reel." Unless you're pitching a TV show. Then call it a sizzle reel to your heart's delight, because that's what they're called in TV. But film? Not so much.)

Keep in mind that for crowdfunding videos, you really don't have to worry about copyright or music issues like you would with your movie itself, or even a trailer: After all, you're not commercially exploiting your pitch video itself. In fact, you may not even show it publicly at all (if, for example, it lives entirely on your Kickstarter page, or as a password-protected Vimeo). So that gives you much freer rein to snag clips from other movies, YouTube clips, stock footage or Grammy-winning songs for which you'd normally pay through the nose or avoid completely. But don't fall in love with these videos—if you don't have all those rights, you won't be able to put them on your DVD extras if and when you finish your film.

Subtitles

Kickstarter has a nice system where you can put subtitles onto your video. Start with English, because your video's probably in English. This is great acces-sibility for deaf potential contributors, but also for every potential donor in a coffeeshop who doesn't want to share your audio with the rest of the world. Kickstarter has a very easy editing tool to add captions or subtitles, but if you're a bit savvy, you can also upload your subtitles through a ".vtt" file. What does .vtt stand for? I have no idea. But basically it's a TextEdit file with the suffix .vtt instead of .txt. There's a bunch of websites that will show you examples.

Essentially you put it together the same way indie filmmakers have been doing subtitles for years for festival, foreign distribution and DVD purposes. My pal, director Matthew Harrison, figured out the nuts and bolts: You write down your subtitles in TextEdit, then import into an Excel spreadsheet. Then duplicate your Final Cut Pro (FCP) video sequence, add marks every time you want a new subtitle to start, and then export the subclips as a TextEdit file (you can probably do something similar in Premiere or Avid, too). Presto! You have a handy dandy list of start and stop points that you then copy/paste into Excel next to each subtitle line. Export the whole thing to Word, clean up the paragraph or tab marks, and export back to TextEdit. To do a .vtt file specifically, there's one more trick where you have to convert frame numbers to milliseconds (hint: multiply by 33!), but otherwise, Matt's technique is useable for almost any subtitle software. The beauty of it is once you're done, you can translate your subtitles into any language (either crowdsourcing from multilingual friends, or just copy/pasting into Google Translate), and export a new .vtt in less than five minutes. You never know when a potential Kickstarter donor will only understand French, Italian, Greek or Yiddish!

Finally, remember that if you're putting together a video, this will likely be the first time your potential backers have seen your work as a filmmaker. If your pitch video is lifeless and stilted, what makes us think your film will be any better? To the extent that you can, you should give your pitch video the same tone and style of your eventual movie. Does your movie have a skinny white guy stuttering directly to the camera asking for money? Unless it's an infomercial for artisanal acne cream, then not damn likely. So why should your pitch video have that? Be creative, have fun and use the video as a tool for yourself and your team to try out different styles, techniques, actors or locations that you plan to use in your movie.

Famous Director Kickstarter Campaigns

From bare-bones indie filmmakers (like me) to established actor/directors like Zach Braff, the Kickstarter crowdfunding movement has also seen Spike Lee's awkward, but passionate, pitch for his new movie. Filled with more boasts of his awesome oeuvre than any information about his new film, Spike's pitch video had the genuine authenticity (and bizarre camera angles) of any amateur indie filmmaker. But with the promise of court-side Knicks seats as a perk for $10,000, or for only $750 a used pair of Spike's shoes, his fans could get in on the action from the ground floor. So just how far up the A-list of directors will Kickstarter appeals go? Just as speculatively, what would some past filmmaker appeals have looked like?

Steven Spielberg's pitch for *Jurassic Park 5*

Pitch video highlight: Spielberg threatens to shave if he can't reach his goal in 30 days.

Best perk: For $1,000 he'll film your son's Bar Mitzvah party.

JJ Abrams/George Lucas' pitch for *Star Wars, Ep. 9*

Pitch video highlight: George and JJ's freestyle rap: "All the Jedi are shrouded, 'cause you know they're fund crowded."

Best perk: $500 cameo in Mos Eisley Cantina dressed as a Vulcan.

Michael Bay's pitch for *Transformers 5*

Pitch video highlight: Megan Fox at a fundraising car wash on Sunset Boulevard.

Best perk: For $100 you get a signed script. For only $50, you get to write the script.

Woody Allen's pitch for *One Night in Ljubljana*

Pitch video highlight: Woody going through his passport, asking what European city is missing.

Best perk: $100 front row seats to Woody's weekly clarinet jazz show. $200 gets you back row seats and earplugs.

Adam Sandler's pitch for *Grown Ups 3*

Pitch video highlight: Shot in stunning black and white by Janusz Kaminski, Sandler sits under a bright red umbrella and silently cries a single tear.

Best perk: For $100 you get to visit the set and kick Kevin James in the balls.

Orson Welles' pitch for *Citizen Kane*

Pitch video highlight: "I will make no film before its time."

Best perk: $10,000 gets a ride on Orson's lap on Rosebud.

Stanley Kubrick's pitch for *The Shining*

Pitch video highlight: Jack Nicholson threatens to stab you if you don't back the project.

Best perk: $5,000 gets a visit to Kubrick's secret Apollo moon set in England.

Alfred Hitchcock's pitch for *Rear Window*

Pitch video highlight: "Good evening, I'm Alfred Hitchcock. And this is my PowerPoint presentation."

Best perk: $500 gets you a personal casting session with Hitchcock (discounted to $250 if you are blonde and promise not to scream until he tells you).

Takin' Care of Business

No matter how you're raising money—whether by donation, crowdfunding or investment—you have to have somewhere to put that money. If someone writes you a check, the first question he or she may ask is (to the chagrin of grammar teachers everywhere), "Who do I make this out to?" Before you blurt out "*Cash!*" (or "*To Whom!*") and start drooling on your Chuck Taylors, you might want to think this out a bit.

For all kinds of legal, insurance, accounting, tax, banking and other liability issues, if you're making a film, you really ought to set it up as some kind of corporate entity, rather than doing it all under your own name. Now, if you're just doing a little short film in your apartment with your buddies, your own camera, no lights and you're not paying anyone, then you probably don't need to go to the trouble of setting up an entity, but otherwise, you do.

Rin-TIN-TIN

Most likely you can and should set up a new bank account for your film project. But if you just walk into a bank and say, "I'd like to set up a bank account so I can make my glorious independent film!" the two things they will likely ask to see are (1) your "Taxpayer ID Number" (TIN, also called "Employer ID Number," or EIN) and (2) your corporate or partnership articles of incorporation paperwork, perhaps including your state-issued certificate of formation number.

Despite what the Supreme Court's Citizens United decision said about corporations being people, there's still one slight difference. People get Social Security Numbers, and businesses get Taxpayer ID Numbers. They're both nine-digit numbers and you need one or the other to open a bank account. Though inexplicably SSNs are usually written as xxx-xx-xxxx and TINs are

xx-xxxxxxx. Why are the hyphens in different places? My guess is it has
something to do with the duel between Alexander Hamilton and Aaron Burr.
Applying for a TIN is relatively simple: You can do it instantaneously online
through the IRS's website (but not on weekends, apparently).

Putting the Love in LLC!

The other thing the bank will need is a bit more complicated. First, you have to
get all your LLC or corporate paperwork sorted out. While there are definitely
shorter versions of this paperwork you can find online, they're probably only
going to work if you're a sole-proprietorship entity (in other words, just you).
Where things get exponentially more complicated is if you plan on having any
kind of investors in your partnership. It is, after all, not called a *partner*ship
for nothing.

In essence, if you have more than one partner, but fewer than 35, you'll need
a stack of papers that could be a good half-inch thick. My partnership papers
have easily exceeded 86 pages for some of my films. It's divided into sections
with scary-sounding names like "Confidential Offering Memorandum," "LLC
Operating Agreement," "Private Placement Memorandum" and "Subscription
Agreement and Power of Attorney." Now, to satisfy the bank itself, you probably
just need the Operating Agreement. But when you approach investors and ask
for their money, you need to give them the full stack.

All this paperwork is pretty much just the legal mumbo-jumbo version of
your business plan. You should probably get a lawyer to prepare this thick docu-
ment for you, though much of what goes in there is pretty boilerplate from one
film to the next. And just send a .doc or .txt file of your business plan to your
lawyer so he or she can copy/paste sections right into the LLC documents; like
your synopsis, budget options, marketing plan, etc.

Wonderful Waterfalls

There's really only one thing you'll need to talk to your lawyer about that isn't
boilerplate, and that's "the waterfall." Mind you, this should be in your business
plan, too. The waterfall is just a careful delineation of what happens if, God
forbid, the film makes money and you need to figure out who gets paid what
and when.

Typically, you'll need to say things like the first money that comes in has to
go to pay off debts (yes, there are *always* some debts), deliverable costs, union-
mandated residuals and commissions on sales reps and the like. If you think
you might do any self-distribution, you might create some wiggle room in there,
too, so you can reinvest the money from one theater's earnings into the next
theater's advertising. The next money coming in usually goes to pay back the

investors their initial investment. Once that's paid off in full (a magic moment known as "recoupment"), the next chunk of money is also usually paid back to the investors for between 10–20 percent of their initial investment (this chunk is variously called "preferred" or "priority" return—which is like an interest payment on the money they gave you). Then after that (or sometimes before it) you might have a section where you pay back "deferred" or "bonus" money to the cast or crew. After all that's paid off, finally you'll be in "profit" mode! Usually at that stage, the investors will get 50 percent of the profit, and the creative team (cast and crew) will collectively get the other 50 percent.

That's a pretty standard waterfall, but there are many variations: You'll need to decide if maybe you're going to pay deferred wages before you pay back your investors. An investor may also insist that you have a hard cap on those deferred wages (fair enough). On my new film, I'm trying something different where cast and crew will actually get their deferred wages paid *pari passu* (fancy Latin for "at the same time as") with the first money that goes to the investors. Essentially that means that investors, cast and crew will all be gross participants in the film—and paid simultaneously from the first real money that comes in (after debts, residuals, etc.). So you can see, there are a few different ways to figure out the waterfall, and you, your lawyer and maybe your first investors need to sort it all out.

Making Sure You're Not a Flimmaker

The full stack of paperwork is what you'll need to give each individual investor when they decide to give you money. Usually, there are about half a dozen places where they'll need to sign, and maybe one or two where you'll need to sign. Most investors—even the seasoned ones—will look at this ridiculous stack of paperwork and appropriately shriek in horror. Tell them it's not a big deal and make it simple for them: Put little sticky notes on the places where they need to sign (or highlight in annotation mode if it's a PDF) and tell them if they're emailing you, they just need to scan those six or seven pages. You'll print, sign and scan your corresponding papers, and you're set! And if they're still concerned about how thick the paperwork is, then you probably don't want them as an investor in the first place.

The Subscription Agreement is the most awkward part of the paperwork: It's here that you have to officially ask your investor if they are rich enough to afford losing the money they're about to invest. It's what the SEC calls vetting to see if they're an "accredited" investor. After the crash of 1929, this seemed like a very good idea to protect little old ladies from getting swindled into giving all their hard-earned dustbowl money to flimflam artists and other hucksters (i.e. independent filmmakers—it's probably not a coincidence that "film" is an anagram of "flim").

The SEC is starting to relax those rules, but it's still a good idea not to swindle little old ladies, or even tall young men. If your unemployed college roommate can't afford to invest $5,000 in your film, then when you inevitably can't pay him back, he will be angry because he can't pay back his dope dealer, and a little on edge because he can't score a fix, so he (or his dealer) might dislocate your face. On the other hand, if a rich one-percenter invests $5,000 and doesn't make it back, he might be more inclined to simply tighten his ascot, adjust his monocle and sip some Courvoisier before mumbling, "Oh dear, old chap," and then return to his game of live, naked-human chess. Checkmate, indeed, sir!

By the way, if you're dating someone and you really want to check on the net worth of your significant other's parents, then getting the folks to invest in your film and fill out one of these disclosure agreements is the perfect way. The down side? If you don't pay them back, you are pretty much obligated to marry their child and give them a minimum of two grandkids with an option on a third.

Registering with the State

Once you've got your paperwork, you also need to register it with whatever state you happen to be in. You may have heard it's quick and cheap to register your company or partnership in Delaware, and maybe that's kinda true. But if, for example, you live and work in California and you register your company in Delaware, you're still going to have to pay the $800 minimum annual tax in California. So you may as well just start by registering in California. The registration process itself is not that hard (some shyster lawyers will charge you thousands of dollars to essentially fill out a one-page form and send it to the right state office in Sacramento). Trust me, this part you can do yourself. The only hitch is if you just send in your paperwork to the state like a regular person, there can *sometimes* be up to a three-month delay in getting your certificate back (which means you won't be able to set up your bank account). Fortunately there are expediting services—probably in every state, but definitely in California— that for a couple hundred bucks will walk your form over to the right state office and get you your certificate or state code number lickety-split. Now *that* might well be worth the money. But check how long those delays are—in California, they've boosted their staffing and the delay is down to just a couple of weeks.

One trick to get around paying California's $800 tax indefinitely is to register your LLC in a cheaper state (preferably one where you do actually have some claim to residency), and then file in California as a "foreign partnership" for just the one or two years you're in production. Just remember if you do this, you'll need to file the paperwork with California to then dissolve your foreign partnership status.

The New Pizza King of Omaha

As far as these minimum taxes go, one thing to keep in mind is timing. If you're going into production in March or April, you might want to hold off on filing with the state until the beginning of January. The states use the calendar year for charging you that tax, so it'd be a waste of $800 to file in December. On the other hand, if an investor is willing to write you a check for $25,000 in November, it's worth the $800 to file as soon as possible so you can cash that check, rather than risk telling your investor to wait until January.

It's axiomatic that investors can and will change their mind. When I was doing *omaha (the movie)*, I met with a man dubbed "the New Pizza King of Omaha" who took one look at my nicely bound business plan and said, "I'm in for 20 grand!" Great news, I thought! But it then took my lawyer two months to prepare the LLC documents. By the time I had the stack of paperwork, the New Pizza King of Omaha was nowhere to be found: Completely vanished in what I can only imagine was either witness protection or a hit from the Old Pizza King of Omaha.

EDGAR, EDGAR, Give Me Your Answer Do

If you're going to be raising money from investors, you need to register everything with the SEC within 15 days after you sell your first shares or units in your LLC, and you can certainly file it prior to any sales. Thanks to the Securities Act of 1933, you're probably going to be classified as a Regulation A filing (under $5 million raised in a given year). Yes, this all sounds a little daunting and someone somewhere will offer to charge you thousands of dollars to file for you. But if you do it yourself, it's free (well, almost).

First, go to the SEC website, and look for something called EDGAR ("Electronic Data Gathering, Analysis, and Retrieval" system)—it's the SEC's version of HAL and only slightly less ominous. First, you have to do a two-page "Form ID" just to get into EDGAR, and you have to get that notarized, scanned and uploaded back to them (so give yourself a couple of days, and count on at least ten bucks to pay a notary at your local UPS Store). Then you give EDGAR a seven-digit "Passphrase" and it'll give you an 18-digit "Accession Number." Then once you get your "Central Index Key" (CIK) and EDGAR "Passcodes" figured out, you'll need to do a "Form D," which is only a few pages long itself. But EDGAR only gives you exactly one hour "from your first keystroke" to fill out the form, so the clock is ticking! Thankfully you should be able to finish the form before EDGAR starts singing "Daisy" and turns off your life support. If all these passwords seem too confusing, then rather incongruously for such a bureaucracy, the SEC has a helpline that they actually answer with a real person, who will walk you through it step by step.

The one slightly tricky question on Form D that you might want to think about prior to starting your hour of infamy is which SEC exemption you're applying for: 504, 505, 506 or any number of other slightly different, arcane variations. As of now, most people use 506(b) for indie-type films. It means that technically you don't have to check different exemptions in every state (which 504 would make you do), and it still allows you to have up to 35 "non-accredited" investors and an unlimited number of "accredited" investors. But you're still only allowed to solicit people you kind of know, rather than advertise on the internet.

Why go to all that trouble with EDGAR and the SEC? Well, technically because it's the law. But really, if you don't do it, is anyone going to know or care? What registering does mainly is protect you from a litigious investor who might claim years later that you were offering unregistered securities. More to the point, it proves to your investors and potential investors early on that you're going to be a responsible grownup when it comes to their money. That confidence will buy you a lot of good will later when you ask them all for finishing funds because you blew your production budget on a Luma crane and a wetdown for Hollywood Boulevard.

If you raise money from states other than your own, you *may* have to formally register your LLC in those states, too. It's a pain, but it may be easier than you fear. If you think you have a skittish investor, then by all means, the more redtape you go through, the more it will ultimately protect you as well as the investor.

Boiler Rooms and Shriners

Oh, and why do I keep mentioning this 35 number? What the SEC is trying to avoid is boilerroom operations in Palm Springs that scoop up hundreds of unsuspecting investors into little more than Ponzi schemes. (And yes, I really did once meet some guys who said they could finance my film through their boilerroom operation in Palm Springs. I asked one of the guys, Joey, how they found the lists of people to call. He said, "My partner Tony was da pit manager at da Flamingo in Vegas, and he got a list to die for!" Suffice to say it was an offer I *did* refuse.)

You also can't solicit investors from people you don't know. Yeah, that sounds weird: If you can only ask people you know for money, how are you going to get people you *don't* know to invest? What the SEC doesn't want you to do is go to a room full of Shriners, make a pitch and swindle money from all those Shriners so they can't afford their little parade cars anymore. Well, that's a paradox that's flummoxed small business owners for years.

With the advent of crowdfunding, the federal government is starting to relax many of these arcane rules. President Obama signed the JOBS Act in 2012 that

was supposed to allow crowdfunders to invest and not just donate. But it's taken over three years for the SEC to come up with something called Title IV and Regulation A+ rules. Rule 506(c), by the way, also lets you advertise, but only if all your investors are accredited (i.e. rich). The various state agencies are taking even longer to get their rules all updated. By the time you read this, you'll probably be able to crowdfund actual equity investors, and there will be several Kickstarter-like companies enabling you to do it online. Interestingly, the folks who run Kickstarter itself have already said that even when these changes go into effect fully, they're not going to jump into that business model: They want to keep their campaigns strictly for donors, not investors. But let's see in a few years how things shake out and if we've returned to the pre-1929 Crash days of flimflam artists, hoodwinkers and scallywags—or if it's a brand new day of innovation, entrepreneurship and creative flowering. The bottom line is with all these changes around the corner, make sure you do your research carefully to see what the latest laws are when and where you launch your fundraising campaign.

Casting Your Banker

OK, once you've set up your entity, you're *finally* ready to get a bank account. While some banks (particularly in LA) may have specific offices to deal with entertainment companies or films specifically, usually those are geared toward writing loans for larger films (with over-one-million-dollar budgets) that are using foreign sales companies, presales, estimates, bonds, etc. But if you're reading this book, that's probably not you. For you, any generic business banker at your local branch will do. In my case, it's been easier to just use the same bank that I use for my personal accounts. If you do that, just make sure you're very clearly setting up different accounts (probably one checking, and one savings) from what you use for personal use. And if you're in a tenuous relationship with someone who shares your personal or other business accounts (a soon-to-be ex-spouse, ex-business partner or ex-parent), then definitely make sure the new accounts require all new passwords and PINs.

For each new film, you probably want to set up a checking, savings and credit card account. If you already know who your producing partners are, it might be a good idea to set up your checking account requiring two out of three signatures. It's a good protection for your whole team, including your investors. They can be assured that you're not going to just run off to Brazil with their money. Also, if you're on set directing, do you really want to interrupt a take to write a check for craft service? On the other hand, once the film is finished and you need to write a check three years later to pay for your taxes, it might be hard to track down your old producing partner who hates you, is dead or has moved to Brazil without you.

Bankers don't have a lot of flexibility in anything they're setting up. But it's still good to develop a personal relationship with them, because at some point along the way, you may need them to bend a rule here, or take some extra time there to help you out. For *Between Us*, we developed a friendly relationship with Gloria, my local branch business banker. Turns out she'd been a SAG actress years before, so we offered her the one-day part of playing Taye Diggs' mom in a wedding scene. Yes, we assured her, she would get to dance with Taye Diggs! She was speechless and nearly fainted. But when the time came, she was a wonderful dancer and Taye said she reminded him of his real mom. Shortly thereafter, though, Gloria retired from banking. Time to cast the next banker!

Hey Buddy, Can You Paradigm?

In all the fuss over *Veronica Mars*, Zach Braff and Spike Lee celebritizing Kickstarter, people were getting stuck in the trees (most of which fall and don't get heard anyway) and missing the forest. The crowdfunding/Kickstarter movement in general is changing the fundamental paradigm of film financing from "investing" in films to "donating" to them.

For years (and yes, this really does go back over 100 years), as filmmakers we've had to give false hope to investors that they might actually see a return on investment for a film, when we all know the odds of that are slim to none. We've all written countless business plans that talk about the success stories of *Clerks*, *Blair Witch Project* or *Napoleon Dynamite* (conveniently forgetting to mention that *Napoleon*'s filmmakers filed a multi-year lawsuit against Fox for screwing them on the backend). We've all relayed tall tales to investors of Harvey Weinstein napkin deals at Zoom (a fancy restaurant at Sundance) and *Paranormal Activity* discoveries by Dreamworks at Slamdance. And then on the next page—in small print, and dutifully required by the SEC—we always say that investing in film is a risky proposition intended only for people who can afford to lose their money. But (wink, wink) *we'll* defy the odds, because our film is *special*!

And we couldn't get money from all our old high school pals working in used tire stores because the SEC required us to "qualify" our investors by invasively asking them if they were rich enough to lose their money to us.

At worst, we've told investors that the good news is that they can claim their investment as a loss on their taxes through an obscure clause in the tax code called Section 181 which may or may not still be in effect. (I once wondered what Section 180 is, by the way: It's a deduction farmers use for fertilizer. In other words, in the eyes of the IRS, film is literally just more crap you can deduct from your taxes. No wonder investing in film gets no respect.) In a time when Steven Soderbergh and Kevin Smith claim early retirement and my accountant indelicately calls what I do "a hobby," let's all stop fooling ourselves.

No one's thriving off indie film, much less getting rich: Adam Smith would laugh at this ridiculous attempt at capitalism.

Meanwhile operas, symphonies, art museums, subscription community theaters—even public radio—all happily get donations from every rich sap in town because they are contributions to "the fancy arts." Society types get their tickets, go to parties, get tote bags and, yes, get a tax deduction. But more important, they get to feel like modern-day Medicis, and feel part of the arts events they're contributing to.

Along comes Kickstarter and its kin, and there's now a way for people to just donate to your film, without the hollow promises, without the awkward net worth questions and without the inevitable broken kneecaps from investors who felt you let them down. Finally, people are starting to view film as what it is: An art form that is worthy of "donations" from "backers" rather than an inevitably doomed business model that needs "investments" that will "fail."

I had a very successful Kickstarter campaign where I raised upwards of $10,000 for my film *Between Us*. Of course, this was in the early years of Kickstarter, when $10,000 was considered a successful campaign. I actually used the campaign as a Trojan horse, embedding my business plan PDF on my Kickstarter page, so as to attract big-money investors. Sure enough, we raised probably another $20–25,000 indirectly through the campaign. People forget—it's called Kick*STARTER*, not Kickfinisher. It's not about the money, it's about the momentum. With what we raised, I was able to set a start date. With a start date, I got a cast that included Julia Stiles and Taye Diggs. And with them on board, we found enough money through investors to pay most of our crew and finish the film. Twenty-three festivals in seven countries later, and hopefully my Kickstarter supporters feel they got to be part of something worthwhile, even if they never see a dime back.

There are now ways to make donations to your Kickstarter or IndieGoGo campaign tax deductible. You need to partner up with a "fiscal sponsor"—a 501(c)3 organization like the International Documentary Association (IDA) for docs, or for narratives, groups like Fractured Atlas, the San Francisco Film Society, Independent Feature Project (IFP) or LA-based The Film Collaborative (TFC). I used the latter of those on my Kickstarter campaign for *Bernard and Huey* because TFC is one of the rare fiscal sponsors that let you combine donations with equity investments. The fiscal sponsor will usually take an additional 5 percent "administrative fee" after Kickstarter takes its 9 percent fee (including credit card fees). It's hard to say for sure that we raised 5 percent more with a fiscal sponsor than we would have without, but at least with TFC, they have a simple PayPal contribution page that stays open long after the official 30-day crowdfunding campaign has ended. With this model, films can finally start to compete with those whiny NPR stations and their ridiculous tote bags.

Crowdfund This

(Slamdance 2011 Opening Night Poem, written just a month after I'd done my Between Us *Kickstarter campaign)*

Back in the day, yes proverbially
That to make a film, or two, four or three
You needed permission, you had to be knighted
Only a studio or investor could make you greenlighted.

You needed someone with money, to say go ahead
We'll pay for your movie, even your overhead
But as costs have gone down, there's no reason for that
To make a film now, you might as well pass a hat

No need to bow down to rich child molestors
Nope, you don't need them now to be your investors
And you don't need a Gates, or a Bloomberg or Buffett
And if they insist just tell them to stuffit

We now live in the age of distributed wealth
Bush tax cuts for all, and Obamacare health
Everyone has some money, though many are suffering
Enough to help every film, though perhaps not for snuffering

You see, in this age of media that's social
It's like the French bread, that we'll call here brioche-al
Soft in the middle, and a little bit yellow
Like the Man of the Year, that Zuckerberg fellow

Set yourself up on a site funded by crowds
You don't need inheritance or to be endowed
Try Kickstarter, maybe, or the Gogo for Indies
Good for Christians and Jews and for Sikhs and for Hindis

Then promote your film on the Facebook with gusto
To your indifferent friends who at first are nonplussed, Oh
You'll wow them with video and amazing boasts
You'll inundate their inboxes with incessant posts

And speaking of French bread, you'll send a baguette
To that fellow Mark Bell, who now runs *Film Threat*
And you'll use the Twitter, it's so much to cope
You'll try getting retweeted by Mr. Ted Hope

The paradigm shift is here, people, and it's a good thing for all of us. The degrading facade of convincing investors that they will actually make their money back is evaporating. The veil of financial success has been lifted. Now, people are giving money to films for all the right reasons: Contributing to the arts, participating in the creative process, getting swag, doing product placement or cozying up to the lead actors. There are plenty of good reasons to give filmmakers money to make a movie, and making that case is now easier for all of us. And that's good for filmmakers and it's good for people with too much money on their hands.

Staffing Up

Despite what you may have heard about auteur theory, or how filmmakers are troubled artists, it's a well-worn truism that film is a *collaborative* medium. You will need a team of people all working together in perfect harmony to bring to life a unified vision. Or at least it's collaborative until some festival in the Caribbean only pays airfare for *one* director to present the film. Grab the ticket, wave goodbye to your embittered collaborators and apply sunscreen!

But until that point, you need to find a team. For most filmmakers, your first cadre of collaborators is going to come from your existing friends, film school classmates, or family. If your best buddies are amazing cinematographers or production designers, it's nice to get them committed to the film early (put their names in the business plan!), but they really can't or won't be able to help you much in early pre-production.

Producing a Producer

What you *really* need is a producer. This is every director's dream: Finding that quintessential

producer who will raise money effortlessly in pre-production, and then spend it supportively in production. Unfortunately, those producers don't really exist.

Producers are either money raisers, or money spenders, but rarely both. And there are a heck of a lot more of the latter than the former. What you really need in the early stages of pre-production is a producer who will help you raise the money, do all your boring paperwork and help you build the rest of your team. If you can find that person, congrats; you won the lottery!!!

More likely, you may find someone that will help *you* do all those things. But it's still mainly going to be *you* doing them. Yes, it definitely looks impressive to investors, agents, actors, etc. to say that you have at least one experienced producer on board. But chances are if they're such good producers, they probably have six other films they're balancing at the same time as yours. You'll be lucky if you get one day a week of quality collaboration out of them. And you have to be OK with that. It's totally fine.

Where to find even these once-a-week producers? Your best bet is to look up the credits of every film that was at Sundance in the last one or two years. Why Sundance in particular? Because the festival does a really good job taking indie producers and elevating their game through panel discussions, producer labs and other networking tools. It's no surprise that while the festival still has room for many first-time directors, the producers tend to come back over and over again.

On my film *Between Us*, that's exactly what I did: I scoured old Sundance credit lists, and just started cold-calling producers. Unlike bigger indie "production companies" who barely acknowledge your existence (hey, Killer Films, I'm *still* waiting for you to read my script!), the scrappy indie producers are a lot more accessible and willing to consider newer filmmakers if the film seems promising. That's pretty much how I found two of my producers, Mike Ryan (a protégé of Ted Hope who'd produced *Junebug*, *Palindromes* and at least five other Sundance films) and Hans Ritter (who'd produced *Hard Candy* and a couple of Gregg Araki films). I rounded them out with two producers I'd worked with on my other films: Dana Altman, who was my producing partner

You'll get donors and backers and pledgers galore
Like a (Meg) Whitman Sampler, you'll feel like a whore
Not that there's anything wrong with turning your trick
You're just pimping your film, and for now that's your schtick

You'll come up with goodies for all different levels
But the problem is detail, in which there are devils
You might promise a T-shirt for a 5 buck donation
That you bought for 10 from an online Croatian

Or you'll give away parts in the movie you're making
For just 20 dollars the lead role's for the taking
You'll auction off crew jobs, as the money comes faster
Your mother's Aunt Trudy just became your Prop Master

And as you near your target and your deadline approaches
You get even more fervent, desperation encroaches
You've run out of ways to harass and to hector
So for the last 40 dollars, you just sold "director"

The good news is you finally just made your goal
Everyone else makes your film, and you sold your soul
You're tired, exhausted; you feel like the undead
You didn't make a movie, but at least you're crowdfunded!

on *omaha (the movie)*, and Barry Hennessey, who'd line produced my film *Open House*, but in the intervening years had won four Emmys for producing *Amazing Race*.

We were all pretty straightforward with each other. At the end of the day, at least two of these guys would probably be busy on other projects, and would ultimately get less prestigious credits and compensation. And whoever did show up to set during production would get the coveted "producer" credit and actually get paid a little. But for the several years it took to raise financing and cast the film, we presented ourselves as a unified front and all weighed in on critical decisions. On paper, we were a killer team!

Meanwhile, back in my garage, what I *really* needed was interns.

Interns and a Clean Garage

Arguably, the main reason to make a film is to have an excuse to get interns who will willingly clean your garage for free. But where do you find these elusive hard-working interns and how do you motivate them to debase themselves with heavy lifting, sorting and sweeping?

If you are in a fairly big film town (e.g. LA, New York, Austin) there are an endless supply of eager young aspiring filmmakers who are happy to work for free to learn how to make movies. Invariably they've either saved up enough of their own money, or more likely their parents are willing to bankroll them for six months until they get their feet on the ground and get a real paying job. Just go on to various production crew job boards (i.e. Mandy.com) and post to your heart's content.

Unfortunately, it's not *quite* as simple as that. A few years ago, two interns working for Darren Aronofsky's film *Black Swan* decided to sue Aronofsky and Fox Searchlight (the film's distributor) because they did menial work and didn't get paid—a fairly straightforward violation of federal labor laws. "Duh," said Hollywood, "it was an internship. What the hell did you expect, you spiteful ingrates!?!" What was initially regarded as little more than a nuisance case slowly started to win its way through the court system. Hollywood (and later the publishing industry, after Condé Nast got sued in a similar case) was forced to pay attention. Studios and production companies slashed their internship programs—turning some into paid positions, requiring the interns to get college credit, or eliminating internships altogether.

A federal appeals court has pared back the victories of the plaintiffs in the initial case, but even that judge reiterated the basic idea of internships being educational opportunities that should be tied to an ongoing course of study. So while the studios can well afford to, and should, pay their interns, it's not so easy with indie filmmakers working out of their garages. If we don't have free labor to count on, then how can we make our beloved no-budget movies? Honestly,

it's a real conundrum the indie film community is wrestling with (or at least should be), and there haven't been a lot of great solutions.

Legally, at least, the best way to find interns is through your local film schools. Most schools will have some sort of industry-relations office and an online means of posting internship opportunities. As long as the interns are actually learning something, doing meaningful work and having fun, you should be on fairly solid ground. Remember, it's not "cleaning the garage," it's "collaboratively developing a creative thinkspace." Just make sure they (and all your crew) sign an ironclad non-disclosure release form on day one to minimize the risk of them suing you later.

Also, be very clear and honest in your intern description: You need interns "to help an award-winning filmmaker with pre-production of an indie feature film." Trust me, that will sound so much more appealing than the prospect of sitting in a windowless office of a big production company reading scripts all summer and writing bitter, condescending coverage for three months. I should know . . .

Terrorist Filmmaking

When I was finishing up my first year of USC grad school, I had already lined up a soul-crushing coverage internship for the summer at some generic production company. Then I saw a notice on a bulletin board at school that said: "Interns Needed: One week of feature film production. Terrorist filmmaking." Well, *that* sounded worth a call, at least. So I dialed the number and a man with a thick Hungarian accent answered, "Hulloh, zis is Jenö Hodi." I asked him what "terrorist filmmaking" was and he laughed like The Count on *Sesame Street*, "Ha! Ha! Ha! I meant to write *guerrilla* filmmaking, but my dictionary vas wrong!"

Turns out Jenö had recently graduated from Columbia University film school (having studied under Oscar-winner Miloš Forman, as he frequently reminded anyone in earshot). One of Jenö's Columbia buddies was "Tall" Paul Wolansky, who happened to be my 6′8″ screenwriting teacher at USC. Paul and Jenö had sold a kickboxing script to a Hong Kong producer named David Hung. Set completely in LA, the plan was to shoot all the exteriors in LA and then go to the Philippines for five weeks to shoot interiors that would match. So Jenö needed some cheap intern labor for the LA part of the shoot. Paul vouched for the project and, along with one or two other USC interns, I signed up.

The first couple of days were pre-production and I was working under the auspices of a scruffy little British producer named Ron Lavery who was a charming mix of Phil Collins and Marty Feldman. Among my jobs was to pick up the Hong Kong producer at the airport and drive him back to Jenö's apartment (sadly, Jenö didn't even have a garage for an office—just his one-bedroom

apartment he shared with his enormous German shepherd named Kolmos who liked to chew on intern balls). I brought the producer David Hung back to Jenö's and David promptly opened his briefcase.

Keep in mind that this was around 1992 when Hong Kong cinema was flowering with the likes of John Woo, Jackie Chan and their epic action films. But many of the lesser Hong Kong filmmakers were deeply under the thumb of The Triads—ruthless gangsters who were known for killing directors and actors who crossed them.

So when David opened his briefcase and it was filled with the better part of $350,000 in cash, I shrieked, "What the hell is that?" David answered non-chalantly, "It's the budget." Turns out David was *not* part of The Triads. On the contrary, he was a short, scrawny man who was petrified of The Triads, so he always shot his films in the Philippines. For him, this US/Philippines co-production with the aspiring arthouse Hungarian director was a big step up.

I was already learning a lot about how to make an indie film that they weren't teaching me at USC. For example, Jenö convinced some rich guy to let us use his beautiful house, swimming pool and jacuzzi for free, in exchange for letting the guy's aspiring 19-year-old actress daughter be in the movie. What the homeowner would only learn later is that the director required the daughter to be nude in the jacuzzi for her big scene. Needless to say, the homeowner wasn't happy. But by the time he found out, we were on to our next location.

Once shooting had started, I was assigned to be the Second Assistant Cameraperson (2nd AC). The 2nd AC is also known as the camera loader and in those days that meant actually loading the 35mm film into the camera and trying desperately not to expose it to light. It's a nerve-racking job even for the most experienced 2nd ACs and for me it was the first time I'd touched a 35mm film camera, let alone loaded one. But by some miracle, I managed not to scratch or expose *all* the film.

The One-Armed Executioner

By the third day of shooting, David Hung, said,

> Dan, you seem to be the only one around here who knows what's going on. Can you come to the Philippines with us to be our 2nd Assistant Director? I'll fly you there and pay you $400 a week for five weeks.

I was flabbergasted. That *definitely* sounded better than going back to a boring coverage job in a non-descript LA office. Thankfully I remembered to ask the most important question you can ask when someone offers to fly you to the Philippines for a paid job, "Is there a return ticket?" David assured me there was, and four days later I was in Manila.

It was a crazy five weeks about which I hope to say more in future chapters. But in short, in addition to Second Assistant Directoring (2nd ADing), I wound up being the dialogue coach on the movie, writing new scenes, punching up dialogue and even getting shot in the chest—twice!—as two different nameless thugs in the movie. By the end of the shoot, the producer asked if I wanted to be the post supervisor back in LA. "Sure!" I said. "What's a post supervisor?" I found out that the main responsibility was finding an editing suite. In our case, that meant renting a room and editing equipment from a very nice porn company on Santa Monica Boulevard named Miracle Films, whose motto was, "If it's a good film, it's a Miracle!" We had three sets of editors and assistants (including my first gig as an assistant editor) working eight-hour shifts 24/7 to get the film cut in three weeks. On the last day of editing, the producer and director—who were constantly at odds about whether it was an action film or an art film—got into an actual (though fairly unskilled) kickboxing fight in the edit suite. At one point, the producer's wife jumped on the director's back and pulled out giant tufts of his thick Hungarian hair. Two of the editors had to break it up, and thus ended post-production on the movie.

Oh, you might be wondering what the name of this masterpiece was. Originally, the title was *Bloodkin*, which particularly when mispronounced with a Scottish accent, sounded like some sort of pudding made from goat entrails. The lab in Manila kept getting our dailies mixed up with another production called *The One-Armed Executioner* and we all thought *that* was a much better title! While we were editing in LA, the director had me show the first reel of the film surreptitiously to a successful South African producer, Anant Singh. A month after the tuft-pulling incident, Singh offered David Hung $550,000 for the film. Hung happily took the money—a tidy $200,000 profit—and went back to Hong Kong. A month later, Singh (who happened to own the rights to a movie called *American Kickboxer*) changed the name of *Bloodkin* to *American Kickboxer 2*, and sold the film for $1.2 million to Trimark.

It is often said that you learn more working on a bad movie than on a good movie. Let's just say I learned a *ton* working on that movie. When the summer was done, I walked back into film school secure in the knowledge of how to make a feature film from start to finish. A year later, I'd be making my own. Meanwhile, most of my friends came back regaling me with their soul-crushing tales of reading coverage in air-conditioned cubicles. The point is, there are interns who should and will jump at the chance to do something interesting on your film—even if you don't wind up shooting them in the chest. Twice.

Shooting the Movie

Casting Your Movie With A-List Actors

OK, now that you've got your script, raised some money and have a team of collaborators, it's *finally* time to start making your movie! But before you can shoot a frame, you've got to cast the film.

Assemble a Team

Contrary to popular wisdom, you don't *need* an A-list casting director. What you need is someone who can *sound* like a credible casting director on the phone. On my film, *Between Us*, I teamed up with Alison Buck, who'd been recommended by my pal, director Matthew Harrison. Alison had recently moved to LA from New Zealand and been working as a casting director in her spare time, while also holding down a day job as a manager. That meant that she had an office, a phone, knew the casting lingo and had the confidence to sound like the movie was happening. Yes, she had some contacts in the agenting world, but that's not why we got her. She also had the stamina to stay committed to the film for what wound up being over four years.

The casting director was only part of the team. My producing team was just as important for their casting *bona fides*. Mike Ryan had shown seven films at Sundance and his claim to fame was helping discover Amy Adams in *Junebug*. Hans Ritter had been instrumental in discovering Ellen Page in *Hard Candy*. And to top it off, as Robert Altman's grandson, Dana Altman had some pretty decent casting genes in his DNA! Finally, as the co-founder of Slamdance, and with some good casting under my belt for my previous film (*Open House* with Oscar-nominee Sally Kellerman, Anthony Rapp, Kellie Martin, et al.), there was proof that I knew how to work with at least somewhat fancy actors.

Aim High

So with that team on paper, we decided to tell people we were making the film for two or three *million dollars!!* This was in 2007–8, so it didn't sound so crazy at the time. At that budget, the prevailing wisdom was to offer the actors something called "Schedule F," which is a SAG designation that means a $65,000 flat rate, irrespective of number of hours, days or weeks they work. Of course, we didn't have a dime. So that meant we were doing "finance contingent" casting. Some of the agents and managers took us seriously (10 percent of $65,000 is still enough to support at least a small coke habit), so they'd get someone in the office to do coverage on the script and we got in the system.

Go to New York

Something I found out casting most of my films is to target junior agents at the big agencies, and specifically ones in their New York offices. The LA talent agents are all running around like crazy trying to get their actors booked into pilot season. TV is where the long-term money is for the agencies. The LA people have neither the time nor inclination to worry about indie films, no matter what their budget. But the New York branches of those same agencies spend more time trying to get prestigious Broadway jobs for their LA-based high profile actor clients. Consequently, they're also better attuned to knowing which actors in their clientele are inclined to want to do (and can afford to do) meaty, "actory" roles—whether they be on stage or in indie films. In general, the New York agents also tend to have gone to classier Ivy League schools, think that they're smarter, and have more time on their hands to actually sit down and read a script (and not just pass it on to a bitter intern to do coverage).

The sweet spot is to find *junior* agents in New York—ones who just finished being assistants, just got their own desks, but don't yet have their own assistants. These are the hungry young bucks, eager to make a mark for themselves by discovering great material and prove themselves to their senior agents, A-list clients and the big bosses in LA. And without their own assistants, they'll actually answer their own phone!

Be Bi-Coastally Curious

From New York, come back to LA. This confuses the agencies, in a good way. If they think you're bi-coastal, they will take you more seriously (Scott Rudin has offices in LA and NY, why shouldn't you?). If you live in LA, get a 917 number. If you live in NY, get a 323. Leave messages at 6 am in LA or 9 pm in NY. Then play them off against each other: "Oh yes, that sitcom actor's good, but your NY colleague has this other Broadway actor that seems more . . . how do I put this? *Substantial.* Do you have any feature actors who are better?"

Don't Have a List!

Every director has some sort of list in mind about your dream cast. Forget it! You will *never* get your dream cast. Not all of them, not on your budget and not on the week you want to start shooting. And then when you do cast someone else, you will always view them as inferior to the person you had in mind when you wrote the script or made your list. This is an important concept both creatively and practically.

Agents spend most of their time soullessly getting offers and pushing them on to their clients. (For this, they went to Penn?) So, when you meet with those junior agents in New York, tell them about the roles, and then say, "Who do *you* think would be good in this?" All of a sudden, it empowers the agents and makes them emotionally vested in the film. They undoubtedly will come up with the exact same list of clients that you would have thought of from scouring IMDbPro, but sometimes they will surprise you and come up with new clients they just signed, or actors bigger than you thought you could get. The point is, these will be their ideas, and they will work ten times harder to get those actors than if you had suggested them. Now they have something to prove to you (and their colleagues), and not the other way around.

Develop Relationships with Agents Yourself

No matter how good or powerful your casting director is, you as the filmmaker need to develop and cultivate relationships with talent agents and managers yourself: Buy them coffee in Park City, take them out to breakfast in Venice, share sushi on St. Mark's. Whatever it takes. This is much better time spent than cultivating relationships with actors: You could spend 20 years buddying up to the next Tom Cruise, but when you finally need to cast your famous BFF, he might happen to be in rehab that month, and you're screwed. But agents or managers that you know will always have other clients available, and will have them for not just this film, but for all your films in the future. That junior agent in New York will be a senior manager in LA by the time you make your next movie.

You may have gotten lucky with a casting director this time, but next year when you want to make a Dogme 95 film in your kitchen, you won't have a casting director to fall back on. It's also more impressive for the young agents and managers to speak with the "director" and not just the casting director. Alison and I had a great system on *Between Us*: If she contacted agents, she would constantly refer to "the director" following up with them, and when I knew agents, I would refer to my "casting director" as following up with them. It gave the impression that we had a real team who cared what that agent thought. And of course, we always said our "assistants" would be dropping off a script, though invariably the assistant was me.

Play the Agency Game

As friendly as you get with one agent, make sure you're also friends with another. Typically you get three bites at the apple with any given agency: If three actors pass on the same script, that agency will stop returning your calls. And if all your actors do come from the same agent, then the power shifts, and you're beholden to that agent—for better or for worse. To keep your casting momentum going, it's best to play the agencies off against each other. Use the nuggets of success with one agency ("oh, you know WME's got the script out to Jennifer . . .") as leverage to get the other agencies to move ("well, yes, I suppose you could slip it to Ben for the weekend read"). Likewise, play the managers off against the agencies. Remember, it's a game. Have fun with it!

Bait and Switch

With *Between Us*, just as we were getting a great cast, the economy fell through in 2008 and there was no way to make a film for any budget. Luckily for me, I got a book deal on a completely unrelated project (*I Am Martin Eisenstadt*) and after it had run its course two years later, I came back to *Between Us*—but this time the approach was to do it on a microbudget. Between Kickstarter and investors, we had about $30–40,000 in the bank. That was enough money to be able to pay actors $100 a day (at the time, that was SAG ultra-low scale if your budget was under $200,000—as of 2015, the rate increased to $125 a day, with budgets under $250,000).

The crew wouldn't get paid, but that was our problem, not the actors' or their agents'. The script was exactly the same as before; we never rewrote it for a smaller budget. So we could go back to the same agents and managers we were in touch with before and they would still take our calls, and use the same coverage as before. Legally, if you have a backed offer they have to pass it on to their clients, no matter how small that offer is. And frankly, an agent will take you more seriously if you have 100 percent of a $40,000 budget in the bank than if you have 0 percent of a $3 million budget in the bank.

Set a Start Date

This is a lesson I learned from Robert Altman: Set a start date, and they will come. For most actors—particularly those who've been on TV series, or big budget movies—they don't need the money. It really doesn't matter whether it's $65,000 for the run of the movie (SAG's Schedule F rate, if you're doing bigger budget films), or $125 a day. They're doing it for the roles. The key thing is the start date. If they're available, they will want to work. Actors abhor a vacuum in their schedules. And there's nothing agents hate more than whiny clients calling

them every day asking why they're out of work. The start date is more important than the budget: No one wants to get left behind.

Make it Real

As soon as you start asking questions like "does your client have any peanut allergies we should be aware of?" (since all you can afford to feed them is PB&J) or "what is your client's hat size?" (to give the impression that you've already hired a wardrobe department), the agents will believe that you really are making the movie.

Magnetic Balls of Iron

You need some serious cojones to pull this off properly. It helps to know that you have backup actors in a pinch. For literally years on *Between Us*, I had been meeting actors for coffee (it's axiomatic that actors don't eat, so you can take them to reasonably nice places and not go broke). So I knew we could always make the film with talented actors if we wanted. Remember, as you cast, most of these so-called attachments will fall through. The microbudget indie will always get trumped by the Spielberg film or pilot shoot for *Scandal*. But as long as they don't *all* fall through the same day, you're fine. In our case, Taye Diggs originally thought he was signing up to be in a movie with Michael C. Hall, America Ferrera and Kerry Washington. But thankfully, as those three all dropped out at different times, Taye stuck with the film and we were able to build up our cast again. And of course, his agent was now even more motivated to help us out (which he definitely did).

Take Advantage of Others' Misfortune

As you get closer to that start date, your ability to cast closer to the A-list actually increases. For *Between Us*, the best example was Julia Stiles. She'd always been floating around our lists (I lied; of course we had lists), but I knew she was booked for six months in a Neil LaBute play on Broadway. One day, her agent called me in a panic *while* I was meeting with one of his other clients. Despite rehearsing for a month, the LaBute play's financing had fallen through two hours before, and they needed to fill Julia's schedule. Was I interested? Yes, make the offer! (I knew her manager was already a fan of the script, having taken him to breakfast in Venice some three years before.) Within 24 hours, Julia called me and said she was in. Two weeks later, she was in my kitchen rehearsing the movie.

Now then, was all this the work of years of careful preparation and planning? Or did we simply take advantage of an actress in her most vulnerable emotional

state and swoop in to save her? It doesn't matter. The point is we made the movie with amazing actors who delivered performances that won awards and critical plaudits.

And by the way, remember that so-called $40,000 budget? Once we did get our actors and started shooting, we got a very nice financier to invest in the film. His check may have only cleared three days before the *end* of principal photography, but clear it did, and even most of the crew got paid. It may not be the ideal way to make a movie, but it's definitely one way.

Oh, and What if You *Don't* Have Famous Actors?

Now, I've been writing on the assumption that you're trying, and succeeding, in getting famous actors to be in your film. But for many of you, if it's a short film, or even most features, your actors will not be famous glamorous movie stars . . . not yet anyway! And even if some of your actors are a little famous, that doesn't mean that all of them will be.

So, along with your casting director, there are a few other ways to find good actors. If you're in LA or New York, you'll want to write short descriptions of each of your roles and submit them to something called Breakdown Services. They might charge a little bit of money, but it's worth it to make you look legit. Even if you're casting big names through big agencies, it's a good idea to submit to Breakdown to make it look like you're serious about casting even the little parts in your film and that you didn't lie about your start date.

Most of the small-to-medium-sized agencies will go through Breakdown each day and scour it for parts that might fit their clients. Just be careful about deciding which email you want to use for the replies: You are going to get inundated with headshots and resumes. Most of them will be people you've never heard of. But you'll be surprised by getting a few famous names in there who, for whatever reason, are repped by smaller agencies. For practical purposes, it also will give you a file of good headshots in case something happens to your fancy actors at the last minute.

On *Open House*, we had a situation where one name actor dropped out the day before principal photography. We turned to our stack of headshots, and picked a similar sort—an older British gentleman. We reached him right away and he was all set to show up to set the next morning. But at 5:45 am, he called Liz Jereski, my casting director, and said that he'd taken a sleeping pill the night before and had just woken up "with enlarged testicles." He was very sorry, but he couldn't make it to set. So after Liz regained her composure (it was not often that she'd awoken to the sound of enlarged testicles), she called our next head-shot on the backup list, Ian Whitcomb, who was able to make it to set by 9 am. Ian (a former teen idol who once toured with Mick Jagger) was great in the film and it all turned out well. As for the prior actor? We certainly hope he recovered.

The odd irony of casting is that the bigger your budget, the less likely you are to actually audition your fancy actors. At a certain level of actors (like who I had on *Between Us*, and anywhere above that), you're making your casting decisions based on meetings, rather than any line readings. The actors are auditioning you, the filmmaker, as much as the other way around. Decide carefully where you want to meet, and use the venue to help suss out the actors' personalities. Sometimes I'd make a point of meeting at a restaurant that I knew had a particularly rude French waitress, just to see how the actors would deal with the inevitable conflict. At other times, I'd meet them at a local coffee shop when I knew it'd be filled with loud, inquisitive middle-schoolers, just to see how they handled the distractions ("Dude, are you famous or something? Where do I know you from, dude?"). But for most actors, in most movies, there is some sort of audition process.

Once you get all these headshot submissions and have narrowed them down to a manageable amount, then you'll need to set a time and place for auditions. You ideally want to find a nice professional office environment with a big waiting area, and then usually a smaller office for the audition itself. If you're working with professional casting directors, they will either have space of their own for this, or have regular venues they rent. But don't get too fussy about your space. On *omaha (the movie)*, we held auditions at the local racetrack (where, yes, we did have an office). On the film I nearly made, *Stamp and Deliver*, I held auditions at my friend Paul Rachman's spacious rental house in the Hollywood Hills. Yes, it was slightly creepy, I suppose, but my two (female) casting directors were there, too, so we maintained an air of professionalism. One of my all-time favorite auditions was there. The late and very great Brittany Murphy portrayed a postal vixen wrapped in stamps, writhing atop a stunned Jeremy Sisto, crying out "Lick me, I'm yours!"

On *omaha (the movie)*, I was lucky enough to get casting advice from one of the all-time greatest casting directors in the business, Lynn Stalmaster (who's featured prominently in the documentary *Casting By*). Having cast everything from *Fiddler on the Roof* and *Harold and Maude* (in the same year!), to *Welcome Back, Kotter* and *Hart to Hart* on TV, Lynn was renowned in Hollywood for discovering future superstars like John Travolta and Christopher Reeve. Fortunately for me, Lynn was also born in Omaha and was happy to help out a fellow native. He was already starting to retire when I met with him at his office in LA. Instead of offering to make a few calls and help me find some big name actors for my first feature (a boy could dream!), he advised me to go with an all-local cast on the film.

Thankfully, he gave me a great tip on how to do auditions. He said to try to get someone other than the director to read the lines with the actors. That way, the director can really focus on the actors. But Lynn said the key is to look at the actors when they're *not* talking. How are they reacting to the other

person reading? Are they staying in character? How's their face and body language? Lynn said anyone can give a *decent* line reading, but only the *good* actors can perform between the lines. Armed with those lessons, I returned to Nebraska and cast the movie.

Speaking of local casting, if you're working outside of LA or New York, then it can be a little harder to find local actors. Check with the local film commission and they'll definitely give you tips on either local casting directors or regional agencies. Use newspapers and local social media groups to spread the word. On *omaha (the movie)*, I already had a good relationship with a number of actors at the Blue Barn Theatre company (rather inexplicably founded by recent graduates of SUNY-Purchase, one of the best drama schools in New York state). Once you find a core group of actors, they'll lead you to others. Even though my lead actors weren't A-list famous actors in the traditional Hollywood sense, they were all pretty famous actors locally. That in turn led to more investors and better support from the local community for both the production and eventual release of the film.

Directing Famous Actors in a Microbudget Film

On *Between Us*, it was gratifying to see the amazing reviews for our four-person ensemble cast, with critics using blurb-ready adjectives like "brilliant," "razor-sharp" and "career-best" to describe the performances of Julia Stiles, Taye Diggs and Melissa George. David Harbour won the Best Actor prize at the Woods Hole Film Fest (even though they spelled his name wrong in the awards announcement). Most obviously, all credit is due to the actors themselves. But a

Callbacks
Slamdance Opening Night Poem, 2005

You try to raise money, from friends and from family
The dentist who cleaned off your plaque
Your childhood sweetheart, your rabbi, your coach
Even your grandmother won't call you back

You look for a cast, you try agents, yeah right
Try to find ingenues who are stacked
Hold auditions, tryouts and cold readings
But nobody calls when you hold your callbacks

Just try for advice, from a friend in film school
That buddy you used to call Zach
Now he's a Bruckheimer director, and he calls himself "Z"
There's no way that he'll ever call back

How 'bout the big actor, who went to your high school
Quite famous for a guy who can't act
Spoke at graduation and said that he'd help you
Like hell that he'll ever call back

Free scripts at Kinko's, the cute clerk winked and smiled
Off your bill she did nicely subtract
But you read in the Trades, she sold your script in her name
There's no way that she's calling you back

Your neighborhood waiter, you tipped more than expected
For latte with vanilla extract
Just booked a gig on TV, a *CSI* corpse
Don't hold your breath that he'll ever call back

You start shooting your film, but deposits mount up
You're insured, and equipped, you've got snacks
But you ran over an actor, who knocked over the camera
So it's doubtful your insurer calls back

Your neighbor's an editor, says he'll work for free
No need for a fancy contract
But he schtups your wife, and your kids call him "Dad"
None of them ever will call back

Hey! You get into Slamdance, yup, you beat the odds
Now it's time for a crowd to attract
With a 9 am blizzard, just one guy buys a ticket
And he's not likely to ever call back

But guess what?
All it takes is that guy to be right
The right guy to attend and react
And the next thing you know
You're a Hollywood star
And none of *your* friends will *you* ever call back.

couple of critics nicely said that I couldn't have screwed up the directing too much, or these performances wouldn't have shown up on screen. So, to answer the question of how to *actually* direct fancy actors on a microbudget film, here are a few ideas.

Cast Well

When I was getting ready to make my first film, *omaha (the movie)*, I was lucky enough to get advice from two great directors. Harold Ramis, coming off *Groundhog Day*, and Robert Altman, who became something of a mentor to me. Both essentially told me that the secret to directing good performances is to have cast the film well in the first place. In addition to just getting *famous* actors in your movie, you also have to get *good* actors. Even if they're good, you also have to make sure they're right for the part, and work well opposite the other actors. Casting is like putting together a giant, blank, white jigsaw puzzle: Once you finally put it together, you can start to paint your picture on it. So the question remains: What do you do between hiring your cast and turning on the camera? And if 90 percent of directing is casting, what's the other 10 percent?

Rehearse

Whether you're making a $200 million blockbuster or a $100 iPhone epic, it might be a good idea to rehearse your actors—especially if it's a dialogue-driven movie. This sounds obvious, but it rarely happens, no matter what the budget. For one reason, SAG says you have to pay actors for rehearsal. Of course, that's only true if you call them "rehearsals," do a formal call sheet and require the actors to show up. But, if you refer to the sessions simply as "get-togethers" or "long lunches" and just say to each actor, "oh, *you're* terrific. *You* don't need to be there . . . but I think the rest of the cast is coming," then trust me, that actor will show up.

On *Between Us*, this is pretty much what we told all our actors and their reps. All four parts are essentially equal in number of lines and depth of character. If you're getting serious actors who are doing the film because they want to do a substantive indie rather than a paycheck studio film, then there is no way these actors will want to skip out on rehearsals, only to be outshone on set by the other three actors. It's a matter of pride, ego and craft. We bluffed with the agents and said we needed two weeks of rehearsal. In reality, I thought maybe we'd get one week at most. But sure enough, all four showed up in my kitchen for rehearsal two weeks before principal photography! (Why my kitchen? Because my garage was already our production office and stuffed with our crew.)

Harold Ramis

When I was getting ready to make my first film, *omaha (the movie)*, I was still at film school and had no connections in Hollywood. But as an undergrad, I'd gone to Washington University in St. Louis, which had one famous alumnus in the film biz, Harold Ramis. At the time, Ramis was known as a top director, screenwriter and actor for such films as *Ghostbusters*, *Caddyshack* and *Stripes*. For any WashU grad, though, he was legendary for having co-written the script to *National Lampoon's Animal House*, based largely on his own experience as a ZBT at WashU in the 1960s.

Before the era of IMDb, email or anything resembling an internet, it wasn't easy to track down a famous filmmaker in Hollywood. I contacted the Directors Guild who told me who Ramis' agent was; I typed a letter and dropped it in the mail. It must have been a slow time in Ramis' schedule, because two weeks later, I got an answering machine message: "Hey, Dan, it's Harold. Give me a call back."

Once I got him on the phone, he was great—we reminisced about WashU, and he told me they'd actually wanted to shoot *Animal House* on campus (the parade scene, in particular, was written with the Delmar Loop firmly in mind). But for some strange reason, Chancellor Bill Danforth (brother of then-Senator Jack Danforth) decided it would be a bad idea. What was he thinking?

I told Harold I was working on my first film and it was a comedy. Did he have any advice for me? He told me to grab a piece of paper. I did. He told me to grab a pencil. I did.

He said, "OK, write this down. Rule #1." Rule #1, I wrote. "Hire Bill Murray." I wrote it down. "Rule #2," he said. Rule #2, I wrote. "Turn on camera."

"Wait, that's it?" I asked? "Yup," he said. "That's all I do." Years later, when I saw *Lost in Translation*, I realized that Sofia Coppola (perfectly to her credit) had just done Rules 1 and 2. By now it's legendary how hard it is to even find Bill Murray (he has no agent or manager, just an 800 number he sometimes checks), let alone hire him. So maybe Harold was right!

When Ramis died in 2014, I tweeted a short version of my encounter with him and his two rules. Bizarrely, that tweet led to me getting quoted in some of his obituaries as one of his celebrity friends. I wasn't sure whether to be honored or ashamed.

Use Rehearsal Wisely

It seems obvious that rehearsal is a good idea, but really, a movie is *not* like a play. Actors don't need to memorize more than a page or two at a time, and there's always opportunity to rehearse on set or run lines during makeup. And if you rehearse ahead of time, it could be three weeks before you actually shoot some of the scenes. Depending on the film, you may prefer spontaneity over stale performances that could sound phoned in. So why bother rehearsing in advance—especially if you're starting with great actors?

For *Between Us*, it turned out to be a great idea: Mainly to get the actors—who were all playing old friends—to develop a rapport together. They all came to the material with very different acting styles and backgrounds, and the rehearsal period helped smooth out those differences and give the dialogue a consistent rhythm and pacing. Since David Harbour had originated the role of "Joel" when it was a play, he knew his character—and most of his lines—inside and out. But there were subtle changes Joe the Playwright and I had made in the adaptation—in character, dialogue and structure—and obviously acting styles need to be adjusted between stage and screen. The challenge for the other actors was keeping up with David, while he adapted his own theater experience to this film.

Overlapping Dialogue

For all the actors, part of the challenge was getting them used to overlapping dialogue—something anathema to traditional TV and studio-level filmmaking. The play had built-in overlaps throughout, and my own style (influenced as it was from Altman) also favored overlapping dialogue. I knew that on set, each actor would have their own lavaliere mic going to an individual track (in addition to a backup boom mic). I'd done this on my prior film, *Open House* (which had an even larger ensemble . . . plus live singing!), so I knew that even on a microbudget, this was still the way to go, even if it takes a little longer in post.

As Altman once told me, why trust the lowest-paid member of the crew—the boom guy—to make artistic decisions about whom we're going to listen to? "*I'm* the fucking artist," he said bluntly. Those decisions are best made by the director in post-production. The other big advantages are you get more natural-istic performances, you never have to do ADR (dubbing in post-production), and your actors never know when they're being recorded. They tend to stay in character longer and give you great nuggets of dialogue before and after takes. Whether you've got a tight, specific script as we had, or an improvised mumblecore film, overlaps are the way to go.

The Sound of Music

The standard, Hollywood way to shoot a musical performance in a film is to have the music prerecorded and then play it back on set while your actors either lip sync or play air guitar to it, like a music video. Unfortunately, it almost always *looks* like your actors are lip syncing or playing air guitar to music that was obviously recorded in a pristine recording studio a month earlier.

An unquestionably better approach is to have your actors or musicians perform live, while you're shooting. It's a tradition that dates back to the Marx Brothers' films, and continued with movies like Peter Bogdanovich's *At Long Last Love* and Woody Allen's *Everyone Says I Love You*. It was a big reason that Bette Midler in *The Rose*, Barbra Streisand in *A Star is Born* and Anne Hathaway in *Les Misérables* all got Oscar nominations or wins. By far, though, the greatest practitioner of this live music technique was Robert Altman, most notably in *Nashville*, but in many of his other films (e.g. *M*A*S*H*, *Short Cuts*, *Kansas City*) there are musical performances, both large and small. Altman told me his technique was to shoot a musical performance in close-up first, shooting as many takes as he and the performers would need. For sound, Altman would use either the actors' regular lav mics, or whatever performance mic might have been visible in the scene. When they were happy with the last take, they'd save that audio and use it for playback on any subsequent master or wide shots, which would be lip sync'ed. The theory here is that the actors can actually *act* while they're singing or playing their instruments, and give you better performances without distracting the audiences with obvious lip-syncing.

When I made *Open House*, we had been planning on using the Altman approach, but came up with a way to do all our coverage with live performances and never used playback. During rehearsals, our music director Andrew Melton would make note of the key the actors were singing in and the beats-per-minute for a rhythm. While we were shooting, he'd be just off-camera playing a small electric piano connected to a speaker that the actors could hear. While playing, Andrew would look at a silent metronome with a blinking light. As long as he played every take in a consistent key and rhythm, we could always sync up and intercut between takes and between camera angles—regardless of whether they were close-ups or wide shots. To the extent that the piano music bled into the lav mics the actors were using, we knew that when we added additional instrumentation in post, it would always mix in just fine.

On our German musical, *Half Empty*, we didn't have the luxury of bring-ing Andrew with us to Europe. So we prerecorded simple instrumentation (guitar, drum, piano) in the week before we left the States, and laid those tracks onto a CD. We even brought along our own little battery-powered boom box. During takes, we'd just hit play and have the actors sing along live. If we were doing it today, we could probably just use iPhones to do almost everything—including both sound and camera!

What's My Motivation?

When it comes to working with actors, you need to appreciate that there are no silly questions, but there are time-consuming ones. All actors—and especially the good ones sometimes—will have endless questions about their characters, motivations and backstories. And that's fine. They will give better performances if they feel confident in their choices. The problem is that on a low-budget film (or for that matter, on a network TV drama) where you're trying to shoot nine or ten pages a day, you simply don't have time to answer these questions on the set. With designated rehearsal (or "get-together") time, you've got the luxury and patience to talk about the meaning of a single word, or what the charac-ter's favorite color is, for hours on end. It may not objectively matter what the answers to these questions are as much as you've shown respect to the actors in talking about these issues and hearing out their concerns. And when you do finally come to set and the question comes up again, you can simply say "We discussed that in rehearsal—don't you remember?"

Trust Your Scripty

I'm a big believer in script supervisors. When you think about it, on any set, 98 percent of the crew is there to make the film look and sound good. But only the director and script supervisor are specifically focused at all on the editorial side of filmmaking (crossing the line, getting coverage, etc.). So when it came time for our rehearsals on *Between Us*, I knew that we'd want our script supervisor, Shannon Volkenant, there with her pencil in hand. If there were any subtle dialogue changes—which inevitably there would be—Shannon would dutifully write them down. And right before our start day, she prepared the final version of the shooting script for everyone. But a good scripty is more than a dutiful stenographer. She (or he) is also the director's most loyal ally. Shannon remembered every little discussion and nuance of rehearsal and the cast trusted her as much as I did to remember it all.

Encourage "Chemistry" Among Your Cast

We were lucky enough to score a deal with the Redbury Hotel—a boutiquey hotel in Hollywood—to house all of our actors on *Between Us*. The hotel management wanted the Redbury to become the new Chateau Marmont, and we assured them of at least one celebrity suicide if things didn't go smoothly. Sadly for them, things went a little too smoothly. The actors all loved the hotel, and we wound up actually shooting two-thirds of the movie there, too. So while we rehearsed in my kitchen for the first week, we transitioned over to the Redbury to work on what would become our actual set. The nice thing was that the actors were getting together on their own at the hotel and running lines and otherwise making chemistry together. And, yes, some more than others ;)

Behave Like a Big Budget Production

Just because you're not paying your actors more than $125 a day, doesn't mean you shouldn't treat the actors as if it's a studio film. The nice thing about working with famous actors is you can actually get a lot of amenities (including actual cars!) for free for them if you know whom to ask. Use their celebrity status to your advantage and you'll all be happier.

It's axiomatic that actors don't eat carbs, and in fact rarely eat anything at all. So you don't need extravagant food, but it does have to be nice. On *Between Us*, my loving wife bought fruit at Costco and cut it up every day for the actors (for rehearsals and gift baskets), and a houseguest became our designated "rehearsal chef" for light lunches of fresh grilled veggies. I think we maybe spent $100 total for rehearsal food, but it was worth every penny. During production itself, I have no idea what the actors ate. They seemed to disappear at lunch break, and return happy, so I thought it best not to inquire.

Big-budget courtesy was important throughout principal photography. You don't necessarily need three-banger trailers for each actor (industry parlance for those big RVs you see on Hollywood sets), but you do need to give them all their own space to relax and gather their thoughts. That was one advantage of shooting in the same hotel where the actors stayed—they could always retreat to their own rooms if they wanted. It helped that we were scrupulous in abiding by our "favored nations" clause in the actor contracts that said we had to pay and treat all four equally in all respects.

Your hair and makeup artists need to be professional and on top of it; that is your team who will ultimately spend more time with your cast than you will. On *Between Us*, a bad experience with supergluing eyelashes on one of our actresses on the second day of production led to tears (or at least would have, had the tear ducts not been glued shut). Appropriate staff changes were made and all was fine after that.

In order to give our cast the impression that at least some of us were trained professionals and not just a ragtag troupe of students, interns and ne'er-do-wells, we brought in the occasional ringer. You know what's cooler than having two Golden Globe-nominated actresses in your movie? Getting an *Oscar*-nominated documentary feature director to shoot their behind-the-scenes interviews. Yup, instead of some 17-year-old kid with an iPhone, I got my pal Adrian Belic (*Genghis Blues*) to do the two-camera interviews on a separately lit set for *Between Us*. (*This* is why I give Adrian a ride to Park City every year in my minivan . . . he owed me one.)

Block Scenes On Set

On the most basic level, directing is simply telling your actors where to stand, and telling your cinematographer where to put the camera. But on an indie film—with limited time, budget and locations—you're lucky if you have full control over either of these elements.

No matter how much you rehearse, your actors will rightfully want to do blocking rehearsals when you get on set. There's no substitute for a real location, with real lighting, props, costumes, cameras and a hovering crew. It's almost pointless to even try any blocking during rehearsal itself. It took me a few (sometimes rocky) first days on *Between Us* to figure this out, but ultimately we settled into a nice rhythm of clearing the set except for the actors, my cinematographer, script super, 1st AD and myself. We'd run the scenes a couple of times, figure out the blocking, then bring in the assistant camera and sound teams to make marks and take focus measurements.

This process isn't that dissimilar, I imagine, to big-budget filmmaking. The differences are more subtle. On a studio movie, you've got time and trained personnel to move lights and cameras around quickly for every setup within the scene. Also, if you're paying your actors big money, they might be more likely to stand where you put them. On an indie film, blocking is more of a suggestion than a directive, and you're more of a "creative partner" than a dictator. It's not called a collaborative art form for nothing.

Working closely with Nancy Schreiber, my kick-ASC director of photography (DP) before the actors showed up on set, we could figure out where were the safe places actors could go that wouldn't require massive lighting moves later in the scene. Our primary locations were a big house (with lots of windows) and a small apartment (with almost none)—both of which presented their own unique challenges. Once the actors showed up, then it was a matter of broadly delineating where they could go, but leaving the minutiae of individual movements and gestures more up to them. The actors and DP all felt part of the creative process, and if they were all happy, I knew I'd get the performances and shots I needed, and still make our days (well, most of the time).

Use Multiple Takes as Your Coverage

The advantage of using name actors—and especially after rehearsing them—is that they tend to be incredibly good at what they do: In general, they wouldn't have become famous if they weren't good actors. They know their lines, they give you great performances, they take direction well and they hit their marks. Inevitably, I was more than satisfied with our first or second takes with every setup. Nancy and her crew nailed the camera and focus moves every time. And with five unique tracks of sound running on each take, I never worried about sound problems.

Actors, though, are by nature interested in trying different nuances to their performance and even if you as the director are satisfied, it doesn't mean they will be. In our case, I knew that lighting changes were taking a long time, but camera changes weren't. We were shooting two cameras all the time (REDs), usually with one on a dolly and one on "sticks" (cool movie lingo for a tripod).

Frequently instead of a true third take, Nancy and I would make subtle camera changes: a slight dolly move, a zoom in, a focus change, etc. that might only take a minute or two to change up, but give us far more options in editing. Takes 1 and 2 on Camera A might have been close-ups, but Takes 3 and 4 might have been two-shots. Meanwhile, our B Cam could shoot reactions from one actor in the first two takes and reactions from another actor on the next couple of takes. So after four or five takes, without tweaking the lights much at all, we could have full coverage of a scene with a variety of performances to choose from. To make matters more interesting, since we were shooting 4K resolution and knew that we'd finish in 2K, Nancy and I could turn a two-shot into a close-up in post if we needed to, almost doubling the coverage we'd shot.

Have Faith in Editing

It's good to have a general sense of how you're going to edit the movie before you start shooting. Are you going to have long shots with a "European" pacing? Then make sure you get the performances you like on set, because you won't be able to change them later. Or do you prefer a jump-cut style? Then get the variety you need from both actors and camera angles—even if that means intentionally making continuity changes.

My own druthers tend to be for a quick cutting style, where I prioritize the audio tracks over the visual. The rhythm of the dialogue dictates the picture (I sometimes close my eyes during editing just to listen to the audio. Other times, though, it's just to take a nap). I think this probably comes from doing *omaha (the movie)*, shot on 35mm short ends—the cheapest way to get film stock for indies back in the 1990s. With short ends (leftover film stock from Hollywood productions), you'd barely get a minute of useable footage on each take before

hearing the dreaded film snapping in the camera and your 1st AC bellowing, "Roll Out!" And with that same movie, we cut the film on the Paramount lot using 1930s-era sync blocks and upright Moviolas (hey, they gave us the rooms for free). If you've ever cut a film that way, you get used to cutting audio first on the little green sync block and then checking picture on the Moviola. It's the original non-linear editing system! Despite the technology change, I cut the exact same way on FCP or Premiere.

Given our multitrack audio and knowing my own intrinsic style, I had more latitude on set with the actors. If an actor was giving me too many pauses (dramatic or otherwise), I knew I'd be able to cut out the gaps in editorial, and speed up the pace. Likewise, if an actor burned through the dialogue without pausing where I wanted, I knew I could always cut to reactions from the other actors and extend moments as I saw fit. I had neither the need nor the time to do 96 Fincher-esque takes on a scene to get exactly the performance I wanted for my final outcome. Just because you have "endless" footage available on digital media these days, doesn't mean you need to shoot endlessly. I think Martin Scorsese once called this "selecting" rather than "directing."

Say Something to the Actors

I remember when I went to film school at USC we had exceptional faculty who taught us every technical step of filmmaking we'd ever need to know. But learning how to actually direct actors was far more elusive. Once, Robert Zemeckis came for a guest lecture. At the time, he was definitely known as a cutting-edge technical director (*Who Framed Roger Rabbit*) and brilliant storyteller (*Back to the Future*), but pre-*Forrest Gump*, he was not exactly known for his dramatic directing chops. But he'd just worked with Meryl Streep on *Death Becomes Her* and he was excited to tell us his secret to directing. We got ready to take notes: He said, "When I wanted Meryl to be happy, I'd say, 'Meryl, be happy' and she became happy! And when I wanted Meryl to be sad, I'd say, 'Meryl, be sad!'—and she became sad. It was amazing!" We were stunned. $50,000 spent on film school and that was it??? But two years later, Zemeckis won the Oscar for Best Director, so maybe he was onto something.

With *Between Us* I kept remembering that dubious advice that he'd imparted. What to say to actors between takes? I frequently went with the Preston Sturges/ Billy Wilder/Kevin Smith method and just said, "Faster. Faster! Faster!!!" But actors don't always like being gears in a stopwatch, so that wouldn't always work.

They all respond differently to in-scene adjustments. With some in particular, I went with variations of "great" and "super." If I really liked a take, I went with "super-duper." For others, we'd talk more about backstory and recall those questions from rehearsals. Some begged for more takes, even when they weren't

necessary, and others declined them when they were. One inexplicably refused to be physically touched.

Methods to their Madness

Every actor brings a different creative process to your production. With *Between Us*, that was very evident. We had one actor who was so "method" he (or she) would hide in a corner deep in character until he (or she) heard "action" and then storm onto set. Other actors were jovial with the crew and chatting away one second, and then could turn into character at the drop of a hat. We even had one actor whom I thought was completely happy-go-lucky off-camera, but a year later I found out that her (or his) personal life during the shoot was in such turmoil (closely paralleling our script), that she (or he) was probably the most method of all the cast even if we didn't know it and she (or he) didn't want to be.

Especially when you're making a dramatic film with characters throwing such vitriol at each other on a daily basis, it's hard to have a "happy" set all of the time. Honestly, making a musical comedy is way more fun! I've heard the story of Sydney Pollack having problems with Dustin Hoffman, who excoriated Pollack on the set of *Tootsie* in front of the crew. Pollack had to grovel with Hoffman knowing he was getting an Oscar-caliber performance. Robert Altman famously faced a near-coup on the set of *M*A*S*H* when Elliott Gould and Donald Sutherland tried to get their director fired.

But as my pal, director Kevin DiNovis, reminded me on *Between Us* after I'd call him in a panic after wrap: "It doesn't matter if an actor is yelling, you're yelling; he's crying, you're crying—what matters is are you getting great performances in the can?" At the end of every day, I'd ask myself that question and know that we had. The film gods had given me this extraordinary gift of four amazing actors who were delivering the performances of their careers. Creating the conditions for the cast and crew to do their best, and having the confidence to know when that's happening, might be the 10 percent that Robert Altman and Harold Ramis didn't tell me about.

Lights, Camera, Cinematographer!

One of your most important creative collaborators on any film is your cinematographer, also known as the DP (called "DoP" outside of the States, so if you want to be fancy, call yours that, too!). In essence, your DP (see, I'm a boorish American) has two broad responsibilities: To get a moving image onto your camera, and to light the sets so you can see said moving image. Lights, and camera—sounds easy, right? But good DPs will do so much more for you—they'll help you work with actors; they'll be there for you in color correcting; they'll be your emotional ally with the cast, crew, producers and financiers; they'll keep

an eye on the coverage and shot selection to help you cut the film together. The best DPs will make you look like a brilliant director even when you're filled with self-doubt and wind up a sobbing fetus huddled in a corner of the set.

Good vs. Nice

When you're hiring your DP, you need to consider two broad issues: Is this person technically good at what they do? And, is this someone you get along with personally? If the answer is yes to both, then you're all set—hire that DP! Even if the answer is no to either, you can probably make it work. If someone's a genius cinematographer, but a pain in the ass on set, you can probably live with it—especially for a short shoot. Conversely, if the DP is your best friend (or spouse, or sibling), but all the shots are out of focus, at least you can talk to him or her about it and try to solve any shortcomings. But if you don't get along with your DP *and* the DP isn't giving you the shots you need, then it's time to find a new DP.

Some directors establish decades-long relationships with DPs, and others like to mix things up and give their films a different look and feel depending on the project. Rian Johnson's worked with DP Steve Yedlin since they were teenagers, and Christopher Nolan met his long-time DP Wally Pfister at Slamdance when Chris showed his first film, *Following*. But even the best director/DP relationships evolve over time. After working together for 15 years, Pfister set his sites on directing his own film, *Transcendence* (which Nolan helped produce), and Chris has had to use new DPs (Hoyte van Hoytema, for example, shot *Interstellar*). As for me, despite good relationships with most of my cinematographers, I've bounced around using different ones on all my films.

Rian Johnson

NAME DROPPER

When I was a grad student at USC, there was a plucky high school kid in Chatsworth (an LA suburb) who used to come by the film school and check the bulletin boards to see which grad project needed extra camera assistants on the weekends. By the time Steve Yedlin graduated high school, he knew more about film cameras than any of the grad students. When he went to USC for his Bachelor's (we warned him not to!), his best buddy there was an equally precocious young lad named Rian Johnson. I'm not even sure

Rian was a film major at all—it wasn't an easy program to get into and it was fairly random who did.

But Rian and Steve were determined to make their own short films outside the curriculum, so we grad students would give them our short ends, and teach them editing, sound design, negative cutting and anything else they needed to know. It was clear even then that these guys were talented and worked well together as a team. When I made *omaha (the movie)*, we had one day of shooting in LA, which we were able to do on the Paramount lot. There was a former Omaha local TV anchor, Michael Scott, who was then a correspondent for *Entertainment Tonight*—so we shot a cameo with Michael on Leonard Maltin's corner of the set. Steve was our camera assistant, and Rian was our production assistant that day (if you see my end credits, you'll see that I spelled Rian's name with a "y"—oops).

Heading into our second year of Slamdance, I was able to program one of Rian and Steve's old USC short-end films, *Evil Demon Golfball from Hell*, into our shorts section. A really inventive, funny short, the film played like gangbusters in front of an audience. Even though Rian himself didn't make it up to Park City for the festival, I recruited him to be a programmer for the next year's fest. I think the experience was so profound (by which to say, haphazard and fraught with drama), he even wrote a tell-all article about it for a magazine at the time.

Around that time, he showed me a brilliant little high school noir script he was working on, called *Brick*. He asked me for a list of producers, and I rattled off a bunch of names of producers I'd met on the festival circuit. Rian dutifully wrote them all down in a notebook, and then couldn't get the film made for at least seven years. When he finally got it off the ground and needed a prop notebook for Joseph Gordon-Levitt's character, he used his old notebook. While on set, they were looking through it and found the old list of producers. Sure enough, among my list was a guy named Ram Bergman, who would indeed become Rian's producer—not only on *Brick*, but also on all of Rian's films, up to and including *Star Wars Episodes VIII* and *IX*. As for Steve Yedlin, the talented teenage cinematographer, at one point I asked him if he was interested in shooting my film *Between Us*; he said, "Sure, but I'm on my way to China next week to shoot Rian's film *Looper* with Bruce Willis. So I can't." Hmm, remind me to ask Rian, Steve and Ram for their short ends on *Star Wars*.

They're Like Actors with Cameras

Hiring a DP is similar to casting from both a creative and practical standpoint. Your best friend from film school could be an award-winning verite-style war documentary cinematographer, but if you're getting ready to shoot a big budget sci-fi space epic, that DP might not be the right choice. You've got to look at their reels, talk to them frankly and check with prior directors they've worked with. For all you know, that award-winning documentary DP might also have extensive green-screen work hidden on her commercial reel, or have shot footage for NASA on the International Space Station, so you might be surprised to find out she's the *perfect* DP for your sci-fi epic. On a more practical indie level, you need to find out if the DP is someone who spends two hours lighting the actors beautifully on their exact marks, or is this the kind of DP more accustomed to lighting the sets broadly, and then following the actors wherever they go? Either style may be appropriate for the right film, right budget and right director, so you need to have a good sense of how *you* would rather shoot *your* film.

DPs are like actors in another important way—the good ones are busy. Perhaps more than most people in the business, DPs have an easier time floating between features, TV, documentaries, music videos and commercials. So, if you're shooting your three-week indie opus during the month of April, but the DP you want to hire has a two-day commercial shoot that pays $30,000 from April 11–12, that cinematographer will probably pass on your passion project that would have paid $3,000 and "net" points. As with casting, you may need to consider a few DPs and only make your final decision once your start date is set.

I remember one day at Slamdance a couple of years ago. We had an amazing coffee talk in our screening room with the late and legendary Oscar-winning cinematographer Vilmos Zsigmond, ASC. He had shot a film in the early 1960s called *Summer Children* that was finally rediscovered and getting its world premiere at Slamdance. Every DP in Park City worth their weight in light would be attending. So perhaps ambitiously, I'd arranged to meet both with Nancy Schreiber after Vilmos' talk as well as with Slamdance alumnus Ben Kasulke (Lynn Shelton's go-to DP). Befitting a man of his stature, Vilmos was brilliant, opinionated and hysterical. In particular, he spared no adjective publicly castigating Woody Allen for changing the brightness settings on their most recent collaboration *after* their color-correcting session. Plenty of people have accused Woody of greater sins, but in Vilmos' mind, none were as serious as screwing with a DP's color settings. In his thick Hungarian accent, Vilmos vowed something to the effect of, "I vill never vork vit zat esshole again!"

Right after the session, I told Nancy I'd meet her in the hallway, then rushed back into our screening room to chat with Ben. I told him to hang on while I talked to "someone" in the hallway, and this farce went on for 20 minutes with

neither the wiser. As it turned out, Ben was busy the month we were shooting, and Nancy was available.

It's Who They *Know*

Another thing to consider when hiring DPs, much more so than any other person on your cast or crew, is how connected they are, particularly in the city where you're shooting and on the budget level you have. In essence, good DPs will also function as something of a producer. Do they have good vendor relations? Can they get free cameras or discounted lighting packages? Better yet, do they have their *own* camera and/or lights? The same goes for their crew relationships: Do they have a reliable team of loyal camera operators, assistants, gaffers and grips? Do they have layers of backup personnel deep in their iPhone contacts? A self-operating single-cam DP who's got the New York indie scene dialed in might be useless in LA on your sprawling multicamera shoot. Likewise, an LA pro who's worked with all the best union studio crews might be clueless when crewing up for your little indie in Atlanta. In essence, when you hire a DP, you're not just hiring one person, you're hiring five or 20 or 100.

With that in mind, it's essential that your cinematographer also develops a good relationship with your producing team. If the DP is asking for a Musco light and a Phantom crane, your producers need to be able to say, "No, we can't afford it. Why not use an LED bank and shoot handheld from a step stool?" Hopefully they'll settle these discussions themselves, but as the director, you're more likely going to be right in the middle of these conversations. You need to be familiar with the tools of the trade, the limitations of your budget and your own creative inclinations. Your producer and your DP will respect you when you settle those discussions decisively and efficiently.

Putting the "DP" in iDentity Politics

Something else you *might* want to consider about cinematographers is their gender. In its almost 100-year history, the American Society of Cinematographers (ASC) has only admitted 20 women out of a total of 800 cinematographers, and most of those were only in the last few years. Now mind you, when I picked Nancy Schreiber (the fourth woman admitted into the ASC!) to shoot *Between Us*, I didn't do it out of an urgent pang for diversity in the film business. Rather, it was mainly more practical reasons like her talent, reputation, availability and contacts. But all other things being equal, I think in retrospect it worked out well having a woman cinematographer on that film in particular.

On many shoots, you'll wind up with a preponderance of one gender or another on the crew. So if the material has heavy dramatic or sexually charged scenes (as we had with *Between Us*), it might help to have at least two differently

gendered pairs of eyes looking down the lens, as either director or DP. There's just a better comfort level for the cast, and a more balanced perspective from the creative team.

Things get a bit dicier when you start delving farther into identity politics. What about a gay film: Should the DP be gay? What about a predominantly Asian-American film? Or would a film about visually impaired characters be better if the DP is blind? When it comes to those questions, you start to get into thornier diversity issues for the full crew (including yourself), rather than the DP in particular. Enter those muddy waters very carefully.

On the other hand, if you do have actors with dark complexions in your cast, make sure your DP has experience lighting them, especially when the actors are in scenes opposite people with lighter skin tones. It sounds racially insensitive, and uncomfortable discussing out loud (especially in the middle of a crowded set), but there are legitimate lighting and color-correcting issues when filming people with different complexions. On *Between Us*, Nancy and her team always had to consider adding or subtracting lights and changing exposure settings when we were shooting scenes with Taye Diggs standing next to the actors who reflected more light (and from a completely objective standard, Julia Stiles and Melissa George are both *very* reflective). So would Taye or I have been more comfortable with an African-American DP? Maybe. But at least we both knew Nancy was experienced in shooting a multi-hued cast and that's what mattered most.

Are They Still Called Films if They're Digital?

One of the biggest conversations you're going to have with your prospective cinematographers is what format to shoot on, what camera to use and which lenses. In some cases, the conversation is as short as, "You own your own RED with SuperPrimes? Great, you're hired!" But most decent DPs can shoot on multiple formats and have access one way or another to a wide variety of cameras and lenses.

The first decision to make is your medium: Film or digital? Twenty years ago, that was a simple choice. Film was the only viable option, and the conversation centered more around whether to shoot on 35mm, Super16 or 16mm—and whether to use color or black-and-white. After a group of Danish directors came up with their Dogme 95 manifesto (not surprisingly, in 1995) and got wide-spread international acclaim for their home-video-looking movies, indie films in the US gravitated toward the tiny video tape format of miniDV. Especially with the development of 24p (24 frames-a-second, progressive) cameras like Panasonic's DVX100 in 2003, those miniDV films had the potential to look more like film (my film *Open House* was the very first feature shot on the DVX100, and sadly, *looks* like the first film shot on that format, since we were

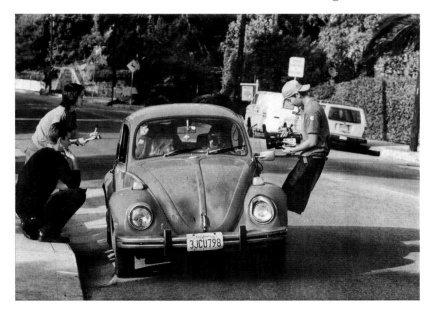

Cinematographer Yasu Tanida shooting a scene from *Open House*. Don't try this at home.

Photo: Dan Mirvish

still figuring out the camera). At the time, the format decision became a balancing act: Either shoot on film and pay the filmstock and processing costs up front, or shoot on miniDV and if you got distribution or big festival play, then pay upwards of $40,000 to blow up the finished version to film.

From around 2005–10, two big changes hit indie film. On the one hand, digital projection started to become the norm, first at film festivals, and later at commercial theaters around the world. Slamdance went to all-digital projection in around 2008 or so, and by 2014, I don't think even Sundance showed any film prints. If there was no reason to finish on film, did it even make sense to start on it? Simultaneously, with the advent of the RED camera to shoot hi-resolution HD on a camera costing under $5,000, and with Canon developing the 5D and 7D DSLRs, the decision got much simpler: If you're shooting an indie movie, it was simply cheaper, better, faster and just as good-looking to use digital. By the early 2010s, Kodak had declared bankruptcy, film labs throughout the world were shutting down, and the question seemed settled. Film was dead, and now the only issue was which of the many digital camera systems to use.

Film's Zombie Resurgence

But film is like a zombie format refusing to go quietly into the dark night. In 2014, a string of summits and manifestos led by the likes of Christopher

Nolan, Quentin Tarantino, Wes Anderson, Paul Thomas Anderson, various film archives, museums, film societies, the few remaining labs and a reorganized Kodak led to a rethinking of film as both capture medium, and to lesser degrees, projection and archive medium. You could say that film has reemerged as more of a boutique or artisanal format. On the one hand, studio directors like Nolan, Tarantino and even Judd Apatow (*Trainwreck*) can afford to demand it for their films. On the low-budget indie side, a generation of filmmakers reared on digital formats is discovering film for the first time: Joe Swanberg, who seemingly used to make a miniDV film once a month, shot *Happy Christmas* and *Digging for Fire* on film. And some, like Alex Ross Perry (*Listen Up Philip* and *Queen of the Earth*) have made shooting on film one of their unique marketing angles.

Artist's depiction of a real film camera

Illustration: Miriam Mirvish

Christopher Nolan and Emma Thomas

After Christopher Nolan submitted his first film, the brilliant 16mm black-and-white thriller *Following* (made for just $10,000), to Slamdance, we rejected it. Big mistake. Fortunately, my festival colleague, Peter Baxter, met Chris (back then, he was just Chris) at a panel discussion after the fest, introduced him to Peter Broderick (who would become Chris' sales agent for *Following*) and told Chris to resubmit the film to Slamdance. Chris was literally the first one to submit the film the next year (I remember, because his submission VHS got code number "1"). This time we made sure different programmers saw it. We all loved it and it got in.

As a rule, Slamdance will only show films in competition that don't have US distribution. But once we announce the films, we'd love it if the films get a deal: When that happens, the distributor usually waits to announce it at the festival itself, and then everyone gets more press. After we announced *Following* was in the fest, Peter Broderick and his plucky team sold the film to the hoity-toity New York company Zeitgeist Films.

The distributor put out a mild press release a week before the festival and I remember the Zeitgeist executives showing up at our screening room the morning we were setting it up in Park City. Led by two artsy New Yorkers who'd never set foot at Slamdance before in their lives, they slunk their pince-nez-adorned faces and black-sweatered torsos into the back of the room. Over the sound of us sweatily building our risers, installing projectors and unstacking seats, they drolly remarked, "Oh, how quaint." And that was the last we ever saw of them.

At the first screening of *Following*, there were a grand total of 14 people there, in a theater that seats 120. Chris and his producer/wife Emma Thomas were flummoxed: They were under the impression that their distributor would promote the film, or maybe their sales reps. Nope, we said. At Slamdance, it's up to the filmmakers. I told them to get their asses over to Kinko's, make a ton of fliers and hit the streets to get people to their second screening. They did, and they had a respectable showing—including some good influence peddlers like film critic/radio host Elvis Mitchell. Eventually they won the Ilford Black and White Award at the festival (yes, this was at a time when there were enough films to have a contested black-and-white film award). Some of the jurors confided in me that *Following* might well have won the grand jury prize that year, but since it already had distribution, it made more sense to help out Heidi Van Lier's film *Chi Girl* (another black-and-white 16mm contender) and give it the top award.

Emma, in particular, wound up staying very involved with the festival: She was an active features programmer for at least two more years after *Following* screened. When Chris and Emma made *Memento*, it screened at Sundance. This made them among the first Slamdance alumni who had their second or subsequent films screen down the hill at Sundance. Chris and Emma (and their four kids) were back at Slamdance for our 20th anniversary in 2014 for a coffee-talk presentation, and Chris noted that the screening room hadn't changed a bit. The only difference was that this time he didn't need to pass out fliers to fill the room.

Because Kodak, and the remaining film labs (FotoKem in LA, for example, or new mobile labs like British import Alpha1) are living on the edge of extinction, they'll make great deals with you just to keep their chemicals flowing. Film cameras are sitting around collecting dust, and you can get them for next to nothing. Veteran DPs and young film crews alike will jump at the chance to use real film. Consequently, the costs of shooting on film, though still more expensive than digital, are not that much more. As Perry says, "Shooting on film

is like anything: if it is of importance you will find a way to make it happen." So if you want to shoot film, run the numbers and you might surprise yourself.

If you do decide to go digital, then you have a world of opportunities available to you. This is where your DP's input makes a huge difference: Some are more comfortable shooting one format—either because they own the camera, or have built up relationships with the camera companies or rental houses. Others may be more flexible in using different cameras and formats for different projects. There are new cameras, formats and even new companies coming out every year. So, as a director, you just have to be flexible and trust your DP to keep up with all the latest, greatest cameras and toys. In the early conversations, be sure to ask pertinent questions about workflow that will affect how you edit. Inevitably, someone will come up with a cool new camera, but then it takes a good six months to a year for filmmakers and the companies to debug all the problems with new codecs, cards, and firmware and software fixes. Better to use last year's latest and greatest than be the guinea pig for this year's and find out from your editor that your DP's been shooting on the wrong settings for the first week of production.

Deconstructing the Cult of Galileo

Forget about the film vs. digital debate, or stressing over how many K resolution is in the hottest camera, at least for a moment. Maybe it's worth deconstructing the very source of how we put moving images onto any medium at all? Allow me, if you will, to reassess our basic assumptions about camera design and ask why we're still using the same basic cylindrical lens system that hasn't changed in 400 years.

Ever since Galileo started messing around with telescopes in 1609, astronomers, photographers and then cinematographers have used cylindrical tubes with internal lenses to look at everything from the stars in space to the earth-bound ones in Hollywood. Inside those mysterious tubes, light goes zipping along, bending and bouncing through different lenses, holes or mirrors, and finds its way to either your eye, a piece of film or a high-tech image sensor. The optical magic happens behind closed doors, so to speak. All the lens elements are safely ensconced in some sort of cylinder that prevents any distracting outside light from sneaking in. But the result is that now we have incredibly expensive lenses with a multitude of super-sharp glass elements, stabilizers and motorized auto-focus systems. The lenses themselves have become sharper, smarter and pricier than our cameras, and definitely smarter than us.

Two of the best films that shared the festival circuit with me in 2013 were *Starlet* by Sean Baker (a Slamdance alumnus who would later famously shoot *Tangerine* on his iPhone), and *The Porcelain Horse* by director Javier Andrade (Ecuador's submission to the Oscars that year). Both films used retro lenses

to glorious effect. Sean and his DP, Radium Cheung, shot on a Sony F3, but "the glass from the Lomo lenses was smuggled out of the Soviet Union and re-housed in Bollywood," Sean told me. "We found them being rented out of a trailer park in Santa Clarita." Meanwhile Javier's DP, Chris Teague, shot on a RED, but used old Nikon still lenses from the 1970s that Chris got in New York. I was completely blown away and jealous of both these films! Although I'm super proud of the look that Nancy Schreiber got out of our RED with its pristine modern lenses, we had to spend a lot of time in color correction and post trying to dirty up our images, adding flares, defocusing and other artifacts so it didn't always look so clean.

Frankenlens and Mir(vishScopes)

After recently getting my first half-way decent camera in about 15 years, I started deconstructing the cult of the high-end lens. I'd bought a Canon Rebel T5i (which uses the exact same sensor as the C-100, but is about $5,000 cheaper). Essentially these cameras are just computerized lens platforms now, and all the Canons have the same EF lens mount, so why not start with the cheapest one? I know it's probably not the camera to use for shooting a whole feature, but it's been great for shooting docu-interviews, location scouting, family videos and, of course, stills. Immediately I started buying old still lenses at antique and thrift stores. I'm especially proud of a 1971-era Nikon 50–300mm lens that weighs in at over five pounds!! Now, *that's* a lens!!! It retailed for $5,000 when it was new, and I got it for $45 at an antique mall in Omaha. With a $10 Fotodiox adapter, it fits perfectly onto my little Canon. With a fancier adaptor it even fit onto a friend's Micro Four Thirds Sony a7 and took gorgeous shots.

I also started buying some even cheaper lenses, including an Albinar 135mm prime. What or who was Albinar? Some cheap store-brand in the 1980s. But I picked it up for $8 at a different antique store in Nebraska, and realized when it had an Olympus mount that I'd need a $45 adaptor to make it fit on the Canon. Instead, I unscrewed it and removed the aperture and a few other metal rings off the camera-end of the lens. I then drilled a big hole in the Canon body cap that came with the camera, and Gorilla-glued it to the back of the lens. To keep things nice and tight, I wrapped it up with my daughter's purple-camouflage duct tape. Voila! My first Frankenlens!

A few months later, I bought a 35mm point-and-shoot plastic panorama camera at a thrift store for $1.50. I cracked open the camera and discovered not one, but two little lenses in there. I grabbed a Canon body cap (I'd bought some extras for just this purpose), drilled a hole in it and taped in one of the lenses. Sadly, everything was out of focus. But it was close! So I grabbed a handy magnifying glass, held it in front and eureka, the image popped into focus!

The author demonstrating the two-handed
MirvishScope

Illustration: Jonathan Mirvish

Dubbing this jury-rigged lens system the MirvishScope, it's a unique two-handed way of shooting. Your left hand holds a magnifying glass and your right hand holds the camera with a small, fixed lens mounted flush with a body cap. By varying the distance, angle and position of the magnifying glass, you can get all kinds of reflections, flares and distortion for any still or moving image. For those of you who dig playing around with tilt-shift, bokeh or "lens whacking," then this is a similarly funky way to get some cool imagery.

What's really fun about the MirvishScope is also the *way* to use it. Normally, with a DSLR or many other cameras, we've got our right hands poised on a shutter button and maybe a thumb or forefinger on a knob or dial. Meanwhile, our left hand is anchored to the lens with our fingers forever slavishly spinning focus and zoom rings. When was the last time you shot something and really let your left hand's freak fly? With the MirvishScope, your southpaw is finally having most of the fun: twisting, turning, moving in and out like a trombonist in a tripped-out jazz solo!

Will I or anyone else ever shoot an entire feature-length film on the MirvishScope lens? Probably not. But for those odd shots where you need an artsy-fartsy look, like dream sequences, flashbacks, hallucinations or just a cool montage, this could be the right lens.

By chance, I'd come up with the MirvishScope around the same time I was doing the Kickstarter campaign for *Bernard and Huey*. We'd hit our modest $10,000 goal within the first ten days of a 30-day campaign, but new contributions were drying up (who wants to give money to filmmakers who've already hit their goal?). So what to do with the next couple of weeks? I'd seen how tech and invention crowdfunding campaigns regularly outpace film campaigns, so

offering the MirvishScope as a mid-campaign reward perk was a unique way of using an invention to support a film campaign.

Walt Disney's Secret Optics Bunker

In order to mass produce MirvishScopes, my intern team and I did extensive research that took us from a Chinese optics company with an office across from the California Men's Prison in Chino, to the San Diego bunker of an 80-year-old optical engineer who'd worked for everyone from Chiang Kai-shek and Walt Disney, to NASA and the Defense Department. After our crash course in optics, we finally figured out a way to make multiple sets of MirvishScopes on a small scale, spending under $10 to make each one, and offering them at the $35 perk level. We looked at it as an affordable and fun lens for any DP, photographer or film student to have in their kit. I was giving my backers a new lens to help them make their movie, while they helped me make mine. We spent a few weeks of sawing, grinding, melting, hot gluing, slicing and other forms of hazardous assembly in my garage and kitchen, and eventually mailed out six garbage bags full of boxes. The postal receipt alone was 20 feet long!

The MirvishScopes took off in their own right: We got articles about them in *IndieWire*, *Filmmaker Magazine* and several photography websites. In the end, about 90 people ordered them from all over the world, and the campaign ended with us reaching almost triple our goal!

A MirvishScope selfie

Photo: Dan Mirvish

After all that, it begs the question: Do you need to reinvent the physics of how a camera works in order to shoot a film? British indie auteur Ben Wheatley and his cinematographer Laurie Rose shot part of their black-and-white period film, *A Field in England*, with a drilled-out Canon body cap with a plastic toy telescope lens glued in. Stanley Kubrick, a former still photographer for *Look* magazine, famously handcrafted some of his film lenses, too.

You don't *have* to go that far. But I will say that after months working on Frankenlenses and MirvishScopes, I will pay a lot more attention to the lenses we use on my next shoot, and not take anything for granted. Meanwhile, all those smug camera nerd assistants hovering around the lens will hopefully respect a director who now knows the optical formulas for reflection and refraction better than they do.

Time to Shoot!

Once you've hired your DP, picked a camera and invented your own lenses, it's time to start shooting! So how do you talk to your DP? That depends considerably on your own level of fluency with cinematography. Some directors—especially those who come to it from acting—may be brilliant at getting performances out of their actors, but may neither know nor care where the camera goes or how it should move. But other directors may have more of a background in cinematography or a passion for visual storytelling—having shot things themselves, gone to film school or carefully crafted storyboards or pre-vis animations. Assuming you've hired a collaborative DP who will compensate for your shortcomings and be patient with your indulgences, you're on the road to success!

Does it Take a Video Village to Raise a Film?

Even the more cinematographic directors need to give considerable trust to their DPs. In the old days of shooting on film, that meant relying on the DP's experience with light meters and film stocks to ensure that you got a usable image. A director would walk around with a cool-looking viewfinder and pronounce loudly the lens size and camera placement ("Low angle cowboy with a 40 from here! I'll be in my trailer till you're ready!") At best, you might get one peek through the camera during a rehearsal and then stand next to it looking at your actors during the takes. Some of the earliest video assist monitors were invented by Jerry Lewis for his film *The Bellboy* in 1960, and by the early 1970s were in widespread use in Hollywood. Even on my first film, *omaha (the movie)*, which we shot in 1993 on Panavision 35mm cameras, we couldn't afford a monitor so we did without. I just had to trust my DP, Andy Anderson, with all the settings and final framing. Fortunately, he nailed the cinematography, and

the film looked great. (Andy, by the way, once took a cinematography workshop with Vilmos Zsigmond in Maine. Vilmos told him, "Andy, you are a vonderful DP, but vit an American name like Andy Anderson, you vill never make it in Hollyvood!" So, for *omaha (the movie)*, Andy is credited as "Oslo Anderson" which we all thought sounded more European.)

These days, many of you will watch your takes looking at a set of scientifically calibrated monitors. It's very tempting to micro-manage your DP when you're seeing your color, framing and lighting in real time. Needless to say, that's infuriating and nerve-racking to the DP—especially when everyone else on the crew is also hovering around "video village." But as directors, you still need to trust your cinematographers—they'll inevitably have more experience with setting LUTs ("Look Up Tables"—some mysterious settings the DPs use), color correcting and other post effects that you may or may not need to do. Turns out what you see is *not* always what you get, for better or worse.

Of course, whether you *should* be directing from video village is another matter. If, for example, you're shooting two cameras, each with its own team of operators and assistants, your DP might be sitting next to you at video village. That might be the only way for both you and the DP to keep an eye on what both cameras are doing simultaneously. If you both know right away if you nailed the take, then there's no need for any playback and the whole set can move on to the next shot from the moment you yell "Cut!" But let's be clear: Actors still would prefer a director who is looking at them directly from next to the camera, staring meaningfully at their performance. They will trust you more, and therefore respond to your direction better. One nice compromise in styles is if you can get your hands on an iPad-like monitor that you hold, while still standing next to the camera. Your producers and makeup artists—and even your DP—can hover around video village to their hearts' content, but your actors will still think you love them. A lot also depends on whether your DPs are operating themselves. If you're shooting with just one camera on an indie film, there's usually no reason to have to hire a separate operator. That's one less person to filter your creative vision, and more practically, one less person to feed, pay and park.

As for doing playback of just-shot scenes, try to avoid it. Assuming you, the DP, script supervisor and anyone else really necessary is looking at the monitor, you shouldn't have to go back and look at it again. The problem with playback is that it grinds the set to a halt while everyone is looking at the shot you just did. Worse, is when the actors themselves look at playback. They'll second-guess their performances and start directing themselves instead of letting you do that. The easiest way to get around the playback issue is simply to tell the actors and everyone on the crew that the cheap equipment you have doesn't do playback. "Really?" they'll say. In a digital world, isn't the ability to do instantaneous playback built into every electronic camera device? Yes, you must insist, but *this* camera is very special, and it's almost like using real film. Oooh, film! Did

Frank Capra have playback? Hell no! So we can do without it, too. Of course, if you're doing an intricate stunt or effects shot and you and the DP *need* playback, just distract the actors with something shiny and don't tell the rest of the crew.

Bump Up the Credits

Just because you've hired a DP and/or line producer with excellent crew contacts doesn't mean all that crew will want to work on some rinky-dink ultra-low-budget indie film. Especially if you're hoping they'll work for free, or close to it.

The most likely way to get people to work on low-budget indies is to convince them that the experience they get will be more valuable than any amount of money you could possibly pay them. So valuable, in fact, that it's a blessing that you're not charging them for this amazing opportunity that so many others are dying to get! There are indeed a few legitimate reasons you might get a potential crew person to believe this line of malarkey, and usually it comes down to experience and/or credit.

For example, if people have been working as production assistants (PAs), and want experience and credits as 2nd ADs, they might jump at those bumps in credit. They'll look great on their resumes and IMDb pages and their parents will be duly impressed. Depending on the various unions and guilds, it might also be a formal way for them to build up their hours or credits to get bumped up to the next level. They might also just want the experience of working with a seasoned crew head, an award-winning director or a level of cast that they might not have worked with before. On *Between Us*, it was amazing how many young camera assistants wanted to work with Nancy Schreiber (Nancy's a legendary DP and a vital role model in the industry). She had her fans!! For my own part, it's not for nothing that some crew members wanted to get to know the guy who co-founded the Slamdance Film Festival—for which they might be submitting their own short films later that year. For many hair and makeup artists especially, the chance to work with fancy Golden Globe-level actors can be invaluable—especially if any of those actors bring that crew person with them on their next big-budget shoot.

Geography definitely matters. If you're in a big film market like LA or New York, there probably are a lot of young, eager crew members who may have just graduated from local film schools. There are simply more people trying to make it in Hollywood than there are in other non-industry towns. The bench is deeper: For every union studio grip, there're 50 more aspiring grips toiling away on commercials, webisodes, industrials and music videos, desperate to get their big break in features. If you're in a small market like Des Moines or Rochester, there may be only four qualified grips or camera assistants in town, and they're all happily well-paid on local commercials. They're going to be far less likely to snub their noses at local production companies or ad agency gigs

to work for free on a three-week indie shoot. They just can't afford to burn their only reliable relationships in town.

Another advantage to working in a film town is there's also a ready supply of young recent grads from regional colleges and universities who've just moved to The Big City and are desperately trying to make any connections in the industry. These bright-eyed twentysomethings may not have gone to "prestigious" film schools like USC or NYU, but it also means they and their parents are not saddled with "prestigious film school debt" to the tune of $200,000. A kid who majored in Film & New Media from the University of Nebraska at Lincoln and just moved to Los Feliz is a lot more likely to work on your indie film for free than a bitter grad student from USC whose parents are deeply regretting that she didn't go to law school. And chances are that UNL grad will be just as competent at tightening the knuckles on a C-stand as the debt-ridden USC alumna (and probably less likely to roll eyes at your dubious *mise en scène* choices).

Finding a Crew with Donut Group Therapy

So how do you find all these amazing young crew members, much less convince them to work for free? The obvious ways are through the internet and social media, from crew-specific sites like Mandy.com to Craigslist. On Facebook, there are countless groups and other means of spreading the word. And if you're near film schools, call your crew positions "internships" and put out the appropriate listings (see "Interns and a Clean Garage" on page 44). Just remember to be straightforward and honest in your postings. If you know you want an all "volunteer" crew, don't lie and promise "union wages." Even if you're not paying anything, if the film has something to offer on some level, you'll at least get people interested enough to inquire.

One thing we did on *Between Us* was to set up a day and time and just invited *everyone* to come all at once. We provided donuts and coffee, and about 40 people all crammed into my garage. It was a fascinating hodge-podge of experienced crew, students and aspiring filmmakers. We passed around a contact sheet and my producer Hans and I explained the film to everyone. We then went around the room and had everyone say their name, experience and what they wanted to do on the film. It was like a weird mix of job fair and AA meeting: "My name is Josh. I'm a grip. And I've been unemployed for two months." Applause and approbation! Afterward, everyone spilled out onto the backyard and Hans and I had a chance for one-on-one conversations with many of the folks who'd shown up. Yes, it was an odd way to crew up a film, but by the end of the day we'd hired our line producer, 1st AD, and countless grips, electrics and camera assistants. The bulk of our eventual crew came from that one group therapy session in the garage.

Another big source of crew came from the fact that our DP, Nancy Schreiber, had just finished teaching a cinematography class at the American Film Institute (AFI). Since we were shooting in May, many of her recent students were available and very willing to work on the shoot. It was a two-camera shoot, so the other operator spot was always rotating among Nancy's long list of contacts and friends. Some were students, but occasionally she'd pull in a ringer like her pal Francesco "Checco" Varese, an ASC cinematographer in his own right. To this day, I can spot the Checco shots in the film that, to my eye at least, bring an Italian aesthetic to those scenes (nevermind the fact that Checco is from Peru). In a perfect world, you'll have the same crew on set every day of your shoot, all working like a well-oiled machine. But welcome to indie filmmaking!

Once you've got your key people on board—your producing team, 1st AD, DP, production designer, costume designer, etc.—you're going to have lots of meetings—scheduling meetings, budget meetings, etc., and usually with just a department head, the producer and you, the director. All of your key people are going to be very busy prepping your film (and probably also finishing up their last job and lining up their next). But along the way it's important to get everyone in the same room and do some kind of "tone meeting." In essence, you're trying to get everyone on the same page creatively. A simple discussion in pre-production about, say, color palettes can make a huge difference down the line.

I remember on *omaha (the movie)*, I knew our final scene would be at Carhenge, where all the cars are painted grey, but that we'd probably have a blue sky. OK, I said, so no blue or grey in the lead characters' wardrobes. I knew our lead actress, Jill Anderson, who's got a pale complexion and dark hair, looked good in red and black. So she was assigned those colors, and strictly only those. We dressed our lead actor, Hughston Walkinshaw, also in red, since by the end of the movie, they're essentially a team. By contrast, we said the bad-guy Columbian jewel thieves (the opposing team, as it were) should only wear green. These simple decisions then informed how the DP lit the film, what choices our production designer made, as well as decisions by hair and makeup. One simple meeting gave the film an intentional, unified color scheme that I could legitimately take credit for as the director. I've tried to have similar meetings on all my films. Inevitably, decisions will diverge from those initial meetings (what, the costume shop doesn't have red?!? OK, how's orange, then?), but at least you'll all have a common reference point on set when colors and egos inevitably clash.

Dress the Part

Setting the mood for your first day of shooting starts at home. Have you ever wondered why such directors as diverse as Alfred Hitchcock, Sam Raimi and Christopher Nolan always wear suits on set? "I wear a suit and tie as a sign of respect to the cast and crew," Raimi once explained to *Uncut* magazine:

I like a very serious and well ordered film set—for me it's the best way to work, and out of that order I like to get a tremendous amount of creativity. And at the same time, the old masters used to dress in a very formal manner on set, and I always thought that it was supercool.

Now, that doesn't mean you *have* to wear a suit and tie on set. But you should dress in a manner that either befits your unique style as a director, that shows respect for the crew (who probably got up earlier than you) or helps indicate the tone or feel of the movie.

Doing a punk rock period movie? Then wear an old Black Flag T-shirt! Doing a western? Wear a duster and boots! Whether it's black-tie formal or film-school grunge, just make sure that you're not dressed exactly like the rest of the crew. The crew and cast need to know that there's one director and especially on the first day, they need to know who that is.

For many directors, it's less about clothing and more about headwear. Robert Altman wore such a distinctive hat, that his hat company named a style after him and gave him free hats for life. For Woody Allen, the floppy Gilligan hats made him stand out on his sets. Robert Rodriguez rocks the bandana. Steven Spielberg made baseball caps safe to wear for directors, and Spike Lee hasn't been seen without a Yankees, Brooklyn or Malcolm X cap since. If you've got a distinctive hat, wear it throughout pre-production and on the first day of shooting—it's a clear shot across the bow to the crew: The director wears the coolest hat on set—*not* the PAs.

Group Hug, Safety and Prayer to the Film Gods

So how best to start on your first big day of production? Since call times tend to be pretty staggered on most shoots, give your cast and crew an hour or two to get everything set up for your first shot. Then just as everything's ready, stop the proceedings and get everybody on the set together for a pep talk. It doesn't really matter what you say, as much as that you say something: You're a team, you're all in this together, you're grateful for everyone's hard work, etc. It's very much about setting the tone for the set—is this a happy-go-lucky funtime set (for example, if you're making a musical comedy), or is it a dour, serious set (since you're making a grim suicide drama)? Is this a set where you want to encourage even the lowliest PAs' input if they have good ideas, or would you rather people keep their ideas to themselves and just do what their told (either is fine, by the way)? Share the passion you have for the film. Remember, some of the crew probably have never even read the script, much less know why you're making the film.

You definitely want to mention something about safety: If people are being asked to do something they think is unsafe, you want to give them the confidence

to object, and to come to you or the producer if there's a problem. Likewise, remind them that even if you (the director) ask them to do something unsafe, they shouldn't be shy about objecting and talking to the producer or their department head. It's the culture of everyone doing everything they're told and not questioning their immediate supervisors that gets people killed or injured on sets. You may even want to make specific mention of Sarah Jones (the camera assistant who died in a train accident on a Georgia set in 2014), or list her on your first slate as many productions have done since her death. At the end of the day, you, the director, are responsible for the health and well-being of everyone who steps foot on your set, and it's a responsibility you have to take very seriously.

Speaking of safety, remember to do a similar safety meeting before every scene in which there are stunts, guns or any other dangerous elements on set. On *Open House*, my production designer showed everyone on set that the BB guns we were using as props were unloaded. So he shot one at the floor, and guess what? It was loaded!!! Thankfully, it was just BBs that bounced off the floor, and no one was hurt, but *this* is why you do safety meetings.

Finally, at the end of your opening meeting, it's a good idea to invoke some sort of deity for a blessing. For most secular films, it's probably good enough to invoke the blessing of "the Film Gods" to grant you a safe, fun and exhilarating shoot. Use examples if you want: "May the soul of John Ford bless this western with his spit and grit!" I suppose if you were doing a faith-based movie, you might want to be a bit more deity-specific in your invocation. But for most films, just end on a good, reverential note. A group hug is a good idea, too. You'll need it. The first day is always a disaster.

Your First-Day Disasters

First days on any big shoot are notorious. It will rain, people will come late, the footage will be glitchy, the wigs won't fit, the accents will be all wrong and the police will shut you down. In other words, there is a very high likelihood that you will reshoot whatever you shot on your first day. So it's important not to get too ambitious when you're scheduling that day. Keep the shot list short, the locations simple and the camera moves to a minimum. Your goal on the first day is really about getting the crew and cast comfortable with one another with a minimum amount of behind-the-scenes drama. The goal should *not* be to get usable footage. If you do, consider it a blessing!

On the night before we shot *Open House*, our script supervisor, Mark Bell (who also was staying at my house), picked up the empty U-Haul truck that would be our sole production vehicle, and parked it in front of my house. While parallel parking, he sideswiped my car and took out my turn signals and front fender. The next morning, we decided that Mark should not be allowed to drive

the truck. So, the other guy staying at my house, camera operator Josh Tunick, took the wheel and drove to our location—a residential neighborhood in high class San Marino, near Pasadena. He parallel parked . . . right into a neighbor's car. (Note, this is why you need insurance!)

So when one of my producers, Mike Lynch, approached me gingerly toward the end of the first day of shooting on my next film, *Between Us*, I should have gotten nervous. Between takes, he told me in hushed whispers that regrettably one of our grips had just crashed one of our two production trucks into a parked car. I just started laughing. Mike couldn't figure out what was so funny. "This is awesome!!" I said. "I've never made a movie with more than one truck!!" As for the accident? "Oh, that's to be expected," I told him.

On *Open House*, after the truck was in two accidents before our first take, we thought the day seemed to be going fine. But then the San Marino police came to the set to shut us down. Wait, we said, we paid $900 for a film permit! Oh, right, yes, but you still owe us *$9,000* for a business license. In essence, it wasn't a shut-down, it was a shake down. Meanwhile, 20 miles away at my house, my casting director Liz Jereski was still auditioning hot young men for one part in the film. She got a visit by the Culver City local cops who had gotten complaints that we were running some kind of "casting call" operation in a residential neighborhood. It's a hell of a way to start a movie!

Hello, My Name is Josh

On a big-budget studio film, Michael Bay can afford to yell at random grips or PAs and neither know nor care what their names are. The crew is getting paid big-time union wages to put up with his abuse. But on your little indie film, you're not paying the crew enough to disrespect them. You need to earn their respect, trust and loyalty, or at the slightest hint of hardship, they'll bolt. Or worse.

During that opening day invocation, you might consider going around your circle of collaborators and have everyone introduce themselves and say what their position on the crew or cast is. Of course, if you have a crew of 50 or more, that may take too long. So how best for you and everyone else to get to know one another, especially if you've cobbled together your crew from disparate sources and contacts?

You could take a page from the military or sports worlds, and use uniforms with embroidered last names. There's a reason the crew of an aircraft carrier dresses in bright purple, green, red, white, blue and yellow shirts, each with a different expertise. It creates a safer, more cohesive way of communicating with a rotating crew of personnel, especially in an environment where you often can't speak or hear (not unlike a film set in the middle of a take). Short of spending the money to make countless color-coded shirts for everyone on crew (that they would refuse

to wear anyway), there are alternative ways of identifying your crew. I would strongly suggest "Hello, My Name Is . . ." stickers for everyone on the first few days of the shoot. Maybe even color code the Sharpies you use to write on them: Green for art department, blue for camera, red for wardrobe, etc. (unless you're shooting with the RED camera, then maybe red nametags for the camera department). This sounds goofy, but when you (and your fancy actors) call a 21-year-old PA by his name to ask for a turkey sandwich, he will be thrilled, and forgive you when you then yell at him for bringing you a ham sandwich.

OK, but what to do when you can't even afford nametags and have a lousy memory with names? If all else fails, just call everyone in any given department by the same name. On *Between Us*, there seemed a preponderance of guys named Josh in the camera department. So for simplicity and politeness, I just told the entire department that I'd call them all Josh regardless of their given names. The art department had a female Erin, and a couple of male Aarons among others. By the end of the shoot, they knew that if I yelled out "Aaron!" it appropriately meant *anyone* in the art department and they should neither take offence nor be confused. OK, maybe not the perfect solution, but at least it was cheaper than uniforms.

Gaining the respect of the crew is more than a trivial matter. Sure, if they don't like you they might just quit and walk out. But what's worse is if they stay and harbor resentment, jealousy and disrespect. One bitter crew member will infect the rest of the crew like a cancer, and gradually grind your production to a dysfunctional halt. Even worse than a bitter crew is a flagrantly vindictive one.

Remember the low-budget kickboxing movie I worked on in the Philippines? The Filipino crew wasn't used to shooting with sync sound, so occasionally one of them would walk around during takes with a rattling metal tray of drinks he'd hand out to the hot crew. The Hungarian director would yell, "Cut!" and then proceed to scream at the crew in what I could only imagine was a string of anatomically correct Hungarian profanities. Since the crew mostly spoke Tagalog, they were a little flummoxed, to say the least. For all kinds of other reasons, they had lost complete respect for the director by the third day. Nevertheless, they still very pleasantly offered him cups of mango juice throughout the five-week shoot. It was only in the last week that I realized that the crew had been peeing in his juice the whole time. Word to the wise: Always open your own mango juice.

If you're wearing jodhpurs on set, be sure to use a megaphone, too

Illustration: Miriam Mirvish

Find the Goat

One way to ensure that you are not the most hated person on a film set is to make sure that someone else is. On many sets, that person is your 1st AD. Traditionally, that's their job. While you quietly whisper "action" and "cut," it's your 1st AD who bellows "*ACTION!!!*" and "*CUT!!!*" "Firsts" (as they're called) are the ones who are hurrying up your DP to set the lights, pulling the actors out of their trailers and yelling at the makeup artists that the time for touchups is over: "*LAST LOOKS!!! PICTURE UP!!! WE'RE LOSING LIGHT, PEOPLE!!!*" Essentially their job is to play bad cop while you play good cop.

Unfortunately, the good Directors Guild of America (DGA)-trained modern Firsts have evolved into smooth-operating, team-building, crew-loving, hi-tech management efficiency machines who barely have to raise their own voice above a whisper when they say "action" into their Secret Service-like wrist coms. And that's awesome: Good 1st ADs are worth their weight in gold—your set will run on schedule, on budget and your crew will be happy to move fast—leaving you, the director, to focus on the fun creative aspects of the job. So why is that unfortunate? Because if the crew doesn't hate the 1st AD, then any resentment and bitterness might fall back squarely on you!

Crews need to hate someone. That's just human nature, and it's true in any office or team environment. So if you don't want it to be you, and if your 1st AD is beloved, then you need to find someone else. You might think it should be a person of authority—the line producer, unit production manager, producer or financier, and if you can, then that's fine. But sadly, many of these producer-types hide in their trailer or office or don't come to set at all. Better still is to find people in a mid or low-level position who drive everyone else crazy. They might be annoying, grating, overly chatty, stinky, slatternly and/or just don't wear underwear. Hopefully their personality flaw is not something that greatly affects their actual job performance, causes a legal liability or slows down the running of the set. Better still if it's someone that you personally can tolerate in his or her own quirky ways. This scapegoat will be a wonderful distraction for all the morning eye rolls, lunch-table chatter, on-set pranks and wrap-party banter. While the crew focuses their ire and ridicule on the goat, they will blissfully tolerate their crazy paranoid director, and the fact that you haven't showered in three weeks and aren't wearing underwear either.

Ready, Aim, Fire!

Another theory of set leadership says that the director should instill fear in the crew by firing someone on the first day. I'm not sure I totally buy that idea, largely because I learned it from the Hungarian director who wound up drinking urine in his mango juice. But when it is necessary to fire someone, make that decision early and do it within the first two days of the shoot, or better still,

before you start shooting. On one of my films, we had a DP who was not only a little prickly to work with, but also gave us shaky, out-of-focus shots. After the first day of dailies, I made a decision with my main financier/producer partner that we had to fire him. How best to do that? Second worst to getting fired is being the one firing someone. It sucks.

So I told my financier: "Stephen, you want to be a real producer?" Yup, he said. "You really want to earn that credit?" Yup, he said. "Well, you're not a real producer until you've fired someone." So once we made sure we had a backup DP in place (always have a backup in mind when you fire someone), Stephen took the firee aside at the end of the second day, and gave him the bad news. It was some version of "things just aren't working out," "it's not you, it's us" or some other gentle let-down, and I backed him up afterwards in my own one-on-one conversation with the DP. By the next day, the whole crew was relieved, and we had our new cinematographer who was great to work with both personally and professionally.

Of course, an even better way to fire someone is to get them to beg to quit. On another film, we had a key crew member who was stressed out, flagrantly pessimistic and uncommunicative. A nice enough guy, but we didn't need that level of negativity right before the shoot. So two days before principal photography began, we had a similar "difficult decision" to make, and I made it. Again, the dirty work fell on the shoulders of two of my producers who took the crew member aside and somehow did a brilliant Jedi mind trick on him: They apologized for letting *him* down and not having enough money for *him* to do *his* job in the way that we knew *he* had potential. By the end of the conversation, he left happy and grateful to be let out of this horrible situation and the next day we had a much better person in that position. There's definitely an advantage to not having much (if any) money to pay people: They invariably have better opportunities available to them, so if you need to get rid of them, they might just take it as a blessing. On the other hand, if you're paying people a ton of money, it's also easier to get rid of them—hey, they got paid well while they were there.

The toughest situations are when you need to get rid of people on your crew who also brought with them some critical element: A camera, lights, a post house or financing. In those cases, you need to weigh your options carefully and often just grin and bear it. Depending on how long they've worked on the film, you may also want to make sure that they're offered some kind of professional compensation, usually a fair credit on the film, or a recommendation for their next job. Credits are cheap, and though it may tread on yours or others' egos, it's often better to inflate someone's credit and get rid of them quietly, rather than have a vindictive person lingering around waiting to sabotage your film.

Of course the *best* way to gain the trust and loyalty of your crew is actually to be a good director! No tricks, no bribes, no scapegoats. Just lead by example.

Be prepared, come up with cool shots, get great performances out of your actors and treat everyone with respect. If the crew sees that you're making an awesome movie, they will get excited and stick with you. They're all filmmakers, too.

Be Prepared

First off, be prepared. For some filmmakers, that may mean doing rigorous storyboards or pre-vis animation. But unless you can afford and control all elements of your locations prior to shooting, it's nearly impossible to reliably storyboard your entire movie. On most low-budget films, you're lucky if you're seeing your locations the night before. So formal storyboarding is usually reserved for specific stunt, action or FX sequences. But remember those full-color storyboards or mood-reels you did when you were raising money for the film? Don't forget about them—they're just as important to share with the crew when you start shooting those sequences.

Second best to storyboarding is to do shot lists. Crews and producers love to see shot lists on their call sheets. They give everyone the confidence that the director has a vision for how to make the day. It shows that the director has consulted with the DP and 1st AD on what the plan is, and it sets the rhythm and pace for both cast and crew. But if you're doing a run-and-gun indie, you might not have the luxury of carefully writing down every last shot the night before you show up on set. It'll cramp your fusion-acid-jazz-like filmmaker intuition, man! But try telling that to your gaffer who's trying to count the amps on your lighting package so the set doesn't catch on fire.

One of my neighbors in Culver City is an amazing union prop master named Dennis Parish. Dennis worked for over 50 years on everything from *The Man Who Shot Liberty Valance* to *Patton* to three Scorsese films, three Altman films, and all the way to helping his daughter out (Hope Parish, another union prop master who lives across the street from her dad) on Quentin Tarantino's *Django Unchained* and Alexander Payne's *Nebraska*. I asked Dennis about his perspective on which directors were best to work with. He said he loved John Ford, who showed up in a chauffeur-driven limo at the studio at eight in the morning ("beautifully backlit"), fully prepared, and left at five every day. More recently, he loved the way Payne worked: Totally prepped, rarely changing his mind during the day. Who was the worst? Tarantino, he said, without hesitation. Why? Because Quentin likes to change his mind a lot. The call sheet might say two people get shot, and all the departments prepare for a certain amount of fake blood, blanks for the prop guns, squibs embedded in walls, costumes, etc. But then Quentin gets "inspired" on set and demands that 23 people get shot in some Mexican-standoff bloodbath. Now, as film fans, we might love Quentin's inspiration, but for the poor crew who has to scramble on set to fulfill his vision, they'll be cursing him throughout the production.

Alexander Payne

I think I was in post-production with *omaha (the movie)* when I got a call from the Omaha/Douglas County Film Commission. Since I had just shot the first indigenously made indie film in Omaha, they wanted me to meet up with another up-and-coming filmmaker from Omaha who needed help persuading his own producers that there was a base-level of infrastructure, cast and crew in Omaha. We were both in LA at the time and I met up with Alexander Payne at the old Ships diner on La Cienega (catty-corner from the Academy Library).

While Alex and I made our own toast (Ships was known for having a toaster on every table), we realized that we'd actually taken some cinematography classes together during the summer of 1986 at UCLA— he was just starting grad school there, and I was taking summer classes as an undergrad since my own school didn't have a film program. Turns out, he'd also taken Mr. Stribley's algebra class at Lewis and Clark Junior High with my sister years before. Yes, Omaha *is* a small town, and we *do* all know each other.

Alex (and yes, I'm pretty sure he was just "Alex" then) said that his producers wanted him to shoot his debut feature, *Citizen Ruth*, in Austin—which at the time was the hottest place for indie film in the central time zone. So I told him how we'd rustled up a local crew in Omaha, found a great local cast base there, and how the film commission, the mayor and the governor would bend over backwards to help get films made there. Alex was able to convince his producers, and I even visited him on set one day when I happened to be back in Omaha while he was shooting a press conference scene. (Pro tip: Always cast the local film critic in a press conference scene—guarantees at least one good review!)

I've stayed in touch with Alexander over the years. He cast my *omaha (the movie)* lead actress Jill Anderson in *About Schmidt*, and for a while, he dated one of my old high school pals who'd also worked on *omaha (the movie)*. Rather coincidentally, my neighbor in Culver City, Hope Parish, was his prop master on *Nebraska*, and another neighbor shoots his electronic press kits (EPKs). At one point, I asked Alexander if he was interested in executive producing my film *Between Us*, and he politely declined since he'd just had a trying experience producing another friend's film.

In LA, both of us were involved a bit with the founding of a fun group of Nebraska expats called "Nebraska Coast Connection" that meets once

a month. It's been spearheaded for almost 25 years by Alexander's old roommate, Todd Nelson. I go at least once a year—it's a great place to find friendly warm bodies who might want to work for free on my next film.

You need to strike a balance: Be fully prepared for the next day, but be flexible enough to find inspiration and capture moments of an improvised performance, a magnificent natural sunset or some other intangible element of movie magic. I personally have a tough time with shot lists—I'm just more of a visual thinker, I suppose. But a fun tactic I discovered on the extensive one-day New York shoot we had for *Between Us* was to do simple stick-figure storyboards on Post-it notes shortly after touring our locations. I even color coded them: Blue for day exterior, yellow for day interior, green for night exterior, etc. I then lined them up on pieces of paper, and created a sort of visual shot list, which we then translated to a written shot list for the call sheet. Then on the day of shooting, if we needed to skip a shot, or shoot it later in the day, we just moved that Post-it to another spot. If anyone on the cast or crew wanted to see where we were or what we were shooting, it was a simple matter of showing them the Post-its.

If you do need to improvise, it helps when it works. On *omaha (the movie)*, at the end of one day of shooting on a farm, we realized that there was a small flock of birds that kept landing on the top of a barn. As the sun set and we hit magic hour, I decided that a really cool shot would be the birds flying off the barn in silhouette. It had already been a long day, so everyone grumbled and thought I was crazy. How are we going to wrangle the birds to land on the barn and take off on cue? Every time someone on crew moved around, the birds took off! So we just all huddled behind the camera and sat *very* still for ten minutes until the birds returned to their roost and settled back on the barn. I whispered, "Roll camera," to Andy, my DP. Then I jumped up and down waving my arms and screaming like a mad man. Sure enough, the birds took off squawking in unison, and we got our shot! The crew rolled their eyes at their lunatic director, but they all appreciated that we got a cool shot, and the extra minutes were worth it.

Two Takes Ahead

Decisiveness is key for a director, and no matter how organized your shot list is, there are still those awkward moments after you yell "cut" where the entire crew is looking at you wondering what's next. As the seconds tick by while you consult with your notes or huddle with your DP or 1st AD, your indecisiveness will very quickly show. So, an important lesson I've learned is that as soon as you say "cut," you *immediately* tell people what the next shot is, or if

you're doing another take or variation on the shot you just did. But if you're truly in the moment with the take you're doing, how can your mind switch instantaneously to the next shot?

The trick is to always think two shots ahead of yourself. For example, if you're doing a two-shot, over-the-shoulder, you tell everyone on crew where you want the actors and how to set the camera. It will inevitably take at least five minutes—and probably closer to a half hour—to reset the actors, hair, makeup, lights, dolly, camera, etc. During *that* time, you should be thinking carefully about what you want your *next* shot to be, even quietly consulting with your DP or 1st AD if need be. The key is to keep people moving and busy—rather than staring at you dumbfounded while you make up your mind. So, if that means making up a superfluous, meaningless shot while you are still trying to work out the shot you *really* need, then do it. Most of your cast and crew won't figure out you're doing a meaningless shot, and who knows, maybe you'll use it anyway. But if that's what it takes to buy valuable think time, then do it. An idle crew is a bitter crew.

Arrive Early, Bring Donuts, Wear Tape

On most call sheets, the first ones scheduled to show up on any given days are the location PAs to put up the little yellow direction signs to show the crew where to go. Sometimes, hair/makeup and the actors are the first scheduled. But regardless of what the call sheet says, you'll set a tremendous example if *you* are the first one to arrive on set. There are plenty of practical reasons for this: Last-minute location changes, immediate questions from the hair stylist or actors, and just the basics of telling everyone "we're starting in this room, looking this way." But the real reason to get there early is that it says to the crew that you're just as willing to wake up at 5 am and work on this film as they are.

And what's better than being the first person on set? Being the first person on set holding two huge boxes of fresh donuts! On your first day especially, but also at random times throughout your shoot, make the time to stop by a donut shop and spend $30 of your own money to buy the crew early-morning treats. Get a wide variety of yeast, cake and crullers. Don't get fritters, Danishes or other fancy pastries though—the crew will fight over them. Can't afford donuts? Then get some donut holes!! Even the best craft service team will take a half hour to set up their food, so the crew will always appreciate the early-morning "director donuts." (Full disclosure: I spent a summer after high school working at Dippy Donuts in Omaha—hence my lifelong affinity toward those tasty round treats.)

Likewise, try to be the last person to leave your set at night. On an indie, chances are that you're the one who secured the location from your old college roommate, and it's probably best if you're the one explaining to him why there

are big scratches in his floor. If not, he might lock you guys out the next morning. From the point of view of your crew members, they don't want to be stuck coiling cables and pulling tape off the floor while they see the director leaving early to go have drinks with the lead actress. What kind of a message does that send? Even if you're just standing around going over the script to plan out the next day, it'll engender tremendous respect from your crew to know that you're putting in the same hours they are. Then when they do leave, and you thank each of them (by name!) for a great day and give them a hug or a pat on the back, they'll drive home satisfied and come back the next day.

Better yet, put down your script, say goodbye to your lead actress and start coiling a cable with your grips, or pull up some of those pesky red or blue tape marks on the floor. There's definitely one school of thought that says that you as the director command greater authority and respect by not sinking down to the level of PA or grip and doing menial tasks. But I've found that even if you just occasionally help your team lift something heavy, move props yourself or help tidy up at the end of the day, your crew will respect you more. It's a balance: On union shoots you may be specifically banned from doing certain things like setting lights or moving cameras, and there's definitely something to be said for letting each crew member do his or her specific job and adhering to strict chain-of-command. But on an indie set, in particular, you also might want to induce the feeling that you're all in this together, and you're just as willing to get down and dirty as you expect your crew to be. You may even want to strap on a token roll of ½-inch camera tape to your belt loop, even if you never use it. On *omaha (the movie)*, we needed to lift a 400-pound dolly up five flights of stairs. You better believe I was one of the people helping lift it, no matter how much the rest of the crew were cursing me up the staircase for demanding a dolly shot on the fifth floor of an abandoned warehouse with no elevator.

Making Your 12-Hour Day

Inevitably, you're going to be working long hours, but remember not to *over-work* your crew. SAG requires a 12-hour-turnaround time for your cast, which means that even if you're willing to pay your actors for overtime past their eight-hour day, you can't effectively work them for more than 12 hours, or else you'll have to start late the next day. The SAG rules can be a pain for your AD team trying to schedule your shoot, but they're also a healthy reminder. Try not to work your crew (or yourself) more than 12 hours a day, either. Volunteer indie crews especially hate over-long days—*they're* probably not getting paid overtime, and they still have to drive home, brush their teeth, sleep, wake and shower the next morning. No matter how much coffee your crafty has on set, you don't want a sleepy crew the next day. For that matter, *you* don't want to be sleepy the next day either. Most film-related deaths and accidents come from exhausted

crew members falling asleep at the wheel and getting in car accidents on their way home. And yes, you'll get blamed if that happens to one of your team.

So keep the days short, even if it means not "making your day." Think carefully about scheduling your full shoot. Three weeks is a luxury on an indie film, but it's better to do a three-week shoot and make your days, than try to squeeze a feature into ten days, burn out or kill your crew, and still not have enough usable footage to cut your film. That's not to say that some films can't be shot in ten days or less: I shot my German musical *Half Empty* in nine days in three countries and we had plenty of usable footage. But that was a run-and-gun improvised movie with virtually no crew. And we still had time to sleep each night.

Within each of your shoot days, also try to schedule the important shots first. Keep in mind that whatever is scheduled for the end of the day might have to be jettisoned completely. Think carefully: Could you still cut your movie without that scene or without that extra angle or camera move? Chances are you won't have unfettered access to your locations to come back the next day and pick up what you didn't shoot the night before. Or maybe you're losing an actor, or your Steadicam, or the light will be different in the morning. So you need to prioritize. Also, think about those end-of-the-day scenes: Could they be shot as "one-ers" (just one setup, with no coverage) and shot quickly?

On *Between Us*, we regrettably were running late for almost every day during our first week: Each actor wanted coverage of their close-ups, lighting was taking too long and, well, it was the first week. So inevitably what happened is that we'd rush at the end of the day to pick up our last scenes. But time pressures

Silhouette on
a staircase in
Between Us

*Courtesy: Bugeater
Films*

Racking focus in the kitchen in *Between Us*

Courtesy: Bugeater Films

can also lead to creative solutions. One scene was supposed to have a fancy Steadicam shot up a staircase, and through a narrow hallway. But we ran out of time, threw up two lights with stark shadows, put our actress in silhouette on the staircase landing and shot the scene with a single camera on a tripod. In the end, it was arguably our best-looking scene in the movie!

Another scene, with our two lead actresses in the kitchen, was also a time crunch the next night. So we set up one camera and just played the scene in a single shot and used aggressive focus-racking instead of cutting with multiple angles. It took about five takes to nail the focus pulls, but it proved to be a quick and elegant solution to shooting a critical page-and-a-half scene. Thankfully, we had actors who were talented enough and rehearsed enough to get through the scene. We also had a 1st AC (Josh Turner) skilled enough to pull off the focusing.

There are still several scenes in the script that we *never* shot because we simply ran out of time, and to this day it pains me to think about them. But so it goes. Remember, your goal on set is to shoot *a* movie—but not necessarily *the* movie you planned to shoot.

My old cinematography teacher at UCLA, the late Frank Valert, used to say:

> You could have a perfect, elaborate shot all designed in your head with crane moves and big lights, and then the producer will say there's no money for it. You can kick and scream all you like, but you still won't get that shot you wanted. So you have to do a different, simpler shot.

The important thing, he said, was, "The audience will never see the shot you *didn't* shoot, only the shot you did. So you just need to make *that* shot as good as

it can be." I've always thought that what he said not only applied to disgruntled cinematographers, but also to directors, and for that matter to every decision you ever make in life in all contexts. If, for whatever reason, your plans change, just make the most of the plan you *do* choose. Those are the only ones the audience will see, and the only ones that count.

Feeding the Beast

If you're not paying your crew top dollar, one of the few ways to motivate them is through their stomachs. Now that you've occasionally fed them director donuts, you need to make sure that their big meal—usually lunch—is an enticing highlight of the day. Lunches are something you need to think about early in pre-production. On a real microbudget shoot, there are generally two ways to go with lunch. Either find restaurants willing to donate food, usually in exchange for some kind of product placement (see "Making Product Placement Work for You" on page 107). Or find someone in your immediate family to make the food. Frequently, this is a good job for parents or other non-filmy family or friends. A few trips to Costco or Smart & Final might add up to a couple hundred dollars, compared to several thousand to pay even a low-end caterer.

Even if you do go with a catered option (for many, the simplest approach), make sure it's food that the crew will eat and genuinely enjoy. Have plenty of options for all types of dietary restrictions: Vegetarian, vegan, kosher, halal, gluten-free or just plain finicky. Honestly, though, if people on the crew have such a restrictive diet, they'll probably be bringing their own food anyway. On *Between Us*, for some reason, my DP Nancy had to eat an egg-white salad from Trader Joe's at exactly 4 pm or she got very grumpy. She brought her own in a lunchbox every day, and believe me, I made sure to remind her about it at 4 pm or we all regretted it.

You also may need to be culturally sensitive about your food choices. I was once working on a music video where it was a predominantly African-American crew and cast, including the director and producers. When dinner showed up and it was fried chicken and collard greens, I had a disturbing feeling that if a white producer had ordered the food, it would have been deemed borderline racist and the crew would have rightfully walked out. But because an African-American producer ordered the food from a local soul restaurant, then it was cool. Likewise, don't order ham sandwiches if you're shooting in a mosque or synagogue. However tempting it is to pad your catering budget by ordering refried beans, unless you have a ready supply of Beano for the crew, you're going to wind up with a set that rivals the campfire scene in *Blazing Saddles*. On *Open House*, we had a great deal with Chipotle that supplied us with burritos for the whole crew for about ten days of the shoot. Who doesn't like Chipotle? Everyone loves Chipotle! (Well, except for maybe Frank Ocean, who sued them

over the use of one of his songs in a commercial.) But by the end of production in hot cramped sets, the crew was begging for *anything* that didn't have beans.

Snacks and other treats are another great way to curry favor with your team (and if you're shooting a Bollywood film, then curry is the operative word). Definitely have a good craft service table set up with fresh fruit, tasty *un*healthy snacks and plenty of hot coffee and cold water. Nobody wants to work a 12-hour day and find stale bagels left over from the day before sitting next to a tub of cream cheese that hasn't been refrigerated since the first day of production. There are definitely ways to stretch your budget even on craft service. On *Open House*, Omaha Steaks gave us free beef jerky. On *Between Us*, ConAgra gave us huge crates of sunflower seeds, SnackPack pudding, SlimJims and popcorn. Not exactly our first choices in snacks, but they were free! Be sure to spice things up with occasional treats (besides just donuts). On all of my films, my mom will make and send the crew boxes of her homemade cookies, especially her biscotti. For this, she always wants to get "Cookie Grip" credit on my films. Robert Altman once had a taste of my mom's biscotti and kindly requested that she send some to *his* sets, too. For that matter, snacks and treats can be a fun way to get your investors or other supporters involved, too. They want to come visit the set? Tell them to stop off at Costco first for a crate of SunChips, and it will ensure that everyone on the crew is their new best friend.

Making an Epic EPK

An important, and often forgotten, subset of your crew is your "electronic press kit" (EPK) team, whose job it is to shoot your behind-the-scenes footage. With your EPK crew, your first priority should be to get sit-down interviews of your principal cast. Those are the interviews you're actually going to need for your EPK (for festivals and distribution), but also for promotional clips on YouTube, Vimeo and of course your DVD extras. But you, the savvy filmmaker, will use your EPK team for much more devious purposes: To distract your producers, butter up your crew and make yourself look like a genius.

First off, make sure your EPK team is loyal to *you*, the director, rather than to the DP, a producer, financier or the studio. Ideally, they should be other film-maker friends of yours—old pals from film school, film festivals or maybe a Russian bath house if that's where you're meeting other directors these days. It's very hard to hire your director friends in any other capacity on your own film; most directors are generalists who may not have a specific skill set that qualifies them for a real crew position. You don't see Steven Spielberg holding the boom on a Francis Ford Coppola film, or Wes Anderson key gripping for Noah Baumbach. And even if they are qualified, chances are either their egos would preclude them from working for their pals, or they're simply too busy to commit to a full three-week shoot. But a day or two to hang out on a pal's set,

eat craft service and bask in the schadenfreude of their best friend's production nightmares? Who wouldn't want to do that?

When my pal Paul Rachman was shooting his first narrative feature, *Four Dogs Playing Poker*, he hired me and our friend Paul Gachot to shoot interviews with his cast. We had great sit-down chats with the likes of Forest Whitaker and Tim Curry. Former James Bond himself, George Lazenby, regaled us with hysterical stories of *On Her Majesty's Secret Service*, rooming with The Who drummer Keith Moon who rode into their flat one day in a hovercraft and "shagging birds" at swinging London parties with the Beatles and the Stones. It was like interviewing a real-life Austin Powers. Director pals should jump at the chance to shoot these EPKs, because it's a terrific way to meet cast. Sure enough, two years after Paul shot his movie, I tried to cast Lazenby in my film *Open House*. (He actually agreed to do it at first, but then his agent called two hours later to say there was some confusion between the $75 a day we offered him, and the $750 a day they *thought* we'd said.)

John Carpenter

NAME DROPPER

One day around 1998 I got a call from my friend Nicolas Chartier—a Frenchman in LA who was something of a producer or foreign sales agent. Honestly, back then, I'm not sure what he was doing, but he was definitely French. Nic said he was working with a French film company that was co-producing a new John Carpenter movie with Sony called *Ghosts of Mars*. The French company needed some behind-the-scenes footage of the film, and they needed it shot in PAL (the European video standard), not NTSC, for the French DVD release. So along with Paul Gachot, we found a PAL camera and hopped on a plane for Albuquerque.

The film crew had taken over a massive gypsum mine west of Albuquerque and had painted a large swath of it with red paint to look like Mars. I'm a huge fan of John Carpenter, especially films like *The Thing, Big Trouble in Little Trouble* and *Escape from New York* ("Snake Plisken? I thought you were dead!"). But *Ghosts from Mars* was not destined to be one of the classics in his oeuvre. Natasha Henstridge was a pleasure to interview, and a real trooper on set. Ice Cube was sneerfully glum and looked like he wanted to be anywhere but a red gypsum mine in New Mexico. And Jason Statham was giddy to be in his first American movie, especially working with Carpenter. Not bad for an Olympic-caliber diver and street hustling raconteur!

Despite the game cast and hard-working crew (many were long-time Carpenter loyalists), we could tell there were some underlying problems with the production. We were on the New Mexico set to shoot some of the big pyrotechnics days of the production—lots of explosions, gunfire and as far as I can remember, Martian zombies chasing Ice Cube.

Filming EPK footage on a movie is really a lot of fun. You pretty much have carte blanche to shoot anywhere on set, talk to anyone and hover over the directors as they yell "action," "cut" and numerous other expletives when things go wrong. Carpenter was a laconic fellow who didn't get too rattled—he'd been around long enough to go with the flow. His wife, also his producer, took the brunt of the stress, but she was a real treat to be around. She particularly loved us because Sony had low-balled her budget and hadn't even sent its own EPK crew to shoot any behind-the-scenes footage. We secretly got her copies of our tapes. She knew even then that Sony was going to dump the film.

After we'd returned to LA and given the original tapes to Nic who passed them on to the French company, we started to figure out that what we were really doing was spying on the production for the French. That's (probably) the real reason we got sent on their big pyro days—to prove that Sony hadn't run off with their $8 million. Oh, as for Nic? Years later, he would become famous for getting banned from the Academy Awards ceremony for bad-mouthing *Avatar*, while the film he produced, *The Hurt Locker*, won the Best Picture Oscar.

Devious Use of the EPKorner

So once you've got your loyal EPK team, armed with little more than a DSLR, tripod and a $20 RadioShack lav mic, you want to get them set up in a nicely lit corner *near* the set, but not *on* it. It's got to be far enough away for sound purposes that they can keep working even while you're shooting on the main set. Your EPK team needs to give your cast and crew the impression that they're speaking confidentially and candidly without the director or other actors in earshot. Have your DP set up the lights, or better yet, your gaffer, key grip or other junior crew member—it'll make them feel important and talented! If you've got some old Mole incandescent lights or broken C-stands, use them as props behind the interviewees to make it look like you're making a real movie.

With the cast, make sure your EPK crew asks the standard *Entertainment Tonight*-style questions: What's your name, what's the movie about, who are you playing, what's it like working on an indie film, how are the other actors to work with (go through them one at a time) and how is the director to work with? Make

The *Open House* EPK with a classic old Mole light in the background
Courtesy: Bugeater Films

sure the actors repeat the questions in their own voice before answering them. It's very important to get all this during production. Once you wrap, you might never see your actors again, and certainly not while they're in hair, makeup and costume, and are in a place where they can be lit, mic'd and shot professionally. Even if you do catch up to them later, they may hate you, or worse, have forgotten you. So be sure you and your 1st AD know when to schedule these EPK interviews. If you have a choice, try to do it fairly early in your shooting schedule—by the last week, it'll be harder to find the time, and you run the risk of a bitter cast saying horrible things about you and the film.

Once your EPK crew is already lit and set up for the cast interviews, you should put them to work also interviewing your producers and other crew members. For one thing, the EPK team may have big gaps in their interviewing schedule—doing maybe two of your lead actors at 10 am and 10:30 am and then not have access to your other actors again until 4 pm, or something like that. Having your EPK team interview your producers does two things: It boosts your producers' egos and makes them feel like *real* filmmakers who made *important* creative decisions in getting this film made (and not just the boring decisions to either raise the money or spend it, depending on which sort of producer it is). These producers will never get interviewed on *Entertainment Tonight* for this or any other film, and you might not even let them talk much during red carpet events or festival Q&As. So let them talk to the EPK crew for as long as they want.

The other reason is a bit sneakier. If you're *very* savvy about your EPK scheduling, you can get the producers off the set and out of your hair while you're doing the one scene that you really did not want them to see you shoot (maybe for creative or financial reasons). They could be droning on quite happily for an hour to your EPK crew about how Ted Hope and Robert Evans were their producorial influences, while your EPK director friend is egging them on and stroking their egos. Meanwhile, you're 100 yards away doing an elaborate Busby Berkeley crane shot with 30 scantily clad mermaids and a trained sea lion you hired with the producer's credit card. This is why the EPK crew has to be loyal to *you*! Likewise, if you need to get the person who owns or manages your location off your set while you shoot the sea lion scene in his swimming pool, then send him for an EPK interview for an hour.

Similarly, you should use your EPK crew to interview all kinds of people on your crew. Most obviously, you should get interviews with your screenwriters (if available . . . which also helps keep them off the set), and your key below-the-line crew like your DP, editor, production designer and costume designer. Since some of these people (especially your DP) will be on set, shooting most of the time, you may have to do the EPK piece with them either during lunch, or after you've wrapped. You'll notice that all of these positions are Oscar-eligible categories. You may never have any expectation of them winning an Oscar for their contributions to your little indie, but in their minds, they do. They want to be asked the key creative questions that their respective guild magazine or fellow Academy members would ask them during an Oscar campaign. And who knows? If your film *is* awards-worthy, then your distributor will actually be able to use these interviews for just that purpose.

Don't stop with your key department heads. If your EPK team has the time, especially between actor interviews, then put them to work interviewing and adulating all kinds of below-the-line members of your crew. Everyone from your script supervisor, to key grip, to location scout, to crafty PA is fair game. If you've got particularly disgruntled crew members whom for whatever reason you can't actually fire, then get them in front of your EPK crew! Your loyal team will ask them all kinds of deep questions about their filmmaking journeys from Tisch to wrangling cable on your film while they're really working on their epic metaphorical screenplay about suicidal transgendered cats that will be *huge* once Joseph Gordon-Levitt reads it. By the end of the interview, they will have forgotten how demeaning it is to work for a slacker filmmaker who doesn't know his Buñuel from his Bertolucci.

Beyond the sit-down interviews, ideally you want your EPK crew to get behind-the-scenes footage on set. The key thing here is to get enough shots of you, the director, looking director-ish, pointing at things and saying "action" and "cut" decisively and loudly—preferably on your biggest stunt, action or extras scenes. Unfortunately, your one filmmaker pal who's doing you a solid

by shooting your EPK interviews might not also be available on exactly your big shooting days. And honestly, some of your best behind-the-scenes moments are going to come when you least expect them, too. Ideally, you want someone shooting behind-the-scenes footage every day of your production. Who's the best person for that? Your still photographer!

Still the One

Back in the pre-digital days, still photographers used SLR cameras buried in giant black soundproof boxes, so that the shutter-mirror click didn't interfere with sound takes. Usually they were shooting black-and-white stills and some-times color slide film. The main reason you needed a separate still photographer was that many distributors and newspapers wouldn't accept the resolution from a frame grab from your 35 or 16mm negative. Even if they did, it was a pain to isolate the negative from a motion picture frame and find a lab that would turn it into a still. Hence, the still photographer would shoot side-by-side with your motion picture film camera.

Things have definitely changed technologically, but not contractually. My foreign sales contract for *Between Us* said we had to provide 200 stills, each with a file size of at least 18 megabytes. Nowadays, if you're shooting 2K or higher resolution, that's probably close enough that you can pull a frame from your actual movie quickly and easily within the comfort of your editing system. You may need to goose it up in Photoshop a bit and turn it into a .tif, but you can get away with it for most purposes, and it won't cost you a cent extra. That said, if you can afford an extra body on set, you should still get a still photographer.

Most decent still photographers that you'd be able to get on a low-budget film will use a DSLR but might not have that big black soundproof box. That's cool—have them just shoot during rehearsals (though keep in mind that the shutter clicks can still be irritating for the cast and crew in the middle of a take, especially a heavy dramatic one). It might be better to find still photographers who use mirrorless Micro Four Thirds cameras that are whisper quiet, and then have them shoot your actual takes.

Getting Your Kill Shots

Given that pulling frames from your film is more viable now, shots of the actors in the middle of a take are nice, but what you really want the still photographer for are the behind-the-scenes shots. Not necessarily because you will ever use a lot of those pics, but mainly because your cast may have "kill" clauses in their contracts, giving them veto power on a certain percentage of the stills that they're in. Actors' agents and lawyers are notorious for overreaching in their kill clauses, and you'll need to push back when you're negotiating.

For example, if you have four people in your principal cast and each has 25 percent veto power over group shots, you conceivably could be in a situation where your still photographer has shot 200 stills with all four actors and because they each kill a fourth of them, you wind up with no usable ones at all. At least with frame grabs, it's a lot harder for the actors to kill them, since they're part of the movie itself. But for the behind-the-scenes photos, the solution is simply to have your still photographer take a ton of shots. Remember, even if a photo is out of focus and overexposed, you can still put it in the pile of stills you show your actors, knowing full well that it'll be one that they kill and will count toward their percentage. So you need to have enough *bad* pictures in there to stack the deck to make sure you wind up with enough approved good pics. Sound like a passive aggressive manipulation of your actors? Well, yeah, it is.

On the other hand, you also need to be respectful and protective of your actors—especially your actresses. Just one still photo with an errant nipslip could be given on Dropbox to your foreign sales agent who gives it to your Sri Lankan pay-per-view distributor as part of your 200 deliverable stills. The next thing you know, your lead actress is splashed over every tabloid on the Indian subcontinent and beyond, and a blurred version of that shot will be the lead story on E!'s *Fashion Police*. Now, on the one hand, that might be good press for your film (assuming the film is even mentioned). But on the other hand, that actress, her agent, her manager, her lawyer, her publicist and even her stylist will never want to work with you again. Actresses these days are so hounded by the paparazzi that they are incredibly skittish about their personal images, and rightfully so. Even if they're not famous yet, they all hope that one day they will be.

On *Between Us*, we had a situation where we had to do an elaborate still shoot during our rehearsal period since two of the characters were photographers. A couple of days later—even before principal photography started—I sat with Julia Stiles for several hours since her character was the model in most of the photos. We pored over hundreds of photos to select the ones we'd use on set; some would be printed and framed for one location, some on a rotating gallery on a plasma screen in the background of another location. I had a wonderful time with Julia, who's got a keen creative eye in her own right, and it was a good bonding experience for the both of us prior to the big shoot. It was also a good lesson for me: Actors know their own visual oeuvre better than you do. Julia realized that some of the shots were too similar to posters from one of her old films, something that I never would have noticed. For me, it was also a preview of the "kill" process that we'd have to do again a year later with all the actors.

Some shots of Julia that were appropriate for set dressing, she and I mutually agreed, weren't right to put out with our publicity stills since they could be used out of context. Specifically, there were some really cool, artsy, black-and-white shots of her biting a coiled phone cord. But as I told her, she had to think about the worst-case scenario: How would she feel if the images showed

Script supervisor Shannon Volkenant on the set of *Between Us*
Photo: Jennifer Rose Pearl

up on a creepy Japanese phone-fetish site? We decided to kill the shots from
our deliverables, even though you can see them in the background of the film
itself.

Point and Shoot

It's sometimes very tempting for the still photographer to take lots of shots
of the crew hard at work on the set. These people have become the still pho-
tographer's buddies, at lunch and milling over the craft service table. On the
one hand, these shots are a great ego boost for the crew—much like shooting
EPK interviews with them. They can be used for crew members to post onto
Facebook or Instagram, and that can be good PR for the film (just so long as
they don't have the actors in the background—make sure everyone on the crew
knows that!). But tell your still photographer not to overdo it: At the end of
the day, you can't really use too many behind-the-scenes crew shots for real
publicity purposes, and ultimately they won't "count" toward your required
deliverable stills.

What you *do* need, though, is plenty of shots of you, the director, look-
ing directorial. Usually, that means standing next to the camera and pointing
decisively. The "director points" shot has become a fun cliché (in 2014, actor/
filmmaker Kentucker Audley started a Facebook meme with scores of pointing-
director shots). But it is a necessary one. Many film festivals and a great many
press will ultimately need a headshot and/or wide shot of the director on set. If,
by the end of your shoot, your still photographer hasn't gotten that definitive

The author points, while DP Nancy Schreiber, ASC, squints

Photo: Jennifer Rose Pearl

shot of you (and chances are, they haven't—since you've probably spent the whole shoot away from the camera, huddled behind a monitor in video village), then take five minutes at the beginning of a lunch break and pose behind your camera with your still photographer shooting away. It sounds dorky, but you need to do it. Second to that, you also need a similar shot of your DP, but this time, with one eye squinted behind the camera viewfinder. DPs don't need both eyes visible in their PR shots, but directors do.

To Infinity and Behind-the-Scenes

Whether your still photographers are shooting a DSLR, Micro Four Thirds or some other camera, chances are their cameras will also shoot video. Even if they pride themselves in being "still" photographers, make sure to hire ones who also can shoot video. As I said, formal EPK crews probably won't be on set most of the time, but still photographers will. You need to deputize the still photographers to also capture moving pictures in addition to stills. Ideally, they'll have some halfway decent way to capture sound (like an onboard Røde mic), but even most internal mics on still cameras will likely be good enough. If they're shooting an actual take, make sure they get a shot of the slate when it claps, so you can sync up the audio with your production tracks if need be when you're cutting your DVD extras. Their tendency may be to mirror your production camera and just shoot the scene or cut when you say "cut." But make sure they're also getting plenty of shots of you and the DP before the takes and right afterwards. Also, make sure they get lots of flattering shots of you talking to the actors between takes, actually looking like you're giving them meaningful direction. In a perfect world, the still photographer will get a shot of you telling your lead actor to pick up a vase with his left hand, not his right, and then you can intercut that with the next take in which the actor does indeed use his left hand. See, now you have footage of you working with fancy actors who actually listen to what you say!

There are other advantages to having a still photographer on set most of the time, always potentially shooting video. Call it "the Christian Bale effect," named for the regrettable incident where the actor was heard in an audio clip cursing out a DP on the set of *Terminator: Salvation*. No actors want to have a hissy-fit go viral on YouTube. So they're much more likely to stay well-behaved if they have a legitimate fear that every outburst might be captured by your video-shooting still photographer or EPK crew. But wait, what about *your* own David O. Russell-style outbursts? No self-respecting director wants those leaked either. That's why your still photographer and EPK crew both need to be absolutely loyal to you. Even if that means that they're turning over their SD cards to you alone, discreetly at the end of each day in a sealed envelope with the Sharpie-written code words "crystal meth for director *only*." If they're turning over their cards to a potentially disgruntled producer, digital imaging tech (DIT) or assistant editor, then there's no guarantee that unflattering images of the actors, or your own off-color outbursts, won't leak without your permission. Just don't let the actors or rest of the crew know that the still photographer reports quite so directly to you. That way, if you spitefully *do* need to leak a YouTube video of an actor's childishness, you've still got plausible deniability.

The other reason to have the still photographer comfortable shooting video on set is because you never know when you need an extra camera for your film itself. When we had to climb a mountain to shoot one shot in the snow on *Between Us*, we had Nancy Schreiber bring the "A" camera—a Panasonic, I think. But we also had a second DP, Sandra Valde-Hansen, who was there primarily to shoot EPK footage on a Sony. Since it was such a remote location in extreme conditions, we had Sandra use her camera as a backup—shooting in parallel to Nancy's for a few usable takes. Sure enough, I think there were some problems with the Panasonic and we may have wound up using some of Sandra's footage in the film.

What if you can't afford or can't find a good dedicated still photographer who can also shoot video? Then you need to find someone who's already on the crew and put them in charge of stills and behind-the-scenes video. Sometimes, that might be camera or lighting assistants who are budding cinematographers themselves. They'll love the extra responsibility (and credit) and work twice as hard for you. Other times, it might be one of your producers or financiers who would otherwise just be hovering around video village nervously worrying that you're going over budget. Put them to work with their iPhone and make them your still photographer: A distracted producer who feels useful is a happy producer! And as a worst-case scenario, take shots yourself: I've definitely used my own stills and behind-the-scenes video on a number of my films. On *Open House*, I had my 35mm SLR strapped to my back for half the shoot.

Whoever you get as a still photographer, make sure it's a nice affable person who gets along with the cast and crew. On the kickboxing movie I worked on in

Packing heat in the
Philippines: One way to
command respect on
any set

Photo: Juan Agrajante

the Philippines, there was this awesome still photographer, who only knew one phrase in English. He'd line up shots of cast members, give them a big smile and say, "I like your style!"

Making Product Placement Work for You

Corporations have had a long history of getting involved with product placement in motion pictures, most prominently dating back to the Bond films of the 1960s (Aston Martin is still reaping rewards from this deal 50 years since they appeared as 007's original car of choice). The Mars chocolate company still rues the day they snubbed Steven Spielberg when they didn't let him use M&Ms in *ET*. Spielberg used Reese's Pieces instead, which essentially launched the bite-sized treats into the marketplace. Speaking of chocolate, remember the classic Roald Dahl book *Charlie and the Chocolate Factory*? When the team making the film adaptation heard they could get Quaker Oats to finance the whole $3 million budget for the film, they changed the title to *Willy Wonka and the Chocolate Factory* so Quaker could launch Wonka Bars as a new candy brand. Fifty years later, the film is a classic, and Wonka has stuck around as a candy brand almost as long.

More recently, product placement has taken on even greater importance in an era when TV commercials are losing their grip on American consumers. In

the age of TiVo, VOD, Netflix streaming and rampant piracy, people are simply skipping or avoiding traditional commercials to get straight to their entertainment. Branded sponsorship of individual TV shows—once a fixture in the 1950s and 1960s—has returned in force to network programming. Top-rated reality shows like *Survivor* and Emmy-winning critical darlings like *Mad Men* have brought us back to an era where sponsorship and product integration go hand in hand. And unlike commercials, these placements are intrinsically woven into the programming so that no amount of commercial-skipping, downloading, syndication or piracy will eliminate the brand association. According to *The New York Times*, some companies will pay up to $500,000 for placement in a single TV episode. These same lessons apply equally to feature films (which ultimately appear on TV at some point anyway).

Short form webseries have become the modern wild west with respect to product placement and corporate involvement in the earliest stages of production. The hotel chain Marriott self-financed the creative webseries *Two Bellmen*—shot, not surprisingly, in various Marriott hotels. Countless other national brands are co-financing YouTube channels, all coordinated through huge professional staffs at multi-channel networks (MCNs) like Disney-owned Maker Studios and its ilk. If you've got favorite Tubers, Viners or Snapchatters each with a million-plus subscriber base, chances are there is money changing hands somewhere for every product they touch in their shows.

Cash and Carry

Product integration (a slightly more palatable euphemism for "product placement") in big-budget feature films is common. But unlike webseries or even TV, on features the relationship is usually more complicated and nuanced than just a simple exchange of funds. More likely, a car company, for example, will agree to run millions of dollars worth of film-themed ads timed to the release of the movie. You've probably seen these kinds of commercials: "Drive the fancy new Chevy Bolt, as featured in the new *Batman vs. Robin* film, coming out August 12th in theaters near you!" Are they car commercials or ads for the film? Well, both. For the studios, that might be $20 million they don't have to spend on marketing. Unfortunately for the filmmakers, that may not exactly translate into $20 million more for the production budget, but at that level of studio filmmaking, no one's complaining. We should all be so lucky!

On an indie film, you don't have the luxury of negotiating with companies for them to place ads timed to your theatrical release: Chances are, you don't know who your distributor is going to be, much less know when you'll get a theatrical release or even if you will at all! For the indie filmmaker, what you need is cash on hand *now* to actually shoot your film and get it in the can. Though rare, it is possible.

On my real estate musical, *Open House*, I thought I might be able to get the real estate community to help fund the film. After all, when was the last time anyone had made a real estate musical film? At one point the National Association of Realtors (NAR) said it wanted to put $200,000 into the film! After a polite exchange of emails, its marketing team then said, "well, maybe $100,000." A week later that shrank to $10,000. One week after that and they stopped returning my emails completely. (I'm guessing by then they'd read the part of the script where people have sex in open houses.)

OK, but even if the NAR passed, maybe I could appeal to individual real estate agents? It was the height of the real estate bubble in the mid-2000s, and I figured a lot of them had some ready cash, and egos to match. I'd planned a title montage for the film with a variety of real estate signs and bus bench ads. I'd try to sell these "opportunities" to existing real estate agents and I got a hold of a list of thousands of realtor emails around the country (thank you, NAR website!). I spammed them all, and heard back from a few—especially in LA, where we'd be shooting. I had a number of meetings, and we ultimately did get a few of our key locations through these relationships.

In one case, we found a beautiful $6 million mansion to shoot in for free. One unintended consequence? While we were shooting in the house, which really was for sale, people kept noticing the prop "open house" signs in front. So in the middle of doing elaborate song-and-dance routines with 20 extras and an equally big crew, our 1st AD would show the house to actual prospective buyers. Hey, we figured maybe the real estate agent would give us a finder's fee if we sold the house for him! Another perk to shooting in a real open house? We saved money by avoiding a location permit from the local municipality; we figured all our crew and cast cars parked in front just looked liked they were there for the open house.

While we didn't raise any actual cash from realtors during production, we did need to raise $10,000 toward the end of post-production to pay for our Oscar campaign (see "When In Doubt, Create Your Own Oscar" on page 187). After screening the film at festivals in Austin and the Hamptons, we made deals with one local realtor in each of those cities to retroactively shoot their signs, and edit them back into the opening montage in exchange for a $5,000 investment in the film. Both realtors were thrilled, and for them, it was as much a marketing expense as it was an investment. They wound up being two of my happiest investors and together accounted for a full 20 percent of the total budget.

However, on an indie film, you'll be very lucky if you can get cash in hand from product placement. Much more likely is you'll get some sort of barter arrangement. Your biggest savings here will probably come in location fees. On *Open House*, in addition to the free houses we got, we also were able to shoot for a full day in the Omaha Steaks retail store in LA. On *Between Us*, we shot

in the Redbury Hotel for next to nothing. But since the hotel was doubling for New York apartments, it presented a challenge in actually showing the name of the hotel within the film. So we came up with a fun plan: We shot all our EPK interviews with the Redbury Hotel logo strategically placed in the background, and even interviewed the hotel manager!

Break Down, Go Ahead and Give it To Me

At some point, early in pre-production, hopefully you or an intern will have "broken down" your script and looked for all the scenes where you could conceivably need specific branded props: Cars, wine, beer, soda, snacks, etc. But keep an open mind: Just because a product isn't mentioned specifically in the script, doesn't mean it can't be in the movie! For the most part, any food or beverage is fair game—you can always sneak them in somewhere in a kitchen, restaurant or dining room scene. Your breakdown is a necessary rough guide, but if it makes sense to place something in your movie because you're getting something valuable in exchange, then you'll find a way to use it. On *Between Us*, we found a potential investor who offered to give us $5,000 in exchange for placing a scented toilet paper holder (an obscure product she'd invented) in the film. We agreed, and put it in a pantry scene, next to the ketchup and duct tape. In the end, though, she didn't invest in the film, and we didn't use the shot.

In general, there are three ways to find and secure product placement: Either by approaching mom-and-pop companies directly, finding the marketing departments of big companies, or especially if they're national brands, then more likely you'll contact them via a third-party consulting company. For the consulting companies, the easiest way to track them down is to go to the website for the Entertainment Resource and Marketing Association. ERMA is the umbrella organization for many of the consulting companies, and you can fairly easily figure out from its website what brands are working with which marketing consultants. Just crosscheck your breakdown with the ERMA list, and you're halfway there!

Once you call the big consultants, they will have a few main questions for you: Is it a theatrical release? Who's your distributor? What's your budget? And who are your stars? Well, if you're like most indie filmmakers, your answers will be variations of the phrase, "uhhhh . . . not sure." That's OK! They might not hang up on you right away. If they don't, try to sweet-talk them. Tell them about how you're an award-winning filmmaker. Tell them the script went to the Sundance Lab. Mention that you're working with CAA on the casting as you speak. Say whatever you need to say (hopefully, honestly) that makes it sound like you're a real film that's going *places* (even if you don't know exactly where). More so now than ever, they're going to need to be wowed by your cast. Even if the film doesn't get a 3,000-screen release, but Reese Witherspoon

Instagrams an on-set picture of herself eating Häagen-Dazs ice cream between takes, they'll be happy. If you don't have a "famous A-list cast," you might be able to get the consultants' interest when you say your Vine-famous cast member has a million subscribers and 500,000 more Twitter followers.

Once you get their attention, read them your breakdown and tell them generally what kinds of products you're interested in. The consultants will read your shooting script to see which of their clients' products fit within the film, even if it's something that wasn't on your original list. Of course, they're also going to be making sure that the products are portrayed generally in a positive light. For example, almost no beer company will let its brand be used in a drunk-driving scene. I said "almost" because as far as I can tell, Pabst Blue Ribbon is the rare exception that simply doesn't care and doesn't mind how you use its beer in your film. On *Between Us*, that came in handy since we have an actor drinking while driving and referring to what he's drinking as "shit beer." Thankfully, Pabst was cool with it and sent us 24 cases of beer, plus all kinds of signage to use in the film.

If you're really nervous about these kinds of associations, you can always send alternate versions of a script, or just redacted scenes. It's a tricky practice, since eventually these companies may see the film ("What?? How did our Chick-fil-A logo get into that pro-abortion Ellen Page film!?! Those Godless Hollywood bastards!") and they and their consulting companies may swear off all indie filmmakers the next time around. So please be reasonably honest about your intentions.

Once the consultants come back with their lists, just be open-minded, and say yes to anything free you can get your hands on. Even if you are two or three months away from shooting, haven't locked your locations and are still tinkering with the script, ask them to start shipping things. Keep in mind, too, that these consultants are paid by their clients—which is to say the brands and companies: You don't have to pay them a dime. They need to show a steady stream of placements for their clients' products, even if it's on small indie films, to help justify their consulting fees. You're there to help *them* as much as they're helping you.

Why get everything, and why get it early? In many cases, you're going to get much more product than you can possibly use in your film. That's fine. Remember all those cases of Pabst we got on *Between Us*? That's how we paid our crew and some of our vendors. On *Open House*, we showed up at one house location only to find that a city crew was loudly repaving the street with tar. Aside from the problem of tracking sticky, black tar into the white-carpeted house, we barely could shoot dialogue or musical scenes with the constant concrete grinding and "beep, beep, beep" backup sounds of construction trucks. So, our location manager, Lee David Lee, grabbed three cases of product-placement Corona and wheeled them over to the construction crew. Needless to say, they found a different street to work on that day! Likewise, on *omaha (the movie)*, we

got a local power company employee near Carhenge to show up early and let us use his crane for $60 and a case of beer. We made sure he only started drinking *after* he operated the crane for us, but we got our sunrise shot! It's not just beer that you can barter: On *Open House*, the cosmetics company Mac gave us a complete kit that we promised our makeup artist could keep after production, so she worked for free.

Food and beverages are definitely the most tangible things you can use during production. You'll definitely need water on any film shoot for your crew—so start writing a water-cooler office scene into your script now if you want Arrowhead for your crew! Pretty much any non-alcoholic drink and snack food is fair game for craft service or lunches. When ConAgra gave us cases of snack food for the crew, oddly enough, it was with the caveat that we *didn't* use them in the film. I personally knew the marketing exec there, and she wanted to support the film and maybe get the actors hooked on their snacks. But she knew that the script itself might be a little too edgy for the conservative Midwestern Fortune 500 company. Fair enough. That's the kind of product placement that's easy to accommodate!

A Clear and Present Necessity

Aside from getting all that free stuff, the real reason you want product placement is a legal and practical one. Once you're done with the film, one of the main things your E&O insurer will need to see are "clearances" for all the brands that are seen or mentioned in the film. The E&O company will also need to see a "clearance report" either from your lawyer or a specialized clearance consultant. In any case, what brands you do see or mention need to be legally cleared—getting each one to sign a release form. So if you've gone through a consulting company or even approached companies directly, you'll already have signed paperwork saying that those products are "pre-cleared." Just make sure your art department or PAs put that paperwork in your binders, and you're good to go!

If you can't get product placement on a particular item for whatever reason, there are still ways to get those props. The easiest (if not always cheapest) is to rent or make props with fictional brand names and logos. Another way to go is the *Repo Man* method, where director Alex Cox made a very funny storytelling point of only using black-and-white plain-label generic brands on *every* food and drink product in the film. Keep in mind, though, not to get too freaked out if you don't have clearances on absolutely all your props and logos deep in the background of every shot.

It's called "errors and *omissions*" insurance for a reason: To cover the distributor just in case some company portrayed in the background is offended by the scene and wants to sue someone. So if you're doing a particularly controversial

scene in a particularly offensive movie, then be more careful. Otherwise, don't overthink it. You're allowed to portray products "in a manner in which they're usually used," as the lawyers like to say. Also, keep in mind that car logos are legally fair game in movies—you don't have to clear every single car going through traffic behind your actors. In fact, you probably don't need to clear any of them, unless maybe your actor is specifically using a Cadillac hood ornament to impale another character.

Signs on buildings are also fair game, as are most building themselves, under a specific exemption in copyright law. If the exterior of a building is regularly visible to the public, you can shoot it without getting a location permit. (Interiors are another matter entirely—you definitely need permission for those.) But use common sense: If you show a building's specific address and then indicate that the building's owner is an axe murderer, you might want to get permission.

My daughter once noticed that an episode of *Saturday Night Live* had a quick establishing shot of *our* street in Culver City, zoomed in on a neighbor's house (a home that actually appears in my movie, *Open House*). Curious as to how they got the footage, we tracked down the shot to a stock company in LA called Footage Bank, which had filmed our street from a public sidewalk. They had no city permits, and paid no location fees to our neighbor. NBC had undoubtedly paid the company top dollar for the footage, but Footage Bank owner Paula Lumbard got very defensive when I asked her about it and she refused to pay a dime back to our neighbor. Legally, my neighbor couldn't do a thing, unless he'd been able to prove harm from being the house associated with *The Hunger Games'* Josh Hutcherson wearing a mullet, singing 1980s songs in a middling *SNL* sketch. (Hmm, but I can't help wonder what Ms. Lumbard's *own* house in Venice, California looks like from the outside.)

Selling Out, Even if You Don't Get Paid for It

The real challenge in using product placement is how to use it without making it look like you're sacrificing your artistic integrity. Much will depend on the nature and tone of the specific film. For example, a romantic period piece set in Elizabethan England will have a harder time incorporating Totino's Frozen Pizza Rolls than, say, a stoner comedy set in contemporary San Diego. Of course, even if you are doing a serious period film, there's no reason you can't have your actors nibbling on Pizza Rolls during their EPK interviews or red carpet arrivals at Sundance.

Additionally, make sure your still photographer takes lots of pictures of the products on your set. Even if you never wind up using shots of the product in your film (depending on your contract, you might not be required to), you can always give the consultant or marketing people a nice still image for them to give to the client and use in social media or their website. On *Open House*, we

got so many different brands of drinks and snacks, we actually wrote and shot an entire scene between two of our actors which entirely consisted of one offering the other a drink and then a snack—somewhat inexplicably in Japanese, no less. We shot roughly 22 versions of the scene, including close-ups of the actors holding and saying each product. We cut it together into a montage and included it as a tongue-in-cheek "deleted" scene on our DVD. Hey, all the products made it onto the DVD—those companies couldn't complain!

Definitely be careful, though, about using your actors in stills or EPK imagery that highlights one of your products: Very often actors will have specific clauses in their contracts precluding you from taking exactly those kinds of "product endorsement" pictures. For them and their reps, they'd rather get paid for them, or worse, may already have an endorsement deal with a rival brand. Similarly, when you're pulling frame grabs for your publicity deliverables, you need to be cognizant of too-obvious brand affiliations. Yes, Julia Stiles was standing in front of a Pabst Blue Ribbon sign in a bodega in one scene in my movie. But no, she does not specifically endorse that beer. On that topic, though, while you're talking to the product placement consulting companies, ask them about perks for your actors if you do indeed get famous people. They may not be exactly the same companies who give your famous actors free cars during production, but they'll know who does.

Killing Two Birds with One Stone

There's *always* a way to make product placement work creatively in your film. On *omaha (the movie)*, we knew that one of the biggest problems with shooting 35mm film in Nebraska is that we'd be at least five hundred miles away from the closest lab, camera house, source of rawstock or post-production facilities. Shipping bills alone for our dailies processing would have torpedoed our meager budget. This was the early 1990s, and American Airlines was doing a lot of product placement in studio films like *Home Alone*. Hmm, I thought, we've already got a shot in the script of an airplane landing at an airport. Why not call American Airlines and see if they'll ship our film in exchange for showing one of their planes? We contacted the company who said to call its product placement consultants in Hollywood. When the consultants heard we had no stars and no distributor, they hung up on us.

Somehow we got wind that American Airlines had a separate marketing guy in the basement of its Fort Worth, Texas office who just dealt with its Priority Parcel delivery service. So I called the guy, and he was thrilled that someone from a movie was actually calling him! He said he'd be happy to help us out with free shipping for all our dailies, and even a couple of passenger tickets, but there was one catch: If we just added a shot of an American Airlines plane touching down in the film, then "those bastards in the passenger division will get all the

credit!" So in addition to the shot of the plane landing, he also wanted us to film a scene of someone taking an American Airlines Priority Parcel envelope and handing it to an American Airlines gate agent in the airport. I knew that we didn't already have that scene written in the script, so I said I'd think about it and call him back.

Meanwhile, one of my producers, Rick Endacott, had just gotten off the phone with the Red Robin hamburger restaurant in Omaha. Rick had been in charge of trying to call every restaurant in the state in order to get free food for the crew for the whole run of the production, and he'd been having pretty good luck—mostly involving simple product placement, like having a cup or a wrapper in the background of a scene. Rick told me that Red Robin was willing to give us a nice free lunch on one day for the whole crew. That sounds great, I said! But there's a catch. They needed us to film their mascot in the movie. Mascot? "Yup," Rick said, "A guy in a giant red bird suit has to be in the movie." I knew we didn't have a scene in the script that called for someone in a giant red bird suit.

So we put our heads together and came up with a plan. Destined for the middle of our title sequence, we'd shoot a quick scene in the airport with a guy in a giant Red Robin bird suit handing an American Airlines Priority Parcel to an American Airlines gate agent. The camera pans quickly back to our lead actor walking through the airport, and he keeps walking. Problems solved: We got our free shipping *and* we got our free Red Robin meal for the crew!

The Red Robin mascot delivers a package in *omaha (the movie)*
Photo: Susan Schonlau

The Locavore Filmmaker
Slamdance 2012 Opening Night Poem

To make a movie, there was once a time,
You just needed a camera, and maybe a dime,
You'd eat foie gras flying LA to New York
No qualms about using a disposable spork

Looking for a studio, you'd try North Carolina
But co-production looked sweet if you'd just visit
 China
Tax credits would be fine, it'd be swell to purloin
them in Detroit, New Orleans, or Des Moines!

You'd rack up frequent miles just for location
 scouting
Then use a Range Rover for out-and-abouting
Movies are focused on actors performing
You've got no time to worry about global warming

But seeing Al Gore regret his happy ending
Reminded you that the earth still needed mending
So without sacrificing your goal to shoot wide screen
You tell your whole crew that it's now time to go
 green!

More than just cans and scripts you'll recycle,
You'll invest in a hipster fixed-gear bi-cycle
You realize you live down the block from Drew
 Barrymore
You cast her because now . . . you're a filmmaking
 locavore!

No matter her part's for a one-legged old man,
You're on a mission more important than Cannes!
You'll shoot in your house, hire your neighbors as
 gaffers
Your twin six-year-olds become production staffers

You'll grow your craft service right there in your
 garden
Environmentally speaking, you've got quite the
 hard-on
For seasoning you'll pull out some weeds that are
 crocus
While the postman holds boom, and your wife pulls
 some focus

If you can walk and if you can bike it
Your vendors must be close, so you say that you
 like it.
One guy down the block has a Steadicam rig
Another has C-stands, that he stole from a gig.

You find an editor who does some great montage
Better yet still, he lives in your garage
Finally time to do your sound mixin'
There's no better place than right there in your
 kitchen!

Livin' La Vida Locavore

Plenty of us independent filmmakers claim to be environmentally friendly as can be, but beyond a few minor lifestyle tweaks (like claiming we just watched *Revenge of the Electric Car*, while bemoaning Hollywood's reliance on sequels), are we really as green as we'd like to think we are? Sadly, probably not. But one way we can help make a small difference to our planet is to take a page from the food movement and become locavore filmmakers—making movies close to home, in order to reduce our carbon footprints. I tried this strategy on *Between Us*, and here are some lessons I've learned from my somewhat mixed results:

Keep Your Homebase at Home

Between Us is set half in New York, and half in Omaha. So naturally, I decided to shoot it in LA! Of course, for practical reasons, this was largely so I could still take the kids to school during weeks of pre-production, and even occasionally see them while filming. My wife certainly appreciated that I stuck around town, despite the fact that our garage had been turned into a production office overrun by interns in cargo pants (who inevitably gravitated toward our kitchen looking for leftovers in the fridge). LA has a huge number of eager, talented young filmmakers, who for various immigration, unemployment or witness protection reasons can't be legally employed, but who want to live out the Hollywood dream and work on movies for free. Sure, some are homeless, but eventually, my family got used to the odd Nebraskan or Icelandic interns sleeping in the garage.

Living in LA, there was also a righteous commitment to stem runaway production and

hire an all local crew (using the term "hire" in the strictly metaphorical sense, since most were the aforementioned "interns"). When we did rehearsals in my kitchen, I enlisted *IndieWire* co-founder Mark Rabinowitz as our official "rehearsal chef," largely because he was bunking in our guest room at the time. And if the local police asked if I was running an illegal business or hotel out of my residentially zoned house, I could always claim Mark was my live-in butler. As for the Icelandic intern in the garage, the less said, the better.

Cast Locally (sort of)

I made a commitment early on to my casting director and producers: We're only going to cast American actors and they need to work as locals in LA. This made pragmatic sense. Most actors like to sleep in their own beds, and actually see their families on the occasional day off. So in theory, you should be able to attract a higher caliber of actors if you shoot in LA and cast locally. And casting Americans wasn't just a form of cultural protectionism (damn you, Helen Mirren!), but rather because we couldn't afford to deal with travel visas or immigration lawyers, and I was nervous about shaky accents. But due to the vagaries of casting, the local requirement lost its primacy the closer we got to shooting. Two of our actors came from New York, one Australian flew in from Argentina, and even the one guy from Studio City wound up staying in the hotel with the rest of the cast, so he could get a break from a colicky baby at home.

Find Locations Close to Home

We had one scene in *Between Us* that required one of our actors to go through a field of snow on a wheelchair, looking at a rustic church. So we scoured the country looking for a classic old church in a location that still had plenty of snow on the ground. Now, I'd already scouted a perfect church in Nebraska, but by the time we were shooting, it was April and there was not a patch of snow to be found in Nebraska, much less most of the continental US.

Fortunately, I go sledding frequently near the summit of Mt. Piños, barely an hour's drive north of LA. I knew from a scouting trip with my son the week

Now your movie's finished and you've done all your edits
You realize you've exhausted all your carbon credits
You're invited to Slamdance but deduce it's too far
Even a Prius can't make it; it's barely a car

So you come up with a plan, perhaps too primeval
Screw it you say, you'll hold your own fest-ival
Right there in your living room, project on the wall
You'll sell tickets on the porch, and popcorn in the hall

Though your DP had failed when he tried to penetrate her
You still convince Drew to ride the bicycle generator
The neighbors all come, including one studio biggie
He greenlit *The Muppets*, and he cast Miss Piggy

The screening's a success and you throw some confetti!
A standing ovation, though Barrymore's sweaty
An agent who'd stopped by while taking a jog
Then asks if you'd shoot the sequel in Prague

After what you've been through, it's not at all ridiculous
He'll fly you right there, on his brand new G6-ulous
The load on your shoulder that you just can not carry more
Is lightened by knowing you were the world's first filmmaking locavore.

Wheelchair in the snow, and a Nebraska church composited into the next shot
Courtesy: Bugeater Films

before (that ended with a minor case of frostbite, an overheated minivan, a welcome tow truck and a build-your-own sundae at a truckstop Denny's) that at 8,800 feet, the summit still had just enough snow to shoot our scene. So I gathered a crew of eight, plus our actor David Harbour, and we drove out to the mountain. We parked near the summit, and hiked for an hour in the snow, all carrying close to 400 pounds of equipment plus a wheelchair. David borrowed a pair of my boots, which split open less than 100 yards into the hike. Wrapping his feet in gaffer's tape, we continued to the summit along the unmarked trail, with no maps or GPS, and with the crew following me on blind faith alone. I felt like Werner Herzog making *Fitzcarraldo*, but with a wheelchair instead of a boat. Just as I noticed a camera assistant glaring at my meaty legs, mumbling something about a "Donner party for Mirvish," a clearing at the summit opened up: No trees, a horizon line clear for hundreds of miles and just enough snow to sell the scene. Oh, and for the church, we just digitally composited in the one I'd seen in Nebraska.

Drag Your Actors Out of Bed

We found our interior "Omaha" house in Los Feliz. Less than a mile away, in Hollywood, we realized the Redbury Hotel had rooms that looked more like New York apartments than any other place we'd scouted in LA. Even more

shocking, the hotel (which was already housing our actors) actually *wanted* us to shoot there, and barely charged us for it. In addition to the apartment scenes, we also used the hotel for two wedding scenes, a restaurant, a bar and even the church interior confessional. In total, we shot two-thirds of the movie there. For the actors, this was a dream: They could roll out of bed, do makeup in one room, snack on craft service in another and cross the hall to the set. For them, this truly was locavore filmmaking.

No, Seriously, Keep it Really Close to Home

For a couple of short scenes, we needed a guest-room that was under construction, and we had to be able to use bright yellow and green paint on the walls for a particularly wild Brazilian love scene. In a fit of extreme locavorism, I offered up my own garage for this purpose. It took a full day to clear out our pre-production desks, chairs and dirty Icelandic underwear, dumping everything in the backyard. We then put my kids to work painting the garage walls, and I instructed my team to bring just a skeleton crew and limited lights, so as not to alert the neighbors. Of course, the entire crew and all our lights showed up en masse. Thankfully it was a Friday night, and the neighbors just assumed it was a raucous, but very well-lit, Brazilian bacchanal in the garage.

If You Travel, Hire Locally

Three weeks after wrapping principal photography in LA, I still needed to get exterior shots of both Nebraska and New York. So while on a family trip back to Omaha to visit my parents, I teamed up with my long-time producing partner who's based there, Dana Altman. Thankfully, one of my cargo-pants-clad interns in LA who was a film student at Loyola Marymount University was spending the summer with his folks in Omaha. Since he knew our Los Feliz location, he scouted an almost perfect match for the exterior in Omaha. Despite protestations from my beloved cinematographer, Nancy (who begged to come with my wife and children on our Omaha family vacation), we used a local cinematographer and literally phoned in our RED settings to Nancy.

Instead of using fancy product placement connections to get matching cars for driving scenes in Nebraska (difficult, particularly since we'd run out of production insurance by then), Dana had the clever idea to call a local dealership and offer them the "opportunity" to loan us cars and have their own employees be our stunt drivers (since they were already insured for test drives). Thankfully, Anthony Caputo, the General Manager at Markel BMW, had gone to high school with Dennis Leary in Massachusetts: "If Dennis can be a friggin' movie star, then so can I!" So we suited up Anthony in Taye Diggs' clothes and he became a stunt driver for the day.

From Omaha, I flew to New York, and crashed with my Slamdance colleagues Paul Rachman and Karin Hayes, and met up with my New York-based producer Mike Ryan. Nancy met us in New York (she's got an apartment there, and was chomping at the bit to get back behind the camera!), but otherwise we mostly hired my pal Larry Fessenden's crew for what turned out to be an incredibly efficient one-day shoot with Julia Stiles. Talk about a good locavore example: Julia even walked to set from her apartment!

Editing, One Pant Leg at a Time

In the digital age of indie film, it's axiomatic that post-production has the greatest potential for locavorism: In theory, you can finish a whole film without leaving your bedroom. For a while, my terrific editor Dean Gonzalez cut *Between Us* at his house on his Mac. When I realized Dean wasn't wearing pants (and probably neither was I), I made him drive over to my house, and we cut the film together in my kitchen while I force-fed him frozen Costco pizza topped with fresh figs and canned capers. We drank leftover product placement Snapple iced tea, and infused it with chopped mint from my garden. Later, what once had been our pre-production office (my garage), transformed easily into a glorious post-production "suite" for finishing touches. We were lucky enough to get Terilyn Shropshire, ACE, to come in for a couple of weeks of additional editing before she had to start working on what turned out to be Whitney Houston's final movie, *Sparkle*. But even then, Terry wasn't off the hook: She was editing at Sony, which is little more than one block from my house. I'd frequently walk over with my laptop, sneak onto the lot and show her new tweaks I was making. We even recorded her doing some off-screen lines (as the mother-in-law on the phone) while Whitney Houston was paused in the background.

Screw the Environment, Do It for Yourself

If you have any kind of regular exercise regime, it will go by the wayside while making a film (see: Smith, Kevin; Coppola, Francis Ford; Welles, Orson; Hitchcock, Alfred). But even in

Hack Attack

Opening Night Poem, Slamdance 2015. That year, we screened one film produced by, and starring, James Franco, as well as a doc about Dennis Rodman's trip to North Korea. If you'll recall, it was Tim League's Alama Drafthouse chain that first agreed to screen The Interview *despite threats.*

It's rare that a film can make quite a dent
Get everyone flustered and terribly bent
Out of shape, out of sorts and indeed out of whack
I'd be remiss not to mention The Infamous Hack

Now on the face, of things in the news
The big Sony Hack did more than bemuse
It crippled a studio, brought a nation to knees
And I'm talking a big one, not one like Belize

I may live in Culver, but I'm hardly a crony
As someone who lives just a block south of Sony
(For real estate agents, it's probably a no-no
But I like to call our neighborhood "SoSo")

So forgive my indulgence, but this story hits close
If someone attacks them, I'll need to take a dose
Of iodine tablets, I've been out stocking
I'm not paranoid, so please stop your mocking

In a story that went from sublimes to absurds
It's a Faustian twist on *Revenge of the Nerds*
For outing the racists, the hackers are heroes!
Until they threaten our films, and then they are zeroes

LA, you can still make some healthy lifestyle choices with your post-production vendors and colleagues! One of my composers, my dialogue cutter, and our color correction, foley and mix stages were all within a two-mile radius of my house, and all conveniently located just off of the Ballona Creek Bike Trail that cuts through Culver City. Though a bit unnerving to carry the entire film in a backpack filled with hard drives (don't tell my producers), it was worth it for the extra aerobic workout alone. Some clever post supervisor should create a conversion chart of minutes-of-raw-footage to gigabytes, to calories-burned-while-biking.

If you're lucky, you will gain 20 pounds on the festival circuit (five at the Napa Valley Film Festival alone). So if you have any faith in the success of your film at all, you'd better get in shape during post. And if you stand half a chance of finding romance on said festival circuit (even from your own spouse), this post-production exercise is a moral imperative.

I'm sure this whole locavore filmmaker thing is easier to pull off if you live and work in New York. Any grungy filmmaker with a Metrocard can do that! The real trick is pulling off locavore filmmaking in freeway-packed LA. And not just for indie films: We should be demanding that Hollywood pay more than lip-service to the environmental cause, too. For starters, they should only hire directors who live in a 300-meter radius of their studios. And to my Culver City neighbors at Sony, I'll walk over in five minutes—open the gate, this time, please!

In a year that saw the retaking of Crimea
It was easy to blame everything on Korea
Not the ones in the South, we love where they're from
Like Bong Joon-ho, a proud Slamdance alum

No, we're talking about the ones in the North
Where the hacks we are told, seem to have come forth
They barely have kimchee, they barely have rice
But they give out Hollywood releasing advice

But what does any of this have to do, with a gathering of indies
Well, I'll tell you my friends; I'll try not to be windy

Slamdance has odd friends, including Rodman, Dennis
Who once attended our party, in Cannes, not in Venice
We're showing a doc, about his trip to Pyongyang
It should be fun, a real sturm und drang!

We're happy to screen a film made by James Franco
I think it will sell out, on that you can banko
And at the end of the day, it was our friend Tim League
Who was willing to spark up, the lights that are klieg

For once in Park City, there'll be real conversation
And not about parties, or swagification
We'll talk about freedom! To make films and to show 'em!
And if someone sees Tim, they should offer to blow 'im

Stand up for our rights, is more than just a slogan
Not just for James, and his buddy Seth Rogen
For all of us have had our share of rejection
We've been blacklisted and barred from projection

But this week in Park City, we'll use our first amendment right!
(Well, except for filmmakers we didn't invite)
So come see our movies, we'll all sing along!
Hack us if you dare, what could possibly go wrong?

Finishing with Abandon

Editing Like an ACE

Editors Are Like Bass Players

Long before you've started shooting, you should pick your editor. The editor is as much a creative partner as your screenwriter, actors or cinematographer. Good editors will save your film, and bad editors will tank it. Take your time in picking one. Watch reels, watch whole films they've done, talk to other directors they've worked with. Make sure they're good at both "micro-editing" (cutting within a scene) and "macro" (the overall rhythms of a full feature). It's like finding the perfect bass player for your emo-grunge-funk band: Find out who their influences are, what their training is, what their editing philosophy is, and most importantly, figure out if you're going to get along with them. And like some of the best bass players, good editors are a little antisocial, have a strong sense of rhythm, work well under pressure, and if you're lucky, have anal-retentive work habits.

You're going to be spending a lot of time with your editor, so it'd better be someone you like. With DPs or actors, if they're brilliant, but difficult, you can always plow through a quick three weeks with them. But you're likely going to spend months (or years!) with your editors in small, hot sweaty rooms. How is their personal hygiene, at least relative to your own? Do they live in close proximity to you? Will you be able to drive to their house or edit suite, or will they want to come to you? Are you allergic to dogs, but find out that the editor has five Rottweilers?

Like good cinematographers, good editors are usually busy. When an editor gets hired on a gig, it could be a six-month or longer commitment for a feature, or even a multi-year commitment if it's a hit TV show. One key difference is that if a DP gets a three- or four-day commercial or music video job in the middle of your feature, you'll either need to reschedule your entire shoot around the DP, find another cinematographer for the full shoot, or for a few days, bring in

a ringer or temporarily promote your camera operator or 1st AC. At least once you've found an editor, if he or she happens to get a high-paying commercial or music video job that takes a few days out of your six-month schedule, that's cool! It won't disrupt your workflow for too long, but it might feed the editor for three months.

In other words, one of the best places to look for editors is within the ranks of commercial and music video editors. Chances are they've banked a fair bit of money, any new gigs will be short-term, and they're probably really hungry to cut their first narrative or doc feature. Many of these editors also work as sort-of independent contractors within large commercial post houses or production companies. Much as you chose your DP for their connections, you should also think about your editor the same way. If editors are at one of these big commercial or post houses, they may be able to bring with them thousands of dollars' worth of valuable infrastructure and technical expertise: Assistant editors, hard drives, color correcting, visual effects, sound post, onlining, etc. If given the choice between a Sundance-winning features editor who works in his parents' basement, and a commercial editor cutting her first feature, but who will work for free *and* bring you a hundred-thousand dollars' worth of free post support, think long and hard about that decision!

Finding Fresh Eyes

Chances are, you will at some point need to fire your editor. Unlike almost any other creative position on a movie, the credit "editor" is the most likely one to be shared between two or three people. How often do you see two credits for a DP on a film, or two different actors playing the same part (unless it's a Todd Haynes film about Bob Dylan)? With editors, there are usually two reasons you see multiple credits: Because they're working simultaneously, or sequentially.

If the post schedule is rushed because of a release date—usually on studio films—multiple editors are hired to cut different sequences of the film. They're usually working in adjacent edit suites, and sharing the same assistants, hard drives and servers. The director just bounces back and forth between them supervising the cut. Even on low-budget movies this happens when there are pressures to complete a film for festival deadlines or pistol-whipping investors (neither of which do I recommend, by the way). On the bad kickboxing movie I worked on in the Philippines and then posted in LA, we had three shifts of editors and assistants working 24 hours a day for three weeks to cut the film—all sharing the same 35mm editing equipment.

Another scenario is that you'll have serial editors, where one will work for three months to get the assembly or first cut done, and then another editor is brought in for the final cut. This is usually done for both financial and creative

reasons. For many editors on indie films, working longer than three months for no money is simply too much of a financial drain. Even if you're paying them a few hundred bucks a week, if they get a better paying gig, they may need to bow out of your film altogether. On *Open House*, which had a very labor-intensive workflow (we had to sync up to 16 tracks of music and vocals before cutting each scene), we started with one main editor who left after a few months because he needed a paying job, and then we transitioned to three more simultaneous editors each working out of their own houses.

You may also want to change editors for creative reasons. There's an old saying that there's nothing as great as your dailies or as bad as your first cut. Watching your first cut will *always* be a dispiriting experience. There's a reason it's called your "first" cut and not your last: It can only get better, and have faith that it will! Hopefully for you, the director, you'll have a vision of how the film is going to evolve with further editing, sound effects, original music, dialogue cutting, etc. But if you show it to producers or friends, they're going to be mortified. No matter how much they tell you they've seen rough cuts before, they will always hate it. They might be able to see through the roughness and give you constructive notes about moving forward, but often not. More commonly the response is "fire your editor." That may be your own response, too.

The phrase used most frequently in this situation is "needing fresh eyes." Even your own editors may recognize that they've been mired in the weeds with the footage and the micro-editing of scenes for so long that they've lost sight of the full macro sense of character, pacing and overall story. If you're lucky, they'll also be exhausted, frustrated and broke, and will happily offer to turn the reins over to another editor. Chances are they've spent the last three months quietly cursing out the DP and the director for giving them such crappy coverage that simply won't cut together or has too many out-of-focus shots that are completely unusable. The easiest way to fire an editor is to get them to quit.

If the editors aren't already heading out the door, but you need to nudge them out, it gets a bit tricky. You need to remind them that making a film is more like a relay race than a marathon—always a good metaphor to overuse! Some variation of "we need more space" works well, too. But if your college girlfriend ever said that to you a day before jumping into bed with her philosophy TA with the Prince Valiant hair and rock-hard pecs, you'll know that it still feels crappy. So, you need to soften the blow with your editors, usually by guaranteeing that they'll still get either the sole, or at least the first of shared front-end, editing credits on the film. In one case, I even gave an editor a post-production producer credit, based on the fact that this person had secured us all our editing equipment. The additional credit was perfectly justified and looked great on the editor's IMDb page. With that in mind, make sure when you're doing your original contract with your editor not to grant "sole and exclusive" credit. If you have to guarantee a non-exclusive, front-end credit, tie it to delivery of the

first cut at least. Of course, if your first editor is the one who secured a full post house, assistants, hard drives or other infrastructural support, then think twice before firing that person at all. You may find yourself in a situation where the editor has too much leverage over you to fire. In which case, either suck it up and make it work, or leave and start from scratch with post.

Cut Yourself

One temptation in making indie films is for directors to want to edit their films themselves. This is either a really great idea or a really horrible idea depending on whom you ask. I remember posing this question to indie-horror auteur Larry Fessenden, and he advised very strongly, "Dan, cut the film yourself! You know the footage better than anyone, you can execute your vision for the film better than an editor, and you're not a *real* filmmaker unless you're hands-on through the whole process!" A day later, I asked my pal, Sundance-award-winning director Matt Harrison (who himself is old friends with Larry, both of their roots going back to early 1980s DIY filmmaking in the East Village). Matt said,

> Dan, do not cut *this* movie! You need an objective set of eyes seeing the footage, not influenced by all the on-set politics and decision-making. You're not a *real* filmmaker unless you're supervising your editor who's doing all the button pushing while you sip coffee and hover impatiently!

Naturally, Larry and Matt both make very valid points. If you spent a full day, and a third of your budget shooting an elaborate *Touch of Evil*-like crane-dolly shot with a hundred extras, but the shot doesn't objectively cut together with your film, are you or a disinterested editor more likely to jettison the shot and move on with editing? First and foremost, the answer lies largely in your own abilities as an editor: Do you know the software, can you edit fast and well, and do you have the undistracted time available to actually cut your own film? If so, then you might be the best person to cut your own film. If not, hire someone.

For me, I take a more nuanced approach to self-editing my films. For one thing, I think of myself as a half-decent editor in my own right, and from the old 35mm film days of *omaha (the movie)* to working on Final Cut Pro 7 on my last few films, I've known the equipment well enough to cut fairly efficiently without slicing my fingers off or erasing the hard drives. But I also recognize that as one of my own producers, my time commitment even in post is still going to be devoted in some measure to producorial concerns: Paying bills, raising more money, figuring out music and sound post, and, of course, driving my kids to school. I also genuinely like the idea of an outside editor having an unbiased view of the footage and seeing it for the first time objectively.

So what I've done on all my feature films is bring in an editor to cut the majority of the film. But for specific scenes, I'll consider myself an "additional editor" and cut scenes on my own. If I have a particular style or rhythm of cutting scenes (which I often do), then cutting a few scenes shows the editors by example the kind of style I'm looking for. Another advantage is that the editors can start to work even while the film is in production. That can be very helpful if they assemble some scenes together and let you know you're missing one or more shots that you can still pick up in your last days of shooting. On *Between Us*, my editor Dean Gonzalez was able to cut sequences of our LA footage together right after principal photography wrapped. Based on those sequences, we were able to shoot matching footage in Omaha and New York a few weeks later. Basically, we knew what holes we needed to plug. The other upside to doing some of my own editing is that when things slow down because an editor gets a spare commercial job to pay the bills, we don't lose overall momentum. It's easy enough to do simultaneous editing these days: Just mirror your hard drives so you and the editor both have access to the footage directly, and just trade your FCP, Avid or Premiere files back and forth.

On *Between Us*, Dean was cutting at his house in Hollywood for the first couple of months. Once I figured out how to mirror the drives and cut on my laptop, I started to cut scenes, too. Unfortunately, the process was still taking a long time—Dean was getting other multi-day commercial gigs, and I would get distracted by all the other crap I had to deal with after wrapping (also, I was inexplicably building a fort in my backyard). We'd only cut about two-thirds of the film several months after shooting and my producers were getting antsy. Luckily, my wife and kids went on vacation for two weeks without me. So Dean drove over to my house every day, and we set up the hard drives and our computers side-by-side in my kitchen. I would cut a scene in the morning, then pass him the FCP file, and he'd fine-cut

The Artisanal Filmmaker
Opening Night Poem, Slamdance 2016

In the quest to keep it real
I'm here to tell you, here's the deal
If you want to be an artisanal director
In a world that's digital
Stand tall, not midgetal
And start oiling up your film school's old projector

When everyone is barely trying
Not much more than CGI-ing
The rift you hear is more than just an occulus
Something we should not all pursue
Can't spell virtual without virtue
Just because the vox demands it in the populous

Like holy sweaters that are moth-entic
I'll tell you how to go authentic
Stop your beard braiding and please pay some attention
I don't want to hear no griping
Are you ready? So start typing!
No electricity is needed, did I mention?

On a manual that is QWERTY
A Remington from 1930
Once I swear was used I'm sure by Orson Welles
Type your script in Courier
Even best if blurrier
The dirtier the better this compels

With no backspace or delete
Your screenplay now it is complete
Only problem is you have just one edition
On this point perhaps I'll harp on
But you might have thought to use a carbon
There is no cure for this unfortunate condition

To shoot on film, I think you must
All the better if there's dust
No point keeping any scratches to a minima
On Jean-Luc Godard's own old Bolex
With whom you traded your dad's Rolex
It came packed with a crumpled *Cahiers du Cinema*

it. We'd switch, and I'd fine-cut one of the scenes he'd edited in the morning. We wound up cranking through the film quickly and efficiently and by the end of the two weeks, we had our first presentable cut!

The other advantage of doing at least some of the editing yourself is that at some point, you'll be the only editor left. After your first two editors have come and gone (voluntarily or not), you still probably won't be done editing. You don't want to be in a position that many filmmakers find themselves in of wanting to recut one last little scene, and having to beg and grovel to get your old editor back or search from scratch for a new one to work for only a day or two. That's where your own editing skill set comes in: If you can just fire up the drives and start the computer yourself, you can make those changes quickly and cheaply yourself. Even four years later, when you have to dive back into the footage to cut your own director reel, you'll be glad you can edit yourself. Of course, the temptation is to keep cutting forever. Some filmmakers find themselves in inescapable black holes of cutting and recutting for *years* and sometimes never finish their films. Often, films aren't finished so much as they are abandoned. Another way of knowing when you're done with cutting your movie? When the hard drives start failing, you're done! Consider it a sign from the film gods that you're locked, and ready to move on to sound.

Your lawyers at Shapiro Dickstein
Advise you not to shoot on 16
Millimeters, but what do lawyers know 'bout art?
And for lenses, here I hope
That you'll choose a MirvishScope
Just two magnifying glasses from K-Mart

For film stock you'll use short ends
From JJ Abrams here I portend
Now you're shooting on the good side of the Force
You'll use puppets and not actors
Why incur the human factor
Yup, you're old school and there's no time for remorse

Use a Moviola for your edit
An old upright, from Mack Sennett
And a sync block used to cut *It's A Mad, Mad, Mad, Mad World*
Use duct tape for all your splices
And for sound use old devices
With ancient mag that's clearly cracked and even curled

And now that you've come a-screening
You're quite proud that you are preening
About your film that's clearly so original
Like bacon beer flavored with lotus
You're so real that you don't notice
All the *other* films that are also artisanal!

Start Strong; Stick Your Landing

I'm convinced that an audience walks away from most movies remembering only the beginning, maybe one or two key scenes in the middle, and the ending. Everything else is just connecting the dots to keep its attention from drifting.

Whoever cuts your film, make sure you spend a *lot* of time cutting and recutting your opening five to ten minutes. If the beginning of your film isn't amazing, then many festival directors, distributors, and ultimately, home audiences, will simply turn off the film. You can't hit any false notes in your opening. The acting, editing, cinematography, music, title sequence have to be engaging and engrossing from the start. In this day and age, you can't have a slow build, even if the movie settles into a "European pacing" for the rest of the film. One

way is to start *in media res* ("into the middle things")—a technique that goes back to the Greeks and Shakespeare, but works like a charm in many films. Amy Seimetz's *Sun Don't Shine* is a great example of jumping into the action with her lead characters fighting madly and only flashing back as necessary. On *Between Us*, the opening shot is Julia Stiles' character opening the door, looking at camera and mysteriously saying, "I got to say, it's a little strange having you two show up at our doorstep like this." It probably took us five months and 30 different cuts before we even found that shot and decided to start the movie with it. Take your time and nail your opening.

It's equally essential to put just as much time and thought into your ending. To borrow a phrase from gymnastics, you've got to stick your landing. That doesn't mean you have to have a happy ending per se. But it does mean you need to have a *decisive* ending that leaves the audience feeling satisfied (or intentionally *un*satisfied if that's what you want). And part of that means paying attention to the details. On Stanley Kubrick's *Full Metal Jacket*, the final scene fades to black and immediately the opening guitar riff from the Rolling Stones' "Paint it Black" starts up. It's not until eight seconds later that Kubrick's first credit pops on, timed precisely to the first drum beats of the song. The timing and tone of your closing credit music is the last emotional cue your audience will have, so use it wisely.

Don't Let Your Post Supervisor Escape to Madagascar

One of the other key people you need for post-production is a post supervisor. Ideally, this is also someone you can secure well ahead of time in pre-production. Good post supervisors will figure out efficient workflows from production straight through to all of post. They'll work closely with your DP, assistant camera team, sound recordist and DIT during shooting. They'll coordinate with your editor, assistant editor, sound post house, color correction and online facilities in post. And if they're still around, they'll coordinate all your deliverables with your distributors.

Post supervisors don't have to be on set and in your edit room every day for your entire process, but they do need to be available when you need them and when crises emerge. So, it's better to pay an experienced supervisor who can work part time or consult, than not have one at all. The technical path from pre-production through to post can be a game of telephone: If your DP is shooting on one format, your DIT is transcoding to another format, handing off to your assistant editor who syncs it and gives it to your editor, by the time you're getting the film back in front of your DP for color correction, it could look completely wrong and still be out of sync when you show up for your final mix.

Even when you have an experienced post supervisor, things can still go wrong with the workflow. On *Between Us*, we realized in editing that some of

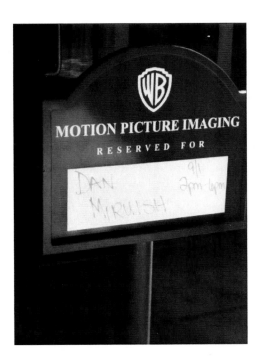

Fancy parking on the Warner Brothers lot!

Photo: Dan Mirvish

our footage was way too dark. But we didn't know whether the settings were baked into the original RED raw files, or if the editing files just got degraded in the transcoding process. Thankfully, we found a friendly color-correction expert on the Warner Brothers lot (fancy!) who took a couple of hours with us, looked carefully at the original footage and declared that we were fine. It was a huge relief!

No matter how reliable you think your post supervisor is, you still need to take responsibility for your workflow yourself. Your post supervisor will not always be there to bail you out of a crunch and hold your hand through a panic attack. No matter how loyal your post supervisors are, they will at some point move on and become unreachable. My post supervisor on *Between Us*, Matt Scott, got an assistant editing job for an IMAX film in the jungles of Madagascar for six months. If you look at a globe, Madagascar is *literally* the farthest possible dry land on earth away from LA. I was on my own whether I liked it or not. If you're tech savvy, you definitely need to be part of the discussion about film formats, resolutions, aspect ratios, frame rates, color space and transcoding. And if you're not tech savvy, then you need to ask questions, research and figure it out for yourself. If you think of yourself as a highfalutin "*actor's* director" who doesn't bother him or herself with trivial technical matters like compression ratios and pixel counts, then you will at some point be a director without a film, just sitting alone in your garage, staring at a hard drive and wondering where to plug it in.

Another more unique approach to the post supervisor position is to make it the same person as your *script* supervisor. When I did a short film version of *Open House* as part of the Seattle International Film Festival's Fly Film Series in 2001, we had two days of prep, two days to shoot and 36 hours to edit a five-minute film (kind of like a souped-up 48-Hour Film Festival). Among the volunteer crew that was assigned to me was a great script supervisor named Mark Bell. I'm not sure that Mark had ever actually been a script supervisor before, but he had very neat handwriting and good attention to detail, the two most important attributes for a scripty. Mark was also a well-rounded filmmaker in his own right and knew his way around an edit room. So, for expediency's sake, he became our de facto assistant editor who knew better than anyone what footage we had from the shoot. This transition from script supervisor to assistant editor worked out so well that I invited Mark to become part of the team in making the feature musical version of *Open House*. On set, Mark was our script supervisor, and back at my house where we were editing, he became our assistant editor and post supervisor. Mark wound up living at my house for five months, and became so intimately intertwined with my family life that when my son was born nine months later, they bore a striking resemblance to one another. Much to the relief of everyone involved, my son looks a lot more like me now!

Teasing Out Your Assistants

One thing I learned with Mark, and also did with our assistant editor (AE), Connie Chuang, on *Between Us*, was to give the AE something fun to do from time to time. The AE job can be a mind-numbing data crunch with occasional breaks for syncing picture and sound. Especially while you're still in production, the AE might be working night shifts so the editor can start with fresh footage in the morning. So once all the drudgery is over, it's nice to assign the assistant the task of cutting an early trailer or teaser. Mind you, this isn't necessarily the kind of trailer that you'll put out on YouTube to promote the film.

What I'm talking about is more akin to a proof-of-life hostage video. It's one that you can show your investors, cast, agents and crew to say, "Hey, look at *this*! We shot some awesome footage, had a ton of fun behind the scenes, and we're cutting away as we speak!" Connie did such an amazing job with the teaser for *Between Us* that our sales reps actually sold the film at the Toronto Film Festival to a foreign sales agent based almost solely on her trailer! Mark Bell had cut an *Open House* trailer right after we wrapped production. Two months later, we screened it during a Slamdance party and raised enough money that night to finish the film. I'm not the only one who's made good use out of these fresh-from-the-can teasers, particularly in Park City: I was inspired by Jamie Babbit, who did a similar thing with footage from her just-wrapped feature *But*

I'm a Cheerleader. She brought a five-minute teaser to Sundance and showed it to acquisitions execs in her condo. By the end of the fest, she had a deal.

The only caveat is to try to get your AE to use original music—or at least royalty-free music—for the teaser. Connie had used an Avril Lavigne song for the teaser she cut together for *Between Us*. It worked great! Too good, even! Because of the music rights, we couldn't use it on our DVD or post it online later to promote the film. For many people, these early teasers are going to be the basis for how you crowdfund your post-production, so think of them as elaborate Kickstarter videos as much as anything else. Make sure you can show it publicly, because if it's good, inevitably you will.

Throughout this entire post process, it's very tempting to treat your AEs like crap. They usually wind up doing the post supervisor's, and often the editor's, work, but they're getting paid like an intern or PA. If you can, give them one or two scenes to edit on their own. The good part of non-linear editing systems is you can always start from scratch and recut the scenes if you'd like. The AEs will walk away from your film with a sense of creative accomplishment, and maybe a little something for their reel. And it pays to stay on their good sides: One of my AEs on *omaha (the movie)*, Moises, became a board member on the International Documentary Association, and he's now an exec at Warner Brothers Television. Another assistant, Kim, wound up living five houses down from me in Culver City, and she and her husband regularly give me a hand on my films. And finally, one assistant, Jon, became a big-shot TV showrunner and a Kickstarter backer on my last film!

Jon Bokenkamp

NAME DROPPER

When I made my first film, *omaha (the movie)* (which counted as my USC grad thesis film), I set a personal goal of using as many local Nebraskans on the cast and crew as I could find. I found out there was a young undergrad at USC from Kearney—a small city in the middle of the state—so I immediately asked him to get involved. But young Jon Bokenkamp was in the middle of his semester when we were shooting, so he made a couple of calls back home on our behalf but couldn't come back to Nebraska for the shoot. Paramount had given us two edit suites on its lot for cutting the film in LA, so Jon *was* able to help out as an AE.

A couple of years later, when Jon had made his own first film, *After Sunset*—a documentary about his love of drive-in theaters—I got him to submit to Slamdance and we screened it in 1996. Jon and I stayed in touch over the years—in part because we were both irregular attendees at Nebraska Coast Connection meetings in LA. Jon became a very

successful screenwriter in LA for a while and also directed his own indie narrative film, *Preston Tylk* (released as *Bad Seed* on DVD in the US). But frustrated with the Hollywood (or in his case, Burbank) lifestyle, Jon and his wife and kids moved back to Kearney. While there, Jon continued writing on such big-budget Halle-Berry-in-peril movies like *Perfect Stranger* and *The Call*. Meanwhile, he developed an interest in renovating the local 1920s-era movie palace in Kearney called The World Theatre. From 2008–12, he spearheaded the restoration of the theater, and made it a national model for small-town, big-screen restoration. It's a beautiful venue, and I screened my film *Between Us* there for my big Kearney premiere.

Jon himself couldn't attend the premiere because he was commuting back to Hollywood: He'd written the pilot and become the showrunner on the hit NBC show, *The Blacklist*. I wound up meeting all of Jon's Kearney buddies at my screening and it's fun seeing their names show up as characters on *The Blacklist* from time to time. A couple of other odd coincidences with the show: Jon's co-showrunner is John Eisendrath—who was one of the first people I met in LA when I went to USC. He'd previously been an editor at *The Washington Monthly* magazine, where I had interned right out of college, and by the time I was making *omaha (the movie)*, Eisendrath was a producer on *Beverly Hills 90210*. I'm pretty sure he even gave me short ends from the show to help us make *omaha (the movie)*. *The Blacklist* pilot was directed by my old pal Joe Carnahan, and the cinematographer was none other than Yasu Tanida, whose first feature credit was my real estate musical *Open House*.

Getting a Little Testy

At some point after you've made it to your first cut, you're going to want to do some kind of test screening. Ideally you can find a screening room and invite at least ten people. Why ten? If you're Jewish, think of it as a minyan. It takes a quorum of ten people to collectively share in a laugh, cry or prayer (if the film is *really* bad, they'll all be praying that it ends soon). Try to mix it up with people who are familiar with the script (like your crew) as well as people who are coming in completely blind to the script and film. Immediately after the screening, have people write down their thoughts. But then also have a lively discussion with them, too.

What you're looking for are consensus concerns—ones that more than a few people are bringing up consistently. Of course, most of those people will have no idea what footage you have and what footage you don't have. Even your own

producers won't always know. So for the most part, don't listen to solutions that people bring up ("ooh, in this scene, you should cut to a crane shot!" or "wow, you should really recast your lead actor"). A test audience is kind of like the parable of the blind people in the room with an elephant, each describing a different part, but none able to identify the elephant. Listen hard for what might be consistent symptoms or problems with the film. But then it'll be up to you and your editor to find the actual solutions.

It's Not Easy Being Green Screened

No matter what genre of film you're making these days, you'll probably need to do some visual effects, and for that, you will quite likely need a visual effects supervisor of some sort. Visual effects are no longer limited to space epics and superhero action movies. If you're making a period western, you may well need to paint out cell-phone towers from a beautiful landscape shot. If you're doing a tense drama, you might have to remove a boom shadow from the background. Doing an artsy 1960s flashback where you want to add grain, flares and frame stutter? Those may all be the job of the visual effects supervisor.

Ideally, if you know you're going to have any VFX, you'll want to find your effects supervisor early in pre-production. On *Between Us*, we found this great guy named Ryan Urban who'd worked on big-budget studio films like *Gulliver's Travels* and *The Avengers*. But like a lot of effects guys (and yes, they do tend to be guys) he was usually working as a mind-numbing compositor on a team of hundreds or thousands of people. For most of these very talented artists, they would kill to be the lead visual effects supervisor on a small indie—if nothing else, just to get them out of their cubicle for a few hours. Usually they can keep their day job, and happily help out their indie friends at night.

We brought Ryan in on pre-production because we knew we had a couple of short, but tricky, effects/stunt sequences, most notably a series of shots where one of our actors would throw a decanter of wine at a plasma-screen TV. For what wound up being just a three-second sequence, it turned into a complicated mix of props, pre-recorded material on the screen, splashing jello and broken glass on the set, giant pieces of Plexiglas, animated cracking and sparks, keystoning images, and compositing in water balloons filled with cranberry juice exploding onto dental floss. Even before we hired Ryan, we needed a simple animated pre-vis sequence to start to figure out which elements we needed to shoot live, which ones needed to be shot prior to productions and what we'd add in post. No one on my pre-production crew knew how to do pre-vis, but my 12-year-old daughter had just taken an animation class, and whipped something together in two hours using a free online program called Stykz.

Even if you can't find a "real" visual effects supervisor, you may still want to assign that role to one of your crew members, just so you've got one person

thinking through some of this stuff (maybe your post supervisor, maybe an AE or someone in your art department). It's not always rocket science, and some things take pre-planning, while other things don't. In one transition scene, we needed to push the camera "through" a TV screen in the background. So, Ryan was on set putting little tracking X's all over the set. It didn't take long, and it was virtually free, but it did take some level of forethought to figure out how the effect could be achieved easily in post. There was one shot where we wanted to add a few wisps of falling snow. I suppose we could have dropped potato flakes in front of the camera, but we only thought of it after the fact. One night of work from Ryan in post, and it was done digitally, and I could dial in exactly the level I wanted!

Sometimes in the modern post workflow, it's hard to tell exactly what's "visual effects" compared to what can and should be done in the color correction process or the onlining stage. On *Between Us*, this was always a source of some confusion for me. I'm pretty good at figuring out how to manipulate most basic effects while I'm safely in the realm of FCP. If I wanted to slow down an image, resize it or even do simple compositing I could usually muscle through a way to do it on my laptop—at least well enough to show the pros as a reference. Knowing which pro to show it to was sometimes the challenge. When every facility and person is bending over backwards for you for free or reduced prices, sometimes it's not as much a technical question as it is a political one.

On *Between Us*, for example, we were editing in Final Cut Pro 7 using the ProRes codec. ProRes is great for editing, and if you're finishing your short film for web purposes or even most festivals, it's fine, too. But if you go to the trouble of shooting 4K on your feature (or higher res), even if you're finishing on 2K (as we were), then at some point, you need to go back to your original raw files and put the film back together. In our case, the color correction facility (The Mill)

Shot with a blank screen on set, we added the New York shot in post-production
Courtesy: Bugeater Films

was the one stitching the film back together from the original files right before we went into the color correction sessions. That meant that in addition to actual color timing, the colorist (Greg Reese) was also doing all the in-frame movements that I had planned on the Final Cut version. Unfortunately, The Mill's system couldn't automatically read all my little movement and zoom settings from FCP. So I had to sit with my laptop and hard drives next to the colorist and call out percentages and inflection frame references throughout the sessions: "Start zoomed in 30 percent, hold that to the 543rd frame, then slowly push in to 43 percent by the last frame of the cut." Hopefully on my next film, I'll have a post supervisor who isn't in the middle of a jungle in Madagascar—there's *got* to be an easier way!

It's certainly true that modern color correction software and hardware is a joy to behold, with virtually limitless possibilities. Well, until you find that there *are* limits and you should have shot something differently to begin with. There's one flashback scene in *Between Us* set in a bar. Our two 40ish actors are supposed to look like young grad students. The plan was to shoot them in silhouette. The plan failed, and all their wrinkles wound up being perfectly lit. No amount of color correction can put someone in silhouette if they weren't shot that way to begin with. The colorist Greg, my DP Nancy and I wracked our brains trying different settings to make the scene work. We tried "digital botox"—essentially using "power windows" to digitally smudge out the wrinkles. But it *looked* like bad digital smudging and would have been too labor intensive for Greg to have done the whole scene even if it was working.

I came up with the idea of obscuring the actors' faces with artificial flares and a subtle film look—as if they'd been shot on 16mm film. I tried it on my laptop in FCP, and within a couple of hours had a working mockup that looked pretty decent. Well, it turned out that The Mill's color correction system couldn't put on artificial flares. They probably had some other people in the building with cool workstations who could have done it easily, but we had already well overstayed our welcome there and weren't in a position to ask for any more favors. (And yes, I did bring them donuts, too.) So, it became a "visual effects" issue. I turned to Ryan who was able to use his own computer to create the flares. Once he'd done that, we brought the footage back to The Mill. Finally, after color correcting was done, the whole film went to another post house called Union that broadly speaking was doing our final online (combining sound and picture). They were able to add the subtle film look for that scene and do a few other odd tricks to the rest of the film, like some slow motion, and then adding the credits. Of course, the credits themselves were generated by a Kuwaiti FX guy I'd met through Facebook who'd just immigrated from England, and was working out of his house in Topanga Canyon.

Sound and Fury

Two other big things to think about in post-production are sound and music. Most filmmakers will probably consider these as two separate elements. Traditionally that's how they've been treated since 1927, when *The Jazz Singer* broke box office records and ushered in the talkies. Normally, after you've locked picture, you find a composer who writes and records music for your film. Meanwhile, you get a dialogue editor who works strictly on the dialogue, an effects editor who might handle sound effects and ambient backgrounds, a foley artist and foley mixer putting in coconut footsteps and ribeye punches, and then a music editor who cuts in the music provided by your composer. Finally, a mixer will put all those tracks together, and voila! You have your movie! The only problem with this traditional approach is that you have a lot of disparate elements going into your sound mix with not much of a cohesive vision beyond what the director might tell each one of them individually. It's the aural equivalent of not having a DP, and then having the focus puller, the dolly grip and the gaffer all working independently, and frequently at cross purposes to one another. You wouldn't decentralize your picture quality that way, why would you treat your sound any differently?

The Breakfast (Nook) Club

Since learning in film school about the pioneering work that Walter Murch did with Francis Ford Coppola (*Apocalypse Now*) and George Lucas (*THX 1138*), I've always been intrigued by the concept of the "sound designer"— a front credit title essentially created for guys like Murch, Ben Burtt and Gary Rydstrom who really get involved with *all* aspects of sound, and frequently before the film's even been shot. Ironically, such a sound designer position is usually only used on either the highest-budget auteur-driven films worked on at Skywalker Ranch, or on the lowest-budget films, when you're hiring your neighbor with Pro Tools in his breakfast nook to do everything from composing to final mix. But most films in between wind up using freelance composers, and either freelance sound post people or a sound house that's little more than an amalgam of staffers all working in separate booths.

On *Between Us*, I was lucky enough to find two partners, Tobias Enhus and H. Scott Salinas, who were not only very talented composers, each in his own right, but also fully fledged sound designers. In addition to composing and performing the music, they were in charge of hiring the dialogue and other sound editors and then they also were the ones who did the final sound mix. Why was this good? It's simple and subtle things like the sound of a bus going by on a city street being in the same key as the music that's starting to swell in the background. You can really only plan and execute those things when you've got the composers intimately involved with the sound design.

Electric cellist
Michael Fitzpatrick
with composers
Tobias Enhus and
H. Scott Salinas

Photo: Dan Mirvish

Mind you, the savvy director still has to stay on top of a sound designer or sound house. I sat in with the dialogue cutter, I helped do some of the footsteps in foley and I even played the very last guitar note on the music track to get the harmonics just the way I wanted them (that's how obsessed I was about sticking my landing). By and large, I had a great time working with Tobias (a mad Swede who likes to invent instruments) and Scott (who lived a quick bike ride away from me). Keep in mind what invariably happens with working composers, sound houses and post houses is that you'll be all ready to start working with them in November, and they'll get swamped by Sundance filmmakers cramming to get their films done in time. Let those other guys rush it—just be patient and start your post in February if you must.

When you're working on your sound, make sure you prepare your tracks so that you can do a "music and effects" (M&E) mix. If and when you sell your film internationally, you'll be required to have an M&E mix which basically is the entire sound (music, sound effects, foley and ambient tracks) minus the dialogue tracks. That way, a German or Turkish or Brazilian distributor can dub in German or Turkish or Portuguese dialogue performed by local actors. It usually doesn't cost a lot more to do an M&E mix, but it does require more forethought when you and your editor and sound team are organizing your tracks and stems. It also means that even if you've got great footsteps or other on-set sound that was picked up by your boom or lav mics along with dialogue,

Remember, it's easier to edit music out than add more at the last moment
Illustration: Miriam Mirvish

you still need to do a full foley pass on *all* your footsteps. Otherwise, your German version will wind up sounding like everyone is walking around in socks. Or worse, the German distributor will simply reject your film for not being technically up to snuff (the Germans are notorious for rejecting films for arcane technical reasons).

Temp Decomposing

One warning about music: You and/or your editor will inevitably succumb to the temptation of falling in love with your temp music while you're cutting the film. It happens to every filmmaker. Your segue-chase-on-ice action sequence will be *amazing* with the throbbing James Horner score from *Patriot Games*! But then you can only afford your buddy with the Pro Tools breakfast nook and his sister, the ukulele player. Your disappointment will be brutal. Better to start with temp music that is at least going to match the instrumentation, breadth and tone of what you'll actually wind up using. If you haven't already chosen your composer before you've started editing, then get tracks from composers you're considering and plug those in as temp music. The final melodies may be different, but you'll get a good sense of which composer's going to feel right for you. There will be other considerations in picking a composer, too; namely cost, physical proximity and the extent to which they have relationships with studios, musicians and sound houses. On *Between Us*, there was one great composer I was talking to, but he was based in New York, and for me, I like to work in the same room as my composers, so I chose the guys who were biking distance from my house.

If you really are desperate for cheap, original, royalty-free music, then there are a few other solutions. For one, you should learn GarageBand on your Mac. If you use Apple's official loops (and of course, whatever other original keyboard tinklings or noodlings you put in), you become the official composer of record for the final song! Not Apple, not anyone else. That means no music contracts,

master use or sync licenses. Even if you have no abilities at all, GarageBand is simple enough that even my daughter at six years old could figure it out. Unless you are an accomplished musician, I wouldn't try to score your entire feature this way. But if you've got a short-form project like a webseries, short film or even your Kickstarter campaign video, then a GarageBand track is perfectly acceptable.

Even best-selling author Malcolm "Big Hair" Gladwell used GarageBand loops for the book trailer for his best-seller *Outliers*. (When my buddy Eitan and I did the book trailer for *I Am Martin Eisenstadt*, we parodied Gladwell's video and even used the exact same GarageBand loops for our music.) If you're doing anything that's going to wind up on YouTube—especially if you hope to make ad revenue from it—you'll need some kind of original music. Otherwise YouTube will automatically siphon off some of your revenue to pay for the music, or ban you completely—depending on what the musician has worked out with YouTube (see "Aarghh! How to Beat Film Pirates at their Own Game" on page 178). Other sources of royalty-free music include mobygratis (with cool tracks from the artist Moby, but only for non-commercial films), and less-famous artists like my pal, composer Ken Elkinson (through his site solxis.com), who also have music available for free.

Song Sung Blue

The other way to go with music is to use existing songs for your film. A soundtrack-heavy film can work out as beautifully as the Cat Stevens songs in *Harold and Maude*, or the Simon and Garfunkel-driven soundtrack to *The Graduate*. Then again, it could also be as unmemorable as the 1980s-driven soundtrack to *Grownups* featuring lesser-known Journey songs slapped over the hi-jinx-prone Adam Sandler and friends.

My advice? Avoid soundtrack songs! For one thing, they're expensive. Music rights for films don't come cheap, or easy. You need to get two kinds of rights on each piece of music: "Master use" for the specific recording, and "sync" for the publishing rights. Because of piracy, one of the only ways musicians (and their publishing companies) can make money is by selling their rights, and I empathize with them. But even before piracy was an issue, publishers were gouging filmmakers. On *omaha (the movie)* I thought it'd be neat if we filled our soundtrack with artists exclusively from Nebraska. I got a whole bunch of bands and singers to contribute their songs on a "favored nations" basis (all got treated the same on a per-second rate—free for festival use, and a nominal amount if we ever got third-party distribution). Even the successful Omaha-based band 311 was cool, offering to compose the entire soundtrack live in one weed-filled sitting. I politely declined, but we did use a couple of their tracks in the film.

Then there was Matthew Sweet—at the time probably the best-known singer-songwriter from Nebraska. My producing partner Dana Altman and I met up with Matthew after a show at the Ranch Bowl in Omaha. We talked to him about using one song in our closing end credits. Matthew was very cool and said sure. His manager was very cool and said sure. Even his label, which controlled the master use rights, were very cool and they said sure! So, we edited the song into our music tracks and we were heading into our final mix at a small facility in Burbank. We got a deal on the place because they were using us to test out the wiring on the used mix board they'd just acquired—a board famous for being the one that Michael Jackson's *Thriller* was mixed on!

At the last possible moment, we got a call from Matthew Sweet's *publisher*. It was EMI, one of the largest music companies in the world, and they owned the crucial sync rights to the song. They said they wouldn't even talk to us for less than $10,000. "We own Matthew," they said bluntly. As is often the case with pop artists, the publishers give the musicians fat signing advances and then they literally own everything they have written, and often everything they *will* write in the future. Even if Sweet had written something new for the movie, EMI told us, they would have controlled the rights. I didn't even need the back of a napkin to do the math: Were we going to make $10,000 in net profits just because we used one Matthew Sweet song in the end credits? Nope; not ever. So we cut the song out, and replaced it with the official (royalty-free) city song of Omaha as sung by my old friend Phil Berman and his band Ben Zona. Luckily, we had that song ready to go as the second song in the end credits, so

Final mix on *Between Us*
Photo: Dan Mirvish

we moved it forward and used parts of our original score to fill out the rest of the end credits.

The other reason to avoid soundtrack songs is a matter of clarity. If the audience is listening to dialogue and all of a sudden you give them song lyrics to listen to, they will be confused: Are they supposed to be getting narrative information from the lyrics or from the dialogue? It splits the focus and dilutes your intent. So my philosophy is if I'm going to use music over dialogue, it shouldn't have English lyrics. Preferably it should be strictly instrumental, or if I must have human voices, I'm sure they're sung in another language, hummed, whistled, Tuvan throat sung, or otherwise vocalized.

If you do decide to use songs in your film it might be a very good idea to get a music supervisor. Good music supervisors will have encyclopedic knowledge of every band under the sun. They will already have relationships with artists, managers, labels and publishers and will steer you clear of the ones you can't afford. They'll handle the paperwork (and there is a *lot* of paperwork) and facilitate the rights contracts and cue sheets. Oh, and if you really *have* fallen in love with your temp music, it's possible that your music supervisor can reach out to that band's people and maybe, just maybe, get you the song. On *omaha (the movie)* we were using temp music from an Australian world beat ensemble called Outback. By sheer luck, we met a music supervisor in LA who personally knew the publisher and they let us use the music, no problem. Our composers assembled our own similar didgeridoo-based ensemble for our composed tracks, and the full soundtrack melded seamlessly.

Music and sound can be very expensive—sometimes the most expensive elements of your whole film. And they usually come along when you've spent all your money. If, at the end of the day, you can find that one person working out of a breakfast nook to do all your music and sound and you think he or she will do a good job, then go for it. But until then, just make sure that you and your film editor are focused on sound while you're still cutting picture; separating tracks, cleaning up dialogue when you can. The closer you are to having a presentable cut of your film, the more likely you are to attract top notch postproduction sound people who might give you a deal. You'll be able to use that temp sound on a finished cut to find additional investors, and you can use that cut to get into a top film festival early (which will give you momentum to raise more money).

If it takes a village to complete your post-production, then try not to be the village idiot who can't figure it all out. Take your time, ask for help, don't spend more than you have and try to keep track of everything yourself. One way or another you'll finish your film.

Festing in Style

Toronto, Toschmonto: Time for a Festival Plan "B"

Once you have finished your film (or at least, one version of your film), you will most likely want to start submitting it to the big A-list film festivals (Cannes, Berlin, Toronto, Telluride, Venice, Sundance) because, well, isn't that what you're supposed to do? For many films that finish post-production in the spring or early summer, the obvious place to start would be to apply to the venerated Toronto International Film Festival (TIFF) which takes place every September. You pay the entry fee to Toronto and the other big fall festivals, you sit back and wait, and then, if you're lucky, you get a rejection letter.

OK, so you didn't get into Toronto and you're crushed. Guess what? You also didn't get into Telluride, Venice or the New York Film Festival either. But I've got news for you: You probably didn't stand a chance with any of those festivals anyway. It's not you, it's them. Don't get me wrong: They're all perfectly good festivals run by nice—frequently Canadian—people. The problem is that the so-called Big Four of the Fall Fests don't cater to small independent films. Toronto did, for a while anyway, but in the last few years, they've found their niche as a pre-Oscar launchpad for studio and big-budget not-so-indie films. Good for them, but bad for the quintessential American indie that desperately wanted to get in. So where does that leave you? Crying in your ramen and cursing those toque-wearing, maple-lickers to the north. Fine. But now it's time to dust yourself off and move on to Plan B.

It's Just as Well. Your Film Wasn't Finished!

Movies aren't finished anymore; they're simply "output." Back in the days of actual "film," you were done when the negative was cut and the lab made an answer print and you could sneak it out without paying. And then your film was *really* done. After that stage, it was too much of a hassle and cost to change anything. But now, just because you submitted an output to a festival doesn't

mean you have to stop editing, or doing sound or music. The worst thing film-makers can do is rush their post-production (or worse, their production) just to meet some arbitrary festival deadline. In 20 years, this will still be *your* film and you'd better be happy with it. Don't rush anything just to satisfy any festival programmer who may or may not like it anyway. Yes, these deadlines are slightly useful in pushing yourself and your editors, sound team and composer toward the finish line (since by now, you're out of money anyway, you need *some*thing to motivate them). But take your time. Plug those hard drives back in and keep cutting. When your hard drive finally crashes, for the last time, *then* you're done.

It's All About Sundance Anyway!

Screw Toronto, you really wanted to premiere at Sundance! So you'll spiff up your "Toronto" version and output your "Sundance" version and send that in, and wait another three months. Oh, and maybe make a second copy, scribble out the "u" and the "n" and send one in to Slamdance, too. Well, yes, you should do that. Your investors, or even your mother, will all expect you (and even pay for the entry fees for you) to go to Park City. And yes, both Sundance and Slamdance show way more American indies than the Big Four Fall Fests do combined. But guess what? Everyone else is submitting to them, too!! So statistically speaking, you probably won't get in. And if you do, then consider it a happy ending, not a *fait accompli*. I don't care whether your film spent five years going through the Sundance lab, or your producer co-founded

Pimpin' in Park City with filmmaker Roger Mayer

Photo: Andrew Edison

Slamdance—there are no guarantees when it comes to Park City. Come up with Plan C now. As soon as you submit your Park City output, get back in that edit room and start working on your next version. And if on the off chance you are reasonably happy with your film, then submit *early* to both Sundance AND Slamdance.

I've been involved with Slamdance for well over 20 years, and I'm still stunned by how many people think they can wait for their Sundance rejection notice to submit to Slamdance. You can't. It's too late then. You know when Christopher Nolan submitted *Following* to Slamdance even though the deadline was in September? In May (of 1998, to be exact)! And that was after having gotten rejected the year before. Those are good lessons for everyone for most festivals: Submit early; submit often; and don't be afraid to submit the next year. I'm always shocked when I hear people say they're shooting in September and still expect to get into Sundance. Fat chance, sucka! (And then I'm shocked again when some do get in.)

So then you move on to Plan C, D and E (aka SXSW, Tribeca and the Los Angeles Film Festivals, all salivating for your world premiere). The next thing you know, a year has gone by and you've got nothing to show for it, but a dozen FCP project files with different festival versions in the name. Your investors are banging on your door, and your mother won't answer hers.

Let's back up and think for a minute . . . what exactly is your goal for all these festivals?

To Get Distribution!

The odds of getting distribution *solely* because you get into one of these festivals is slim to not much. But that's probably because you still think the brass ring is Harvey Weinstein outbidding Sony Picture Classics' Michael Barker in the lobby of the Eccles Theatre at Sundance. Well, it is, but as über indie lawyer John Sloss put it, "I used to say the odds of getting distribution were 1%, but now it's 100%. It's just that the definition of 'distribution' has changed." He's right. One way or another, you can still get your film seen by people through some combination of third-party distribution, aggregation and self-distribution, with people seeing it via theatrical, VOD or streaming.

So, the question becomes, are festivals a necessary element to getting distribution? Well, they're nice, but they're not essential. There's still nothing better for getting distribution than winning Sundance, but the odds of that haven't changed in 20 years. But there are a lot more ways to skin the cat now: Set up a distributor screening, get a producers' rep, send out screeners to distributors directly, etc. Now, you still may need some kind of a hook to get distributors or reps to take the film seriously (i.e. name actors, critical attention, festival awards, public controversy), but those don't have to be from an A, or even an

A– festival. Honestly, there aren't a lot of big deals getting made at any festivals outside of Park City. But that doesn't mean there still aren't plenty of good reasons to go to lots of other festivals.

Producer's Reps vs. Foreign Sales Agents

For American indie films, a "producer's rep" usually means a person, company or agency that represents the film itself (as opposed to the director or the producer) and tries to find the film a distributor. First and foremost, this usually means a domestic (aka North American) distributor. But the producer's rep might also be tasked with selling international rights directly to foreign buyers. More likely, though, that is the job of the film's "foreign sales company" or "foreign sales agent." Sometimes the producer's rep will help find you a foreign sales company, but in other cases, the foreign sales company may come on board first (for bigger indies, the foreign sales company might help you finance the movie with pre-sales or estimates if you have a big-name cast). If producers' reps get involved early with films, they might also be helpful in getting them into major festivals. But don't count on it. Remember, they also rep a number of other films, so prior to and during the festivals, they will have conflicted interests. Their tendency is also to pick up a film right before it goes to a big festival, and if it gets good buzz, they might sell it. But if it doesn't get attention and they can't sell it, they'll effectively ignore the film after the festival. Try to pick reps that will stick with the film beyond your first festival.

Most of the big Hollywood agencies have small indie film departments, where they both act as producers' reps, and also *claim* to be able to raise money for films before they're made. Honestly, though, they tend to be more effective as producer's reps than they are at securing financing. In addition to the likes of CAA, UTA, WME, ICM, Gersh and Paradigm, there are also some very good non-agency producers' reps like Cinetic (John Sloss' company) and Submarine in New York, and Circus Road and XYZ Films in LA. There are also a few individual producers' reps, most infamously Jeff "The Dude" Dowd who was the inspiration for the Coen Brothers' *The Big Lebowski* character. The bigger agencies won't usually charge up front, but will take as much as a 10 percent commission. Smaller companies and individuals may ask for $5–10,000 upfront, and depending on that rep's track record, it might be worth it. No matter whom you pick, do your due diligence, and talk to both recent clients as well as acquisitions execs, if you know any. Even if you pick an otherwise

respectable agency or rep, keep an eye on their own expenses and commission checks. A big Hollywood agency that was repping one of my films charged me $800 for screening the film to distributors in its own screening room. A few years later, the same agency sent me a check in which it had deducted a whopping 76 percent commission. It was vaguely premised on what our distributor *would* have paid us had they not first paid our residuals (residuals that mostly went to that agency's own actor clients). Foreign sales companies are especially known for inflating their own "marketing" expenses, which often includes the tab at the Petit Carlton bar in Cannes, so make sure your contract has appropriate limits in place.

If you are an American filmmaker and you're considering foreign sales companies, be sure to find out if they have relationships with international film festivals, especially if you're talking to them at the beginning of your fest run. Some companies do, some don't. International festivals have a much stronger tradition of being influenced by foreign sales companies than US festivals do. Likewise, international filmmakers often rely almost solely on their home countries' foreign sales companies to apply to international festivals. Unfortunately, most of those companies have neither the time nor interest in applying to some really awesome festivals, especially in the US, including Sundance! The reason for that is that most US festivals don't pay screening fees: They may be a lot of fun for the filmmakers, but for the foreign sales companies repping the film, they're money-losers. For example, a foreign sales company repping an Israeli film would rather get it booked on the Israeli and Jewish film festival circuit in the US (which tends to pay screening fees) rather than submit to Slamdance or Tribeca. So if you're an international filmmaker, just take matters into your own hands and start submitting the film yourself!

Don't Buy Into the Premiere Arms Race

Even before you hear back from Sundance, you will undoubtedly start submitting to SXSW, Tribeca and LA. And all three will tell you in no uncertain terms that they really, really just want premieres. F'real? They're all nice festivals (you'll meet other filmmakers, you'll get good local press and a little industry attention) but none of them get much of an audience beyond their local base. That means you're now waiting almost a full year from finishing your film to showing it. And for what? So an audience member in New York, who's never set foot in Austin, can be the first person to see your film? After being in this festival world for 20-plus years, I'm still dumbfounded and disturbed by

this escalation of the premiere arms race. Whatever happened to giving momentum to films that play at multiple fests? So, screw 'em. You should use their premiere paranoia to your advantage.

Play Them Off Against Each Other

OK, if that's how they're going to set the rules of the game, then you just need to play it better than they do. Use your festival virginity to the best of your ability—it's your one ace in the hole. Play the festivals off against each other: If they want your premiere, then they need to give you a quick answer. And if they say yes, see if you can get a better offer from the next festival. And if you're a true festival Jedi master, you can find a way to play both anyway. I pulled that off with *Between Us*, doing a "double North American premiere," first at the Hamptons and again at Woodstock a week later. If nothing else, playing these games gets the festival programmers to take your film seriously and brings your film to the top of their piles. The next best thing to a "yes" is a quick "no" so you can move on without uncertainty.

Volume, Volume, Volume

If you're not getting into the top tier festivals (and even if you are, but don't wind up with a deal or award right away), I'm a big believer in a quantity-based festival strategy. With *Between Us*, we played in 23 festivals in seven countries, winning awards at a couple. That sounds impressive, right? Because it is. Not that many films pull that off these days. And it will continue to sound impressive to distributors, press, audiences and your own investors. What multiple festival dates give you is the intangible sense of momentum that you don't get even from a single A-list festival appearance.

There are thousands of festivals around the world, and it's doing yourself a disservice by just applying to the top dozen or so. OK, but with so many festivals to choose from, where does the struggling filmmaker start?

Pick a season and go for it: Spring fests? Try Atlanta, Sarasota, Dallas or Omaha! Fall? Oldenburg, Woodstock or Napa Valley. Just think six months in advance and work from there. Don't wait until you've gotten rejected from the biggies. The best way to narrow your search is to focus on what your goals are from the festival circuit.

Get Reviews

Need to start building your press kit with blurbs? Then regional and international festivals are a great way to get reviews. If they're good, then you milk them for pull-quotes for your poster, press kit and website. And if they're bad

(unlike, say, a *Variety* review in Park City), no one has to know that you got them. With social media the way it is, you can pimp a great interview from a local blog or TV station through YouTube, Facebook or Twitter and get it seen by as many people as you want—frequently more than during a busy festival like Sundance, where the signal-to-noise ratio buries you in the static. Work with the festival press office to let them know you (and your team) are prepared and available for any and all interviews and photo ops.

Meet Your Audience

With all these wonderful "distribution" options these days, chances are good that you will not get a life-affirming theatrical release. Even if you do, you'll be lucky if a dozen people show up at any given screening. If you want the unique experience of seeing your film with an appreciative audience, who are then eager to hear you at a Q&A, then the festival experience is the only way you'll get that. Even if you have a 3,000-screen studio release, at most you'll only be meaningfully in theaters for a couple weeks. If you made a comedy, there's no better feeling than seeing an audience laugh. If you made a horror movie, there's nothing better than seeing them shriek. This is a big part of why we all make movies. So have fun with it and go to where the audiences are.

See the World!

Most people work to get money to go on vacations to see the world. If you made a movie, chances are you didn't get paid. But that doesn't mean you can't skip ahead to the vacations-around-the-world part of the great American dream. It's no coincidence that Sundance is held in one of the best ski resorts in the US. A lot of festivals are held in really nice places around the world. Always wanted to visit the Parthenon? Then apply to the Athens Film Festival! Want to ski in an Olympic-caliber ski resort in North America? Then screw Park City and head straight to the Whistler Film Festival in Canada. Beaches your thing? Then try the Bahamas International Film Festival! If you made a feature, many festivals will fly you there. And almost all will at least put you up; if not in a hotel, then on some hot volunteer's couch. You could do worse!

They're "Romantic"

I remember hearing Kevin Smith talk at the 1994 Independent Feature Film Market, some nine months after he premiered at Sundance: "On the festival circuit, even I can get laid." He's right. If you're a pasty-faced filmmaker who's been bivouacked in your Williamsburg loft subsisting on LaCie drives and

melba toast for the last two years, then chances are you don't have a significant other anymore. You need to get out there. Seriously.

Festivals are filled with young, eager volunteers looking for inspiration from the next Kevin Smith. Many of them are "actresses" or "actors" eager to meet "directors" or "producers" and won't at all mind a little "air-quoting" at the closing night afterparty. If you're happily married, festivals are a great place to wine and dine your spouse, without pesky children interrupting. If you're unhappily married, they're a great place to start over. In short, festivals are romantic. In our second year of Slamdance, two volunteer filmmakers conceived a baby who is now old enough to legally drink alcohol even in the state of Utah. We've had countless filmmakers find their future spouses at Slamdance (and a few who've lost them). We even had a director propose to his girlfriend *during* his Q&A! Both romantic *and* a brilliant PR ploy. Mazel tov, Joey and Kendall!

Meet New Money

You probably won't ever pay back your investors, so if you have any hope of making another film, you're going to need new sources of financing. Think about it: Who goes to film festivals? Rich people, that's who. If society couples can throw festival parties in their mansions, they can certainly invest in a film or donate to a Kickstarter campaign. They're also easily impressed by young, shiny filmmakers who remind them of how their own kids have disappointed them. These are your new best friends. There are even some festivals that go out of their way to assign wealthy "hosts" to visiting filmmakers. And if you're *really* lucky, you may even find romance with one of those young divorcees, widowers or heiresses.

Get DVD Extras

Just because your movie is done doesn't mean you have to stop shooting EPK material. Festivals are a great opportunity to keep shooting video about your ongoing film journey. Use those videos to keep your crowdfunders and investors up-to-date and vicariously sharing in your world-hopping adventures. The potential for added content is enormous. In 2005, filmmakers Susan Buice and Arin Crumley chronicled their festival adventures in amazingly complex and elaborate videos that essentially were a continuation of their self-referential film *Four-Eyed Monsters*. In doing so, they created the medium of video-blogging and got tons of additional press for becoming the first vloggers on iTunes.

For *Open House*, I recorded our various escapades on the festival circuit, including making finger-sandwiches at all our screenings. I also filmed bizarre encounters like Sally Kellerman's impromptu reunion with former presidential candidate George McGovern at the Hamptons Film Festival. Sally had

Sally Kellerman with George McGovern
Photo: Dan Mirvish

campaigned for McGovern's 1972 campaign at rallies with Warren Beatty and other celebrities, and McGovern remembered her quite fondly. At our out-of-competition screening at Slamdance, I filmed the audience in infrared video, and used the audio track as a bonus "Slamdance-a-Rama" soundtrack for our DVD—in essence, a glorified optional laugh track. While jurying at a festival in Santiago, Chile, in 1999, I made a point of going to a protest that turned into a bloody riot. I filmed myself amid the Molotov cocktails and tear-gas, and wound up selling the footage when I got back home.

At Slamdance 2015, James Franco did an hour-long coffee-talk session with filmmakers, in support of *Yosemite*, the film he starred in and executive produced. When director Gabrielle Demeestere needed bonus material for her DVD release, she was able to get Slamdance's official video footage of the coffee-talk! But don't count on festivals to shoot your panel discussions, Q&As, intros or red-carpet appearances: Make sure you bring an accomplice, or enlist one on the spot, to film yourself and your team up on stage.

Meet Other Filmmakers

This is probably the most important reason to go to film festivals that you will not realize until after you've gone to film festivals. You've spent years asking every one of your friends for money or favors, and chances are you don't have many friends left. There's no better place than a film festival to make new ones! You'll retell war stories, compare cameras and lenses, bemoan actors and agents, warn each other about distributors, and dream up future collaborations. The good festivals know how to put all the filmmakers in one place, goose them

Oscar nominee Bill Plympton (center, standing) joins us at the Slamdance Hot Tub Summit

Photo: Jason McLagan

up with alcohol and snacks, and let the friendships blossom. The better festivals stir the pot with jurors, honored guests and special events. In the Bahamas it was filmmaker paintball on a deserted island, and a festival shuttle on a Heineken party bus. In Oldenberg in Northern Germany, it's all-night parties at a fire station, and screenings in a prison. In Napa Valley, it's wine tasting and Maserati test drives (preferably not at the same time). And at Slamdance, I'm quite proud of our annual Hot Tub Summit, the wettest panel discussion in Park City.

The festival circuit is not just a means to an end. If you think it is, you'll forget to have fun along the way. You're stressed out enough making your movie, now's the time to enjoy yourself. So remember to have fun!

How to Avoid Going Broke Applying to Film Festivals

Wow, you might be thinking, film festivals sound awesome! Just try to get your film into as many festivals as you can, and build momentum from one to the next. Unfortunately, most of these festivals have entry fees ranging from $50–100, plus postage. And to get into 20 festivals, you might need to apply to 50 or 100. If you're a broke filmmaker, how can you possibly afford to apply to so many festivals? Chances are you budgeted some money for festival applications, and then promptly spent that money during production as part of your contingency. So here are a few more steps to help you save money.

Putting the Festiv Back Into Festival

*Slamdance Opening Night Poem 2013, while I
was in the midst of my* Between Us *festival tour.
Everything in this poem really happened to me.*

So, one day at the Hamptons, just was past Labor
 Day
I'm not wearing white, just very light grey

I talk to a critic, From the Wire that's Indie
Forehead unadorned, no trace of a bindi
He said how goes it Dan, you got a new flick?
Of course, yes I do, I just finished my pic!

North American premiering, at the Hamptons
 tonight
I just met Alec Baldwin, and now we are tight
Really? he said, You're not at Toronto?
Nope, I said proudly, and then I said pronto

I world preem'd in Germany, just a week ago
In Oldenburg, you really should go
Why'd you go there? He said with a snort,
Why not choose Venice? As if to retort

Or why not just wait, for Sundance or SouthwestBy
Or wait 9 more months for the Beca that is Tri?
I explained that I finished my film on a Thursday
I then went to Europe and screened it on Friday

From Germany I flew, AirChina to Greece
I screened in Athens, I said with caprice
To 700 people, I'm festing with skill, man!
I saw the Parthenon, with director Whit Stillman

And from there to the Hamptons, then crossing
 New York
Woodstock a week later, is that crazy like Björk?
A movie rarely plays both, I said with aplomb
The film must not suck, or be a stink bomb

And then on to Memphis, the same time as
 Virginia
Two states in one weekend? I'm a festival ninja!
And I sat on a plane with a doc Oscar winner
I saw Woodward and Bernstein, and ate BBQ
 dinner

Then at Napa Valley, where the biggest names
 cater
I drank wine and ate food, made from rabbit and
 gator
To St. Louis I traveled, where I went to college
They put me on the jury, 'cause they thought I
 had knowledge

From there on to Spain, in Gijon in the north
Their 50th festival, they said to come forth
I met filmmakers from Ecuador, Korea and Serbia
A Russian, a Greek and from Tehran's suburbia

Be Selective

Yes, there are thousands of festivals around the world, but do your homework. If you see a festival that sounds nice, see what films they showed the year before. Would your film fit into its program? If it's a Gay Cuban Festival that only shows Caribbean films in Spanish, and you have an Arabic-language Israeli Vampire epic, then you should probably pick a different festival. Dig deeper. Track down some filmmakers who attended the year before and ask them what they thought of the festival, and also if they have a contact for the head programmer. Withoutabox and FilmFreeway (the two dominant festival application portals) can be helpful in narrowing down your festivals and good for deadline reminders, but they're the tip of the iceberg: Don't count on them solely.

Make a Personal Connection to the Festival Programmer

Try to figure out who the main festival programmer is. Sometimes it's the "artistic director," sometimes a "senior programmer"— the titles are different for every festival. Read their websites and look at their press releases. All top festival programmers have egos that get fulfilled by putting themselves in their own press releases. So that's usually the best way to find out who's really calling the shots. Then try to track down their personal emails, not just the "info@suchandsuchfestival.com" on the contact page. Or call them. Or find them on Facebook or Twitter and send a message that way (and try not to give the impression you're stalking them). It really doesn't matter *what* you say as much as that you establish a personal rapport and that they remember your name, and the name of your film. (Oh, and if you're looking for a personal connection at

Slamdance, it's not me: I'm not involved in programming any more.)

Offer Your Premiere Status

Ask them if your movie is right for them. You may already know the answer to this (see "Be Selective"), but they don't know you know. So ask. Keep it short and direct: A one-sentence logline, names of fancy actors if you've got 'em, and what your premiere status is. Remember, all festival directors love to play premieres, so even if you don't have a famous cast, it will get their attention if you offer them your World Premiere. And if you've already had your world premiere, then offer your International Premiere, North American Premiere, Iberian Premiere, Canadian Premiere or Dakota Premiere. If every festival screening isn't some kind of "premiere," then you're just not creative enough. Virginity is relative when it comes to films.

Offer Up Talent

Whether it's fancy actors, a hipster band on your soundtrack or an Oscar-winning executive producer, you should probably suggest that they might attend the screening. Don't over promise, but don't be shy either. Festival directors know full well that actors won't always be able to come, but you can't invite your actors if the festival hasn't accepted the film first. Likewise, no one's going to blame the film director if the actor is shooting another movie at the time of the festival. As much as we all think our actors are going to join us in the hot tub in Park City or the wine tasting in Napa, they're called "actors" because they "act" and tend to have different agendas and schedules than yours. The good news? If they can't come to a festival, then you, the filmmaker, are the star attraction, not them!

Ask for a Waiver

It never hurts to ask for a fee waiver. No one will think less of you for asking, and some festivals routinely waive their fees. Many don't. But you won't know which is which unless you ask.

They made me an offer, to screen on Closing Night
With fireworks in a castle, I said "Outasight!"
Two days later in Canada, I'm eating granola
At the Whistler Film Fest, and I ride a gondola

My film played in Australia, where my investor presented it
An earthquake in Anchorage, could not have prevented it
On a tour that consisted of fire and ice
I then went to Bahamas, 'cause I heard that it's nice

With filmmaker paintball, and nudes on the bar
The festival took us, on boats near and far
I ate frittered conch, from a shell that was broken
I met gigolos performing word that was spoken

And lo and behold, I won a prize from the jury
An aluminum fish! Man, I'm not in Missouri!
I finally returned to my kids and my spouse
They did not recognize me, I snuck into the house

And so I ask you, dear critic, of my quest
Was it best to have waited for an A-listed fest?
That may never have come, and I'd wasted a year
Waiting by the phone, living with the fear

That no bigwig would dig it, at Berlin or Cannes
Then I'd start over again, but this time in Spokane
'Cause when you finish a movie, I tell you, I posit
Just go out and show it, don't leave it in the closet.

Life is worth living, so if you're feeling restive
You can't spell "festival," without feeling festive!

Don't *Ask for a Waiver*

If after you've contacted the fest director, offered up your premiere and falsely promised your A-list actors, the festival director will likely reply, "Yes, your film sounds great; please send it to my attention." That's usually code for waiving the fee. Just send in the film and don't pay the fee. If the festival really still wants the fee, the festival coordinator will ask for it two weeks later. But by then, the festival director's probably already watched your film.

Aim Foreign

Many international festivals get state funding and don't have application fees. Track down those festivals and apply. What do you have to lose?

Mail Smart

You could still go broke mailing DVDs around the world. FedEx or DHL can charge up to $80 for a package to Europe, and more if it's a rush. For one thing, apply early and avoid rush postage. Have faith in the US Postal Service. Forget the high-priced couriers (remember, UPS is just another way of spelling "oops"). To send an international Priority Mail package from your neighborhood post office is only around $16, and usually gets to where it needs to go in under two weeks. USPS now has tracking numbers on all domestic and some international packages. And if it still gets lost, stuck in customs or delayed, you can always strike up a nice email relationship with the festival coordinators while you're tracking down the film. When it finally does arrive, they'll know all about the film and watch it right away.

Submit Vimeo Links

Especially for international submissions, festivals are increasingly happy to just get a password-protected Vimeo link. More of their programmers can watch the film simultaneously, so you can submit the film instantaneously (handy for late deadlines) and for you, the mailing costs are free! Just make sure that you're happy with the quality of your Vimeo, and use an easy password. Even if you're uploading your film directly onto Withoutabox or FilmFreeway, be sure to send the fest a link to your Vimeo version directly, too. Paranoid about getting bootlegged? You should be so lucky!

Hand-Deliver Your DVD

Forget online links. A DVD is much better quality and shows that you cared enough to burn a disc and scribble your name in Sharpie. It's much less likely to

get lost in the festival's system if it's a DVD. Or maybe it's the other way around . . . hard to say, really, so ask the festival coordinator, who by now is your new best friend. Every fest will have different preferences.

Meet Festival Directors at Other Festivals

If you have a film that didn't get into Toronto or Sundance, it still might behoove you to visit. There inevitably will be festival panel discussions, brunches or parties where you can track down hungry festival directors from international or regional fests and schmooze them with a DVD directly. Sure, they might get drunk and lose it, but you never know. If nothing else, you've made a personal connection and can follow up later.

Bribes and Blackmail

Yes, bribes can be expensive. But if you have leftover product placement beer from your production, put it to good use. The coordinators and interns at a festival office won't know how old it is! And what better way to make sure your film gets "in the system" and not "lost in the mail" than to hand-deliver it taped to a case of Pabst Blue Ribbon or a box of a dozen cronuts? And if you still can't afford a bribe, then go with blackmail. I can't think of a festival director alive who doesn't have some embarrassing Anthony Weiner-esque selfie floating around Instagram or Facebook somewhere. It's your job to find it and put it to good use.

Top 23 Sundance/Slamdance Rejection Rationalizations

1. The application must have gotten lost.
2. The DVD had a glitch.
3. Withoutabox screwed it up somehow.
4. Application? Were we supposed to send in an application?
5. Us? Oh no, we never applied . . .
6. . . . we wanted to finish color correction.
7. . . . we're still editing.
8. . . . we're still shooting.
9. . . . we barely finished the script.
10. We're waiting for a *real* film festival. Like Cannes. Or St. Louis.
11. Screw Sundance, they're snobs.
12. Screw Slamdance, I'm a snob.
13. My film's not gay enough.

14. My film's too gay.
15. It's really more of a SouthBy film.
16. They just don't appreciate art.
17. My film's not artsy enough.
18. They only took films that had gone through the lab.
19. They didn't want to take too many films that had gone through the lab.
20. I didn't have a big agency behind me.
21. My big agent overplayed his hand.
22. They're racists.
23. Sundance? Never heard of it.

We Are Slamdance
Slamdance Opening Night Poem 2004, on the occasion of our 10th annual festival.

We were rejected, we persevered
We revolted, we're revered
We've been at it for ten long years
Or maybe nine, who really cares

We were young, we were desperate
We were hungry, and pathetic
We were stubborn and obtuse
We were gluttons for abuse

It was late, there was snow
We had no place to go
Set up shop in the Prospector
Please don't tell building inspector

Next door to Sundance, in their face
We had no choice, it was the place
Without acceptance, we were done
Unwatched films are no fun

Nothing to lose, here we be
See our movies. Why not, they're free
And so it started in '95
And look, we've kept the beast alive

Through blizzards and through ice
Broken projectors sure aren't nice
We've been chased all over town
Up to the Silver Mine and down

Through Olympics and town scandals
Accused of being the worst vandals
We've screened from China to New Bedford
Even one with Mr. Redford

How to Start Your Own Film Festival: The Birth of Slamdance

So what do you do if you *still* can't get into any film festivals? Or maybe, what if you're getting into festivals in every city in the world except your own hometown? For many filmmakers over the years, the answer has been to start your own damn film festival! How hard could it be? Well, it's not rocket science, but it is a lot of hard work. And you always have to ask yourself: Do I want to be a filmmaker, or do I want to become a festival director?

Sundance or Bust

From 1989–94, independent film in the US was 100 percent synonymous with the Sundance Film Festival. For filmmakers, the path to Sundance often led through the Independent Feature Film Project (IFFM) in New York (now called IFPWeek)—held at the time at the Angelika Theater in Houston. You'd finish your film, screen it at the IFFM, get discovered by Sundance programmers, get invited to the festival and be the next Steven Soderbergh, Quentin Tarantino, Richard Linklater or Kevin Smith! The flip side was that if you *didn't* get into Sundance you were dead in the water: You wouldn't get distribution, you wouldn't get an agent and you

even wouldn't get into other regional or international festivals (they all just used the Sundance program as their quick guide for programming American indie films).

With that in mind, Dana Altman and I had our first real screening of *omaha (the movie)* at the IFFM in 1994. Remember, this was the pre-internet age—no email, no web, no *IndieWire* or Facebook and cellphones the size of a sourdough baguette (if you had one at all). After working largely in isolation from other indie filmmakers, we showed up in New York and met other filmmakers who'd also just finished their first movies. Among others, we met Shane Kuhn and Brendan Cowles, who both lived in LA, but had also just shot a film in Nebraska, called *Redneck*. One night during the IFFM, Dana had a sudden realization that we should get all these filmmakers together and create some sort of means of staying in touch and comparing notes. "There was a sense in the mid-90s that indie film—and Sundance in particular—was focused on New York or LA filmmakers," says Dana. "Those of us with midwestern roots felt isolated and needed to crash the party to survive."

The next day, we had a big meeting in the lobby of the Angelika to discuss just such an idea, which people seemed to embrace in theory, if not in practice. We all said our own films would get into Sundance, and we swore we'd see each other again in Park City in January! But we also shared talltales of filmmakers who'd been rejected by Sundance, but did renegade screenings on their own in Park City. Twice in the early 1990s, the New York collective Film Crash (founded by Matthew Harrison, Karl Nussbaum and Scott Saunders) held bootleg festivals in Park City hotel rooms. In 1994, a pre-*South Park* Trey Parker, Matt Stone and Jason McHugh screened their film *Cannibal the Musical*, and separately, James Merendino screened his movie *The Upstairs Neighbor* in hotel screenings, too. In each case, the efforts had garnered at least a little press attention, so we all

We've had rockstars, we had Roots
LeAnn Rimes showed up in boots
Guns N' Roses, Perry Farrell
One Counting Crow or two if you count Sheryl
We've had DJs, and yes woe be
Unto you if you missed Moby

Throughout it all were movies
Not too many, just enough
A dozen features and some shorts
Each year would do the stuff

Keep it small, that's the deal
Keep it intimate and real
Always something to discover
Meet a friend or screw a lover

With yellow ducts for our decor
We've even won a Palme d'Or
(not too shabby in my humblest opinion)
We've had Spirit winners on our roster
And a film once won an Oscar
(we're happy to take credit for our minions)

We are balding, we are grey
We are pregnant, we are gay
We've had virus, flu and ptomaine
We take Zoloft, we take Rogaine

We've been married once or twice
We've had kids; a few are nice
We're anonymous and famous
We are cool and we are lame-ass
We've made movies about porn
We've made movies about corn
(we especially like films about the anus)

We defy accounting sense
We deny that we owe rent
We are arrogant and bitter
We are skittish
We hang together, not alone
Cheaper than therapy or clones
Don't hate us because some of us are British

We do yoga, we smoke crack
We like films in white and black
We are whores, we are bums
We will work for little crumbs

Try to sellout to the 'Wood
Holly' like us, Holly' should
Our alumni let us boast
Two billion dollars we have grossed

Yet we're belittled, we're ignored
Faintly praised but not adored
Our self esteem is quite occluded
Yet with grandeur we're deluded

We're a cult, a trend
A family, a movement
We're a parasite, a host
We like hermaphrodites the most
(we're in denial that we need any improvement)

We are the Borg, we are the Force
We are the Matrix, yes of course
You never know if we'll show up in Lisbon
We are Batman, Fantomas
With facial growth like Cantinflas
We will not die, no matter what prevailing
 wisdom

So in conclusion, let me add
It's been fun, yes, it's been rad

We've had our heads right up our buttses
For a decade we've been putzes
But what the hell,
How 'bout ten more years of going nutses!

thought, those kind of screenings weren't a bad "Plan B" in case our own films didn't make it in.

Meanwhile, we were all begging the Sundance programmers to come to our respective IFFM screenings. With *omaha (the movie)*, we were the rare film with a color poster. A local Omaha ad agency had generously donated several glaring yellow-and-purple, horizontal posters they'd designed for us. When we put them in vertical poster cases, invariably people had to twist their necks to read the title of the film. Between the bright neck-cracking poster, and Robert Altman coming to our screening, we wound up being one of the buzzed-about films of the IFFM, according to *The Hollywood Reporter*. One junior Sundance programmer was at the screening and said he liked the film. We had a major indie distribution exec tell us she loved the film and wanted to pick it up . . . if we got into Sundance. I got a fancy Hollywood agent out of the IFFM. Many years later, I heard that both Miramax and Fine Line were stalking us at the Angelika, and if one company had made an offer on the film, the other was poised to counter it. Sadly, neither made an offer.

Anarchy in Utah

December rolled around, and Sundance made its selection announcement. Of the 95 completed narrative feature films at the IFFM, Sundance did not select a single one. We were crestfallen. The next morning, Shane Kuhn called me up: He said why don't we take Dana's amorphous idea about filmmakers working together and combine it with the Plan B of renegade screenings at Sundance. We'll all share resources and put on our own alternative film festival *during* Sundance! I figured—sure thing! We had nothing to lose, and everything to gain. I drafted a list of potential names for the festival (including "LoserFest95"), but when Brendan came up with "Slamdance: Anarchy in Utah, The First Annual Guerrilla International Film Festival" we all knew that was a keeper. It was definitely a name that would lend itself well to a T-shirt and poster. Shane had spent a year at the University of Utah in Salt Lake City, and was able to get its film department to agree to host Slamdance in its screening rooms on campus. We naively assumed that it was close enough to Park City that we'd get Sundance audiences coming to check us out.

We started contacting other filmmakers, mostly the ones we'd met at the IFFM. One director who lived in LA, Jon Fitzgerald, seemed organized, so we

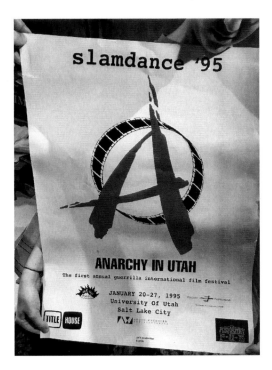

My daughter Rebecca
holding the original
Slamdance poster

Photo: Dan Mirvish

got him involved early. A filmmaker named Paul Rachman, who'd just made the short *Drive Baby Drive*, heard what we were up to, and he suggested we do a whole section of shorts, in addition to features. When he said that his producing partner was a trained projectionist, we decided we should let their film in. I knew a guy at *Variety* who ran a front-page story about Slamdance on the slow news week before Christmas, announcing what we were up to. He didn't indicate a way for other filmmakers to get in touch with us, but did mention that I had a seasonal job at The Good Guys electronics store in Westwood. So filmmakers started showing up in the store, and Shane and Jon would sometimes come by at the end of my shift and we'd watch submissions on the big screen. Once, I was in the middle of selling a 13-inch Sony TV to Kevin Pollak (who was getting ready to go to Sundance with *The Usual Suspects*). Joel Michaely, who'd helped produce a film directed by TV's *Punky Brewster*, Soleil Moon Frye, ran up to me and submitted his VHS tape for Slamdance. Pollak was stunned, but I still managed to talk him into the five-year extended warranty!

Variety had a deal with the nascent America Online network (remember all those free CD-ROMs in the mid-1990s?) and the article got picked up by AOL's newsfeed. Philadelphia filmmaker Eugene Martin, in particular, heard about Slamdance through AOL and he contacted us. All together, we wound up with a dozen features and a dozen shorts eager to combine resources and put on a show.

That couple of months between announcing Slamdance and actually putting it on were a little nerve-racking. The festival director at Sundance left an intimidating voice message on Shane's answering machine. Filmmakers who were friends of ours and had committed to Slamdance were getting cold feet and dropping out. Dana called Robert Altman, and told him we had this crazy festival idea, and asked if we should be worried that we would wind up being blacklisted by Sundance. Bob thought about it a moment, and said decisively, "Eh, fuck 'em." The Pope of Indie Film had blessed Slamdance—what more could we want? (Of course, 22 years later Robert Altman is dead, and we're still blacklisted . . . so I'm not sure how that worked out.)

The University of Utah's film department got nervous that they'd lose all their perks with Sundance and at one point they told us they were dropping out of the arrangement. Oddly, it was the head honcho at Sundance that eventually told the university to stick with us, because he knew that Sundance would get decimated in the press if it came out that they had quashed us. Honestly, at that point I was hoping we'd get shut out. We would indeed have gotten amazing press and wouldn't have had to do all the hard work of running a festival. Sadly, we had to drive to Utah and figure out how to put on a film festival!

Prospecting for Screening Rooms

Almost all the filmmakers stayed in one condo in Salt Lake City not far from the university. We realized almost as soon as we started our screenings that *no one* from Park City was coming down the mountain to find us in Salt Lake City. (But on the map, they looked *sooo* close together!) Filmmakers Lise Raven and Frank Hudec (who had a film called *Low*) led the charge and rented a 16mm projector from a vendor in SLC. I drove with them in the back of their rental compact car—a rolled up screen sticking out my window, blizzard snow blowing in my face. We went to one of the main hotels in Park City, the Prospector Inn, and found a friendly night manager who had no qualms about renting us a tiny conference room. It was 30 feet down the hall from the hotel's big conference room, which was one of Sundance's main screening venues. We used the lobby pay phone to call our compadres in Salt Lake and told them to haul ass up the mountain. Meanwhile, we asked the pimply faced young night manager if we could borrow his Xerox machine. We ran off a couple hundred fliers indicating that Slamdance had made it up the hill to Park City! By the morning, the Sundance wait line went right past our little screening room, and we scheduled our films for 15 minutes after each Sundance start time. Their overflow crowd walked right into our free screenings!

We started running all our 16mm films at the Prospector, in addition to keeping all our screenings going at the university, including all our 35mm prints. By the middle of the week a filmmaker named Chris Glatis called the condo

and asked if he could get his short film into Slamdance. We politely told him that we were half-way done with the festival, so it was too late. That's too bad, he told us. He had rented a 35mm projector and was running his film at the Yarrow Hotel in the heart of Park City already. Really, you have a working 35mm projector in the middle of Sundance? Congratulations, Chris! You're in Slamdance!! So we coopted his projectors and were able to start running our 35mm films (including *omaha (the movie)*) in one of the main hotels at Sundance.

By then, a few real Sundance filmmakers were dropping by to see our shenanigans. Oscar-nominated animator Bill Plympton, who had a film in Sundance that year, came to watch *omaha (the movie)* and *Drive Baby Drive*. Sundance jurors Whit Stillman and Samuel L. Jackson heard what we were up to (Sam's wife LaTanya Richardson was *in* a Slamdance film). One unnamed Sundance competition feature filmmaker (who chooses to remain anonymous, even now!) told me the Sundance festival director warned him, "Stay away from those Slamdance guys. They're troublemakers!"

Time for IndieWood

The year 1995 was pivotal in indie film. It was at around this time that Miramax became part of Disney, Fine Line became part of Warner Brothers and Sundance was the epicenter for this Hollywood-ization of indie film. It was at the festival that year that Fox launched Fox Searchlight (with *Brothers McMullen*) and within a couple of years, every studio had its own independent film division. Sundance had embraced the limelight, showing more films by second-time directors, films with bigger stars and budgets, and films with distribution deals already in the works. It had largely forgotten about the first-time directors like us Slamdancers who had been so inspired by that first generation of Sundancers.

Consequently, the press were turning on Sundance. Slamdance was the perfect sidebar story to write: A group of renegade directors holding onto the true indie spirit! After interviewing me about Slamdance, *The New York Times* declared us to be a group of "cheerful! subversives" (and clearly, that description has stuck). We found ourselves, Slamdance and our films mentioned in newspapers and magazines around the globe. We'd finally broken through the Sundance hex: Our films got invited to other regional and international festivals (often playing side-by-side with Sundance films), some films got distribution and filmmakers got agents. By the end of the week, there was a feeling that Slamdance was working so well we should try it again the next year. Filmmaker Peter Baxter (who'd aptly enough produced the Slamdance feature *Loser*) and I met with the Yarrow Hotel manager, and we put down Peter's credit card as a deposit for the next year.

Steven Soderbergh

About a month or two after we did the first Slamdance Film Festival in 1995, *omaha (the movie)* screened at South by Southwest in only its second year of having a film festival. After a screening of Steven Soderbergh's film *The Underneath*, I went to the afterparty and was a little reticent to meet Soderbergh. After all, at that point he was synonymous with the Sundance Film Festival. He'd single-handedly elevated Sundance to international sanctitude when his film *Sex, Lies and Videotape* won the festival and then the Palme d'Or at Cannes in 1989. I thought if there was one filmmaker in the world who would be pissed that we'd started Slamdance, it would be Steven Soderbergh.

So when a local SXSW volunteer introduced me as one of the dudes who started Slamdance to a somewhat inebriated Soderbergh, I expected Steven to slug me upside the head. Instead, he hugged me and shouted, "I LOVE Slamdance!" Turns out, he had soured on Sundance owing largely to a feud with Robert Redford. Among other things, Redford had dropped the ball in producing Soderbergh's *King of the Hill*, and stolen the directing reins from Soderbergh on *Quiz Show*. Soderbergh also told me he'd become disillusioned with Hollywood in general and hated his experience on *The Underneath* (which was awkward since I'd just told him how much I loved the movie). Instead, he was throwing his energies into producing a little indie film and directing (and acting) in an even more experimental indie. He said they'd both be great for Slamdance.

Sure enough, the next year at Slamdance Steven brought us Greg Mottola's debut feature *The Daytrippers*, which starred Parker Posey, Liev Schreiber and Hope Davis. During that second year at Slamdance we had 35mm projectors that were constantly breaking down, with scratched prints and muddled sound. During one screening, Soderbergh and I were huddled next to the projector trying to fix it while it was still running. "Dan, hand me that screwdriver!" Screwdriver! "Pliers!" Pliers! ZAAPPPP. "AAAHHH!" Yes, he got (mildly) electrocuted. But the show went on, and the audience loved the film. At the Q&A, Soderbergh stood up and vowed "Next year, I will do what I can to get Slamdance some decent projectors!" And indeed he did, putting in his own money for us to get projectors from the same company (Boston Light and Sound) that provided equipment to Sundance. *The Daytrippers* went on to screen at Cannes' prestigious Critics Week section and Mottola's had a great career directing films like *Adventureland* and *Superbad*, and TV shows like *Freaks and Geeks*.

That next year, Soderbergh delivered on his promise to bring his own experimental indie film, *Schizopolis*, to screen out of competition at Slamdance '97. It's a weirdly wonderful trippy movie that revived Soderbergh's joy of filmmaking (the next year, he made *Out of Sight* with George Clooney, and he was back in the Hollywood game, but doing it on his own terms). *Schizopolis* was a huge inspiration to all the new film-makers at Slamdance that year. Steven saw one other film at the festival while he was in town: A little Cleveland indie film called *Pieces* by two self-described knucklehead brothers, Joe and Anthony Russo.

Our Napoleon Complex

It may have been groundbreaking in the US, but in the international context of film festivals, what we started with Slamdance was not so unique: In 1969, the French Directors Guild, including such luminaries as Louis Malle and Robert Bresson, started its own sidebar fest at Cannes called Directors Fortnight (aka Quinzaine des Réalisateurs). Disgruntled critics (aren't they all?) started their own section at Cannes called Critics' Week (Semaine de la Critique) in 1962. Both sections are still going strong 50-plus years later, and are still run completely independently from the official sections in Cannes. Of course, this tradition dates even farther back to the Salon de Refusés ("exhibition of rejects") in France starting in 1863, where painters like Courbet and Manet staged their own unofficial art show in defiance of Emperor Napoleon III. Now, Robert Redford may be short, but he's no Napoleon. In 1996, he was asked about Slamdance and called us "parasites" in *Interview Magazine*. He was right, of course, but it was still the best press we could have gotten, ensuring our street cred for years to come.

Slamdance also wasn't totally unique in the US. Plus or minus a year from when Slamdance started also saw the launches of other significant festivals like South by Southwest's film fest, the New York and Chicago Underground Film Festivals, the Hamptons Film Festival and the Los Angeles Independent Film Festival (now called the Los Angeles Film Festival). With the addition of AFI's Film Fest in LA, and Tribeca in New York (started in the wake of 9/11), and the rise in prominence of Toronto's festival, Sundance's absolute hegemony over North American indie film premieres would be over (sort of).

Sundance tried to squeeze us out of Park City for years. The festival would outbid us for every venue we could find. After the Yarrow caved to Sundance in our third year, we found a friendly family-run hotel at the top of Main Street called the Treasure Mountain Inn (TMI). Unlike most of the corporate-owned hotels and resorts in town, the TMI was run by Thea Leonard and Andy

Beerman, a mountain-town hippie couple who'd been spurned by Sundance in prior years. Like in an old western, Sundance had pull with the sheriff and city council. For at least our first decade or so, they tried to run us out of town by whatever legal means they could try. But 22 years since we started, the sheriff has long since retired and the TMI's Andy is on the city council. The locals love us, by and large, because they have an easier time getting tickets to Slamdance events than Sundance ones.

Peter Baxter is still running the festival, and we've largely stuck to our original mission. The main competition is devoted to first-time directors, with small budgets and no distribution in place. We're still at the TMI, which I've affectionately dubbed a "snowball's throw across the street from Sundance." We have two small (hot and cramped!) screening rooms and a crowded lobby at our disposal every year which gives Slamdance a warm intimacy that's somehow absent from Sundance. And of course, we have an annual Hot Tub Summit at the TMI's massive jacuzzi. Audiences come for both festivals, and the folks who now run Sundance have finally warmed to our existence . . . a little!

Marc Forster

Raised in Germany and Switzerland, Marc Forster is a brilliant Hollywood director known for such big-budget films as *World War Z*, *Finding Neverland*, *Monster's Ball*, *Stranger than Fiction* and *The Kite Runner*. But his very first feature was a little-seen comedy called *Loungers* that won the Audience Award at Slamdance in 1996. That was the same year that Greg Mottola's film *The Daytrippers* (produced by Steven Soderbergh) won our Grand Jury Prize. This being only our second year of Slamdance, it was our innaugural year for both jury and audience awards. I left the fest a few days early in 1996 since I was about to get married. But from what I've heard, *The Daytrippers* may have technically scored higher on the audience ballots, but it was decided it would be better to split the jury and audience awards and give two different films the top prizes.

Honestly, this sort of thing goes on more than you think at film festivals, and in subsequent years we put in a much more rigorously mathematical approach to the audience award process at Slamdance. There are times when the more subjective juries may want to adjust their own decisions based on what film's getting an audience award. So, for at least the last 15 years or so, we've given our Slamdance juries the option to know how

the audience balloting is going, or not. What they do with that information is up to them. So some years we have had double winners, but more often than not, the vote gets split naturally anyway.

Marc Forster's *Loungers* got lucky another way. Slamdance '96 was supposed to have hosted the world premiere of *Swingers*. The filmmakers had submitted *Swingers*, we programmed it and put it in our printed program. But at the last minute, they told us they couldn't finish the movie and had to withdraw from the festival. Remember, back then, films were truly finished *on* film. Ending up with a final print, complete with optical soundtrack, was a big deal. You couldn't just output a DVD from FCP. So *Swingers*—which arguably could have outmatched either *The Daytrippers* or *Loungers* in both audience and jury votes—was out. Two months later, the filmmakers had a distributor screening at the Director's Guild on their own and sold the film for several million dollars to Miramax. It couldn't have worked out better for Doug Liman, Vince Vaughn, Jon Favreau, Greg Mottola *or* Marc Forster.

As for Marc, despite his Slamdance win, he struggled for a few years trying to make it big in Hollywood, and *Loungers* itself barely got a release. Eventually he got frustrated, and decided to use miniDV cameras to just shoot his next film on a micro budget. (This was in the wake of the Danish Dogme 95 revolution that made miniDV filmmaking acceptable as a format for indie films.) So around 2000, he made his second feature, *Everything Put Together* (starring Megan Mullaly in a rare dramatic turn), and it premiered at Sundance to widespread critical acclaim. I ran into Marc that year at Main Street Deli (still the cheapest place to get a sandwich in Park City) and we had a chat that had a profound effect on me. I told him I'd also been struggling in Hollywood to get my sophomore film (*Stamp and Deliver*) made on a sizable budget. Marc gave me a great pep talk about just making *something* on DV—rather than wallowing in despair. DV was the wave of the future, and you could still get great actors to star in your films! Combined with seeing some of the films at Slamdance that year (including Debra Eisenstadt's *Daydream Believer* and the Maggio Brothers' *Virgil Bliss*), I had something of an awakening to what had been a three-year funk. It was the spark that led me to make *Open House*, my real estate musical shot on miniDV.

Years later, when I was getting ready to make *Between Us*, I contacted Marc and asked him if he was interested in exec-producing the film. Always a gentleman (that European upbringing, no doubt), he kindly thanked me for thinking of him but said that he was about to sign on to a project that would keep him exceptionally busy for the next couple of

years. I thanked him, too, and wished him luck on his mysterious new project. A week later I read in the trades that Marc had signed on to direct the new James Bond film *Quantum of Solace*. Yup, "busy" was an understatement!

Slamdance at 15

Opening night poem at Slamdance 2009

Fifteen years.
Oh Crap, has it been that long?
It seems like yesterday that we went wrong.

We were warned that instead of filmmakers we'd be
Festival programmers for one year or three
But *fifteen*!? No way.
Not a chanced, and no how'd.
There'd be a new black list, we'd be disavowed

When we started, *Sun*dance was barely that old.
Fifteen years later in the snow and the cold
It's hard to remember how things started back then
The myth has grown from the who and the when

Oh yes, I was there at the start, at the beginning
When under my hat, my hair was not thinning
Everyone you bump into, everyone that you meet
As you walk down the hill, as you walk on Main Street

They'll all say they were there, they'll all say they remember
From the occasional gay to the odd Mormon church member
Oh yes, I recall, Slamdance was the thing
Put together with gum, bailing wire and string

We held up a flashlight and crowded around
All movies black and white, hardly any had sound
Back then there was film, spliced with cement
Our two volunteers were not aged of consent

Oh yes, I recall, they'll say and they'll swear it
I had the first Slamdance T-shirt, for 10 years I'd wear it
Or maybe they'll say that they had an original poster
But they're full of bluster, and they're quite a boaster

Billions and Billions

The films in Park City may not spin the world's turnstyles, but the filmmakers who make them most definitely will. Slamdance has minted Oscar winners, Palme d'Or winners and countless filmmakers who've gone on to show their second or third films at Sundance. But if the proof is in the pudding, then take a slurp of this:

Just looking at first-time directors who've screened over the first 21 years at Slamdance, their worldwide box office gross for films they've directed or produced is more than $13.34 *billion* (according to Box Office Mojo). It's also worth noting that the filmmakers currently behind the reigns of the Marvel, DC and Star Wars universes are Slamdance alumni. Hollywood? You're welcome.

The list of financially successful Slamdance alumni includes such successful filmmakers as Christopher Nolan and Emma Thomas (*Inception*, *Batman*), Oren Peli (*Paranormal Activity*), Marc Forster (*World War Z*), Jonathan Chu (*Step Up*), Rian Johnson (*Looper*), Seth Gordon (*Identity Thief*), Gina Prince-Bythewood (*Beyond the Lights*), Mike Mitchell (*Shrek Forever After*), Lynn Shelton (*Laggies*), Joe and Anthony Russo (*Captain America 2 and 3*), Jared Hess (*Napoleon Dynamite*), Benh Zeitlin (*Beasts of the Southern Wild*) and such TV showrunners as Lena Dunham (*Girls*) and Jon Bokenkamp (*The Blacklist*).

Many international filmmakers who've enjoyed great success worldwide also are proud Slamdance alumni, including South Korean

auteur Bong Joon-ho (*Snowpiercer*, *The Host*) and Frenchman Frédéric Forestier (*Astérix aux Jeux Olympiques*). In both cases, their first times on American soil were to present their earliest films at Slamdance.

Oh, and that's just the first-time directors Slamdance showcased in competition. If you add in directors we've screened out of competition (typically not their first film), the worldwide collective gross adds up to over $15 billion. That's more than the annual GDP of Malawi and Tajikistan *combined*! If you start to include actors, producers, distributors and others that have been a part of Slamdance (i.e. Ben Affleck, Matt Damon, Mark Ruffalo, Ava DuVernay, Vince Vaughn, Roger Corman, et al.), there's no telling how high you could tally.

Most film festivals that have been around for 20 years or more can probably boast similar numbers, and I'm sure Sundance itself is no exception. But what's unique about Slamdance is it's actually programmed and organized by its own alumni filmmakers, and we've created a community unrivaled by any organization our size.

When Hollywood inevitably does ignore us, who do we have to turn to? The most important connections Slamdancers make aren't the agents, producers, distributors or press. Nope. It's each other. Slamdancers are friends, colleagues, codependents for life. Slamdance is group therapy without the therapy, and frequently not in groups. "By filmmakers for filmmakers" is more than just an empty festival slogan in search of punctuation. When we need to borrow a camera, bootleg editing software or just get a referral on a good criminal defense attorney, Slamdancers call on one another. When we've been dropped

They were at a secret Slamdance opening night bash
Where they had a threesome with Moby and Slash
They snorted coke off the chest of a masseuse named Carol
They were the one who puked on Perry Farrell

Before Bond had Forster and Batman had Nolan
They'll talk of virginities offered and stolen.
Soderbergh sightings are the legends of stuff
You know who was conceived here? Shia LaBeouf!

Whether they were here as a filmmaker or layman
They'll say they did shots with Ben Affleck or Damon
They'll recall when *Napoleon Dynamite* was proposed
Then the next year, down the block when the deal was closed

Maybe they were the one who got kicked by Vince Vaughn
Or dropped tabs with Ken Kesey before he was gone
Or bumped into Carl Lewis as he ran down the hall
They'll even claim we had a tribute to Leni Riefenstahl

Well, as someone who knows something about things that aren't true
I can neither confirm nor deny what you heard about U2
Maybe they played here, one night right after a screening
It's amazing the people we've had here convening

But when the altitude's high and you're feeling imbalance
I remind you of the line from *The Man Who Shot Liberty Valance*
Despite uncomfortable seats which your bottom is wedged in
Remember:
When the legend becomes fact, then print the legend.

by our agents, screwed by our distributors and ignored by festivals the world over, we know that there will always be a plate of garlic chicken and a room full of fellow Slamdancers with whom to share our pain and flaunt our joy. That's why we're different, and that's why we're still around.

Distributing and Beyond

Top Sexy Things You Get to Do When You Think Your Film is Finished

OK, so you've spent seven years making your indie opus, another two years playing the festival circuit and somewhere along the way you even managed to sell your film and get distribution! Hooray, you're done and the party's over!! Your goal by this point is undoubtedly to move on and start working on the next film.

But wait a second, just because you've "sold" your film and you "got" distribution doesn't mean your job as a filmmaker is "done" (or that you finally need to stop using "air quotes"). On the contrary. You're *still* staring at a 20-to-life sentence for your film. Here're a few of the top sexy (and by sexy, I mostly mean "crappy") things you still need to do. Even if you're just starting your film project, you should read these—you can avoid a lot of future aggravation if you know what you're heading into and prepare appropriately.

Deliverables

Whole articles and books can and have been written about what you need for deliverables. Simply, they are the things you have to deliver to your distributor before it'll even think of paying you. Deliverables consist of paperwork (E&O insurance, chain of title, cast/crew contracts, production notes, receipts, dialogue list, etc.) and all your physical/digital elements (the movie itself, sound stems, M&E mix, DVD extras, key art, poster, trailers, etc.).

Now if you and your team were on the ball from pre-production through post, you'll undoubtedly have most of this paperwork already stashed in binders and folders somewhere. Better still, you'll have it all digitized in one handy-dandy hard drive or in a cloud-based system. But if not, you can count on endless hours of scanning, emailing, Dropboxing and searching for all these documents. And remember, by this point, you won't have an army of PAs and interns to do

the scanning for you, so try to get as much of it done during production, while people are still eager and available to help. While you're doing it, be sure to back things up to multiple clouds the same way you back up picture and sound files.

Meanwhile, try to get a single hard drive on which to put all your "physical" elements. Your film itself might be the simplest thing. But make sure you've got *all* your sound tracks, stems, mixes, etc. and make super sure everything has the same 2-pop on it. Just because we're living in a digital age doesn't mean you shouldn't put old-school SMPTE 2-pops on every track. And just when you think your film is great, some pimply faced kid in QC (Quality Control) somewhere will either catch a bizarre glitch on one frame of film and make you redo everything, or worse, *not* catch something he should have.

On *Between Us*, we thought we'd delivered all our 5.1 audio tracks at the same time as the film. Turns out we were missing a few surround channels on our drive, had to go back to the sound house (which fortunately hadn't dumped them), and delivered the tracks two weeks later to our distributor. By then, the distributor had laid their seven-second logo over our 2-pops and proceeded to put our surround channels in what they thought was the beginning of the film. The QC guy didn't catch it and oops: The surrounds were now seven *seconds* out of sync! It took months of aggravation to sort things out.

The worst part about deliverables is that just when you think you have it all delivered, your distributor will gently remind you that you have one more thing left to do before it'll pay you. And just when you've finished that, you'll get a new distributor—maybe this time a foreign sales agent—who will give you a deliverables list that is at least somewhat different from what your first distributor demanded. And did you have a nice post or sound house that gave you all those late-night freebies to get your mix done in time for Sundance? Guess what. It won't be so nice to you when you go back a year later and ask for even more work on your deliverables. So get that M&E mix, and full 5.1 done while you're doing your first festival mix. That may well be the last time you're allowed to set foot in your sound house.

E&O Insurance

As the name implies, errors and omissions insurance covers you and your distributor for all the legal crap you probably forgot to take care of when you were actually making the film. There are only a handful of companies that do E&O for indie films, and you've got to do your due diligence and get bids from at least a couple. But E&O isn't cheap—plan on around $5,000 for a feature. In the old days you could probably squeak by without E&O if the network or distributor agreed to cover you on their general E&O policy (Sundance Channel used to do this), but I'm not sure how often that happens today, even with the smaller VOD companies.

Repair Relationships

Suck it up if you can. Pucker up if you must. Lawyer up if you have to.

If you've gotten this far in the process you've probably pissed someone off: An investor, a producer, a spouse, a key grip, a post house, a makeup artist with a litigious father, who knows? Chances are, someone wasn't given a credit, or paid as much as they thought they should have been. Someone *will* be mad at you, and even more so when they hear you've been traipsing around the globe to glamorous film festivals. Or worse, when they see you humblebragging on Facebook that you've sold your film for what they can only imagine is an ungodly sum of riches. This is the price of "success" for an indie filmmaker. But unless you plan on changing your name and moving to Trinidad (to say nothing of Tobago), you need to find a way to salvage these relationships or they will haunt you for years: emotionally, financially and/or legally. Do whatever apologies, IMDb credit-giving, therapy or promises you need (a free couch to sleep on in Park City? Sure!), but get over these spoiled relationships and move on.

Promote Your Friggin' Movie

Whether you get a full-service distribution sale with a mini major, a little VOD deal with a small company, or you're self-distributing out of your garage, if you want people to see your film you have to get involved. No one's going to work harder than you to promote your film. So, just because your distributor has an in-house publicist or you paid out-of-pocket for an independent marketer, booker or publicist, you can't slack off when your film is released.

When I self-distributed *omaha (the movie)*, I stood in front of the old Laemmle Sunset Five in LA for 13 weeks with a sandwich-board passing out fliers. When *Between Us* was getting a 50-city theatrical release from a small distributor, I was still calling theater managers in Sheboygan, doing podcasts in Hollywood, Skyping in Q&As when I could and live-tweeting Q&As when I couldn't. The advantage this time was that I was working with an infrastructure of a distributor who could do most of the bookings, ads and underlying PR. I could focus a bit more on the fun stuff (like throwing corn cobs at our audience), but it was no less work than with my other films. That's partly how I chose the distributor, Monterey Media, in the first place: Was this a company that would keep the director at arm's length because "they know better"—or was it one that would harness the energy of the filmmaker to work together to promote the movie? Fortunately, it was the latter.

Just because your film is going straight to VOD, or is enjoying a gentle Netflix, Hulu or Amazon deal, doesn't mean you're off the hook with shameless self-promotion. On the contrary: If your film is on Netflix and nobody knows it's on Netflix, is it really on Netflix? The way its search algorithms and "new release"

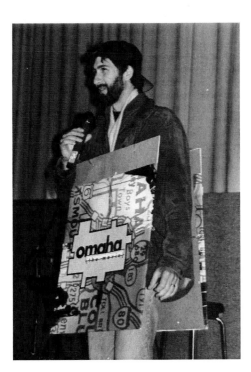

Wearing a sandwich-board at a
film festival in Edmonton

Photo: Dana Altman

section work, the answer is no. This is where your thousands of social media fans and followers come into play (even if people add your film to their Netflix queue prior to its release, that's still meaningful). Strap on a digital sandwich-board and get pimpin'! Put out press releases, get your actors tweeting, photoshop President Obama inspecting your DVDs at an Amazon distribution warehouse; whatever it takes to keep getting the word out there! If you think it took a sustained effort to do your crowdfunding campaign, double that effort to actually release the film. Even if you never make a dime for your investors, cast or crew, they'll never be able to fault you for not working hard enough to try.

DVD Extras

Arguably one of the most fun parts of finishing a film is now sadly one of the least in demand. Until Netflix and other streaming services figure out a way for audiences to listen to commentary tracks and watch deleted scenes or other bonus material (some, like iTunes, make an attempt), the era of the extras-stuffed DVD are over. That said, putting all these bonus materials together has other advantages.

For one thing, most of your extras—at least the video ones—are very well-suited for YouTube or Vimeo. At some point you're going to want to embed them into your personal website, Facebook page or your Seed and Spark campaign for

your next film. You can still post your commentary or other audio tracks onto podcasts, or audio sharing sites like SoundCloud. Rian Johnson, for one, did this for the theatrical release of *Looper*, and I've posted mine for *Between Us*.

Speaking of those relationships you need to repair, let your bitter makeup assistant (with the grumpy Century City lawyer father) do her own commentary track. And did you have a scene you had to cut out . . . the one featuring your own wife and kids as glorified extras to make them happy? Put it on your DVD and you'll always have a perfectly preserved home movie you'll be able to find!

One warning about extras: They will sneak up on you, so work on them early. One minute you'll sign a deal with a distributor, and the next minute it'll want you to deliver your extras within two weeks. All that behind-the-scenes footage your EPK crew and still photographer diligently took on set, and the footage you shot on the festival circuit, isn't going to edit itself. Get crackin' and start editing on flights between those festivals!

Crowdfunding Perks

Remember all those perks you promised your Kickstarter supporters? Chances are some of them included DVDs or digital downloads of the finished film, or other perks you couldn't deliver until after making the film. You may have forgotten about them, but your backers haven't. But perhaps more important than the perks are the updates. Your backers primarily got behind you because they wanted to take part vicariously in your filmmaking journey. So keep sending out those updates, with both the good news and the bad. An updated backer will want to back your next film. And if, God forbid, you need to do another Kickstarter campaign to pay for your E&O insurance or self-distribution, you'll want to make sure your first set of backers sticks with you.

Taxes

Unless you've set up your film through some shadowy entity in the Cayman Islands, chances are you're going to have to deal with taxes at some point. And that point is probably once a year, on April 15. Even if you haven't made money on your film, you've still got to tell the IRS about it. Hey, you might even get a nice deduction (assuming you have any other income to deduct from).

If you're in California, every LLC, LP or Corporation has to file taxes and pay a minimum of $800 for as long as the business entity exists. Other states vary, but if you file in Delaware, and work out of a fetid hipster garage in Silver Lake, the California state government will still want its $800 a year. Even if you've never set up a formal entity for your film and just run the money through your mattress, at some point, you will have some explaining to do to The Man.

Accounting

And who's going to file those taxes for you? Last time I checked, most of you who went to NYU and USC became MFAs, not CPAs. So that means finding an accountant. And not just your Aunt Harriet who's a whiz at TurboTax. It's got to be someone who fully understands the vagaries of filmmaking, and also how to handle partnership or corporate filings with multiple investors and/or crowdfunded donors. Among other things, they've got to know the most recent status of Section 181, which keeps disappearing and reappearing on the tax code each year, largely at the whim of Congress.

K-1s

If you've got any kind of a partnership or corporation with investors, one of the most important things to do is issue them K-1 forms every spring (they're like a 1099 for investors). Hopefully you've got well-heeled, arts-patronly investors who don't mind that they won't be making any money. But no matter how forgiving they may be about their investment itself, they will *not* be forgiving if their K-1s are late.

If investors are filing taxes by April 15, that means they're meeting *their* accountants no later than March 15 to hand them all their K-1s and 1099s. That means you need to get together with *your* accountant no later than February 15 so he or she has time to issue your K-1s. Your investors will be mighty pissed if their K-1s are so late that their accountants have to file extensions on their taxes. It may not cost them more in taxes, but it *will* cost them more in accounting fees.

Oh, and if you're like me, and you've got investors who happen to be farmers, here's another little thing they didn't teach you at Tisch: Most farmers (and fishermen, too!) in the US are required to file their taxes on March 1, not April 15. So that means you need to do everything six weeks earlier. Meet with your accountant in early January and issue your K-1s by the first week of February, if not sooner. If you ever see me in Park City during Slamdance huddling over my MacBook Pro between screenings, chances are I'm frantically checking bank records, doing Excel spreadsheets and calling my accountant in LA.

Write Checks

One of the coolest things you might hope to do at least once in your life is to write checks to your investors. It is such an anomaly in this business and hopefully your investors appreciate how rare it is. The only downside is that in order to write checks, you have to: (a) keep strict spreadsheets on how you're divvying up your money proportionately; (b) find your checkbook (which you probably haven't used in the three years since production); and (c) find one of

your producing partners (because you oh-so-responsibly set up your account years ago to require dual signatures).

Assuming your producing partners haven't all taken off to Louisiana to work in TV production, and you find a mutually available time to get together to write checks, then it also means stuffing envelopes, addressing said envelopes, writing a nice update cover letter, buying stamps and going to the post office. While you're at it, you should send all of them DVDs of the film. A satisfying experience, yes, but still very time consuming. Oh, and you'd better make sure that you've got everyone's current addresses, or you'll be paying $31 per cancelled check when you realize a year later than an investor may have moved crosstown, but his ex-wife didn't.

One downside to writing checks to your investors? If they happen to be from a state other than yours (i.e. Nebraska investors, if your LLC is based in California), then your accountant has to issue them a separate out-of-state investor form and they'll probably need to file taxes in your home state as well as their own. It may not cost them much more in taxes, but it will be a drag on their own accountants. But if you're to the point where you're even writing checks, then it's a small price to pay for success, right? They should be so lucky!

Residuals

Filmmakers never used to worry about residuals all that much: Those fun little payments that actors, writers and directors mysteriously get every time one of their movies runs on late night TV. Everyone just assumes that someone else is responsible for them. And back in the old days when getting distribution meant signing with a reputable specialized wing of a Hollywood studio, those distributors would automatically sign "assumption agreements"—meaning that they would assume responsibility for residual payments (of course, being divisions of Hollywood studios, they had 20 other ways to screw you down the road anyway). But these days, if you're signing a deal with anything but the biggest distributor, chances are they won't be signing any assumption agreements.

What that means is that in four or five years, SAG (and the other guilds you might have dealt with) will come knocking on the door of whoever signed the original production agreement (probably you) and say, "Ahem! Your film's been playing on Showtime for the last eight months and on VOD in Sri Lanka. You now owe $10,000 in residuals or you won't get to use SAG actors on your next film."

Rather than wait for that dreaded knock, you might proactively want to start paying residuals yourself (especially if you're going to be one of the beneficiaries of them). But it's not as simple as just writing a check to SAG. You actually have to go through one of the big Hollywood payroll companies. Even if you used a smaller (cheaper) payroll company for production, there are only a handful of the big boys who have specific residual departments.

The good news is they're very nice about it, and don't charge an arm and a leg to work on it (just a percentage). The bad news is that it's *still* very complicated and time-consuming, even when dealing with an experienced payroll company. The categories that the guilds use for different kinds of digital and TV platforms aren't necessarily the same accounting categories that your distributor might use (and, with an Orwellian nod, some actually go back to SAG's 1984 contract). At her keynote speech in Toronto a couple years ago, William Morris Endeavor agent Liesl Copland coined the phrase "Analytic Black Hole of VOD." Well, your residual accounting is about to get sucked into it. And as we learned in *Interstellar*, once you get sucked into a black hole, what seems like hours to you will be like years to the outside universe.

On *Between Us* (my only film that's paid any residuals), it took close to a year from first approaching a payroll company to finally getting paid. And as the producer, *I* was mostly writing the checks myself. In one case, the payroll company (Entertainment Partners) sent a check to the WGA to forward on to me. Two months went by and still no check from the WGA. I told both the Guild and Entertainment Partners to cancel the check and send me a new one. Four days later, the WGA sends me the original check—postmarked the day *after* I told them that the payroll company was canceling it and sending me a new one. Talk about passive aggressive: The WGA sent me a check they *knew* I couldn't deposit! Later, the payroll company was supposed to send a director residual check directly to me (though not in the DGA, I'd put a clause in my contract requiring DGA-equivalent residuals). I'd sent Entertainment Partners a check from our company account and they were just supposed to take taxes out and send it right back to me. Three months and two cancelled checks later, we realized that they were sending my checks to an address I hadn't lived in for 18 years. So . . . triple check that the payroll company has your correct address.

By the way, since many residuals are calculated as a percentage of "distributor's gross," rather than producer's gross, it's entirely conceivable that you'll owe residuals on money that you, the filmmaker, haven't even seen yet. Good luck with that!

Archiving

Despite what your spouse may supportively, but adamantly, suggest about "dumping all that crap," you actually *do* need to save a lot of what went into your film. If you're lucky, your distribution deals will eventually expire and you'll be able to redistribute or relicense your film on some fancy new format or delivery platform that hasn't been invented yet. Want to sell all your cool 16mm film school shorts to people with Apple watches or Google contact lenses? Then you probably need to find those films and figure out how to digitize them first.

Whether you've got reels of negative, boxes of miniDV tapes or stacks of hard drives, the first step is figuring out where to put them. Yes, a nice temperature-controlled salt mine would be ideal, but that kind of archiving is expensive. You can also think about donating to the Library of Congress, your film school alma mater or a few other independent archives, like the Sundance Institute and UCLA. The problem is if you archive everything off site somewhere, then you can't easily access it (like when you decide to ditch indie filmmaking and want to recut your reel to get a TV directing job). So if that means keeping stuff in your garage, attic or other not-exactly-temperature-controlled environment, make sure everything's at least a foot off the ground to avoid flooding catastrophes, and a couple of feet under your ceiling to avoid overheating. You should also make sure that at least one copy of your finished film itself (your most valuable asset) is with one or more of your producers or parents, preferably outside of your nuclear attack radius. Get another nicely labeled new hard drive stuffed with all your deliverables that you keep on a middle shelf. Indie vet Matthew Harrison writes serial numbers on all his hard drives and keeps a running FilemakerPro document with the directory of each drive. Then he puts the drives neatly in U-Line cardboard boxes, with the serial numbers on the side.

For a more passive, long-term approach, you could also do what many TV networks are doing and store everything onto LTOs (Linear Tape-Open), which are magnetic tape cartridges that are supposed to outlast both hard drives and HD tapes. Indie filmmaker Sean Baker (*Tangerine, Starlet, Take Out*) has put most of his films (including all the extra deliverable materials) onto LTOs, with a TextEdit file explaining what everything is. Then he's locked them in a safety deposit box at Chase Bank. Those LTOs should last 30 years, but whether anyone will still have an LTO deck to read them is another issue. Filmmakers Kelly Reichardt and Larry Fessenden did a successful Kickstarter campaign in 2015 to raise $20,000 to do a new telecine of Kelly's first film, *River of Grass* (shot on 16mm). But they've had the support of their distributor Oscilloscope, as well as Sundance Collection at UCLA, and Tribeca helping them with the logistics and Kickstarter perks.

Escaping Your Distributor

You will spend half your life as a filmmaker trying to get a distributor, and the other half trying to get *rid* of your distributor. At some point, your distributor will screw you, whether willingly or unwillingly. If it's the former, you'll likely first need to hire an accountant to audit the distributor; hope you have reserve money set aside for that! Then you'll need to get a lawyer to extract yourself from the distributor's iron grip (and not just your old production attorney, but quite possibly a litigator, too).

Just as likely, your distributor will be a well-meaning company that's been struggling and will simply go bankrupt. I remember one call I got from a distributor of my film *Open House*: "Hi, Dan! The good news is we owe you $50,000. The bad news is we're going out of business next week. Bye!" Either way, you'll need to keep your lawyers and accountants on speed dial for at least the next ten years.

Dissolving Your Entity

Even if your distributor doesn't screw you, all your annual costs will mount up, especially taxes and accounting. Probably within three to five years, you'll realize that you're spending more money to keep your corporate entity alive than you're bringing in. Time to write a nice letter to your investors and officially call it quits and move on. But to dissolve your LLC still requires new forms and filings with your state and the feds, and it takes time and some effort to deal with it (in other words, a few more billable hours for your accountant and/or lawyer).

The nice thing is, you're still (more or less) allowed to keep your bank account open even for your dissolved LLC, as long as it's not an interest-bearing account. Keep at least a few hundred bucks in there as a reserve to pay for hard drives, lawyers, auditing fees or otherwise setting up the next distribution deal. Your investors will be cool with that, as long as you explain it well. More importantly, keep your Excel spreadsheet updated with how much you still owe your investors, actors, crew, and of course any other debts you might still owe.

Rinse, Repeat

When all's said and done, try to make sure you're still left standing with the rights to your film. If you were smart, you put a clause in your original LLC agreement that says *you* keep the film after dissolution and hopefully your distribution agreements say you keep the rights when the distributors go bankrupt. Also, either before or after you dissolve the LLC, make sure it's clear who gets the copyright to the film after you die. Who knows? Maybe the baby you conceived on the festival circuit will want to remake your film in 50 years and will be looking for a clear chain of title.

Within the last couple of years, I was able to sell the digital rights to my first film from over 20 years ago, *omaha (the movie)*, to aggregator FilmBuff, which eventually got it onto Amazon, Fandor, Hulu and Vimeo. FilmBuff was able to digitize my old Betacam telecine (which had been stored for decades on a middle shelf in my garage and thankfully worked just fine). I still had an Excel spreadsheet with my investor allocations. I was able to track down all of the living investors and the heirs of a couple of the dead ones. I sent them very tiny checks (for some, as little as $8.14) and I wrote them a nice long cover

Don't Get Distribution
Opening Night Poem, Slamdance 2008

Whatever you do, *don't* get distribution!
Maybe it's me, but that's my intuition
Advice like that blows minds four dimensional
Not what you'd expect, wisdom unconventional

But take it from me, a gimpy indie film vet
Allow me to assist you, to aid and abet
Your decision in case people comes propositioning
They've got a fat check-book, they've come acquisitioning

If they take you to Zoom, and not Main Street Deli
If they wear nice cologne and if they're not smelly
Instead of the Super Bowl, they watch lacrosse
If they show up with a lawyer, and his name is Sloss

They'll offer you hits on their clove cigarettes
Then they'll write the contract on cloth serviettes
They'll grab you by the jugular, or artery carotid
They'll make you sign on the line that is dotted

The deal's announced, and it's got lots of digits
But there's something inside you that's still got the fidgets
Just a few niggling things that are slightly haunting
The deal now is done, but the deliverables daunting

You've got great ideas for your run that's theatrical
But the booker they hired is quite geriatrical
They said thirty cities, with one in Nebraska
But the twenty-nine others are all in Alaska

They promised a hefty commitment to marketing
Told you what demographics that they were targeting
For your film about punks who shoot up margarine
They took out an ad in AARP Magazine

With the DVD now it is your chance to edit
"Put in what you want!" in Park City, they said it
Sorry, no room for your commentary with sailors
Because it turns out that they have 22 trailers

They forget to send screeners to all of the press
This doesn't seem prudent, but you acquiesce
Why, they're professionals!
Trust them!
They've done this before!
But that nagging voice inside you implores

Their team of pros who market and sell
Don't have a clue and they don't give a hell
And what profits there are, they have camouflaged
'Cause the company's gone bankrupt, it's been arbitraged

letter, explaining how the film had performed, and what its cultural impact had been over the years.

Perhaps it wasn't the financial success we'd all hoped it'd become, but it did serve as a launch pad for Slamdance (which, by the way, all my investors had signed off on when we started the festival). Some of our crew members went on to amazing careers in their own rights (i.e. Rian Johnson, Jon Bokenkamp and James Duff) and the film paved the way for such Nebraska filmmakers as Alexander Payne and Nik Fackler. The investors were thrilled to hear from me, and one (who himself had gone on to a very nice political career, ultimately serving as a Secretary of Defense) wrote me a very moving handwritten thank you letter. So, as I raise money for subsequent films, I can point to my long-term commitment to my first investors as yet another selling point to my future investors and backers. It may take them 20 years to recoup their first eight dollars, but at least they'll get their K-1s on time!

Aarghh! How to Beat Film Pirates at their Own Game

If you're like most young-ish filmmakers, you grew up and matured in an open source world of Napster, YouTube and BitTorrent. Whether it was making mixtapes for your college girlfriend, or ripping CDs and DVDs with your film school pals, "appropriating media" might have been a way of life for you to consume and share your favorite songs, films and TV. You scoffed at FBI warnings on VHSs and mocked MPAA PSAs. You've mashed up, mixed up and just plain stolen your way through the early twenty-first century with nary a tinge of regret: Hell, we're living in an open source world, and this is just one way to stick it to The Man!

Until you started making movies yourself. And tried to sell them. Guess what, mister and ms? You *are* The Man now!

For indie filmmakers, dealing with the world of piracy is a bit more complicated than for the big corporate studios. For them, they know it's bad, and they can quantify just how bad it is and they can afford a room full of lawyers to do something about it. But for indies, we have a more nuanced relationship with pirates.

Your rights are tied up for twelve more long years
And during that time, and between all the tears
You take solace in knowing that at least you're better off
Than the unemployed acquisitions execs (whose lawyers were Sloss)
So take it from me, just have fun with your flick
Just play it for friends and with friends have some kicks
A couple of fests, or a podcast instead
'Cause if you sell your soul, you'd be better off dead.

On the one hand, as "entrepreneurial producers," we want to make money from our films and have a fiduciary responsibility to our investors to make sure we get paid every time someone watches them. On the other hand, as "gifted and misunderstood Artists," we want to share our Art with the World—the more people who see it, the merrier! And on the third hand, as "content creators," we just want to expand our personal branding and rack up our hits, clicks, tweets and swipes.

The first step to dealing with piracy is to figure out if and where your film is being pirated. Try Googling your film, and be sure to use Search Tools to narrow down the search to the last week or month. Depending on how common your film title is, you may also need to search by your own name and/or your actors' names. Also, get to know how your film title translates into other languages and search those, too. In general, there are a few ways your film is going to show up pirated: Either streaming directly on a site, as a downloadable file, or as a shared file through BitTorrent. And if you're really lucky, your film will show up on the streets of New York or Shanghai as an actual DVD! Here are a few different strategies that indie filmmakers have used to various effect:

The Whack-a-Mole Takedowns!

The most obvious and blunt approach to dealing with piracy is to send Takedown notices. Known formally as DMCA Letters (named after the Digital Millennium Copyright Act which loosely governs media piracy), it's a fairly standard and simple three paragraph letter in which you state clearly that you own the copyright, that some bastard is pirating you, the URL you found it at and how you demand that they take down the file or face your wrath, indignation and fury. There are a number of sample DMCA Takedown templates online, so it's easy to write. Then, just keep a copy on your desktop and get ready to use it. Often.

The hard part is figuring out where to send the Takedown letter. If the film's streaming on even a pseudo-legit site, just find the contact info and send it directly there. You never know; maybe your distributor put it up there and just

never told you? Or maybe your distributor sent it to an aggregator who sent it to a sub-distributor who got it on a site that's actually legit. Believe me, if it is actually there legally, they'll let you know. But usually, if it's there illegally, they'll just quietly take it down within a matter of days.

Harder to deal with are the shadowy class of dubious streaming sites whose contact info might be in Cyrillic or Mandarin if it exists at all. For these, and Torrents, the best you can do is send the DMCA Takedown to Google so at least the pirated version isn't easily searchable. Google makes you go through a gantlet of questions first, and then intimidates you with a warning about a website called the "Lumen" database. (It was formerly known as "Chilling Effects," which sounded too creepy. But Lumen was the name of Julia Stiles' victim/serial killer in *Dexter*, season 5, so it's *still* creepy.) Lumen lists DMCA Takedown notices, but if you really are the copyright holder, don't worry about it. And *then* you have to have a Google account, sign in and finally send Google your Takedown notice with the appropriate URL. At least by then, you can list multiple URLs (up to a thousand) and send them all in at the same time. You do also have to list one legitimate site where your film appears, assuming you have one. Google will usually take the sites down from their searches within a couple days.

Unless you have the time to spend an hour a day at least once a week, this will ultimately prove to be an elaborate game of Whack-a-Mole. Torrents will crop back up, Russian sites will respect your DMCA notices with all the integrity of a porous Ukrainian border, and Google will continue to intimidate you with Lumen warnings. Even if Julia Stiles is *in* your movie.

Oh wait, won't your small distributor handle all this? Not likely. Small distributors don't have the time or personnel to deal with this, and besides, according to the DMCA, *they're* not the legal copyright holders, they're only a licensee. And your foreign sales agent has even less time or legal standing to deal with it. If you need more help, groups like Copyright Alliance and Creative Future are good resources and advocates.

Make Money **From** *the Pirates*

When you're sending DMCA Takedowns to Google, the one site that it won't handle is YouTube, which seems ironically frustrating, because Google *owns* YouTube! But it turns out the reason is they want you to go directly to YouTube which is trying to get copyright holders like you to sign up for a program called ContentID. If you sign up for the program, you upload a reference version of your film, and then YouTube will automatically find pirates and give you the option to take down the site, monetize it (take a percentage of their ad revenue) or do nothing. The system gives you the flexibility to keep up with and engage with fan mashups and tributes, while still monetizing or blocking major offenders. As filmmaker Ellen Seidler wrote in an extensive analysis of ContentID,

"Sounds too good to be true right? Well, kinda . . . but, despite overblown claims and systemic weaknesses, it's better than the alternative (rampant piracy)."

Rich Raddon, a former indie film producer and director of the Los Angeles Film Festival, took his career one step further. He now runs a Venice-based company called Zefr whose sole job is to have hundreds of employees scour YouTube sites for clips of mainly studio films, and get a piece of the ad revenue for their studio clients. Tubers keep their fun mashups, the studios and YouTube make money, and it took an old indie filmmaker to put it all together and hire a couple of hundred other indie filmmakers to make it happen. Zefr even has lunch-time filmmaking seminars for its employees and actively encourages them to keep making movies themselves.

The Fakeout!

So, if you don't have endless time and patience to keep sending Takedown notices, what else can an enterprising filmmaker do? The team behind Rick Alverson's Sundance film *The Comedy* (including my *Between Us* producer Mike Ryan) had a brilliant technique. They simply uploaded their own version of the film with the appropriate title, keywords and tags. The first ten minutes of the film were exactly the same as the movie itself, but then all of a sudden it cut to a 90-minute shot of star Tim Heidecker standing on a boat flipping off the camera. The point was, the filmmakers successfully crowded and confused the marketplace. Anyone who spent the time to download the boat version wasn't likely to risk that time to download a second version that may or may not have been the real one.

Indie filmmakers aren't the only ones using this technique. My pal Frédéric Forestier's big-budget film, *Astérix aux Jeux Olympiques* (aka *Asterix at the Olympic Games*), was released by French distributor Pathé in 2007. As a preventive strike against pirated copies of the film, Pathé secretly released 4,000 versions of the film on Torrent, but only the first three minutes of each were real. Psyche!

Using the Pirates to Screw Your Distributor!

Ever find yourself in a position where you have your three-hour director's cut of the film and it's awesome? And then your producer or distributor will come along and Harvey Scissorhands a new 85-minute version to shoehorn into a few theaters before going full-on VOD to cut their losses? Sure, you could plead your case in the court of public opinion, get lots of press and maybe, just maybe, your directors-cut version gets seen at a festival in 20 years during a posthumous retrospective. But that doesn't do you much good, does it? So don't get mad, get even!

Create an airtight alias, upload your director's cut version onto Torrent and let the pirates champion your cause by watching *your* version of your movie! On the one hand, your distributor or producer will go ballistic, as should you ("I'm shocked, shocked that there is a pirated version of my film! I can only imagine some intern at the distributor's office posted it. I'll sue!"). But if it goes well, you'll generate even more publicity for the film, more people will see both versions of the film and it'll cement your legendary outlaw status. Your distributor will make more money, and you become a hero. It's a win–win. So much so, that even if you completely get along with your distributor, you might want to collude with them in creating two different versions of the film and orchestrating this exact scenario.

Embracing the Pirates!

If you can't beat 'em, join 'em. My pal Richard Schenkman made a terrific film a few years ago called *The Man from Earth* which succeeded in getting a US distribution deal from Starz/Anchor Bay. But a DVD screener got ripped and posted on Torrent sites a couple of weeks before the official release date. From out of nowhere, the film jumped over 7,000 percent on IMDb's MovieMeter, garnered an 8.8 rating and became a bona fide viral hit! While all the piracy made it impossible for him to sell foreign rights to the film (definitely a downside), Richard did figure out a way to get PayPal contributions from many of those pirates and fans who loved his film. Not a fortune, but "enough to equal what should have been the license fee from a small-to-mid-sized European country." As Richard put it, "If that's not crowdfunding, what is? Sure, it's after-the-fact, but it's not sales. It's donations. It's love." Eventually, his film broke even financially, and he used its widespread fanbase to finance a Kickstarter campaign for a TV series pilot.

Slut-Shaming the Advertisers

How do all these piracy sites survive? Largely through ad revenue, and many of those ads are from mainstream bluechips companies like insurance agencies, household items and other big-name consumer brands. The brands' ads show up through online placement companies, ranging from Google and Yahoo! to other smaller agencies. The big brands get plausible deniability and the money keeps flowing; approximately $227 million a year by one estimate. But increasingly there's pressure for this common practice to end. From *The New York Times* to *Adweek*, there has been a steady drumbeat to start blacklisting piracy sites much the same way online advertisers successfully steer clear of porn and hate sites.

I saw one pirated version of *Between Us* on YouTube—and mind you, not even a good one. It had a grey-ish center through the whole movie, the aspect

ratio was wrong and it cut off the last two minutes of the film (all in an effort to thwart YouTube's ContentID). But the title of the file was quite clearly "*Between Us 2012 Full Movie.*" Any halfway decent algorithm could have figured out that it was a pirated feature film. Before the movie ran, there were pre-roll ads, typically 30 seconds each.

My interns and I ran a little experiment and refreshed the page 128 times. The ads ranged from retail (Amazon, Walmart, Fry's) to technology (Google, BlackBerry, T-Mobile) to consumer products (Charmin Ultra Soft, Gillette, Schick). But far and away the most prevalent sector to advertise—32 percent of all ads—were film and TV companies. There were ads from Fox, Warner Brothers, Netflix, NBC, Universal, Hulu, BET, TVLand, Lifetime, et al. Most of these are member companies of the MPAA, which itself virulently fights piracy. If MPAA companies are putting that much money into supporting YouTube (which gets most of the ad revenue), then they've got the clout to demand that YouTube do a better job of policing piracy on its site. If you're looking for examples of how piracy hurts the indie filmmakers more than the studios, this is one way: The studios can always advertise on piracy sites or pirated YouTube films, knowingly or not. So at least they're getting some value out of piracy. But indies don't have the money to advertise films on pirated versions of Hollywood films.

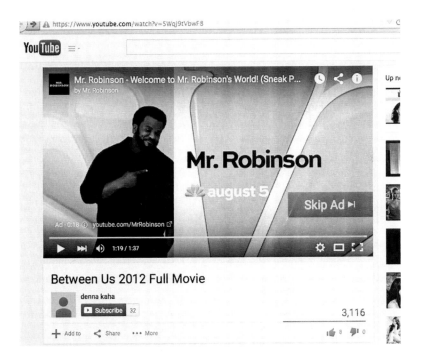

NBC's preroll ad on a pirated YouTube version of *Between Us*

Frame grab pirated from YouTube

As a lowly filmmaker, what can you do to help slut-shame these advertisers? Make notes, take screengrabs and start entering the conversation directly. Send invoices to the big name companies for your cut of their revenue. Compile YouTube videos of mainstream ads on piracy sites. Put out press releases and write your own op eds in *The New York Times*. Oh, and mention their names in books like this one (hey, you pirate-lovin' butt wipes at Charmin, I'm talking to you!). All publicity is good publicity, and if you're part of the conversation, your film will be, too.

Make Piracy an Essential Element of your Release Strategy

As I've said before, the era of expecting to make money off of your films is largely over. "Investing" has been replaced by "backing" a film. Instead of finding rich dentists to fund your film and promising to make them money, and then failing miserably at it, filmmakers now are relying on crowdfunding campaigns to finance part, or in some cases the entirety, of their budgets. And with "backers" rather than "investors," you have neither the obligation nor the capability to actually pay them back. Besides, you'll probably never see residuals from your "legit" distributor anyway. So, really, does your film have to make *any* money at all? If the answer is no, then that frees you up considerably just to get the film out there to audiences by whatever means you can. After all, most festivals pay no screening fees, and we all happily clamor to get our films screened in as many festivals as we can. Is that really so different from piracy?

Especially for shorts, webseries, but also for some features, it might make more sense as an artist or content creator just to get your film released for audiences to enjoy. Isn't that why you got into filmmaking to begin with? Well, maybe.

When I made my short Marine recruiting satire *The Few and the Proud*, I played a couple of film fests and turned *down* a $500 offer from Atom Films, which wanted all rights in perpetuity. Instead, I put the film on YouTube, eschewed any ad revenue and tagged it such that to this day it is the number one video that shows up when you Google "Marine recruiting." Four years after posting it, it consistently gets 400 views a week and has been seen by close to half a million people, far more than have ever seen all my features put together. The comments reflect that the film is being seen and enjoyed by active duty Marines and Army personnel all over the world—hardly the audience that would have seen the film in Park City. For me, this was the right medium getting to the right audience at the right time. As an artist, what more could I want?

On the feature side, Greek filmmaker Stathis Athanasiou released his film *Alpha* under a Creative Commons license, which essentially means it's free. The movie, which played at Thessaloniki and Slamdance festivals to critical acclaim, was largely crowdfunded, and to the extent that it's ever going to make Stathis any money, it'll be through transmedia performances of the film along with live

musicians and actors performing in front of the screen projection. So, if you want to see a pirated version of the movie, you can, but you'll miss out on the full performance experience.

Use the Pirates to Pimp Your Merch

You could use the model that musicians have had to deal with since the age of Napster: If you can't make money selling your music, then commodify your performances and pimp your merch. Filmmakers need to adapt to this model, too. If festivals are screening your film for free, then go to a local college and get paid for a guest lecture and sell DVDs or tote bags after each of your screenings. Most festivals will have no problem with that. Or go the Kevin Smith route, create a massive fan base, and just go on the full-on lecture touring circuit. And if the pirates are showing your movie, then place your *own* ads for film-related T-shirts, DVDs and other fun extras. You can use Google ads as easily as Procter & Gamble, so keyword and tag your ads so they'll show up on piracy sites and searches, and start pimpin' your own merch. So, if your movie *Aardvark Alert* is already showing up on Torrents, then at least place Google ads for direct sales of *Aardvark Alert* T-shirts to show up every time someone searches *Aardvark Alert*!

Use Piracy to Charge for Product Placement

Remember, for 65 years even TV shows were given away for free, over the airwaves, and the networks figured out how to make money through commercial time. Nobody called that piracy! So, another solution is just to build more product integration and product placement into our films, no matter how "artsy" we'd like them to be. In that regard, the more a film is pirated, the better it is for the corporate sponsors. Getting companies to realize this and actually put hard cash into independent films is still no easy feat. They barely do it for Hollywood films, and they're less likely to on indie films. But in a bizarre way, the proliferation of piracy makes it an easier case to make. Every time someone watches *Between Us* and sees my characters drinking Pabst Blue Ribbon and/or driving a BMW, those companies are getting free advertising—regardless of whether the film is seen on a pirated site or through legitimate means. The challenge for me and other indie filmmakers is to quantify those eyeballs and charge appropriately for them on our next films. Ahoy, mateys, it's the wave of the future!

What Operas and Sharknado Can Teach Indie Films

When agent Liesl Copland coined the term "analytic black holes" to describe VOD analytics, she was right. Filmmakers and even their distributors have no idea how many people are seeing their movies, paying how much money,

and barely knowing when and where they're available. We have more luck quantiying how many people are pirating our films on BitTorrent!

Theatrical presentation is still the emotional gold standard of independent film. We make movies to be shown in front of audiences. OK, but other than playing at film festivals (always the best audiences anyway), and a handful of expensive four-walls in LA and New York that largely get ignored anyway, is theatrical distribution dead?

No! But it may have to change. Thanks to George Lucas insisting on digital projectors for Jar Jar Binks, and then the studios using 3D bonus fees and other financial incentives to muscle digital projection into theaters around the world, the era of film prints is just about over.

One side effect of this changeover is that more and more theaters are now nimbly able to show one-time only streamed events like operas, symphonies, live British theater, concerts and sporting events. Finally, theaters are starting to figure out what to do with all their extra screen time on weeknights and afternoons. Aha! Opera lovers are retirees who don't mind going to a 6:30 pm Met performance of Shostakovich's *The Nose* on a Wednesday night. They can hit the early-bird special at Coco's and head to the theater for a show! Typically, one of these events will screen just once or twice, but in hundreds of theaters simultaneously, often as a simulcast of a live performance.

Companies like Emerging Pictures have been streaming indie movies over the last few years into art house theaters and non-traditional venues. But a newer phenomenon is for other distributors (and filmmakers directly) to take advantage of these built in "satellite" networks for one-night screenings in multiple theaters simultaneously, particularly in otherwise mainstream multiplexes.

After its twitterific Syfy Channel debut, *Sharknado* took advantage of the buzz and played for one night only on Regal theaters nationwide (through satellite distrib NCM Fathom Events). Indie stalwart Richard Schenkman's horror film *Mischief Night* screened appropriately on October 30, 2014, through SpectiCast's 1,600-screen network before getting its VOD and TV releases.

SpectiCast also screened my film *Between Us* to 29 mostly suburban Marcus Theatres locations throughout the Midwest. I billed it as our "Massive Midwestern Big-Screen Blitz" since it screened from Fargo to Sheboygan, Omaha to Columbus, and Elgin to Oshgosh. I'm a firm believer in filmmaker Jon Reiss' theory that we need to "eventize" our theatrical presentations. Technology permitting (which it wasn't) I even tried to do a multi-theater Skype Q&A afterwards, to give some added value that wouldn't be available on VOD or streaming. If nothing else, it was nice to show the film in its full 2.35 aspect ratio on big screens with 5.1 surrounds. I didn't work with an award-winning ASC cinematographer just to make an iPad video.

Now would I rather have my movie play for full-week runs in Chicago, Madison or Minneapolis "traditional" art house theaters? Sure. The bottom

line though is it's become increasingly tough for smaller films to get—and then hold—bookings in traditional art houses, when they're up against the Weinsteins and Searchlights of the world. But as Scott Mansfield, head of Monterey Media, my distributor for *Between Us*, put it, "wouldn't you rather play one night in a town, rather than not play a week there at all?" With so many mid-market urban art houses controlled by Landmark or a handful of bookers, it's nice to see some fresh competition in the marketplace. Monterey similarly had luck bundling my film with Sundance winner *This is Martin Bonner* and Toronto alum *The Lesser Blessed* at other theaters through similar networks.

When I did self-distribution on my first film *omaha (the movie)*, I bucked tradition, playing mostly in the Midwest, and frequently at mainstream AMC and Carmike theaters. Screening indie films (self-distributed or otherwise) was a new concept to them then, too, but they were eager to give it a try. In a pre-digital age, that was with 35mm film prints, usually playing for a full week at a time. In the end, we worked our way out to the coasts and wound up at Laemmle's in LA.

These experiments may not generate earth-shattering box office bonanzas. By some accounts, even the *Sharknado* midnight screenings barely grossed $200,000 (speaking of analytic black holes, it's hard to get firm numbers on these things). But if a multiplex has to keep its lights on anyway on a Monday night, it can't hurt to have a unique excuse to sell some more popcorn. These operas and symphonies are doing surprisingly well. And if we're not careful, there won't be any screens left for indie films. Instead of complaining about digital projectors and how no one goes to the movies anymore, let's take advantage of this unique moment in film technology. *Sharknado* and Tosca? You've got company!

When in Doubt, Create Your Own Oscar

Speaking of analytic black holes, like all good Hollywood stories, this next one starts with me

Analytic Black Hole
Opening Night Poem, Slamdance 2014

Last fall in Toronto in a widely seen speech
It's worth looking back now, I do beseech
From the Morris named William who's on an Endeavor
Came an indie film agent whom I think is clever

With last name of Copland and first name of Liesl
She used PowerPoint as a modern-day easel
And so like a Cassandra who prophesied doom
A hush fell upon the Canadian room

We were excited last year for Video Demand On
It's a topic she did quite a bit then expand on
VOD, it would save us! We were told, and we trusted
That the numbers made millions if they weren't adjusted

On Netflix, on Amazon, and yes even on Hulu
With new viewers from Maine all the way to Honolulu
So much for projection, that ship has sailed
Theatrical is dead, that model has failed!

We'd rather use iPads that load like molasses
Or watch latest movies on our new Google glasses
We complained for so long about noisy crowds
But where are they now when film comes from the clouds?

Alone in your bedroom, with no one behind you
Watching alone, is that what we're resigned to?
But if this model works and we all make more money
Then that's OK, the future looks sunny!

Everyone would watch movies on platforms transactional!
But when the math would come in, it looked more . . . *sub*tractional
Say wait a minute, we said to distributors
Where's the cash flow? Where are the contributors?

It's complicated now, so we rely on aggregators
But we couldn't keep track, we became abdicators
You see, with no numbers, no way to keep track
This system is silly, this model is wack

"Analytic Black Holes!"
She warned, she exhorted
Were not self-sustaining, could not be supported

You can't know if there's money, if you don't know who's watched,
And if there's no money, then the system is botched.
Distribution is grim as a model financial
The evidence is there, more than circumstantial

To expect to make money on films that are indie
Is like trying to twerk in the age of the Lindy
But now I say to you, my fellow makers of stuff
Keep your pants on, not like Shia LaBeouf

Don't worry about not having all this silly data
The death of VOD: an accompli that is fait-a
So who'll see your movie? When all's said and done?
Film festival audiences, that's who, my son.

They're still ongoing, and coming in droves
They see each fest as a film treasure trove.
If you're smart, and you are, you've abandoned investors
You're strictly Kickstarted, There's nobody who pesters

So if no one makes money, so what, and don't sweat it
You did it for fun, to write, shoot and edit
We're artists, I tell you, with a capital A!
It's time we expect to be treated that way

Starving, yes, sure, but praised for our work
Like operas or painters, I say without smirk
So ignore the doomsayers, ignore volumetrics
Just marry well, someone say, in obstetrics

But if you must make a movie then at least name it well
Start with a letter that's alphabetical
Because VOD, and I know this sounds horsie
Favors film titles that begin A, B or C

So I've got a suggestion, a money-winner for certain
If you're lucky people will think it's pervertin'
About a filmmaker, Hollywood takes its toll
Just bend over my friends, and call it
"Analytic Black Hole"

coming out of a proctologist's office. You see, I'd made my little ultra-low-budget, real estate musical *Open House*, starring such notables as Oscar-nominee Sally Kellerman, *RENT* star Anthony Rapp, cult idol Ann Magnuson and several other fancy actors. This was the early 2000s when Danish directors were making handheld video Dogme 95 films that looked like crap but went on to win the Palme d'Or, so a musical Dogme film where the actors all sang live on set seemed like a good idea at the time.

Open House played at a few festivals and audiences and critics generally loved it. Distributors saw it, liked it and all said, "That's nice, kid, but what are we supposed to do with a real estate musical?" I dunno, I said—we're at the height of a real estate bubble—maybe release the movie?! Or maybe sell it to India, where there are a billion people who all love musicals? But no luck. The film was in limbo; in movie purgatory. So there I was, depressed, disillusioned and I was walking funny from the proctology visit.

Just then, I got a call from my dear friend Arianna Bocco who was working for Miramax at the time (this was shortly before the Weinsteins had a falling out with Disney and started their own eponymous company). I said, "Arianna, what a surprise! Are you calling because you're now interested in picking up *Open House*?" She laughed, "Not in a million years." "So why are you calling me?"

"Dan, have you ever heard about an Oscar category called Best Original Musical?" "That's crazy talk," I told her, "I've never heard of such a thing!" She explained, yes, it's true! The category Best Original Musical had been on the Academy books for a few years but had just never been activated. Activated? I wondered. Yes, she said, the rules say that in any given year if there are five original musicals, then the Academy activates the category, three

films are nominated, and one wins. The catch is that the Academy has very strict, arcane rules about what it takes to be eligible to be one of those five films.

The film truly has to be an original film: It can't be an adaptation of a Broadway play, and it can't have any unoriginal or repurposed songs. So, *Chicago* wouldn't have counted. *Moulin Rouge* wouldn't have counted. Hmm, so what does it need? I asked. Well, the rules say that the movie needs to have at least five original songs, by the same songwriting team, and the songs have to tell the story of the movie—they can't just be superfluous soundtracks.

The reason Arianna was calling me was that Miramax *thought* they had two films that were going to be eligible for the category. They were looking for a few patsies like me to fill out the category, get it activated, secure the nominations and win. As it turned out, *Open House* was indeed completely eligible for the category. It was a truly original film musical that had about a dozen songs and all by the same songwriting team (myself included). So I told Arianna—yes! Count us in! I mean, everyone knows that if you get an Oscar nomination, *some*body will pick up the film for distribution so they could slap "Academy Award Nominee" on the poster and DVD box. And these were 60 percent odds that we'd get a nomination!

As it turned out, though, the two Miramax films, for different reasons, were *not* eligible for the category. They were screwed. But by now, this sounded like a terrific idea, so I took the ball and ran with it. I just needed to find four other films. How hard could that be?

Go Team America!

I got in touch with our old Slamdance progenitors Trey Parker and Matt Stone who had just done their puppet movie *Team America: World Police* for Paramount. It had six songs, and that made it eligible. So we got them to submit, with Paramount's blessing.

Disney had one of the last of their big-budget, hand-drawn animated films that year, a rare flop called *Home on the Range*, with music by Alan Menken. Keep in mind that this entire category was largely spawned when all the big Disney animated films of the mid-1990s kept winning all the best song *and* best score Oscars—largely, by Alan Menken, who by now had eight Oscars. Of course, the rest of the music branch—all the classical composers—were sick of him winning best score just because "Under the Sea" was deeply hummable. With the thinking that the other studios were going to emulate Disney and make more animated musicals, they decided to carve out this Best Original Musical category. But animation followed the Pixar model rather than musicals, so it became this odd orphan category. Bottom line: We got Alan and Disney to submit. (Thanks in part to their publicist, the late Ronnie Chasen, who was mysteriously killed six years later at a traffic stop in Beverly Hills.)

I'd worked with Neil Young and his producing partner Elliot Roberts before (they were at one point going to produce my modern-day postal western *Stamp and Deliver*). I got Neil and Elliot to submit their obscure 16mm film *Greendale* that Neil had directed (under his *nom de film*, "Bernard Shakey"). It was a companion piece to an album he did, but technically he shot the movie before the album came out, which made it eligible. The Academy forced Elliot to show up at its Wilshire office with a box of receipts just to prove the relevant dates.

So that was four films. We needed one more. The obvious thought was, screw it, I'll just make another one! How hard could it be?

This was August of 2004 and the deadline for the Academy was December 1 at 5 pm. I was still busy going to film festivals with *Open House*. As a matter of fact, I was getting ready to go to the Oldenburg Film Festival, in northern Germany, just three weeks from then.

I realized I'd be going to the festival ("the Sundance of Germany") with one of my actors, Robert Peters, and my British producing partner, Stephen Israel. I'd been before, and I knew the festival always had a lot of great German actors and musicians there. I was friends with the festival director, Torsten Neumann, who's a producer in his own right. So we said, let's just shoot another musical . . . *in Germany*!

Big in Germany

We came up with a simple improvisable storyline about an American "happiness consultant" going on a book tour who falls in love with his German publishing liaison. We wrote 12 songs in two weeks, and Torsten cast some actors and rock stars—by telling them some version of the story that gave the strong impression they were going to win an Oscar. The bulk of the crew consisted of me, with a video camera in one hand and a mic in the other. Sometimes we wrangled a German to hold the mic. We prerecorded CDs with instrumental versions of the music and brought our own battery-powered boom box. The actors would sing live and improvise the dialogue. We spent four days in Hamburg and four days in Oldenburg, and even shot on the Air France flight to Europe (right before they lost our luggage). We realized we could get a free layover in Paris, so we wrote a song for Paris and we'd shoot there for a day, too.

But of course, we didn't want to make a movie good enough to take votes away from *Open House*. It just needed to be eligible. So, we had nine days to make a *bad* German musical. It was like a real life version of *The Producers*.

Mareike Fell, our lead German actress, who'd been assigned to us (a very talented, successful actress in her own right), picked us up at the airport. She said all the German actors were very excited about this Oscar campaign. But she said she had two problems herself: She can't sing, and she can't improvise. "You're perfect!" I said.

We had all kinds of adventures in Germany: Filming at the biggest triathlon in Europe; shooting a rock concert in a deserted bank; paparazzi and teenage fans chasing us around (apparently our German actors were much more famous than we thought); spending a crazy night in Hamburg's red light district with Germany's most celebrated pimp (who punched out a man stuck in traffic who dared cut in front of the pimp's Bentley); and French gendarmes nearly confiscating our camera for filming at the Eiffel Tower.

But we got a version of the film, at that point titled *Big in Germany*, in the can, and started to slap together a cut of the movie in just a couple of months. Things got complicated when goodhearted, but stubborn, Robert decided that he wanted to get the director credit on the German film. Owing to a quirk in the SAG contract, he basically could demand whatever he wanted or the film might never have been finished. Tough decision for me, but basically it came down to whether I needed to be the one who got the directing credit, or whether I needed to get the film done in order to serve the higher purpose. So I capitulated. Robert got the director credit, and I got my fifth film to activate the Oscar category. This also guaranteed that the film (at least in a rushed first cut) wouldn't take any votes away from *Open House*. I'd found my own patsy.

A Tree in the Forest

Meanwhile, I still had to get *Open House* qualified under the basic rules of the Academy. That meant it had to play for a minimum of one day a week, for one solid week, in LA County. Thanks to George Lucas doing *Star Wars Episodes 1–3* movies digitally, the Academy had just changed their rules to allow for digital projection and not just 35mm film. But there were only 12 Academy-qualifying digital theaters in LA, and 11 were controlled by Technicolor, which had a lock on what they played. And they weren't going to play my little movie. But the 12th theater was the Magic Johnson Theater on Crenshaw Boulevard, and we made a deal with them to show *Open House*.

But it was still going to cost money (close to $2,500 to get the film onto a server, and another $2,500 to rent the theater), and I also needed to raise money to mail VHS tapes to all 270 members of the Academy's music branch and take out a couple of small ads in the trades. I figured I needed about $10,000 in total.

I was still going to US festivals with *Open House*, so I reached out to local real estate agents in both Austin and the Hamptons, where we had back-to-back screenings that fall. In less than two weeks, I found one realtor in each place to put in $5,000 in exchange for editing in a two-second shot of their "Open House" signs in our title sequence montage. And of course, they all loved being able to tell their friends that they were a part of this crazy Oscar campaign. Quickest money I ever raised! It also proved that (a) you *can* make money at a festival even when you screen out of competition and (b) it's never too late to do product placement!

In the end, we got the film transferred for free (thus saving $2,500 of the money we'd just raised), but still had to pay the Magic Johnson Theater. It's not unique to do a "stealth" Oscar-qualifying run in LA—lots of small films do it with the hope that they'll do a wider run if they get a nomination. So we didn't invite anyone to the screening, and we screened at noon every day for a week. If you want to guarantee that nobody will see your movie, screening a micro-budget real estate musical with an all-white cast in the middle of South LA is a good way to do it.

I attended almost all of the screenings just to make sure they went off as planned. But on the one day that I came a few hours late to the theater, I asked the manager how the screening had gone. She said there was a new projectionist on duty that day and she didn't know if he'd pushed the button. They hadn't sold any tickets, so she really couldn't say for certain whether it had played or not. No one in the non-existent audience had complained, and the projectionist wasn't sure. *WHAT?!?* The Academy is such a stickler about the seven-consecutive day rule that I called the Oscar staff to ask the philosophical question at hand: If nobody is there to not see a movie, how do we know that the movie didn't screen? It's the ultimate tree-in-the-forest question. The Academy was bewildered and thankfully told me to hang up and pretend that I didn't call them.

Race to the Academy!

Back to *Big in Germany*: We finished it up, and on December 1, at 4:55 pm, Robert and I raced to the Academy building on Wilshire. The elevators weren't working! So we ran up the staircase to the seventh floor and slapped the DVD on their desk. "Oh crap," the dutiful staffer said. "You did it. You bastards pulled it off." You see, we'd been telling them all along that we were going to make the German film—we knew that they're so persnickety for the rules, we didn't want to run afoul one iota. They never believed for a second that we would pull it off. "What kind of an idiot makes a bad German musical just to get an Oscar for his other film?" Me. I'm just *that* kind of idiot!

A few days later, the Academy staff sheepishly took the five films to the Board of Governors' meeting. All the studio heads were there. Tom Hanks was there. Important Hollywood people like that, who want to do everything in their power to cut down the number of awards and the length of the Oscars—not *add* a category.

So they took a look at who had submitted: Trey and Matt, who showed up on acid wearing *dresses* the last time they got nominated. Neil Young, who *didn't* show up the last time he'd been nominated. Alan Menken, who has *too many Oscars*! And this punk-ass, Slamdance-starting Mirvish fella who showed up with two films whose *combined* budgets don't add up to the cost of an Oscar gift basket. There's no way in hell they were going to give *any* of us the Oscar!

So they cancelled the category.

In a rather awkward response to the press, the Board of Governors claimed that none of the films were "Oscar-worthy" (despite the fact that four out of the five had Oscar nominees involved in the films). But ultimately the Academy said they were their rules and they can change them if they want.

We Wuz Robbed

We were dumbfounded. Naturally, we took umbrage. Because really, what else could we take?

So with umbrage comes press: The *LA Times*, *Variety*, *Hollywood Reporter*—even Reuters picked up the story and it ran all over the world. Because everybody loves to read about the Oscars.

We didn't want to get too upset, though. With *Open House* we were still eligible for Best Song, and by now everyone in the music branch of the Academy knew who we were. The *Hollywood Reporter* said we were a dark horse among the top 16 contenders for Best Song. With the support of Matt Stone, the IFP, Slamdance and other groups we even launched "The Indie Musical Challenge" as a way to encourage other filmmakers to make musicals in the future (and we got more press for doing it). My parents and young daughter helped me mail out 270 VHS tapes to Oscar Music Branch members. Ultimately, we only spent $7,500 of the $10,000 we'd raised to do the campaign. Despite best efforts, when the Best Song nominations were announced, we didn't get one.

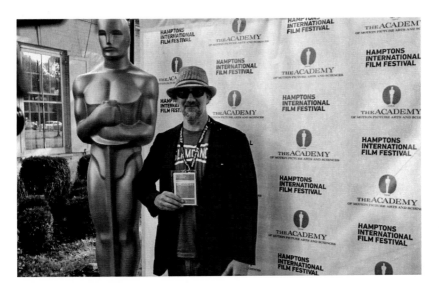

As close as I've come to an Oscar

Photo: Michael David Lynch

Transmedia Verse
Opening Night Poem, Slamdance 2010

"Indie film is dead," is among the prevailing opinions
The majors killed all their minors, the minors fired all their minions
But take heart, all us filmmakers, for the beast is not dead
The audience is still there, they just need something else instead

So we need to adapt, to these changing days
Where no one sees movies, and worse yet, no one pays
But no need for outrage or being defiant
Just be flexible, be limber, be supple, be pliant

Film, TV, and web, those distinctions are fuzzing
Transmedia's the word, that's the one that is buzzing
What's that you say? What the hell is transmedia?
Did you just make that up? Is it even in Wikipedia?

Yes, I tell you it's real, just ask Lance Weiler
He'll concur with a grin, that guy's a good smiler
Transmedia's what you call it, when you haven't succeeded
In traditional formats, and your career has receded

But no one has to know that. Say you're "omni-platformable"
But be confident when you say it. Don't come off as lukewarmable
Just create a character or style or gimmick or story
Be it funny or sad or a little bit gory

Maybe it's clever, or dumb, or maybe just crap
But then put it on iPhones, and call it an App
A radio play, or maybe graphic novel!
Tell everyone you're successful, and successes don't grovel

It could work well on Twitter, now that'd be a feat
Despite no Writers Guild contract for 140-character tweets
Forget the label "filmmaker." You'll have to sooner or later
Even though talent don't sleep with a "content creator"

And give up those dreams of Oscar and Emmy
Your transmedia heroes are now Ashton and Demi
So embrace the future and give it a hug
Write a book, sing a song, sell a tote bag or mug

It took a while, but all the press and hoopla did lead to getting distribution for *Open House*—from the newly formed Weinstein Company of all places! Now they could put on the DVD box in great big letters: "From the film that changed the rules of THE ACADEMY AWARDS!!" The DVD became a cult hit, and the Weinsteins liked it so much they raised the idea of turning it into a Broadway or Off-Broadway play. We even made a video game based on the movie.

As for the German film? Robert, the actor who took the directing credit, spent a year recutting it, and it actually turned out pretty good, too. Originally titled *Big in Germany*, but renamed *Half Empty*, it played the festival circuit, won a prize at the Santa Barbara International Film Festival and also got a small distribution deal. There are a lot of stupid reasons to make a movie . . . and we found one.

To this date, I believe I'm the only filmmaker who's ever actually *made* money on an Oscar campaign for a film that nobody saw, in a category that didn't exist.

How to Make Money *From* an Oscar Nomination

So, what happens if you *do* succeed in getting an Oscar nomination? If you're like my pal Adrian Belic, who's feature documentary *Genghis Blues* got nominated for an Oscar in 1998, you're still milking that award to this day. The movie was about globetrotting Adrian and his brother Roko traveling to Mongolia with a blind Chicago bluesman to meet up with a Tuvan throat singer. Since then, Adrian's made a couple of other excellent films, but largely he's traveled the world to film festivals, conferences and other gatherings on the strength of being an "Oscar nominee." Remember, the only thing better than being on the festival

circuit is being on the jury circuit, and the only sure way to get on the jury circuit is with an Oscar nomination under your belt.

Speaking of belts, Adrian is a guy who once took the Trans-Siberian railroad to the Vladivostok Film Festival, and then two days later got chased out of town by the Russian oligarch husbands of the festival volunteers he'd "befriended." He's had countless other adventures, including sneaking into Afghanistan a week after 9/11, live-transfusing his rare blood type into a South Sudanese orphan undergoing an amputation, and skiing across Liechtenstein. Adrian makes the Dos Equis World's Most Interesting Man look like a DMV desk clerk. Has Adrian made a dime? No. But for at least four straight years, he managed to live rent-free in a two-story Beverly Hills poolhouse behind a mansion (with complete access to the tennis court and race car, of course).

Benh Zeitlin, who nabbed an Oscar nomination for his first feature, *Beasts of the Southern Wild,* toured every country in the Caribbean as a pretext for location scouting his next movie. Film commissions and tourist bureaus opened their arms to Benh, who island-hopped for months. Who wouldn't want him to turn their placid little island cultures into his next Oscar-worthy film? I personally caught up to Benh at the Trinidad and Tobago Film Festival, where I was

Adjust your ambitions, and get out of your slump
Be happy your film screens at a diesel gas pump
Now don't blame me, I'm just the messenger
"We must have ideas, vision, and courage," once said Arthur Schlesinger

I don't mean to pressure, I don't want to coerce
But we'll all do just fine in this transmediaverse!

Adrian Belic shooting the EPK for *Between Us*
Courtesy: Bugeater Films

on the jury. See, even on the strength of being a filmmaker "who changed the rules of the Oscars," you can still scrape by on the jury circuit!

But how do you actually make hard cash by getting an Oscar nomination? The gift bags are sometimes worth over $100,000, but usually the good ones only go to the prestige nominees for actors and actresses. If you've got a short or a doc, you'll be lucky to get a comb and a Target giftcard in your Oscar bag. You might pick up some more interesting things at so-called gifting suites that pop up around LA (and Park City) during awards and festival season. But since 2008, the IRS has been cracking down on the big-money gifts.

When it comes to *actually* making money on the backs of the Oscars, your options are limited. Even if you win one, you're banned from actually selling it. But in 2001, shortly before the Academy Awards telecast, I came up with a foolproof plan for one nominee in particular to make a boatload of money.

The Accountant

Still reeling from the Enron scandal, the Arthur Andersen accounting firm was losing clients, cowering under Congressional investigation and facing a criminal indictment from the Justice Department. This was a company desperately in need of some good PR. And they were in luck! With arguably a billion people around the world getting ready to watch the Oscars, it was the perfect place to rehabilitate the company's image, and there was even an Oscar-nominated film that year called *The Accountant*! OK, so it was a live-action short film whose award would probably only be announced somewhere between a Debbie Allen interpretive dance tribute to *A Beautiful Mind* and an ABC promo for *Barbara Walters' Most Fascinating People*. But an Oscar is an Oscar, and more importantly, an Oscar speech is an Oscar speech. A guaranteed 30 seconds of prime time TV real estate.

The Accountant had won the Jury Prize at Slamdance that year, and I knew the director was a very nice fellow named Ray McKinnon. I suggested to Ray that he kindly offer to sell some of his prime "thank you" time to Arthur Andersen.

At the time, ABC was selling commercials for $1.4 million per 30-second spot, so that worked out to $46,666.67 per second. Perhaps Ray could get up to the podium and say something to the effect of, "I'd like to thank the fine folks at Arthur Andersen for inspiring my film. When it comes to accounting, you can trust Arthur Andersen!" Speaking at a reasonable clip, Ray could spit that out in about eight seconds and charge Arthur $373,333.36. That would more than cover Ray's investors, do wonders for the embattled company's image and still leave 22 seconds for Ray to thank his actual friends and family.

But why stop there? Why couldn't Ray sell all his "thank you" time? I mean, if you were Ray's mom, would you rather be thanked at the Oscars or have Ray thank Ralston Purina and pay you a cut of the $47,000 worth of time it

took to say "Ralston Purina"? And Ray shouldn't have limited himself just to companies. Why not offer his services to any individual who's always wanted to be thanked at the Oscars? Why not *someone else's* mom, as long as they were paying?

Ray also had a chance to boost his earnings in the apparel department by simply wearing a "Trust Arthur!" yellow button on his lapel. Adding up all his potential placement and thank you offerings, Ray could have netted half a million bucks easily. Arthur Andersen wound up spending far more than that in legal fees every day for the next ten years and still went out of business.

As for Ray, he did in fact win the Oscar in 2001! Sadly (for him, I suppose), he ignored my advice and didn't make any money from either his attire or his thank you speech. But the Oscar did help his career. After acting in such shows as *Deadwood* and *Sons of Anarchy*, and directing the feature *Chrystal*, Ray is probably best known now for the award-winning Sundance Channel show he created, *Rectify*. Short of winning an Oscar, though, is there any other way for indie filmmakers to migrate to TV?

Top Ways to Become a TV Director and Take a Meeting

Some filmmakers spend their summer vacations on a Greek island, lounging with their Peloponnesian lover while watching old VHS bootlegs of Cassavetes films. I, on the other hand, spent my summer vacation of 2014 going to at least one meeting a day in order to become a TV director. Mind you, I'm not giving up on indie film. But it's common knowledge that TV is the new indie film: It pays well, it's more creative, it's more instantly gratifying and all the cool kids are doing TV now. Hell, the Amazon pilot list alone has more Sundance alumni directors than the Sundance Channel!

Thankfully, I had some guidance in this process. My buddy Matthew Harrison (after winning a prize at Sundance, he directed a few episodes of *Sex and the City*—before it was cool to be a TV director) had attended some panels at the DGA to reboot his own TV career. I went to a great one there, too—led by Miguel Arteta (who's successfully straddled the indie film and TV world for over a decade). Between Matt's exhaustive notes, Miguel's inspirational words and some tips from a few other filmmaker pals like Joe Russo and Joe Carnahan, who've both had success with TV, I was set for my summer of meetings!

Here's my simple distillation of how to turn your burgeoning lifestyle as an indie filmmaker into a lucrative and creatively fulfilling career as a TV director! And even if you're still looking down your nose at TV, most of these lessons will come in handy prepping for *any* Hollywood meeting: Agents and managers, development and acquisitions execs, and even ad agencies and production companies.

Recut Your Reel

If you've directed one or more reasonably decent indie films, you've got plenty of material already for a killer reel. Remember, the execs who will be watching these have limited time and even shorter attention spans. They're like teenagers with expense accounts. So keep your reel under three minutes, or shorter if you can. Show as many recognizable "name" faces as you can. Show you can use movie toys: Cranes, dollies, green screens or drones. Show explosions and guns. Use cool swish-pan sound effects and awesome music. And zombies! Remember: You're going to be competing with veteran TV directors who cut their reels with footage from *actual* TV shows they've already directed. So your reel has to look at least like you know what TV looks like. When you're done, stick it on Vimeo.

Redo Website

You know how you spent three years begging thousands of people to "like" the Facebook page for your last Canon 7D mumble-slasher epic? Forget it. You need a simple, clean, easy-to-find website about *you*. It literally should be www. FirstnameLastname.com. If you don't have your own URL, get it now. And then find an elegant web design for it. Not a blog—a website. So forget Wordpress. I used something called CargoCollective—it's meant for visual artists, but works well for filmmakers and handles Vimeo embeds nicely. I'm sure there are plenty of others. Whatever you do, just make sure you can control, design and update your own content easily. Don't farm it out if you can help it. And if you really can't do it yourself, find a cool Syrian refugee web designer in Europe who's already motivated to finish jobs quickly and move on.

Once you have a site, keep the main page elegant: The first thing people should see is your reel. Make sure it works well on mobile devices, too (since chances are someone will be seeing it while on the toilet). Something that will make you look like a *real* TV director is to have extended scenes or clips that are grouped by genres that "sound" like familiar TV genres: Drama, Comedy, Multi-Cam, Sci-Fi, Docu. It doesn't matter that all those clips could have come from your one and only movie. Deconstruct your film (or films) and recut them into these genre-specific reels. These can be a little longer than your main reel, but also consider what would happen if an exec stumbles upon your Comedy reel first on Vimeo or through an email link from a colleague, without seeing your main reel? So make them all graphically and stylistically consistent, and don't reuse the same material much, if at all. Make sure there's a graphic with your web URL at the end or beginning of each reel. Finally, your website should have your basics: A bio (a *short* one), photo and contact info. Check out mine at DanMirvish.com for an example.

Update Your IMDb and Wikipedia Pages

The first thing any exec will do is check out your IMDbPro page (sometimes you can even hear assistants typing it in based solely on your caller ID . . . before you've even said hello!), so make sure it looks impressive: You've won awards! You work nonstop! Your StarMeter number is better than theirs!

Anything you can do to goose your page, you should. Did you loan a boom pole to a friend for her film? Then make sure she puts you in as a "production consultant"! Just optioned a script from your cousin? List it in development! Do the photos of you look like you're standing next to a big camera? They should! Make sure your contact info looks impressive *and* will actually let someone contact you, even if that means it's your own cell phone and email. Put your reel up on IMDb, too. As for Wikipedia, make sure you have a page. Trust me: The execs won't, and they'll be impressed that you do. Make sure your Wikipedia page or IMDb bio have at least something cool in there that humanizes you: You ran for the state senate in Utah, you survived Ebola in Liberia, or your grandfather invented cream cheese.

Make a List

Whether you have a stone-cold agent at CAA, or you're cold calling yourself, start making a personal list today. Do it in SimpleText or TextEdit: This is a list you will keep long after your cracked bootleg of Word 11.1 has ceased to function on your Apple self-driving iCar's display screen. Organize it by network, studio, production company (or "pods" as they call them in the TV biz) and individual shows and showrunners. Write down every assistant's name and email: An assistant today will be running HBO in ten years. And she will be flattered that you remembered when she was an assistant. (And then she will call security about the stalker.)

Execs in the TV world move around a lot—so write down any identifying notes that will refresh your sense memory ("obsessed w/ Dunkin Donuts," "red hair / went to Wellesley," "awkward silence / don't stare at nose!") Most of your research you can do through a combination of IMDbPro (which usually has phone numbers but rarely emails) and *Variety* (which often says what shows execs are working on). If you know one name at one company and you search it on LinkedIn, it frequently will tell you other names at the same company or people with similar job descriptions at other companies. But all these sources tend to lag, so Google the trades to see who's been upped, nixed or ankled lately. And remember that CAA agent you have? When she dumps you in a year, she's not just going to hand you her digital rolodex. So develop your own contacts and relationships personally.

With Whom to Meet

You need to realize that in order to get a job as a TV director, you have to be approved and hired by a holy triumvirate: The showrunner, the network and the studio. Most people will tell you that showrunners (or on some shows it's the "producing-director") have the most say, but even they need to get approvals from the suits at the network and the studio (and/or production company). Even if you have a personal relationship with a showrunner, you're still not a shoo-in. I had one showrunner friend tell me point blank that he'd never stick his neck out for a friend: Because if the friend screws up the episode, it's his own ass on the line. So, by all means, get in touch with your old film school or festival buddies who are now running shows. But know that the first thing they'll tell you to do is get cozy with the suits and then come back to them.

Speaking of showrunners, *if* you can find a producing-director on a show or a regular director, it might be worth "shadowing" (essentially standing around eating craft service). But if you already know how to direct, then shadowing really only leads to an actual job if you've previously laid the groundwork with the suits and the showrunner. Otherwise, you're putting on ten pounds for nothing.

And which execs to meet with? At some companies they'll divide their ranks between "development" execs and "current series" execs—in which case, you want the current series ones (who handle shows once they're already up and running). They're less sexy than their development counterparts, but they're also more likely to hire you. In other companies, though, they may divvy up their staff by genre: Comedy or Drama execs might handle both development and current. And the bigger companies and networks will divide into both comedy/drama and development/current.

There's been a lot of talk about diversity in TV directing lately. One manager told me that you can't book your first job "unless you're a woman, minority or friend of JJ Abrams." So I talked to an award-winning Latina feature director friend and she said it's *still* impossible to break in: What happens is the few minority directors get hired *a lot* and aren't exactly motivated to mentor new directors who will then take those precious jobs. The ones who are women *and* "of color" count as twofers in the unofficial diversity quotas, so they tend to get hired more than white women. *Canadian* white women, though, also count as twofers if the show they're on shoots in Canada, which requires a certain percentage of local cast and crew.

But skinny American white Jewish guys? Forget it. I talked to an indie film director friend of mine who actually *is* friends with JJ Abrams. He said try as he might, even JJ couldn't get him hired on one of his shows! (Turns out, one of JJ's other friends had screwed up a prior episode.) In other words, everyone's looking for an excuse to say no. You just need to give them a reason to say yes.

(And if that means strenuously not denying you're transgendered one way or another so they can meet some sort of quota, then so be it. What are they going to do, look under the hood?)

How to Get the Meetings

Remember, part of these execs' jobs is to hire new directors. Not often, and probably not you. But they have to meet directors somehow, and they rarely go to film festivals (they're prepping for pilot season during Sundance/Slamdance, and shooting them by SXSW). Also, when a director saunters in, these are simple, low-stress meetings that all execs like to have in their schedules from time to time. Make sure they know you're asking for a "general" (exec-speak for "general get-to-know-you meeting") to meet as a director, rather than being there to pitch a show. Essentially it's a first date, and neither of you are expected to put out.

By and large, TV execs are inclined to hire (or at least consider) indie film directors: We know how to work on a tight schedule, shoot nine pages a day and do it on a budget. I asked one TV exec on the Fox lot if they ever meet with commercial directors and she just laughed. She said she'd even rather have an indie director than a successful studio one, who only knows how to shoot a page-and-a-half a day and demands a fresh latte with every take.

One secret is to know what time of year is least stressful for them to take meetings. Summer turns out to be great for this—a lot of people are on vacation, but it's usually the senior execs. So if the person you want to meet with *is* in the office, then it might mean that the boss who's usually breathing down his or her neck is in the Hamptons. By the time fall rolls around, many suits are too busy taking pitch meetings for new shows to meet with directors. By winter, they're all obsessed with pilots. And by late spring, they're busy meeting with writers who are all scrambling for staff positions. But as many of the cable networks and production companies go on a year-round schedule, it's hard to predict who's going to be ready when.

You just have to be patient and persistent. You're never going to be a top scheduling priority for them. Your meeting will get cancelled, sometimes with only an hour's notice. Don't get mad. Just contact the assistant (or have your people do it) and calmly ask for the boss's next "avails." And give your "avails," too. But don't look desperate: Never give the impression that you're just sitting around in your underwear all day playing Minecraft just waiting for Hollywood to call. Instead, hint that you're meeting with other, more powerful networks or getting your next feature made. I had some meetings that were rescheduled over 20 times over the course of three months. But by the time you get in the room, no one will remember how you got there.

Joe and Anthony Russo

NAME DROPPER

Joe and Anthony Russo were two guys from Cleveland whose film *Pieces*—a little ultra-low-budget 16mm noir comedy—made it into competition at Slamdance in 1997. They seemed to bring half of Cleveland to the festival (in reality, the rather extended Russo family) all wearing matching black-and-white baseball caps with the *Pieces* title. They all walked up and down Main Street promoting the film and they packed their screenings. Steven Soderbergh, who was at Slamdance with *Schizopolis*, came to a screening, liked the film and told the brothers he'd take them under his wing. Sure enough, when Soderbergh set up his production Company, Section Eight, with George Clooney, the Russos moved to LA and got an office there.

Meanwhile, Anthony and Joe stayed actively involved with Slamdance, serving on the programming committee for several years. They were known for their idiosyncratic taste and we all loved arguing with them about what they did and didn't like. They would always watch films together, and since Slamdance had a policy that all film submissions had to be watched by a minimum of two people, they had the power to make or break a filmmaker in a single sitting. In one memorable episode, they rejected a certain film that no one else saw. Thankfully, that filmmaker would reapply to the festival the next year, get in, win an award and make five billion dollars on his subsequent films. After that regrettable incident, Slamdance instituted "the Russo rule" which states that the two people who watched a particular film couldn't be siblings or spouses.

While working with Soderbergh and Clooney, the Russos made *Welcome to Collinwood*—a remake of an obscure Italian film—and in order to get the financing, producer Clooney had to be in the film. Despite this star power, and decent reviews, the film didn't do well at the box office. But enough people in the TV world saw it and the Russos started directing single-cam comedies at a time when the TV schedule was dominated by multicam sitcoms. They directed the pilot for *Arrested Development*, and were directors and producers on that show for years, winning Emmies and setting the standard for what would become a wave of single-cam, indie-film aesthetic TV for much of the mid-2000s. After spending years in TV and an occasional film, they got the gig from Marvel directing *Captain America 2: Winter Soldier*, which oddly enough starred Robert Redford as the bad guy. They've since gone on to do the next *Captain America* and *Avengers* films.

The Russos have been loyal Slamdance supporters over the years: Anthony met his wife Anne when she starred in the Slamdance '98 film *Pariah*. And the brothers have been back several times, appearing at my annual Hot Tub Summit, and our big 20th Anniversary appearance with Christopher Nolan, who to this day has no idea that the Russos were the ones who slowed down his career. Anthony—who now lives down the block from Nolan—is petrified he'll find out.

Research Their Shows

No matter who you meet, make sure you know what shows are on their companies' slates. So if it's a network, look up their schedule. If it's a production company, check IMDbPro and Google the trades. While you don't have to have an encyclopedic knowledge of all the shows (that's more for when you're up for a specific job on a specific show), you do need to be able to fake a passing knowledge of all of them. So watch a few episodes on the company's website, or Hulu, or your favorite Russian piracy site. Or in most cases, just watching season trailers or "best of" scenes on YouTube will give you a sense of the shows, as well as having a passing knowledge of key showrunners, actors and character names.

Research the People

Spend some time researching the exact people you're meeting with. Check them out on IMDb, *Variety* and LinkedIn. See if you have any mutual friends on Facebook (but *don't* friend request them . . . that's just creepy). Google them to see where they worked before, when they got promoted to their current position, what schools they went to and if they've been involved with any scandals you should avoid making reference to. And then do the same with the assistants who helped set up the meetings. (When you walk in: "Hey, don't I recognize you from 'SC'? Go Trojans!")

Go Early

Plan to go early to your meeting. In LA, we all know traffic can be a nightmare, so plan accordingly. But it's more than just not being late (a definite no-no). When you get to the building, take a quick photo of the building directory and staff directory if there happens to be one. Later that day, zoom in and I guarantee it will give you other ideas of people to meet with, and sometimes their direct extensions: "Hey, I was just over at Sony and your name came up . . ."

Once in the office lobby, make nice with the receptionists—they will be important assistants next week, and execs by year's end. When you walk in, chances are you'll literally be looking down at them. Resist the Seinfeldian temptation to stare down their shirts, or smirk at their prematurely receding hairlines.

Of course, if you happen to get a meeting with Warner Brothers TV, try to schedule it for the weekly "Smooth-Jazz Friday." The receptionist/security guard is the amazing Don Bookman who's worked there for 25 years. Don's also a professional musician who's got his sax tucked under his desk. He'll serenade you in the waiting room and wish you a hearty good luck as you go to your meeting. Don is awesome! He once introduced me to another guy standing near his desk. Turns out *that* guy was the exec in charge of the new directors program at Warner Brothers TV! And be sure to ask Don about the years he spent playing in a band with President Bill Clinton's brother, Roger. During the Clinton administration, they were cultural ambassadors and Don's got a crazy story about the time they visited North Korea that rivals *The Interview* in its absurdity. What does it say about Hollywood when the most talented—and politically connected—person on the lot is the security guard?

The Pre-Meeting Meeting

If there's a couch and a chair in the waiting room, sit in *the middle* of the couch. Why? So when a team of four or five people comes in, they'll have to sit around you and talk over you. This is perfect for eavesdropping. By virtue of the fact that they're a team (often carrying some kind of presentations, paperwork or scripts), it means they're pitching a show. Which means they haven't hired a pilot director yet. Introduce yourself. Talk to them. They'll be more nervous than you. You're meeting with the same company as them, so you've naturally got the same credibility and status as they have. Exchange cards and wish them good luck. Over the course of my summer of meetings, I met studio heads, Silicon Valley investors, award-winning screenwriters and showrunner friends of mine in lobbies. In most of those cases, the lobby meeting wound up more productive—or at least more interesting—than the real one.

Check for Breaking News

You want to make good use of your early arrival time. It's easy to get distracted by the glossy Hollywood magazines on the little tables. Chances are, you haven't seen a real honest-to-God paper version of the Hollywood trades in a long time. Some of these could be collectors' items!

Instead, whip out your iPhone and do a search limited to the last 24 hours. If there's breaking news, you want to know it. Did the company just get nominated

for 15 Emmys that morning? Did the show you binged on overnight just get cancelled? Did one of their lead actors just get busted for mescaline possession on a transatlantic flight from South Korea (she swore she thought it was kimchee)?

When you congratulate them on their good news, or commiserate on their bad, you do more than just break the ice. It shows them that you pay attention to, and respect, both TV as a medium, but also the TV exec lifestyle as a career choice. No execs want to hire a pretentious indie film snob, and you've got to dissuade them of that preconception even if you are one.

Do You Take the Water?

There is an ongoing debate among my filmmaking colleagues who have faced the age-old dilemma: Take the water or don't take the water? Every assistant in Hollywood will make you this Faustian offer. Are you so low on the Hollywood totem pole that even the most basic sustenance of life has to be doled out to you in 12-ounce plastic bottles of contempt? If you take it, do you give up your soul? Have they won already? And if you don't take the water, is that a sadistic way to exacerbate the already tense relationship between the exec and the assistant? ("Wait, did my assistant offer you water? Kelly, did you offer him water?!? Kelly, goddammit, you're fired!!!!"), or is it a keen trick to expose the inner dynamics of a fraught office staff and find their weaknesses? Sun Tzu, I'm told, never took the water.

Another solution is to take the coffee. For me, I know I do better in a meeting if I'm overly caffeinated. I have more energy, I talk faster and I look more excited to be there! But, if I start drinking the coffee when the meeting begins, the caffeine will only kick in when I leave the parking garage after the meeting.

The trick is to drink your own coffee an hour *before* the meeting. When you first arrive, the assistant or receptionist will offer you water, but they'll always have coffee if you ask impertinently. Keep it simple and ass-kickin': Black, no sugar. That way you and the assistant don't have to deal with stir sticks, sugar packets or creamers, and the uncomfortable moment of looking for a little trash can just as the exec wants to shake your hand.

Because there's no cream, the coffee will be hot—if you're a wussy like me, probably too hot to drink. But fake a couple of sips in the meeting. Then, when you're rattling off humorous bon mots and indie-film horror stories a mile a minute, the exec will think it's the coffee talking and you're not just a crack addict or have unmedicated ADHD. TV execs like to know that you've got a lot of energy—especially if you're pitching yourself for comedies. If you look listless and boring, your episodes will be, too.

Choose Wisely Where to Sit

The exec may give you a cue to sit in the least powerful seat in the room. Don't take the bait. Instead, walk in the room like you own the network and sit with your back to the window (if there is one). In an ideal situation, you want the exec squinting at your backlit silhouette, not the other way around.

If they lead you to a conference room (especially if you're meeting with more than one person), go to the short end of the table that faces the door. Make the execs sit on one of the long sides, or better yet, with their backs against the door.

Whatever you do, never sit with your back to an interior glass window, unless the blind is pulled. Otherwise, the assistants are going to be signaling non-stop to their bosses that they have an urgent phone call or their next appointment just got there. But if the *execs'* backs are to the interior window, you can always nod-hello to random people who walk by the hallway. The execs will think you know their rival colleagues in the office—or worse, you're squash buddies with the boss—and they will respect and fear you more.

Wear or Do Something Memorable

As I've learned, most shows aren't going to hire a new TV director for their first season. They want the seasoned veterans for the first and even second years. And if a show's been on the air for four or more years, then all the episodes will be directed by either cast or crew members who were promised episodes. Either way, they're not going to hire fresh meat. So maybe, just maybe, a show in its third year will have one available slot!

So why do these meetings at all? Because in a year or two or five, when you're buddies with showrunners, they'll try to get approval from the network or studio, and the suits will say, "Oh, yeah! That guy with the hat, the goofy shoes and the funny Oscar story? I kinda remember him. Sure, give him a shot!"

You're playing the long game here, so the execs you meet with have to be able to visualize you if they're going to remember you. At the profound risk of sounding like a douche for calling it "personal branding," that is kind of what you need in order for people to remember you. All those IMDb credits melt together with everyone else's. But a strong photo on IMDb that looks like how you looked in the meeting could make all the difference in the world. Then again, spilling your scalding coffee on their laps and wiping off their crotches with your clammy hand will also make you memorable.

Tell Funny Stories About Yourself

TV is looking for "storytellers." I'm convinced someone in suit school taught them this. So, tell them some stories! Beginning, middle, end. One or two good

personal anecdotes will show them you understand basic story structure and that you're fun to be around. They like that.

Lynn Shelton

Lynn Shelton's first film, *We Go Way Back*, won the Grand Jury Prize at Slamdance in 2006. It was at the festival that I met Lynn, and her perennial cinematographer, Ben Kasulke, who won the Kodak Visian Award for Best Cinematography at Slamdance, too. I have fond memories of congratulating them during the closing night party of Slamdance 2006. It was a party also made memorable because that was the year I was in a wheelchair, owing to my broken leg. On my way to the festivities, I went through the icy drive-thru window at an adjacent Wendy's in my wheelchair and they refused to serve me (in rather flagrant defiance of the Americans with Disabilities Act). I went back to the party, grabbed a dozen Slamdancers with cameras (including members of our punk lesbian band Maxitit) and Wendy's still refused to serve me. Instead, they summoned four Utah State Highway Patrol vehicles that blared out, "You in the wheelchair! Pull over!" Proving that there's nothing worth doing if you're not going to get press for it, I was able to get the *Washington Post* to run my picture with a half-page article in its gossip column. I was going to get interviewed on Fox News about it a few days later, but perhaps gratefully, was bumped because Vice President Dick Cheney shot his hunting partner in the face.

Lynn and Ben are a big part of the Seattle film scene, which has been percolating for years, with never quite the highs or lows of Austin, Atlanta, New Orleans or Albuquerque as a regional hub for indie filmmaking. And like Richard Linklater and Robert Rodriguez in Austin, Lynn has put herself out there as a beacon of the Seattle film scene. She's lobbied the state legislature for tax incentives, written op-eds and helped other local filmmakers along the way.

Lynn's been a great inspiration to myself and other filmmakers for her ability to attract fancy Hollywood actors into incredibly low-budget films. When I was casting *Between Us*, some chance conversations on the streets of Park City and follow-up calls in the weeks after were a real shot in the arm for me that I was heading in the right direction on my approach to casting and budget. Lynn told me how before shooting *Your Sister's Sister*, she had one famous actress firmly committed to star in the film with Emily Blunt and Mark Duplass. With less than a week before shooting, the actress dropped out and Lynn immediately cast Rosemarie DeWitt and shot the movie that

wound up becoming a festival and critical favorite. She swore me to secrecy on the real budget of the film, but trust me, it was very, very low. And that was already her fourth feature and came after her Sundance hit *Humpday*. It was a testament that though she was already getting traction in Hollywood (she directed an episode of *Mad Men* that same year), she returned to her indie-film model that allowed her to keep making the movies she wanted to make. Like fellow indie-filmmaker-turned-TV-directors Jill Soloway and Jamie Babbit, Lynn has found a nice balance between getting paid the big bucks to direct TV episodes and develop her own pilots, and bounce back to both indie and larger-budget features.

Ask Them Personal Questions

Let's face it, no one ever asks some of these junior execs how they got into the business. And like everyone else, I'm sure they have interesting stories—working in the mailroom at Gersh, getting yelled at by Scott Rudin or doing stuntwork on a kickboxing movie in the Philippines. Laugh at their stories! Look impressed that they went to CalState Northridge for film school! Nod appreciatively when they tell you they really want to go to Sundance one day! Remember, their parents have very little understanding or respect for what they do, so at least you should.

Get Something Out of Each Meeting

You will not walk away from any of these meetings with a job. You know it. They know it. And that's fine. But that doesn't mean you should walk out empty-handed either.

If you're at a network meeting, ask the execs if they have any colleagues you should meet with at their partner studios. If you're at a studio, ask them about network execs you should meet. Maybe this was a comedy meeting, but you also want to meet with their drama person? Maybe there's a director they think you should shadow? Get names! It's not a bad idea to have a pen and scrap paper handy to write these down—either while you're sitting there, or as soon as you duck down the hall to use their restroom. (Trust me, after all this coffee, you're going to want to use the restroom before you get back in your car.)

Make sure you have some actionable follow-up when you leave: You're going to send them a screener link to your last film. They're going to send you a pilot script that's kicking around. You're going to teach them how to play squash over the weekend. Whatever it is, just make sure that the meeting isn't the last time this person ever hears from you. They may not know it yet, but you'll be back.

The Parking Garage Meeting After the Meeting

Like Bob Woodward's cryptic liaisons with Deep Throat, sometimes your best experiences are in the parking garage after the meeting. When leaving Nickelodeon, I ran into a successful director friend who was on his way to meet the execs I'd just met with. He put in a good word on my behalf and I secured an even better follow-up meeting a few weeks later. And after an altogether dispiriting meeting at HBO (they rarely hire directors outside of their show-runners' inner circles), I was surprised to actually get an offer! Mind you, it was the parking valet offering to buy my 2003 Mazda minivan, but an offer is an offer. Now, if I could just get Showtime to make a counter-offer, I will have made it in the TV biz!

The Eight Stages of Success for an Indie Filmmaker

A Viral Sensation Filmmaker—a filmmaker who's never been invited to a film festival

A Festival Favorite Filmmaker—a filmmaker who's never gotten into Sundance

A Critically Acclaimed Filmmaker—a filmmaker who's never won an award

An Award-Winning Filmmaker—a filmmaker who's never gotten a Spirit Award nomination

A Spirit Award-Nominated Filmmaker—a filmmaker who's never won a Spirit Award

A Spirit Award-Winning Filmmaker—a filmmaker who's never been nominated for an Oscar

An Oscar-Nominated Filmmaker—a loser

An Oscar-Winning Filmmaker—a has-been

Epilogue

Well, that's it. That's how to make a movie and become a wildly successful independent film director! Of course, if it was that easy, everyone would be a wildly successful independent film director. Take everything I said with a giant block of horse-licking salt. Find your own way, subvert the system and have fun doing it. You only live once, so go through life with a wink and a knowing smile.

In 1995, when my film *omaha (the movie)* was screening at SXSW, I attended a panel discussion with a veritable pantheon of indie filmmakers of the mid-1990s, all at the top of their game: Steven Soderbergh, Richard Linklater, Robert Rodriguez, Michael Moore and Gregg Araki. The first four guys regaled us with tales of wildly successful first films that propelled them to the heights of their careers. But then Araki, who was showing *Doom Generation* at the festival, spoke. He said it's such a rarity to be like those other guys and hit a homerun out of the park with your first film. Instead, you could be like Gregg and slog away at four very low-budget films until you've finally built a body of work—*a career*—that gets you the recognition you need to make a brilliant fifth film that gets you on a panel like that.

You could spend years waiting to make a big-budget film. Waiting for the right script, then waiting for the right cast and then waiting for the right money. If you take away one thing from this book, it's that it's always better to make the low-budget film than *not* make the big-budget one. As Araki said, you're building a body of work, not just a single movie. Any goofy fool with an iPhone can be a filmmaker. But it takes a cheerful subversive to be filmsmaker.

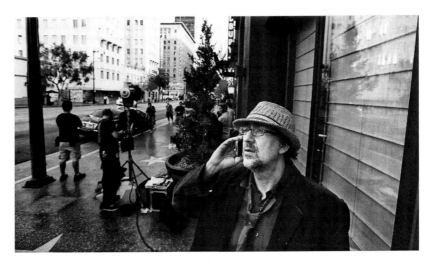

Hello, Hollywood? It's me, Dan . . . Hello? Hello?

Photo: Jennifer Rose Pearl

Index